# Beauty Power & Grace

# Beauty, Power

# & Grace

## The Book of Hindu Goddesses

### KRISHNA DHARMA

WITH ILLUSTRATIONS BY

## B.G. SHARMA

### AND

## MAHAVEER SWAMI

MANDALA
PUBLISHING

SAN RAFAEL, CALIFORNIA

# Contents

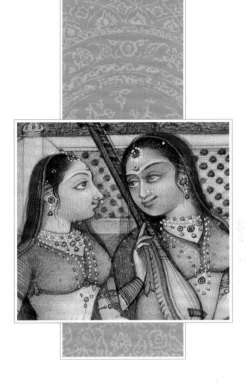

# FOREWORD

IN A WORLD OF UNFATHOMABLE MYSTERIES, THE VISION OF THE GODDESS PERSONIFIES THE QUALITIES THAT ATTRACT US TO NATURE'S BOUNDLESS WEALTH: BEAUTY, POWER AND GRACE. THROUGHOUT TIME, HUMANS HAVE PERCEIVED A PERSONAL PRESENCE BEHIND THE FORCES OF NATURE AND IDENTIFIED THEM AS GODS OR GODDESSES. PRIOR TO RECORDED HISTORY FEMALE FIGURINES, RIPE WITH CREATIVE POWER, WERE AMONG THE FIRST SACRED OBJECTS FASHIONED BY HUMAN HANDS. ANCIENT SOCIETIES OFTEN FOUND A DOMINANT PLACE FOR THE FEMININE IN THEIR SACRED LORE, AND MANY OF THEIR MOST POWERFUL DEITIES WERE GODDESSES. INDEED, THE GODDESS HAD AS MUCH OF A UNIVERSAL PRESENCE IN PREHISTORIC TIMES AS ANY GOD.

Theories abound concerning what developments in human society or psychology resulted in the rise of patriarchy and the steady decline of Goddess worship. While the question is fascinating and worthy of investigation, it is perhaps better left to more academic endeavors. Instead, the purpose of *Beauty, Power & Grace* is to introduce the female aspect of Divinity as she appears in India to contemporary readers, and by doing so, to make a small contribution toward redressing the imbalance

caused by ages of patriarchy. We hope to present a personal vehicle for those interested in connecting to the feminine aspects of Divinity and to describe the landscape of the worlds in which they reign.

Some may consider it presumptuous for a man to attempt such a thing. But in fact, the Goddess is as important for men as She is for women, if not more so. How can anyone truly appreciate

the Divine while denying the Divine Feminine? From the perspective of Hinduism it is understood that all souls have an essential nature beyond the temporary physical body—male or female—that they presently inhabit. The soul that now appears in a male body may later appear in a female body through the process of reincarnation or *samsara*. And on a deeper level we may find the soul's qualities transcend the confines of the typical gender of our experience.

The women's movement has recognized the importance of discovering or creating new religious forms that prioritize images of the feminine and thus more adequately give expression to their own spirituality. An integral part of this process has been to revive ancient Goddess traditions, for instance, the worship of the Great Mother and Nature found in so-called pagan religions such as Wicca. Others have recognized the potential for finding meaning in the goddesses of classical Greek or Roman mythology.

These seekers of the Goddess inevitably discover that the longest living and most developed traditions of Goddess worship in the world are found in India. Many are especially attracted to the iconography and rituals of the powerful warrior and mother goddess figures of Shaktaism, such as Durga and Kali.

While the Hindu pantheon is full of many other goddesses, this book is intended as a general introduction to both the popular deities and those lesser known in the western world. Their stories are gathered from various ancient texts, including the *Mahabharata,* the *Ramayana*, the Puranas and later works by devotional mystics in the Hindu traditions.

The Bhagavad Gita famously proclaims the following about Divinity: "Of women, I am fame, prosperity, speech, memory, intelligence, faithfulness and patience." Thus Saraswati, the goddess of wisdom, Lakshmi, the goddess of fortune and Ganga and Yamuna, the great river goddesses, all personify these qualities and the powers they bestow.

The goddesses are usually seen as manifestations of one Supreme Goddess, who is understood differently by the followers of India's various religious sects. The Shaktas believe that the supreme truth is most adequately expressed as a fully independent female Goddess, whereas the Shaivas and the Vaishnavas worship her as the *shakti*, or energy of the Godhead.

Like most traditional cultures, Hindu society observed a clear demarcation in the roles of men and women, particularly when speaking of ideal behaviors. As such, it adhered to the more or less universal division of sexual spheres, where the male occupies the outer, more public world, and the female rules the inner, more private world.

It is not possible in this brief preface, or even in this book, to fully investigate this duality, which nevertheless seems to be fundamentally situated beneath all cultural variants. Though the roles of men and women have evolved in modern societies, deep-rooted psychological differences in the genders remain as immutable as their physical differences. Popular books like *Men Are from Mars, Women Are from Venus* continually point this out.

Nevertheless, it must be said that cultures that attempt to enforce idealistic views of masculinity or femininity on men and women are the source of much of the world's misery. No man is psychologically or even physically an absolute male; nor is any woman the perfect image of the archetypal female as socially constructed. Both the man who tries to suppress any feminine characteristics, as well as the woman who similarly tries to uproot all masculine tendencies, put their true personal identities at risk. Those societies that enforce stereotypical roles for men and women jeopardize their vibrancy, their creativity and even their humanity. The natural inherent qualities of men and women are to be celebrated, but each individual is meant to discover and make his or her own individuality bloom.

The 19th century Indologist Max Muller coined the terms kathenotheism or henotheism to describe how Hindus seemed to worship each god or goddess as the Supreme Being, one at a time. This is the concept of *ishta deva*, or worshipable deity, by which the seeker becomes attached to the particular form of Divinity revealed to them, appropriate to their spiritual need. The particular genius of the polytheistic worldview is that the multiple forms of gods and goddesses allow us to recognize that human beings, like them, are individuals and can seek personal and spiritual fulfillment through a variety of different paths.

But whatever the superstructure of Hinduism, with its countless gods and goddesses, its substructure is unitarian. The authors of the Upanishads, India's sacred wisdom, intuited one undifferentiated truth underlying all existence. They did so fully aware that this world is one in which everything comes in pairs, in dualities of pleasure and pain, loss and gain, life and death and male and female. While these dualities exist primarily in this material world, they are seen to have their origin in the eternal, spiritual world.

One of India's most influential philosophical systems, Sankhya, puts great emphasis on the dualism of Nature and Spirit. It associates Nature with the feminine and Spirit with the masculine. As the goal of Sankhya is for Spirit to become free of Nature, this dualism has degenerated through time to a generalized fear and distrust of womankind in Hinduism, especially among those who follow the ascetic paths of yoga.

For the Vedantins, however, this is not the highest understanding. The Divinity that underlies this duality is neither male nor

female in the bodily sense. We are the ones projecting those designations upon the Divine. The ancient text *Satapatha Brahmana* states:

> *In the beginning, there was one Soul. But alone, it was not happy. it desired a second. So it grew until it took the shape of a man and a woman locked in embrace. And so the One Atma divided into two parts: man and woman. And from that pair came all this universe.*

In the vastness of India's cultural and spiritual landscape, many traditions that recognize and worship the Goddess have remained almost unchanged for thousands of years. These traditions see the power and beauty of the Goddess as one with God and reflective of a universal truth that male and female are simply different aspects of one supreme, absolute truth.

Finding the psychic unity symbolized by the embrace of the primordial Divine Couple is what Carl Jung called the *coniunctio oppositorum*, the "union of opposites." According to psychologist Karl Stern, the androgynous nature of the Godhead indicates that polarity in union is an expression of the fullness of being. Plato, in his *Symposium*, tells the powerful myth of the splitting of the original androgynous being, which has doomed all men and women to seek their "other half" for as long as they live.

The famous Tai Chi icon, showing the harmonious unity of Yin and Yang, cleverly symbolizes this idea, even including two dots reminding us that nothing is ever absolutely one thing, and that its opposite lies hidden within. The Sri Chakra *yantra* described in the eleventh chapter is another great symbol of the integrated unity of opposites, the harmonizing of spirit and matter. Furthermore, another famous symbol of this unity is found in the Ardhanarishwara, the combined form of Shiva and Shakti, as well as in the devotional tradition of Vaishnavism that celebrates the unified form of Radha and Krishna.

The very pervasiveness of this idea in the world's esoteric traditions, though often obscured by other conceptions of the Deity, is deeply revelatory of human psychic and spiritual nature.

As the author is an adherent of a specific Indian religious tradition, Gaudiya Vaishnavism, his vision of the Goddess has been shaped by the theology revealed in that school. Founded by the mystic Sri Chaitanya, this school was inspired as much by his ecstatic personality as by his teachings. In time he was seen to personify the union of God and Goddess in his own person. His official biography, *Chaitanya Charitamrita*, explains: "Radha and Krishna are one in their identity but they have separated themselves eternally. Now these two transcendental identities have again united in the form of Sri Chaitanya."

In the mystic tradition that grew up around this inspiration, though Radha was understood to encompass all aspects of the Goddess within her, it was specifically the powers of beauty, love and ecstatic joy that were identified as her supremely defining characteristics.

Though the Vaishnava concept of Divinity is often thought of as fundamentally masculine—God as creator, maintainer and destroyer of the world—a closer study reveals that it is the Goddess who ultimately shows her superiority through the quality of her love and beauty.

Krishna Das, Sri Chaitanya's biographer, summarizes this mood as follows:

I am the complete spiritual truth, full of unlimited joy, but Radha's love maddens me. The strength of that love is unknown to me and it always overwhelms me. That love is my teacher and I its dancing pupil. Radha makes me dance in many ways. Her love is all-pervading, which leaves it no room for expansion, and yet it still expands constantly. There is certainly nothing greater than Her love, which is devoid of pride. She is the abode of all love and although I experience great joy in being the object of that love, Radha's joy is ten million times greater than mine. I hanker to taste Her joy but I somehow cannot. If therefore I accept Her mood and become the abode of love like Her, only then will I be able to taste it. Only then too will I be able to experience the way She sees me and feel the happiness She feels when She sees my love for Her.

Thus, the Vaishnava concept of the Goddess declares that both masculine and feminine qualities are necessary ingredients for spiritual progress. Nonetheless, the qualities generally associated with the feminine, such as love, compassion and humility are considered the most essential.

In the balance of inner and outer worlds, it is ultimately in the inner world that the individual finds fulfillment. In bringing some of the most loved and frequently told stories about the Goddess to the western world, *Beauty, Power & Grace: The Many Faces of the Goddess* endeavors to provide a taste of that fulfillment to its readers.

The Publisher

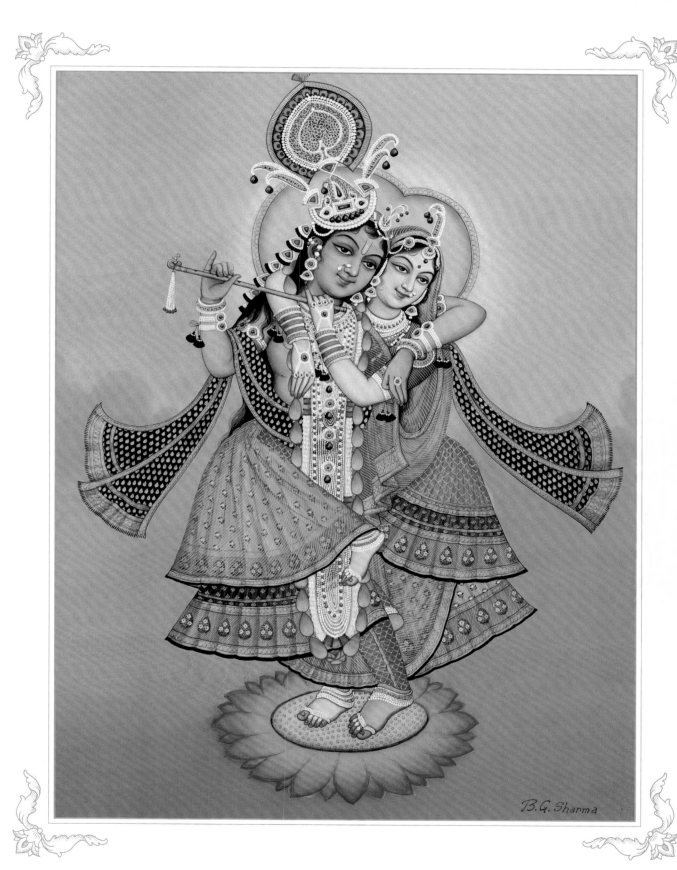

B.G. Sharma

*vande tāṁ draupadī-devīm*
*pāṇḍavānāṁ pati-vratām*
*yā sadā dharma-rakṣārtham*
*satyārtha-śaraṇāgatā*

*I bow down to Draupadi Devi, the devoted wife of the Pandava brothers,*
*who always took shelter of the Supreme Truth in her search for justice.*

# DRAUPADI

A FEW YEARS AGO, INDIA WAS STRUCK BY A STRANGE PHENOMENON. AT PRECISELY THE SAME TIME EACH WEEK, THE ENTIRE COUNTRY WOULD VIRTUALLY GRIND TO A HALT. OFFICES CLOSED, SHOPS STOPPED TRADING, AND THE MARKETS EMPTIED. TAXI AND RICKSHAW DRIVERS ABANDONED THEIR VEHICLES IN THE MIDDLE OF THE ROAD. EVERYONE SEEMED TO BE SCURRYING TO FIND THE NEAREST TELEVISION SET, WHERE THEY WOULD JOSTLE FOR A PLACE AND THEN SIT, TRANSFIXED. IN SOME AREAS, A SINGLE TELEVISION WOULD BE SURROUNDED BY HUNDREDS OF PEOPLE WHO PRACTICALLY SAT ON TOP OF ONE ANOTHER IN ORDER TO GET A BETTER LOOK AT THE SCREEN.

What was the reason for all of this? It was the weekly showing of India's epic, the *Mahabharata*, which had been serialized for television. Even though it is said to be five thousand years old, this fabulous tale, with its mystical sages, gods and goddesses, heroes and heroines, showed that it was still able to mesmerize Indians of all creeds and classes. The allure of the *Mahabharata*, however, is not limited to India, and with authoritative translations now available, this ancient story is quickly gaining popularity in the West as well.

The central heroine in this sacred history of times long past is Draupadi, the divinely born daughter of the mighty king Drupada. Draupadi is not a goddess in the normal sense that we might understand. She is not worshiped on any altars and you will not find her name included in the Hindu pantheon. However, as you will discover from the stories told below, she was an extraordinary woman with an abundance of godly qualities. As with many other such personalities described in this ancient literature, she is said to be

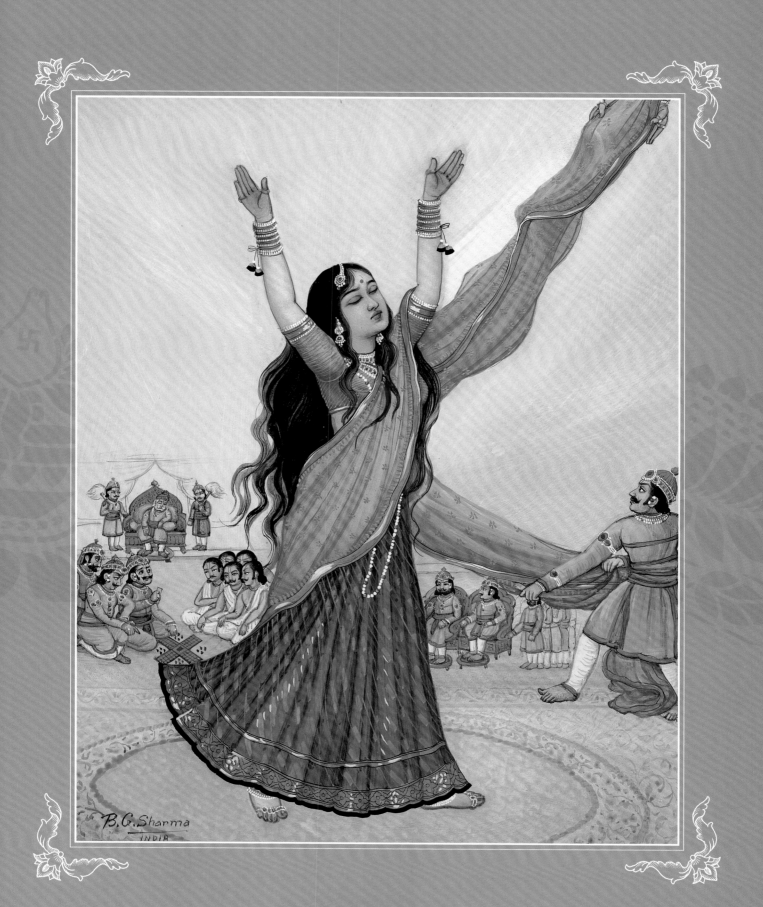

a divine incarnation coming to act as a perfect role model for human society.

Draupadi's wonderfully human example is one that both men and women can follow. In the face of great difficulties she displayed patience, tolerance, forgiveness, resilience, fortitude and, above all, unswerving faith in the Divinity. Though we may find these qualities hard to emulate, Draupadi is nonetheless a truly empathic character. At times she found herself overwhelmed with fear, anger, loathing and a burning desire for vengeance. How she dealt with these urges, redirecting them into higher sentiments that lead toward self-realization, forms one of the most fascinating themes in the *Mahabharata* story.

Hindu women hold Draupadi's example in particularly high esteem, for she was able to accommodate five powerful husbands, doing so with such expertise that even the goddess of fortune sought her advice. She followed her husbands into a life of exile and shared their hardships without complaint, and yet, in her rejection of injustice and relentless insistence that her honor be defended, is far from a purely submissive or one-dimensional figure. Indeed, she exemplifies the courageous empowerment of truth and the all-encompassing protection that comes from surrender to the Supreme. In traditional Indian society, men generally address their wives as *devi*, or goddess. No one could be more deserving of this honorific title than Draupadi.

Here then is the story of this divine heroine, through which we can catch a glimpse of her sublime character.

## THE FIRE-BORN MAIDEN

King Drupada was seething with anger. The military preceptor Drona had utterly humiliated him. Never before had he suffered a defeat in battle such as he had at the hands of Drona's students. And now Drona possessed half of his kingdom, having condescendingly allowed him to retain the other half. That was the most crushing part. It would have been better if Drona had killed him outright. Drupada breathed heavily as he pushed his way through the forest. He hungered for revenge.

King Drupada plunged deeper and deeper into the woods. He was looking for help from the ascetic brahmins who lived there, for only they could overpower the mighty Drona with their mystic potencies. Coming to a clearing, Drupada saw two such sages sitting by a sacred fire, chanting mantras and making offerings to the gods. He waited until they were finished, then bowed before them and said, "O best of men, I seek your as-

sistance. Help me regain my honor and I will bestow much wealth upon you. I desire a son who will avenge my disgrace by killing Drona. You alone can give me this blessing."

The elder of the Brahmins, who were brothers, was named Yaja. He greeted the king and offered him a seat. "You are welcome here, sir, but you should know that we have no interest in wealth, nor indeed in any worldly gain. We are not, therefore, inclined to fulfill your desire."

Harboring the hope of changing their minds, Drupada offered to become the brahmins' servant. It was not unusual for kings to render service to sages, so they agreed to let him stay in their ashram for as long as he wished. The younger brother, Upayaja, had been attracted by the king's offer of wealth, though he had said nothing at first. After Drupada had endeared himself to Yaja by a year of selfless service, however, Upayaja suggested to his brother that they try to fulfill the king's desire. "After all," he said, "Drupada has served us well and we should show our gratitude."

"Very well," said Yaja. "Let destiny run its course. Tomorrow we shall perform a ritual that will bestow a mighty son upon Drupada."

Yaja instructed Drupada to fetch his queen from the city, and the next day he began the sacrifice. He poured offerings of butter into a blazing fire and chanted Sanskrit mantras to invoke the presence of the gods. Suddenly he said, "Come forward, good queen, for your children are about to appear."

Drupada's wife had not expected this to happen. She was flustered and said, "How can my children appear? I am not even pregnant!"

"It does not matter. The sacrifice is complete and the sacred prayers and oblations will now bear fruit," said Yaja, and as he spoke, a celestial being rose from the flames. In the full bloom of youth and strikingly handsome, he stepped from the sacrificial altar, fully clad in regal armor, his hand resting on the hilt of the long sword that hung from his belt. As he looked around fearlessly, a disembodied voice announced from the heavens: "This is Dhristadyumna, conqueror of armies, who has appeared to slay Drona."

Drupada's face broke into a great smile. Perfect! That was all he wanted. But in a moment, his expression turned to astonishment as a second figure emerged from the embers. Yaja smiled at the king, "Your wife desired a daughter. Here, then, is the best of all womankind."

A maiden of incomparable beauty stepped forward. Her complexion was dark, with greenish black eyes shaped like lotus

petals. Her long and curling bluish-black hair cascaded down her back. The contours of her shapely body were visible through her shining silk garments. The nails at the tips of her graceful fingers shone like burnished copper. She emanated a sweet fragrance like that of blue lotuses, which carried for a distance of two miles. No man could look upon her without his mind becoming captivated. Drupada, who had often seen the gods and their consorts, felt she had no equal anywhere in the universe.

Again the heavenly voice was heard. "This is Krishnâ, who has appeared to do the work of the gods and to bring about the destruction of countless evil princes."

Taking their two extraordinary children, Drupada and his wife returned to their kingdom. The girl became known as Draupadi after her father, but was also called Krishnâ due to the blackish complexion that was reminiscent of the great god himself. They also called her Panchali, the princess of the Panchala kingdom.

## AN IMPOSSIBLE CHALLENGE

Some years passed and the king began to think of finding a suitable husband for his daughter. Dozens of kings and princes from all around the world had petitioned him for her hand, but he had refused them all. Draupadi was meant for a special person and Drupada already had someone in mind. He remembered how, on the day of his ignominious defeat, he had been particularly impressed by one of Drona's disciples named Arjuna. This handsome prince had earned the reputation of being the best of warriors and the finest archer the world had ever seen.

Although he desired Drona's death, Drupada had a grudging admiration for his talents as a teacher of the martial arts. He also recognized that Drona's beloved protégé Arjuna would make the best possible husband for Draupadi. At the time, however, Arjuna and his four brothers, the Pandavas, had been forced to abandon their kingdom due to palace intrigues and had not been seen for over a year.

After consulting with his advisors, Drupada devised a plan. He would set a test for winning Draupadi's hand that only Arjuna could pass. The king had a target set atop a huge pole; this target was hidden by a rotating plate that had one small hole in it, just large enough for an arrow to pass through. He then declared that any man who could shoot an arrow through the hole and hit the bull's-eye would win Draupadi's hand. Drupada hoped in his heart that Arjuna would come there and pass the test.

The day of the challenge arrived. Thousands of kings gathered in Drupada's city, drawn there by descriptions of Draupadi's beauty and other desirable attributes. When all the challengers and spectators had assembled in the vast stadium, Draupadi entered, bearing the garland of lotuses she would place upon the successful suitor. As soon as the kings saw her they were struck dumb by her exquisite beauty. When they found their voices again, they leapt up and began bragging to one another: "I shall win this astonishing maiden!" "I will easily pass the test." "Draupadi shall be mine!" "No! She shall marry me!" "Fools! How will any of you take this girl while I am present?" Jostling one another and boasting in various ways, they could hardly take their eyes off the princess.

Draupadi's brother Dhristadyumna stood up and announced, "I solemnly promise that whoever is able to lift this bow, string it, and hit the target on the pole shall win the maiden." As he spoke he pointed toward a great bow lying on a table near the target.

One by one, the kings stepped up to try their hand. Many could not even string the stiff wooden bow. Straining hard, they could only manage to bend it half way before it suddenly sprung back, hurling them to the ground where they would lie miserably while the other kings laughed.

Draupadi looked on apprehensively. She had no desire to marry any of these boastful men. She was especially fearful that a prince named Duryodhan might win her. Though Duryodhan was a cousin of the Pandavas, he hated them and was responsible for their exile. Draupadi knew him to be a degraded and immoral man who would stop at nothing to achieve his ends. Thankfully, he failed the test, but he had a powerful friend named Karna who she felt would almost certainly succeed.

Like a moving mountain, Karna stepped forward and looked up at Draupadi lustfully, making her cringe. Karna was similar in character to the arrogant Duryodhan, but he had been raised in a charioteer's family and his status as a warrior of royal blood was uncertain. Exercising her prerogative, Draupadi loudly proclaimed: "I will not wed a mere charioteer!"

Insulted, the warrior glared up at the princess, his teeth clenched and his brow furrowed, but she only looked away impassively. Throwing the bow down in anger, Karna stormed back to his seat.

Then a bearded Brahmin youth rose from the crowd and came forward. He asked, "Are Brahmins also permitted to take this test?"

Dhristadyumna nodded and the youth, after folding his palms and offering a prayer, took up the bow and strung it in an instant. He then knelt down and took careful aim, stretching the mighty bow to its limit. There was a resounding crack as he released the arrow; in practically the same instant, the target came crashing down and clattered on the ground, pierced completely through.

## FIVE POWERFUL HUSBANDS

Amid the huge commotion that ensued, Draupadi garlanded the youth, who was indeed none other than Arjuna. He quickly led her out of the stadium and took her back to the potter's hut outside the city where his mother and brothers were waiting. As he entered the hut, he called out, "Mother, come and see the prize I won today!"

"Whatever it is, may you and your brothers enjoy it equally," his mother replied without looking. But when she came out to greet him, she saw Draupadi and her mouth fell open in surprise. "What have I said?" she moaned. "How can the five of you share this one girl? At the same time, how can my blessing, once made, be revoked?"

Arjuna's mother, Kunti, had never spoken a lie and vowed that she never would. She wasn't sure what to do, but Arjuna's eldest brother Yudhisthir said, "Clearly destiny has decreed that this princess shall be a wife to all of us."

Draupadi looked down shyly. Five husbands? It was certainly irregular, but she said nothing. Having already accepted Arjuna as her lord, she would do whatever he asked. And Arjuna was saying nothing, silently accepting his brother's order. The princess therefore considered her marriage to all five brothers to be the will of the Supreme, which was always auspicious.

Later, however, when King Drupada heard of what had happened, he had doubts. "Is it not sinful for a woman to have more than one husband?" He consulted with Vyasa Deva, the greatest of all the sages, who was visiting his kingdom at the time. Vyasa Deva took him to a secluded place and told him, "This marriage has been ordained by the great god Shiva. In her previous birth, Draupadi was the daughter of a sage in the forest. While still a young girl, she prayed to Shiva for a husband. Pleased by her asceticism, Lord Shiva appeared to her and offered her a boon. In her excitement, the girl repeated the words *patim dehi* ('Give me a husband') five times. Shiva laughed and said that since she was so enthusiastic, she could have five husbands in her next life."

Vyasa Deva concluded by reassuring the king, "The god Shiva cannot ordain anything sinful, so have no doubts about her marriage to the five Pandava brothers."

Draupadi married the brothers on five successive days. Not long after the weddings, they were restored to their paternal kingdom, where they lived happily for some years in their prosperous capital city of Indraprastha, so named because it was built by Indra, the king of the gods. Draupadi took charge of all the palace affairs. She competently managed the many thousands of palace staff while also personally tending to the needs of all her husbands. With the passing of every day, she increasingly endeared herself to them with her humility, grace and gentility.

## THE GAMBLING MATCH

After failing to win Draupadi's hand, Duryodhan returned to his kingdom disappointed and angry. Like every other king who had participated in the contest, he had been overcome by desire for the princess. It had been particularly annoying that his archenemy Arjuna had won her. Karna felt the same way; his annoyance and envy were compounded by the humiliation of Draupadi's refusal to let him even try the test. The two men plotted together and devised a scheme to win the Pandavas' kingdom by means of a rigged dice game. When it was all arranged, they invited the five brothers to play.

Yudhisthir could not decline. "It is my vow that I shall never refuse a challenge, be it a fight or a gambling match," he told his brothers, and so they made their way to Duryodhan's city, entering the great assembly hall where the match was to take place.

The game went according to Duryodhan's design and Yudhisthir lost vast amounts with every wager. Before long, his kingdom and all his wealth had been lost to Duryodhan, who laughed sarcastically and asked, "What else will you stake, O great king?"

Yudhisthir sat with his head bowed. He had lost everything, but perhaps there was some way to win it back. The king had faith in the supreme control of God, whom he recognized as Krishna. If Krishna, for whatever reason, wanted to reduce him to a beggar, then what could be done? Even so, he hoped that he could still salvage the situation. He looked up at Duryodhan and said, "I shall now wager my youngest brother. With him I shall regain my wealth, with which I wish to serve God and my people."

Duryodhan grinned wickedly as the loaded dice were cast again. As they rolled to a stop, his voice rang out, "I win again. Your brother is now my servant." He and Karna danced around, relishing every moment of their triumph.

One by one, Yudhisthir wagered each of his brothers and lost them. Then he bet himself and lost again. A smile played on the corners of Duryodhan's lips. "You still have Draupadi," he said, "Bet her and you can win your brothers and everything else back."

Yudhisthir had reached the point of no return. Sweat streamed from his face as he announced, "So be it. I shall now wager Draupadi, whose every limb is perfectly formed and whose eyes resemble the petals of an autumn lotus. That princess, who possesses every accomplishment, who in order to care for us all is the last to take rest and the first to rise, and whose beauty incites desire in every man, shall be my final wager."

Yudhisthir watched in utter dismay as the dice rolled against him once more. Prince Duryodhan laughed loudly and called out to a servant, "Go and fetch Draupadi. She now belongs to me."

The servant went to the inner chambers of the palace, where Draupadi was sitting. He told her what had happened.

"How can this be?" Draupadi asked. "What man would stake his wife in a gambling match?"

She demanded that Yudhisthir himself come and confirm the news. The servant went back to Duryodhan who then ordered his brother Dushasan to bring her. "And you had better not take no for an answer," he warned him.

Dushasan went before Draupadi. "Come, princess, we have won you fair and square. Don't be timid. Go and present yourself to your new master, Duryodhan."

Draupadi stood up, weeping loudly. It was her monthly period, so she was dressed in only a single cloth and her hair had been left unbraided. There was no question of her going out in public. Covering her pale face with her hands, she ran out of the room. Dushasan roared in anger and gave chase. Grabbing hold of Draupadi's long, wavy hair, he forcibly pulled her along the palace passageways toward the assembly hall, ignoring her plaintive cries.

Draupadi protested and pleaded with her aggressor, "You despicable wretch! Let me go. You should not take me before the assembly. How can I appear there in my present condition?" Dushasan laughed, "What does your condition matter? Even if

I choose to bring you there naked, you cannot object. We have won you and you must now abide by our order."

He dragged the wailing Draupadi into the assembly hall and threw her to the ground before Duryodhan, where she fell with her cloth in disarray and her hair disheveled. The dishonor she felt was immeasurable. Her husbands and the gathered nobles sat for some time in a shocked silence that was broken only by Draupadi's sobs and Duryodhan and Karna's triumphant cackling.

Then Draupadi rose up from the floor like a flame. She looked around the assembly and began speaking angrily, "Everyone present here is learned in scripture and devoted to justice. Among you are my elders and my teachers. How is it that you can all witness this atrocity and do nothing to stop it?"

She looked toward her husbands. Why were they silent? Surely Yudhisthir was bound by some subtle consideration of dharma, of religious codes, and was therefore inactive. She saw him check Bhima, the strongest of her five husbands, who seemed ready to explode with rage.

Karna was enjoying every moment. The humiliation that Draupadi had inflicted on him by refusing to let him even take the test to win her hand still embittered his heart. He laughed mockingly, "So, princess, it seems you selected the wrong husbands after all. Who will protect you now?"

Draupadi did not even look in Karna's direction. Instead, she turned to Duryodhan's blind father, Dhritarashtra, who was presiding over the assembly. "Great king, why are you sitting by without a word? Shame on you! Over the generations, the royal Kuru dynasty has earned a reputation for justice and morality. That reputation has today been destroyed through this most vile deed."

Draupadi fell to the floor, crying helplessly in distress. Karna's voice echoed in the hushed hall, "Take no notice of this servant woman. What does she know of morality anyway? She has five husbands! She is no better than a prostitute, so what difference should it make to her whether she appears in public half-dressed, or even completely unclothed?"

Dushasan voiced his agreement. "I already told her that. She belongs to us now."

Karna laughed. "Make her take off her clothes, Dushasan," he ordered. "Let us see her naked."

Pulling Draupadi to her feet, the Kuru prince took one end of her cloth and began to forcibly strip her. The helpless princess tried to resist, but it was useless. Only one refuge was left to her now. Folding her hands together, she prayed to Krishna, "O Supreme Person, lord of all the worlds, see here my plight. Please protect me."

Though Krishna was in his palace many hundreds of miles away, he was able to hear Draupadi's cries through his inconceivable power. He swiftly ran out of his palace and within moments entered the assembly where the princess was being violated. Undetected by anyone, he began providing an endless supply of cloth to cover her. As a result, no matter how much Dushasan pulled, he could not undress her. Soon a huge pile of cloth lay on the floor and the exhausted Dushasan gave up trying.

At that moment, many portentous omens manifested: jackals cried, the sky became dark, the earth shook, and the images of the deities in the temples appeared to weep. Dhritarashtra realized that things had gone too far. Draupadi was clearly under divine protection. Fearing her anger, he tried to pacify her, "Ask me for a boon, princess, anything you desire."

Draupadi asked that her husbands be released from slavery, and that their weapons be returned to them. "It shall be so," said Dhritarashtra. "Ask again for something more."

Draupadi shook her head. "Just as a fire burning in the hollow of a tree destroys it, so does greed destroy a person. I shall therefore ask for nothing more. Now that they are free, my husbands will be able to acquire whatever else we need through their own virtuous deeds."

## FEEDING THE TEN THOUSAND

**K**rishna's display of mystical power in saving her had considerably calmed Draupadi, but she still burned with outrage over the way religious principles had been violated. Above all else it was an insult to Krishna, whom she revered as the basis of all morality.

Draupadi longed for vengeance against her aggressors. She vowed that she would not braid her hair till Duryodhan and his followers had all been killed. "Only then will virtue be avenged," she said. "My unbraided hair will remain as the symbol of Dushasan's dire act."

Though Dhritarashtra had delivered the Pandavas from slavery to Duryodhan, a new condition was imposed on them for losing the gambling match: they were obliged to spend twelve years in exile in the forest. Nevertheless, it was plain to everyone that Duryodhan's relentless hostility toward the Pandavas could only end in war. Knowing this, Draupadi said to Bhima, "When that time comes, I want you to kill the wretched Dushasan and fetch me his blood. Only then will I braid the hair that he so viciously pulled, and in the center parting, I will use his blood as vermilion."

During their twelve years in the forest, Draupadi again rescued the Pandavas just as she had after the gambling match. One day after they had finished their evening meal, a powerful mystic named Durvasa and his ten thousand followers came and asked to be fed. Duryodhan had sent him, knowing that the Pandavas would find it impossible to offer him and his followers adequate hospitality. Durvasa was famous for his anger. Duryodhan knew he would curse the five brothers if they did not satisfy him, and the curse of such a powerful sage could destroy even the gods.

It so happened that Draupadi had been given a divine cooking pot by Surya, the Sun God. It remained full until she had served everyone and taken her own meal. But Durvasa's arrival was timed for a time after she had herself eaten. The pot was empty and she could not cook with it again till after the next sunrise. Disaster threatened. She urgently consulted with Yudhisthir, "What shall we do? Durvasa will doubtlessly curse us if we are unable to offer him and his men a meal."

Yudhisthir agreed, but he had an idea. "I shall ask him to first take his bath in the river while we prepare his meal. In the meantime, you must pray again to Krishna. This is our only hope. Krishna will never forsake you, for you are his unswerving worshiper."

When the sage and his followers had gone to the nearby river, Draupadi offered her prayers to Krishna. "My Lord, please save us. We have no other shelter."

Then, as if he had been there all the time, Krishna walked out from behind a bush. He smiled at Draupadi and asked, "What can I do for you this time, my princess?"

Draupadi explained her dilemma and Krishna said, "I will do all in my power. But first, like Durvasa, I am also hungry. Please feed me."

"But Krishna, that's the very problem I face. We have no food."

"This is no time for joking, Draupadi. Show me your pot."

Draupadi fetched the magic pot and offered it to Krishna. "Whatever I have is yours, dear Lord, but this pot is empty."

Krishna looked at it carefully. He found a small particle of rice stuck to the rim and put it in his mouth. He said, "Draupadi, I am satisfied with whatever you give me, for you offer everything with love. This tiny piece of rice has therefore filled my belly. Now, have someone fetch Durvasa and we will see what we can do."

There was still no sign of any food to offer the ten thousand ascetics, but Draupadi had full faith in Krishna and so she did as he asked, sending Yudhisthir's youngest brother Sahadeva to find Durvasa.

However, as soon as Krishna had eaten the rice particle, Durvasa and his followers down at the river suddenly began to feel very full. They looked at one another, belching as if they had just eaten a huge meal. Durvasa said, "We had better leave. We have put Yudhisthir to the trouble of cooking for us and now we can't eat anything. He is dedicated to the service of God and is therefore very powerful. He is quite capable of burning us to ashes with his angry eyes."

Durvasa recalled a previous incident when he had offended someone like Yudhisthir. It had almost resulted in his death. Taking his disciples, he quickly headed off into the forest, his water pot swinging back and forth as he jogged away. As a result, when Sahadeva reached the river there was no sign of any of them. He went back and told Yudhisthir, who marveled at the incident. He guessed what had happened. By satisfying Krishna, the Supersoul of all beings, Draupadi had automatically satisfied the sage and all his disciples.

## WAR AND RECONCILIATION

hen at last their exile ended, the Pandavas were cast, as expected, into a great war with Duryodhan and his followers. It raged for eighteen days and toward the end Bhima killed Dushasan. He then went to Draupadi and gave her his blood, which she smeared on her head as she had promised. "Now justice has been done," she said. "But I cannot feel any happiness after seeing so many brave warriors die."

Many millions had died in the war and the softhearted Draupadi felt compassion toward their grieving relatives. During her time in the forest she had continuously urged her husbands to fight the war, desiring vengeance on her assailants. Now that it was done she felt remorseful. Had it been worth it?

Yudhisthir consoled her, "Do not blame yourself, dear lady. This was the arrangement of the Supreme. We are all his instruments, especially those of us who, like you, always desire to please him."

Draupadi contemplated Yudhisthir's words deeply. Perhaps it was true. Nothing could happen without God's will, but did he not reciprocate his worshiper's desire? Was it not her desire for vengeance that had brought about the war? She hoped not. Her only desire was to serve her husbands and God. She did not want her emotions to get in the way.

But soon Draupadi was again racked by powerful feelings when Destiny took yet another tragic turn. She had given birth to five sons, one by each of her husbands. They had been just old enough to fight in the war, but on the very last day of the hostilities had been killed in their sleep. The cowardly murderer was none other than the son of Drona, Ashwatthama, who had taken up arms on behalf of Duryodhan.

When the news of her sons' deaths reached Draupadi, she cried out in grief. "How could this happen? What coward would kill sleeping boys?"

On hearing that it was Ashwatthama, she said to Arjuna, "Bring me the head of that so-called Brahmin, so that after cremating my sons I can take my ritual bath of mourning standing on it!"

Arjuna went after Ashwatthama and soon captured him. Binding him like an animal, he brought him before Draupadi and threw him to the ground at her feet. "Here he is, dear lady."

Draupadi looked down at the wretched Ashwatthama with a mixture of contempt and compassion. Death was doubtlessly a fitting punishment for him, but he was the son of Kripi, a respected and much loved lady whom she knew well. Kripi had already lost her husband in the war and if Ashwatthama were to die then she would lose her only child as well. She was suddenly overcome with compassion.

Draupadi looked up at Arjuna, who was standing with his sword at the ready, looking toward Krishna and Yudhisthir and waiting for them to give the order. She slowly said, "Spare him. Even though he has done wrong, he is a Brahmin and should be accorded some respect. And what will be gained by giving the noble Kripi, his mother, the same grief that I now suffer?"

Tears ran down Draupadi's face. It was not easy for her to show mercy to Ashwatthama. One part of her would have felt great joy to see Arjuna sever Ashwatthama's head from his body. To have lost all her five sons in one day, even after they had survived the war, was a devastating blow, especially since they had been the victims of such a senseless crime. But she had had enough of vengeance. Adherence to virtue always led to auspiciousness, and forgiveness was the highest virtue.

Krishna approved of Draupadi's words. "She has spoken well. Let this sinful man be released. Banish him to the forest instead."

## ASCENT TO HEAVEN

At the end of their lives the Pandavas retired again to the forest, taking Draupadi with them. Dressed as ascetics and carrying only staffs, they walked toward the Himalayas and began to ascend the mountains. They trekked for many days, fasting continuously, till one by one they fell and died. The first to fall was Draupadi. When all her husbands had also died they found themselves reunited in the higher planets of the gods. There they beheld Draupadi, appearing in a shining form as a goddess and sitting by the side of Indra, king of the gods.

Seeing Yudhisthir gazing at her with amazement, Indra said, "This lady is the goddess Lakshmi, prosperity incarnate. For your sake she appeared from the sacred fire to become a part of Drupada's family."

Indra then told Yudhisthir and his brothers to bathe in the celestial Mandakini River. They did as he asked and, when they emerged from the river, appeared in forms exactly resembling Indra himself. He then said to them, "All of you in former lives have been kings of the gods, just like myself. Only for the purpose of divine pastimes did you take birth among humans."

Indra explained that Yudhisthir, his brothers and Draupadi were eternal associates of Lord Krishna. "Wherever Krishna goes for his pastimes, you will also go. For the good of all beings, Krishna is forever appearing in some world to display human-like activities. Like a magician he creates the material universe, enters it for some time, then winds it up. His only business is to bring everyone back to pure spiritual consciousness, and souls like you eternally assist him."

Thus, the *Mahabharata* underscores the perpetual connection and love between the Divine and devotee, especially as articulated in the Bhagavad Gita, the epic's centerpiece, where Krishna's message of selfless surrender is encapsulated. This teaching is exemplified by the actions of the Pandavas, through all the vicissitudes of a life full of challenges. Draupadi is one of the prime examples of this devotional ideal; her life story panoramically highlights this core teaching, otherwise known as *sharanagati*.

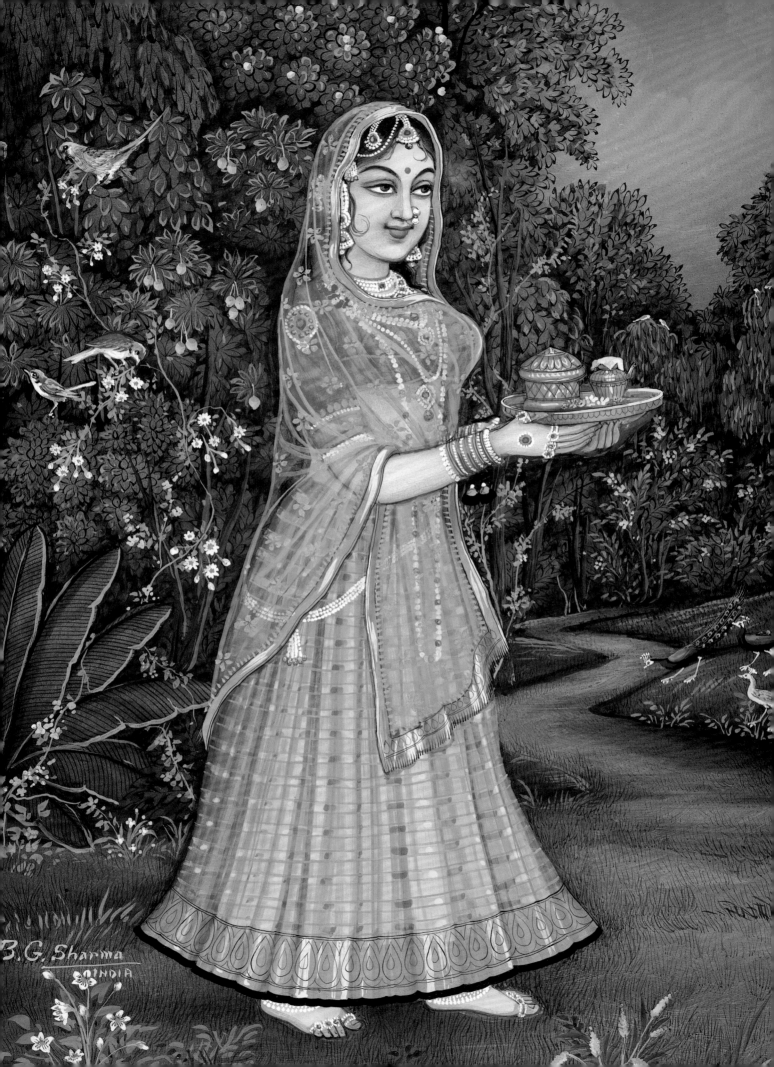

*jaya devi bhakti-dātrī*
*prasīda parameśvari*
*jaya devi subhadre tvaṁ*
*sarveṣāṁ bhadra-dāyini*

*Glories to you, Subhadra, the bestower of bhakti! Be kind to me,*
*O ruler of the universe! Please bestow auspiciousness on us all.*

# SUBHADRA

IN PURI, A COASTAL TOWN IN INDIA'S EASTERN STATE OF ORISSA, STANDS A MAGNIFICENT TEMPLE DEDICATED TO THE LORD OF THE UNIVERSE, JAGANNATH. THOUGH THE PRESENT STRUCTURE DATES BACK TO THE TWELFTH CENTURY, THE SITE ITSELF IS MENTIONED IN THE ANCIENT HISTORICAL TEXT KNOWN AS THE *SKANDA PURANA*. THERE IT IS STATED THAT LORD BRAHMA, THE GOD OF CREATION, ESTABLISHED THE FIRST TEMPLE TO LORD JAGANNATH IN THAT SPOT, AND THAT IN ONE FORM OR ANOTHER, IT HAS EXISTED CONTINUOUSLY FOR OVER 150 MILLION YEARS. THE VEDAS DESCRIBE TIME AS CYCLICAL, WITH DIFFERENT AGES CONSTANTLY WAXING AND WANING. PURI HAS EXISTED AS ONE OF THE OLDEST AND HOLIEST PLACES IN INDIA THROUGHOUT ALL THESE AGES.

Surrounded by a twenty-foot-high stone wall, the temple covers an area of some 400,000 square feet. Three deities sit on its main altar: Jagannath, Baladeva and Subhadra. These are forms of Krishna, his brother Balaram, and the goddess Yogamaya. In the temple compound, there are also more than a hundred smaller shrines dedicated to various other gods and goddesses. Five thousand priests serve the deities in a multiplicity of functions, including 650 cooks who prepare 54 huge food offerings daily. Each day, as many as 50,000 people visit the temple.

It is strictly forbidden for non-Hindus to enter the Jagannath temple, and gatekeepers enforce this rule rigidly with the aid of large sticks. However, in order to allow even the non-Hindus to be blessed by their sight, the three six-foot-high deities come out once a year to take part in a great celebration known as Rathayatra, the "Festival of the Chariots." A million pilgrims attend this carnival, all of them hoping for a glimpse of the deities as they ride on their separate chariots, a sight said by the *Skanda Purana* to destroy all the accumulated reactions of bad karma.

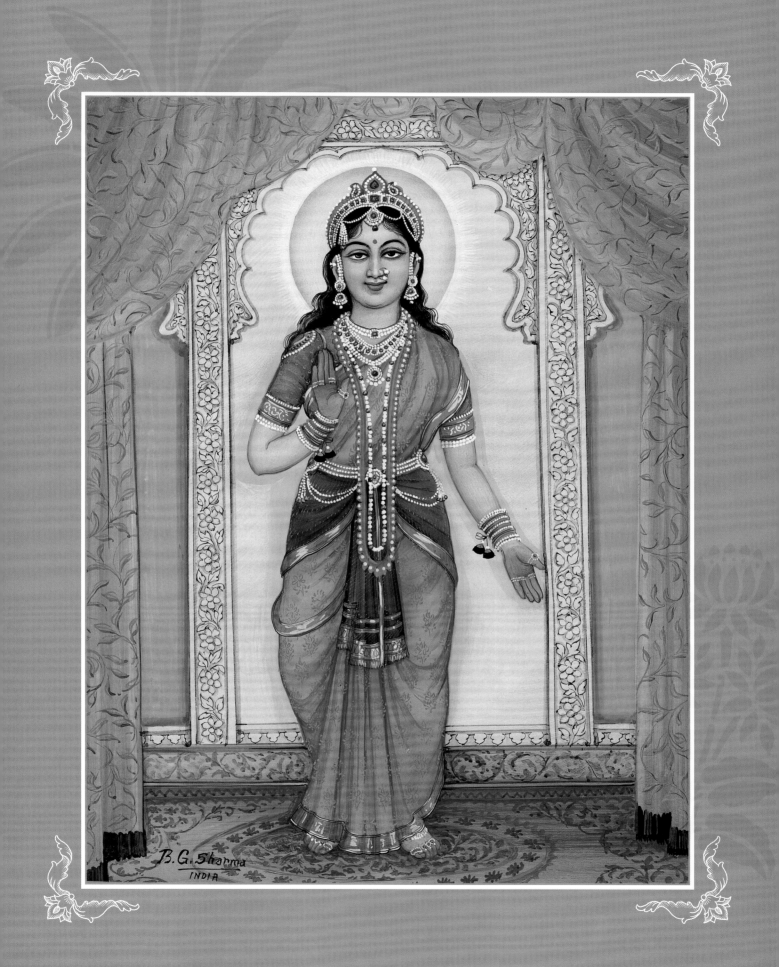

B.G.Sharma
INDIA

## GOD'S INTERNAL ENERGY

In the Festival of the Chariots, Subhadra rides in the middle of the procession, just as she sits between the two other deities on the temple throne. Gorgeously decorated with colorful silks and flowers, she makes for a dazzling sight as she is pulled along by thousands of worshipers.

Known by many other names, Subhadra is understood to be the "internal energy" of the Supreme. This energy manifests the spiritual world and the living beings, and is usually called Yogamaya (the "external energy," or Mahamaya, manifests the material illusory world of our experience). When Yogamaya appears within the cosmos, she takes the name Subhadra and plays the part of Krishna's sister.

Herein lies an esoteric truth about the Divine. Although personalities like Subhadra are extremely powerful incarnations of spiritual energy, rather than display that power in godlike demonstrations whereby they move heaven and earth, they choose instead to enact simple pastimes in intimate relationships with Krishna and his associates. Such pastimes reveal high spiritual truths that are meant to attract us toward the Supreme, and to enable us to experience blissful love. This is the chief function of the internal spiritual energy: to connect the living beings with the Supreme Person or God. Subhadra, or Yogamaya, does this in a variety of ways, some of which are illustrated in the following stories, beginning with that of her birth during Krishna's most recent appearance.

## BIRTH OF THE UNBORN

Some 5,000 years ago in the city of Mathura, a prince named Vasudeva was wed to a princess named Devaki. As was the custom at the time, the bride's brother Kamsa took up the reins of the newlyweds' chariot in order to drive them home after the ceremony. Along with them came Devaki's dowry, consisting of 400 decorated elephants, 2,000 golden chariots and 10,000 horses. The air was filled with the fragrance of costly incense. Bugles, drums and conches resounded loudly as the great procession made its way down the broad city streets, which were strewn with flowers and lined by thousands of people who cheered and congratulated the royal couple.

Hardly had they traveled a mile, however, when a disembodied voice suddenly boomed from the sky: "Kamsa, you fool! You are driving the chariot of the woman whose eighth child will kill you."

Kamsa's hand flew to the sword by his side. Who had said that? In a panic he looked up in the sky and all around him, but could not see who had spoken. It must have been some god who had issued the warning, so surely it was true. The wicked Kamsa's mind raced to the only conclusion he was capable of reaching—Devaki might be his sister, but if she were a threat to his life, it would be better to kill her first.

Without a second thought he grabbed hold of Devaki's hair and drew his sword. Vasudeva immediately jumped up and raised his hand to stop him. Though he knew Kamsa to have a cruel and volatile nature, he tried to pacify him with gentle words.

"Kamsa, dear brother, you are the pride of your family. Great heroes sing your praises. How then could you kill a helpless woman, especially your own sister on her wedding day? How will this affect your good name?"

Kamsa lowered his sword slightly. He was not sure. Divine omens were rarely wrong and of what use was a good name to a dead man anyway?

Vasudeva went on. "Why should you fear death? Every being who takes birth must die, sooner or later. Death is born with life. We will all move on in due course, taking nothing with us but the reactions to our deeds. Why, then, commit a sin that will come back to cause us suffering, particularly when that sin can in no way avert death?"

Vasudeva argued in various ways, but Kamsa was too rattled for reason. His brows furrowed, the shameless prince raised his sword aloft, ready to strike. Vasudeva realized that he was fully intent on killing Devaki right then and there. He made one final, desperate plea.

"Wait! Here is what I will do. It is not Devaki who is a danger to you, but her children. I promise you that as soon as Devaki has a child, I will immediately bring it to you and you can do with it as you like."

Kamsa finally lowered his sword. This was a better idea. Certain that Vasudeva could be counted on to keep his word, he said, "Very well, I accept your proposal."

Vasudeva could only hope that something would happen to Kamsa before harm came to anyone. For the time being, he had at least saved Devaki's life. And if one of her children was destined to kill Kamsa, nothing could prevent it from happening, no matter what Kamsa did.

## Yogamaya's Mission

**S**haken but relieved, Vasudeva and Devaki returned home. A year later, Devaki gave birth to a boy and, true to his promise, Vasudeva brought the child to Kamsa.

Seeing Vasudeva's honesty, Kamsa gave him a broad smile and said generously, "Keep this baby, dear brother. The omen said the danger was to come from your eighth child, so what do I have to fear from this one?"

Vasudeva went home again, but he knew that Kamsa could not be trusted in any way. His worst fears were soon confirmed when Kamsa staged a coup and usurped his own father's throne. Then, Kamsa's fears from the prophecy were enkindled once more, and he had Vasudeva and Devaki imprisoned in his castle, and their son killed.

Over the next seven years, Devaki gave birth each year, and each time Kamsa murdered the child before it was even a day old. After the life of the seventh child had been taken in this way, Krishna decided to make his appearance in the world. In a past birth, Vasudeva and Devaki had prayed to the Supreme that he might become their son, and now Krishna intended to fulfill their desire. Before this came to pass, however, he spoke to Yogamaya, the personification and expansion of his divine energy.

"The time has come for you to appear in the world. I myself shall soon enter Devaki's womb. I want you to go to the village of Gokula and there become the daughter of Yashoda, King Nanda's wife. Use your powers to prepare the world for my coming. Pacify the minds of my devotees and clear the way so their enemies may be destroyed. After your advent in the world, you will be known by different names such as Durga, Bhadrakali, Kumuda, Chandika, Maya, Madhavi and Ambika. Most people will worship you for material desires, which you always fulfill, but those who are truly intelligent will worship you as my eternal energy. In this way they will attain the supreme spiritual abode."

Not long thereafter Devaki became pregnant for the eighth time. She glowed like the sun and Kamsa found it impossible to even look at her. He was waiting anxiously for the eighth child, and though he had again considered killing Devaki before she could give birth, he was not even able to go near her on account of this protective aura. As she was still locked in her quar-

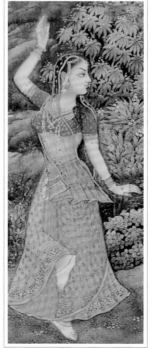

ters, Kamsa ordered the guards to let him know the instant the child was born.

Imperceptible to human eyes, various gods came to Devaki's room and worshipped the Supreme Lord who had taken up residence in her womb.

When the time came for Devaki to give birth, Yogamaya exercised her power, casting all the guards in Kamsa's castle into a deep sleep. Krishna then came out from Devaki's womb, displaying his godly four-armed form with a multitude of valuable ornaments decorating his body. Vasudeva and Devaki looked at their wonderful child with astonishment and prayed to him. He then transformed himself into a normal, two-armed baby.

## Subhadra's Divine Appearance

**B**y Yogamaya's influence the door to Vasudeva and Devaki's room, which had been kept bolted, swung open. Vasudeva picked up his divine child and walked out of the room, as if in a trance. Without thinking, he made his way past all the sleeping guards and out into the night. He walked swiftly with the baby until he came to the Yamuna River. He saw in front of him a dog crossing the stream, apparently walking on some stepping-stones. Vasudeva followed the animal to the other bank and continued on his way till he arrived at Gokula, where the cowherd woman Yashoda had just given birth to a baby girl.

Yashoda was sleeping after the labor of childbirth, so Vasudeva quietly placed his own child on her bed and then left with the girl. When the cowherd woman woke in the morning, by Yogamaya's arrangement, neither she nor anyone else was able to remember that she had given birth to a girl rather than the boy left there by Vasudeva.

Vasudeva returned to the castle and, as soon as he entered his room, all the doors closed and locked behind him. The guards awoke the next morning to the new babe's cries and immediately ran to Kamsa. "Come quickly! Devaki's eighth child has been born."

Kamsa jumped up from his bed and ran to Vasudeva's room, his disheveled hair falling around his face. "Give me that child!" he yelled.

Devaki held the girl tightly. "Dear brother, please don't kill her. What harm can she do to you?"

Ignoring her, Kamsa lunged for the baby and Devaki cried out, "No! Spare her, please. It is not right to kill a girl under any circumstances. You have already killed all my other children; allow me to keep this one little girl."

"Don't be stupid," Kamsa roared. "This is the eighth child. It has to die."

He snatched the baby from Devaki, intending to dash her on the stone floor, but the girl slipped at once from his grasp. She flew out the window and rose up into the sky. Transforming herself into the mighty goddess Durga, she manifested eight arms brandishing a bow, trident, arrows, sword, shield, disc, conch shell and club. She was decorated with flower garlands and dressed in the finest silk robes. Surrounded by a host of celestial beings who worshipped and praised her, she thundered, "Kamsa, you are a fool. What will you gain by killing me? He who will slay you has already been born somewhere else in this world."

She then returned to Devaki's arms as a baby. Contrite, Kamsa ran from the room, ordering that his sister and her husband be released from prison. The couple then returned home where they raised the girl, who they named Subhadra.

## SUBHADRA'S MARRIAGE

Subhadra grew up to become an extremely beautiful maiden. When she reached the age of sixteen, her family began thinking about arranging a marriage for her. For some reason, her brother Balaram felt that Duryodhan would make a good husband for her, but Subhadra found even the suggestion unimaginable. Even so, she said nothing for fear of upsetting Balaram.

It so happened that at this time, Arjuna, the Pandava warrior, was touring India on a pilgrimage. When the five Pandavas married Draupadi, they had made a pact not to interrupt each other's private moments with the wife they shared. If any of them did so, he would have to spend twelve years going to the various holy spots in search of absolution. One day, Arjuna ran through Draupadi's room to fetch his weapons while she was alone with Yudhisthir, and though he had done so only to help someone in an emergency, he was obliged to keep to the agreement.

In his travels, Arjuna eventually came to Prabhasa, a pilgrimage site not far from the island city of Dwaraka, where Krishna and all his relations—the Yadus, Bhojas, Vrishnis and Andhakas—

were then living. While Arjuna was there, the residents of Dwaraka also came to celebrate a religious festival. Arjuna happened to catch sight of Subhadra, decked with every ornament, in the midst of her girlfriends. As soon as he beheld her, he was possessed with desire.

Krishna recognized his friend Arjuna despite his beard, and when he saw him contemplating Subhadra, he joked, "How can the heart of a pilgrim be agitated by the god of desire? This is my sister, Subhadra. She is my father's favorite daughter. If your heart is fixed on her, I shall gladly speak to my father on your behalf."

Arjuna immediately consented. He desired her as his wife, not only for her beauty and feminine virtue, but also because he felt that such a marriage would strengthen his connection to Krishna.

Krishna said, "She would surely make you a good wife, and you are more than qualified to be her husband, but how will you get her to choose you? No *swayamvara* has been planned in which she will select a husband. And Balaram wants her to marry Duryodhan. I am not keen on the idea, but he is a city father and my older brother. No one wants to go against his wishes. I think your only chance is to kidnap her."

Krishna had a further suggestion: "Subhadra lives in Balaram's palace and never appears in public. You could pass for an ascetic. If you stay here for the rainy season, as would any other itinerant monk, then Balaram will invite you to his house for meals. He likes to entertain holy men and usually has Subhadra serve them to get their blessings. This is the best way for you to see her and she you."

Arjuna nodded approvingly. This was a good plan. He wanted to make sure Subhadra liked him before he whisked her away. He would not steal her against her wishes. If she was not attracted to him, he would leave her in peace.

With this in mind, Krishna entered Dwaraka and announced to his pious clansmen that a wandering saint of unexcelled piety had come to accept their hospitality.

As Arjuna walked through the magnificent gates to the walled city, he was overwhelmed by its opulence. Sixteen thousand white palaces, one for each of Krishna's sixteen thousand queens, expanded out in circles from the city center. They were all inlaid with gold and jewels and shone brilliantly. Many magnificently domed temples stood on all sides. Sacred chants and the sounds of sublime music filled the air, while billows of fragrant incense wafted on the breeze. The streets were lined with trees bearing blossoms of every hue. There were gardens brimming with celestial flowers and jeweled fountains standing in crystal ponds. Golden chariots and decorated elephants moved here and there,

and finely dressed citizens strolled along the spacious avenues, which were also inlaid with gems. Arjuna gazed about in wonder as he made his way through the teeming metropolis.

Balaram soon arranged for Arjuna to be brought to his palace and offered hospitality, just as Krishna had expected. Subhadra served their guest and immediately captivated him. Dressed in blue silk garments, with golden earrings and ornaments, and curling black hair, she could have enchanted even the gods. She waited on Arjuna with grace and poise, while he struggled to look anywhere else but straight at her.

As Subhadra placed the dishes before Arjuna, their eyes met and she felt her heart stir. She looked more carefully at the supposed ascetic. He was not like other sages Balaram had brought to the house. Underneath his cloth, she could see broad and powerful shoulders. As he reached out to take the dishes she served, she noticed his well-defined arms, which bore bowstring scars. She decided that he looked more like a warrior than a monk. Moreover, it was obvious that behind his beard he was a strikingly handsome man. Subhadra wondered who this ascetic, with his dark, wandering eyes, really was.

## LOVE BLOOMS

he rainy season period is called Chaturmasya, for it lasts four months. Throughout this time, Arjuna remained in Dwaraka and was a regular guest at Balaram's palace. Subhadra was always there to serve him, and their attraction for one another grew. One day, Krishna came by and spoke with his sister about her marriage. When Subhadra confided in him about her feelings for the strange ascetic, Krishna's eyes opened wide in apparent surprise. "But what about Duryodhan?" he asked. Subhadra winced and looked away.

Then Krishna mentioned Arjuna and how he strongly desired to marry her. "In fact," he said with a conspiratorial smile, "Arjuna has already come to Dwaraka to seek your hand."

Subhadra's brows narrowed and she looked pensively at Krishna. Was he suggesting that the handsome ascetic was really Arjuna? Of course! How could she have thought otherwise? What monk walked with the gait of a prowling lion? Did any ascetic ever eat that much food? Subhadra became excited. Arjuna had come to win her hand! That would be infinitely better than marrying the arrogant Duryodhan. But what would Balaram say?

Reading her mind, Krishna caught hold of her hand. "Do not say anything to anyone about this. It must be kept secret, especially from our brother. I am sure Arjuna will find some way to arrange matters."

The four months of the rainy season were almost over. Balaram invited the young ascetic to his palace a final time. Again Subhadra served him, surreptitiously showing him with coy glances and smiles that she knew who he was and that she would gladly go with him. Arjuna took the dishes with trembling hands. He could hardly eat.

In the following days he thought of nothing but Subhadra. He asked Krishna when would be the best time to steal her away. "I am sure she desires me as much as I do her. But how can I kidnap her? She is confined to Balaram's palace, which is no less than a fortress of the gods."

Krishna told him that his chance would soon come. "A festival is to be held on the mainland," he said. "Subhadra will be attending. If you choose a moment when our men are relaxing, you will be able to catch them off guard and abduct her without any obstacle."

## THE ABDUCTION

rjuna realized that this was probably the only opportunity he would get. He waited impatiently for the day of the festival, going over the details of how he would abscond with Subhadra. At last the day arrived. He waited for evening when everyone would be most at ease. Putting on his armor, he mounted the chariot Krishna had given him and waited behind some trees near where Krishna's family was celebrating the festival.

Suddenly he saw his chance. Subhadra had just come out of a temple and was with only a few of her friends. Arjuna spurred on the four powerful stallions and they surged forward, pulling the chariot and thundering toward the princess. She looked up in surprise at the sound. Seeing the chariot charging toward her, sending up clouds of dust, she guessed at once that it was Arjuna. She saw him standing on the chariot with reins in hand, a great bow slung on his back. Breaking away from her friends she ran in his direction.

As Arjuna came closer to her, he slowed the chariot and reached down for her hand. "Princess, I am Arjuna. Come with me now and become my bride."

Subhadra happily took hold of his hand and he pulled her aboard. He wheeled the chariot around and sped away before anyone had a chance to act. Within minutes he was racing along the road to the north, heading for his own city.

Balaram and the Yadavas ran about in fury. What rascal had the nerve to abduct their princess before their very eyes? They called for their weapons and chariots, "Give chase to this wicked wretch. His head is coming off!"

"I think it was Arjuna, the Pandava. I would recognize that chariot driving anywhere."

"Yes, it was definitely Arjuna. I have seen him many times. Only he would have been bold enough to attempt such a folly."

"Let us go to Indraprastha, his capital, lay siege to it and demand Subhadra's return. And if we catch up with him...."

Uttering curses and threats of all kinds, the heroic men of Dwaraka donned their armor and made ready to give chase. In the city, the master-at-arms blew his trumpet to summon the army. A huge clamor arose as warriors ran in all directions, taking up all kinds of weapons.

Balaram convened an emergency council of war. When the army leaders were all present he stood up and spoke, "Arjuna has insulted our family. Without asking our permission he has snatched Subhadra. For this he deserves to be put to death."

Loud shouts of approval greeted this speech, but Krishna remained silent, even as everyone else leapt up with their weapons held aloft. Noticing this, Balaram said, "Quiet! Everyone sit down. Krishna does not seem to agree. Let us ask him for his opinion."

As the assembly became silent, Krishna spoke: "I do not think anything inauspicious has happened. Arjuna belongs to the noble Kuru line and his brother is emperor of the globe. What shame is there in our family being allied with them by marriage? But how else could he have won Subhadra? No *swayamvara* was planned for her, and as a proud warrior he could never have begged us for her hand. In such circumstances, the religious law books permit a Kshatriya to kidnap a bride, if she is favorable to him.

"But if you insist on trying to take Arjuna, remember who he is. He is the world's greatest bowman and warrior, and would fight ferociously to keep Subhadra. So consider carefully whether it is worth risking such a battle. Besides, now that he has taken her, how can she be married to anyone else? Let us instead accept this as a divine arrangement and welcome Arjuna into our family."

There were still some murmurs of disapproval and uncertainty, but Krishna continued to speak, dispelling all doubts by describing Arjuna's noble qualities. At last, everyone agreed to approve his union with Subhadra. Messengers were sent out and the couple was brought back to Dwaraka where their wedding was performed with utmost pomp and celebration.

In that last year of Arjuna's exile, Subhadra gave birth to a son they named Abhimanyu, who went on to become an unrivalled hero in the battle of Kurukshetra.

## Subhadra Meets Draupadi

Twelve years and many adventures had passed since Arjuna had seen his brothers and Draupadi. After their joyous reunion, Arjuna went to see Draupadi in her quarters. Although accepting more than one wife was not uncommon for powerful warriors like Arjuna, it sometimes caused rivalry among the wives. Fearful of this, Arjuna delicately approached Draupadi. She was in no mood to speak with him, however, and as he entered her chamber, she turned away from him and said, "What brings you here? Shouldn't you be with your new bride? She must be missing you."

Arjuna took a deep breath. "Most beautiful lady, forgive me. I...."

"No, you need not say anything more to me, great hero. Surely it is truly said that a second tie loosens the first one, no matter how tight it may have been."

Arjuna shook his head in protest. "My dearest queen, you should know that my love for you has not diminished in the slightest."

Draupadi said nothing. She moved over to her window and looked out, tears pricking the corners of her dark-lashed eyes as she rotated the prayer beads in her hands.

Arjuna entreated her for some time, but she remained silent. Realizing that he could not change her mood, he left her chamber and went to Subhadra. He asked her to dress as a cowherd girl. "Go to Draupadi in this guise and she will remember her beloved Lord Krishna, who began life as a cowherd. You will thereby invoke her affection for him. Then you may introduce yourself."

Dressed in a simple cloth, Subhadra was brought before Draupadi. The servant girl who showed her in said, "This maiden desires to become your servant."

Subhadra immediately bowed before the Queen and said, "I am here to do your bidding."

Draupadi had never seen Subhadra and did not realize who she was, but seeing her humble demeanor and reminded of Krishna by Subhadra's rustic dress, her heart melted. She raised her hands and blessed her, saying, "May you become the wife of a hero and the mother of a hero. May you have no rivals."

Subhadra thanked her for her blessing and then introduced herself. "I am Subhadra, Krishna's younger sister." Feeling all her jealousy and anger dissolve in the face of Subhadra's refined conduct, Draupadi stepped forward and embraced her. After this the two ladies went on to become dear friends.

Lord Shiva asked the Ganges River to accompany Saraswati and help her complete her mission. Thus the two mighty rivers flowed across the plains of India with the pot of fire until they reached the western ocean, where Saraswati threw the *badavagni* deep into the water, where it still lies, living on as a metaphor for deep-seated, hidden resentments.

# THE GODDESS OF SPEECH

 At the dawn of creation, a great battle took place between the gods and the demons. It raged for thousands of years. At last, Vishnu, the Supreme Being, put the demons to flight and they scattered all over the universe, hiding wherever they could. One of them, Sumali, hid on Earth, living incognito as a human king.

One day, Sumali was walking with his daughter Kaikasi when he saw the god of wealth Kuvera passing overhead in a magnificent golden chariot. "Just see the powerful Kuvera," he said to Kaikasi. "He is the son of the sage Vishrava. Dear daughter, you are now of marriageable age. If you were to approach Vishrava and ask him to accept you as his wife, he would surely give you sons as great as Kuvera. Such sons would doubtlessly be able to lead us demons to victory over the arrogant gods."

The gentle Kaikasi bowed in obedience to her father and went at once to the mountain ashram where Vishrava lived. She stood shyly before the sage, looking downward.

Vishrava, sitting in silent meditation, sensed her presence. He opened his eyes and inquired, "Most beautiful girl, who are you, and to whom do you belong? Why have you come here?"

"Great sage, you should be able to divine my purpose with your own mystic power. I am too shy to tell you."

Smiling, the sage read her mind. "I see that you desire sons by me, gentle maiden. I am attracted to you and will accept your hand, but you have approached me at an inauspicious time. It is now the evening twilight, when ghosts and demons come out. You will therefore have fierce and cruel sons, given to evil deeds. O lady of shapely limbs, you will bring forth Rakshasas, who are fond of drinking blood."

"My lord, be merciful. I do not wish for such offspring."

"It cannot be otherwise, for you too are of the demon clan. However, your last son will be virtuous and learned, true to my seed."

In due course, Kaikasi gave birth to three sons and a daughter. The first two sons, Ravana and Kumbhakarna, and the daughter Surpanakha were all hideous looking, though possessed of tremendous strength. They very quickly became avowed enemies of the gods. Kaikasi's fourth child, Vibhishana, however, was gentle and righteous, just as Vishrava had promised.

When they attained maturity, the three boys went high into the Himalayan Mountains to perform austerities in order to supplicate the great god Brahma. When the four-headed deity finally appeared before them, they each asked him for benedictions.

"Make me invincible in battle and make it impossible for anyone among the gods or demons to slay me," requested Ravana.

"So be it," said Brahma.

"Grant me knowledge and the strength to remain fixed in virtue, even amid the greatest difficulty," asked the pious Vibhishana.

"It shall be as you say."

Finally it was the giant Kumbhakarna's turn. This demon was particularly powerful. Immense in size, with arms like thunderbolts, he had already begun his career of terrorizing the gods and creating havoc wherever he went. He folded his palms and prepared to ask for a benediction. His huge voiced boomed out: "Grant me a boon, O lord."

At that time a delegation of gods approached Brahma, unseen by the demon. They prayed fervently, "Lord of the universe, hear our plea. No boon whatsoever should be given this demon. He has already gone to the heavens where he consumed a dozen assistants of Indra, the heavenly king. He has also eaten alive a number of celestial nymphs, as well as many sages and other humans. What will he do if made even more powerful by your benediction?"

The gods asked that Brahma, under the pretense of giving a blessing, should instead delude the demon. "In this way the universe may yet be saved," they said.

Brahma recognized that this was a job for Saraswati. He summoned her and when she came before him, he said, "Goddess, become the speech in Kumbhakarna's mouth."

Throughout the traditional lore of India, there are many instances where individuals make utterances intending to say one thing, but where their words carry quite a different meaning. Thus, for example, what may have been intended as a vilification of God becomes a poem of praise. The sages always point out that this is due to the intervention of Saraswati, who is never pleased to hear her Lord impugned.

Saraswati understood what was wanted of her and replied, "As you say, my lord."

Brahma then asked the demon what he desired. The colossal Rakshasa was fatigued by his asceticism, allowing Saraswati to intervene without difficulty. Thus, though he thought that he was saying the Sanskrit word *nirdevata*, meaning, "Let there be no gods," he instead said, *nidratva*, "Let me sleep."

"It shall be so," said Brahma. "You may sleep uninterruptedly all year round, rising for only one day every six months."

The god then disappeared, leaving Kumbhakarna in a state of bewilderment. "How did these words come out of my mouth?" he wondered, as he drifted into a deep slumber.

# A FOOL BECOMES A GENIUS

araswati's ability to grant learning and skill to anyone is illustrated in a popular story about Kalidas, sometimes called "the Indian Shakespeare." This great poet, who wrote in the Sanskrit language, lived some 1,500 years ago during the reign of a king named Bhima.

This king had a beautiful daughter who was also highly intelligent. Her father hoped to marry her to a court minister named Vararuchi, but the girl stipulated that she would only wed someone more intelligent than she. Whenever a suitor came she would challenge him to debate and defeat him. The same happened to Vararuchi, who became greatly annoyed and began to wonder how the princess's swelling pride might be curbed.

One day, as the minister was walking along the road, he saw a man sitting in a tree sawing on a branch. He noticed that the man was positioned in such a way that when the branch was sawed right through, he would fall to the ground.

Vararuchi called up to him, "Hey, you there! Stop sawing or you will fall down."

The man looked down. "What are you talking about?" he called back, and went on sawing. Sure enough, he soon dropped to the ground with a crash, his saw flying from his hand.

The fool looked up at Vararuchi in wonder and said, "How did you know I would fall? Are you some kind of seer?"

The minister's face twisted with amusement. How could anyone be such an imbecile? Surely this was the village idiot. Then he began to think. Perhaps this was a good opportunity to get one back at the princess. He smiled and said, "I have studied the sciences, you see. But the king has sent me to find a man worthy of the princess. I think that you are just the person I have been looking for."

The man, whose name was Kalidas, got up and dusted himself off. "Me? And the princess? How could that be possible?"

"Just do as I say and she will be yours."

Vararuchi then had Kalidas dressed in the finest clothes and told him that he would be introduced to the princess as a suitor. "But don't say anything at all," the minister cautioned. "When the princess starts asking you questions, just use hand signals to reply."

Vararuchi demonstrated what he meant, showing Kalidas some *mudras*, the symbolic hand gestures used by sages.

The next day, the minister took the fool to see the princess, introducing him as a prospective husband. Sure enough, she challenged him to a philosophical debate. "There is but one universal spirit," she said, raising one finger.

Kalidas said nothing, but held up his hand in one of the gestures shown by Vararuchi. The minister, who was standing nearby, gasped. "Incredible!" he said. "What a perfect response!"

The princess was not sure what Kalidas' gesture had meant, but rather than reveal her ignorance, she put forward another argument. This too was answered by a gesture from Kalidas. This went on for some time, with Vararuchi and the other ministers expressing loud appreciation each time Kalidas gesticulated.

Finally Vararuchi said, "I think you have met your match, princess. He has countered every one of your propositions."

The princess was baffled. She had no idea what or how he had answered her, but before she could protest, her father said, "Excellent! We shall immediately begin making preparations for the wedding."

Soon Kalidas and the princess became husband and wife, but on their first night together it quickly became clear to the princess that she had been duped. Her husband was obviously a prize fool. Furious, she ejected him from the palace while the ministers stood by, snickering.

With his head bowed, Kalidas shambled along the road. How humiliating! Why was he such a dull wit? He made his way home and sat before his altar to the Goddess, at which he had always prayed daily. Bowing low, he said, "Please help me, dear Mother. Give me some good sense and intelligence."

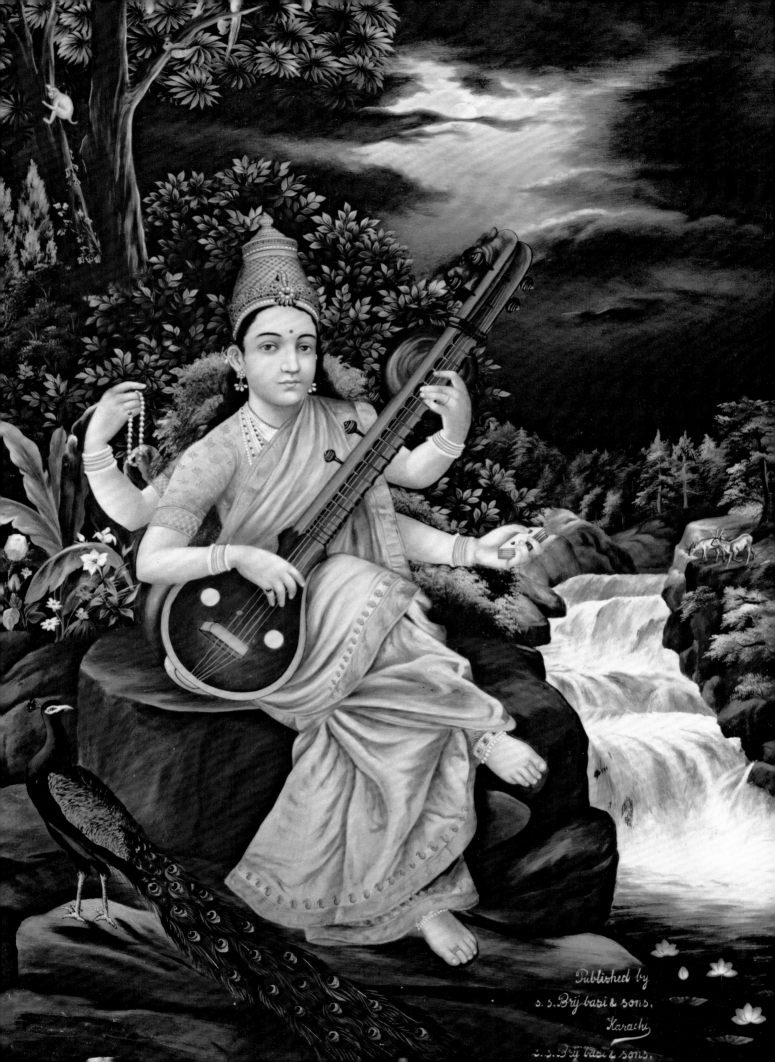

Published by
s. s. Brijbasi & sons.
Karachi
s. s. Brijbasi & sons.

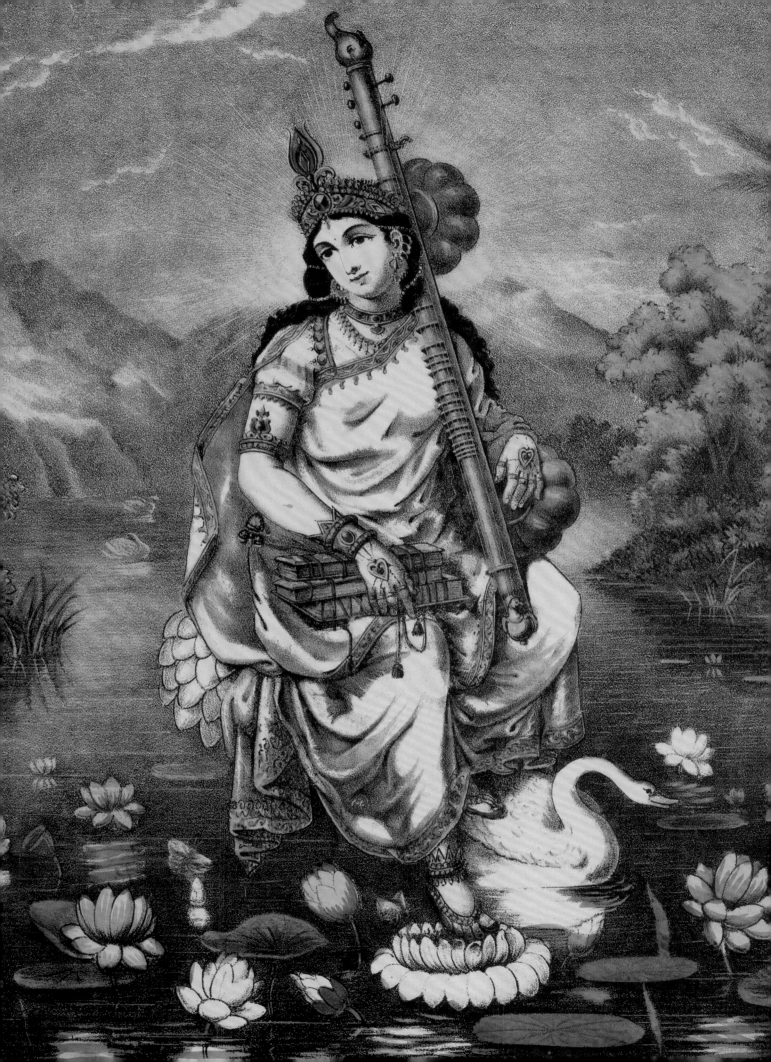

He prayed like this for a long time until finally he had a vision of the Goddess, who appeared to him as Saraswati. "I am pleased with your worship," she said. "By my grace you will become a great poet and playwright." Kalidas' mouth fell open and the Goddess inscribed some Sanskrit letters on his tongue. Then she disappeared.

Shortly thereafter, Kalidas became famous as an author and intellect. He returned to the princess and she, suitably impressed, accepted him back as her husband.

## SARASWATI'S GREATEST BLESSINGS

he story of Kalidas shows how the Goddess can bestow great material benedictions, but she can give much more, as the next story illustrates. This is a historical account that took place in Bengal some 500 years ago. At that time, there was a great scholar named Keshava Kashmiri who had traveled the length and breadth of India, challenging and defeating all his contemporaries. This was the culture of the time; just as we have great sportsmen today who compete against each other, in those days in India there were many learned scholars who would continuously debate one another.

Keshava Kashmiri was so good at argument that he became known as a *dig vijayi*, "one who has conquered in all directions." He too was an ardent worshiper of goddess Saraswati, daily spending several hours chanting mantras in her praise. It was said she had given him the benediction that she herself would appear on his tongue whenever he spoke, thus making it impossible for him to be defeated. All the scriptures and the sciences of logic and grammar were at his command. Often, his opponents in debate could not even understand the introductory portion of his arguments. As a result, he had won such an intimidating reputation all over India that no one dared face him, let alone challenge him.

Having heard that the greatest scholars were to be found in Bengal, Keshava made his way to the main center of learning there at the time, a city called Nabadwip. Traveling in a regal procession of elephants, horses and men, he entered the city amidst a great fanfare. News of his arrival spread fast, but the city's many scholars kept themselves hidden. They too had heard of Keshava's blessing from Saraswati. How would it be possible to defeat him? They gathered together in consternation. What could they do? Their reputation and that of their city would be destroyed if they could not defeat this daunting *pandit*, or scholar.

Another exceptional personality was living in Nabadwip at the time. His name was Nimai Pandit, and he would later re-

veal himself to be an incarnation of Krishna. However, at the time, he was keeping himself hidden and people simply saw him as a young but learned Brahmin teacher who ran a small school of his own. Only a few of his closest associates knew his true identity.

Some of Nimai's students came to him and told him of the dig vijayi pandit's arrival. "He has thrown down a challenge. If no one is prepared to meet with him and debate, he wants the entire town to issue a written admission of defeat."

Nimai smiled, "Listen brothers," he said, "The Supreme Lord does not tolerate excessive arrogance. He acts quickly to remove it. Like a fruit-laden tree, a truly learned man bows his head in humility. So too will Keshava Kashmiri's head soon be bowed."

That evening, Nimai went as usual to the banks of the Ganges and began giving lessons in Sanskrit grammar. Dusk faded into night and the gently flowing Ganges sparkled beneath a full moon. The handsome Nimai, still only a youth, sat at ease in the midst of his pupils. Raven-black curls of hair fell around his golden-complexioned face and his eyes appeared like lotus petals. He exuded an air of gentle compassion and love as he spoke, establishing and refuting various arguments, always concluding that life's goal was to lovingly unite with the Supreme.

At that time, Keshava Kashmiri arrived at the river, accompanied by his many followers. Seeing the effulgent Nimai surrounded by students, he was intrigued. He inquired from one of them, "Who is this person?"

"This is Nimai Pandit," the student replied.

Keshava considered that his moment had arrived. Here was another so-called pandit. He would soon take care of him. After bowing to the River Ganges, he went closer to Nimai and sat down. Nimai saw him and welcomed him warmly. "Your reputation precedes you, sir. Everyone is speaking of your scholarship."

Keshava's head tilted back a little. "It is nothing," he said, with a dismissive wave of his hand. He went on, a hint of sarcasm entering his tone, "I hear you are a scholar in your own right. People speak highly of your lessons in beginner's grammar. They tell me your students are expert in the word jugglery of basic grammatical systems."

Nimai held up his hands and laughed. "Oh, I am not much of a teacher. I can't impress my students very much and they don't really understand me either."

The pandit's head went back a little more as Nimai continued,

"My dear sir, you are a learned scholar in all sorts of scriptures and very experienced in composing Sanskrit poetry. I am only a boy—a new student and nothing more. I would therefore like very much to hear you compose something extemporaneously. Perhaps you could kindly display your skill by describing the glory of the Ganges."

Keshava at once agreed and began to compose verses of Sanskrit poetry in praise of the River Ganges. The speed of his composition astonished his listeners. His voice resounded like a continuous roll of thunder as he expertly presented an eloquent poem of over one hundred intricate stanzas, reciting without pause for a whole hour. Nimai's students sat with their mouths agape. They had never heard anything like it. The alliteration, assonance, metaphors and many other literary ornaments amazed them. When the pandit had finished, they turned toward Nimai, wondering what he would say.

Nimai thanked the pandit and said, "Sir, there is no greater poet than you in the entire world. Your poetry is so difficult that no one can understand it but you and Mother Saraswati, the goddess of learning. Please therefore explain the meaning of one verse to us. It will make us very happy to hear you personally expound on your own composition."

"Why certainly," replied Keshava. "Which verse would you like me to explain?"

The pandit hardly expected Nimai to remember any of them, but without hesitation the young scholar from Nabadwip repeated word for word one verse that Keshava had intoned about half way through his recital:

"The greatness of mother Ganges always brilliantly exists. She is most fortunate because she emanates from the divine feet of Vishnu, the Supreme Person. She is a second goddess of fortune, and therefore always worshiped by both gods and humans. Endowed with all wonderful qualities, she flourishes on the head of Shiva, the best of the gods."

The pandit looked in awe at Nimai. "I recited those verses like the blowing wind. How could you perfectly recall even one of them?"

Nimai smiled. "By the grace of the Goddess someone may become a great poet. Similarly, by her grace, someone else may have the gift of total recall."

Keshava nodded in agreement. "Yes, anything is possible by her grace."

He then explained the meaning of his verse. When he had finished, Nimai said, "Please explain this verse's exceptional qualities as well as its faults."

The pandit snorted, "There is not the slightest fault in that verse. Rather, it has all the esteemed qualities of simile and alliteration."

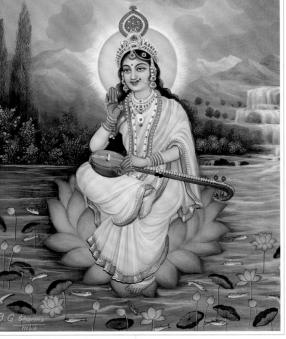

Nimai spoke humbly. "My dear sir, please do not become angry if I ask you again. Are you sure it has no flaws?"

"What do you mean, flaws? This verse is perfect. How can you suggest otherwise? You know nothing at all about such poetry." Keshava scowled in annoyance.

Still speaking gently, Nimai said, "It is true that I am not on your level, and that is why I asked you to explain. But I have heard about these things from higher circles. Based upon that I can point out both ornaments and faults in this verse, if you will permit."

"Very well, then. Let me hear your so-called analysis."

There was complete silence as Nimai spoke. "I find five ornaments and five faults here. Please hear these from me and then give me your own judgment."

Nimai then listed the five faults. "There are two instances of unclear meaning and one each of contradictory conception, redundancy and broken order."

He showed exactly where each of the faults lay in the verse. "A predicate should not precede its subject and you have done this twice, once in the first line and again in the third. I shall show you how and then point out the other problems."

Nimai carefully explained all the faults and then listed the embellishments, greatly praising them. He concluded, "Your skill is wonderful, but a poem blighted by fault is ultimately disdained. You have achieved dazzling talent by the grace of your goddess, but your poetry needs to be properly reviewed."

The pandit was dumbstruck. He wanted to reply but no words could come from his mouth. Nimai's analysis could not be refuted. Keshava's head fell and he breathed heavily. How had this mere boy defeated him? Why had the Goddess blocked his intelligence and allowed him to make those mistakes? She must have somehow become angry with him. The criticisms made by Nimai were beyond the capacity of any ordinary person. Surely Saraswati herself had spoken through him.

Shaking his head, the pandit said, "My dear Nimai, I am astounded at your ability. You are not a student of literary criticism and do not have much experience. How then were you able to make such an analysis of my work?"

Nimai could understand the pandit's heart and he replied in a joking way, "You are right. I know little about such things. Whatever I said must be understood to have been personally uttered by the goddess Saraswati."

His face mournful, Keshava stood up to leave. He went away and began offering fervent prayers to the Goddess, asking her why she had chosen to humiliate him through a boy. "Have I offended you in some way? Until now no scholar could even look at me. This was only possible by your grace. Have I now lost your favor?"

Praying and praying, the pandit gradually fell asleep. Goddess Saraswati then came to him in a dream. She said, "My dear Keshava, hear my words. Do not tell anyone what I am about to reveal or it will not be good for you. Nimai is my eternal consort and master, the lord of the entire cosmos. Out of shyness, I hesitate to stand before him. I could not therefore appear upon your tongue as I have always done before. But you should not see this as my displeasure with you. Indeed it is a greater blessing than anything else I have ever given you."

Saraswati told him that the ability to defeat others in argument was nothing wonderful. "It may bring you some small pleasure, but if you abandon your pride and take refuge in God, you will experience a much greater happiness."

The Goddess told Keshava to go the next morning and offer respects and worship to Nimai, accepting him as the all-powerful Supreme. She then disappeared and the pandit awoke. When morning arrived, he followed her directions and went to Nimai.

"My Lord, I now know who you are. Forgive me. I was puffed-up with my so-called learning. Destiny has favored me with your audience. Please bless me."

Nimai embraced him and said, "You have truly received the grace and mercy of Saraswati. What use is knowledge that is not connected with God? When death comes it is all lost. Only spiritual knowledge of the self and the Supreme has any value and lasts forever. Cultivate that and worship the Supreme. Then you will be truly happy."

The pandit followed Nimai's advice and became famous throughout India as a great saint.

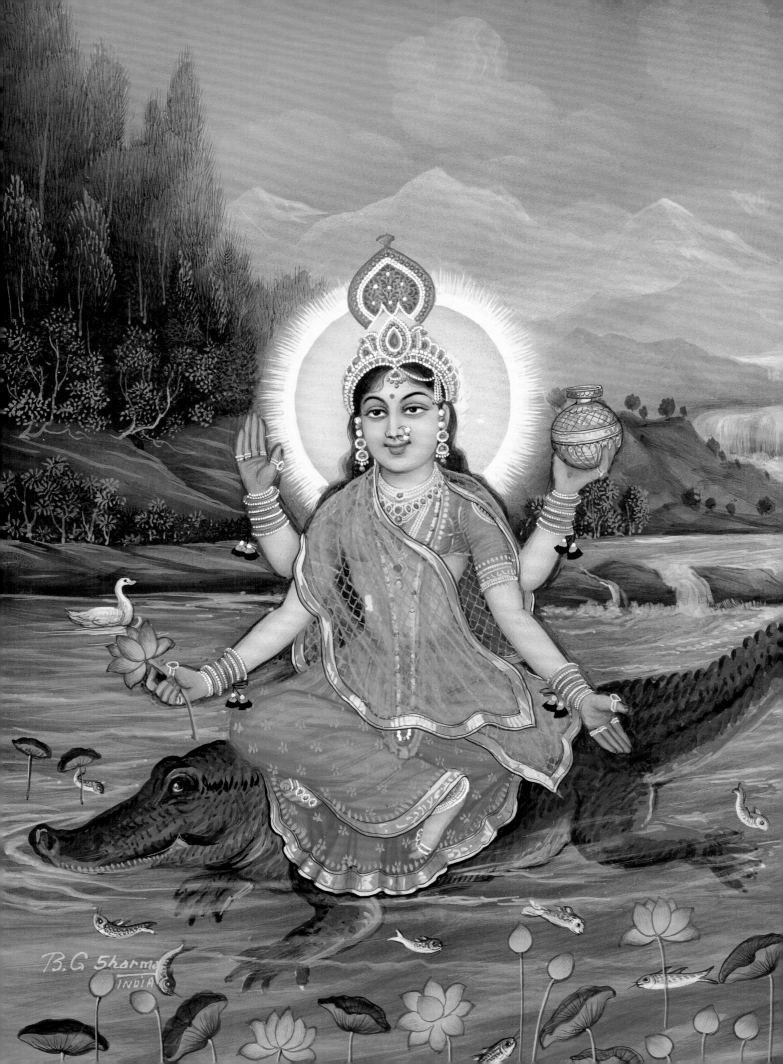

# GANGA

O F ALL THINGS HELD HOLY IN HINDUISM, THE GANGES RIVER IS PERHAPS FOREMOST. EVERY TWELVE YEARS THE BANKS OF THE MIGHTY RIVER PLAY HOST TO THE LARGEST GATHERING OF HUMANITY ANYWHERE ON THE PLANET, THE ANCIENT KUMBHA MELA FESTIVAL IN ALLAHABAD. MILLIONS OF PILGRIMS JOSTLE TO BATHE IN THE SACRED GANGES WATERS, AN ACT THEY BELIEVE CAN FREE THEM FROM THE CYCLE OF BIRTH AND DEATH. NAKED SADHUS, SAINTLY PEOPLE WHOSE LIVES ARE DEDICATED TO SPIRITUAL UNDERSTANDING, LEAD THE WORSHIP OF THE RIVER WITH NUMEROUS CEREMONIES AND PRAYERS. AFTER BATHING, THEY SMEAR THEMSELVES WITH MUD FROM THE RIVERBANKS IN A RELIGIOUS ACT INTENDED TO FURTHER SANCTIFY THE BODY AND PURIFY THE MIND.

For Hindus, the river is a deity, a goddess named Ganga, who is usually depicted riding upon a great crocodile with a golden pot and lotus flower in her hands. Her waters are considered sacred because, according to the Vedas, they flow from Lord Vishnu's foot. Many eons ago Vishnu appeared in the form of a dwarf named Vamana. In order to reclaim sovereignty over the universe for the gods, who had been defeated by the demons, he took three incredible steps that spanned the entire universe. One of these punctured the very fabric of the cosmos, opening a window to the spiritual realms and allowing the waters of the Karana, or Causal Ocean in which the universe floats, to seep in.

# The Appearance of Ganga

In the epic *Ramayana*, a sage named Vishwamitra describes how the goddess Ganga was born and later came to Earth as a river. The story begins with the presiding deity of the Himalayas, a god named Himavan. He and his consort Mena, the daughter of the celestial Mount Meru, had two exceptionally beautiful daughters. The elder of the two was named Ganga. She became a holy river at the request of the gods. The other was called Uma or Parvati, who later became Lord Shiva's wife.

After their marriage, Shiva and Parvati sported together in conjugal bliss for many thousands of years. The gods became anxious. They knew that if Shiva's vital seed was released into Parvati—also a divine being of unlimited might—the couple would conceive a child so potent that the universe itself might be threatened. With Brahma at their head, they went to Shiva and fell prostrate before him.

Brahma said, "Mighty lord, we are afraid that you and your wife's offspring will incarnate your combined powers and thus incinerate the worlds by his mere presence. We therefore entreat you to retain your vital energy and to not discharge your seed."

Shiva, ever compassionate to all beings, replied, "I shall do as you ask, for a request from the gods cannot be refused. However, my vital seed has already been displaced from my heart. Tell me where it should be allowed to fall."

"Let it fall upon the earth. Only the earth can withstand its intensity, for she bears the weight of all things."

Shiva then released his glowing seed, which spread over the entire globe. The gods were fearful that it would split the earth asunder. Brahma turned to Agni, the fire-god, and instructed him, "Go with the wind-god Vayu and move across the earth's surface. Suck up Shiva's mighty seed and place it in the divine Ganga. The gods previously asked me to provide them with a powerful commander for their army. On being impregnated with this seed, Ganga shall bring forth a radiant son who will fulfill that role."

After bowing to Brahma, Agni raced across the earth and gathered up all of Shiva's vital fluid. He then went before Ganga and said, "Be pleased to receive Shiva's seed, O Goddess!"

Ganga assumed an ethereal human form of indescribable beauty, causing Shiva's seed to melt and permitting Agni to impregnate her with it. But as it coursed through her veins, she cried out to the fire god, "I cannot bear this blistering fluid, which has been made even more fiery by your touch."

At Agni's suggestion, Ganga immediately expelled Shiva's semen from her body. It emerged as a brilliant stream that fell upon the Himalayas, where it became a vast network of gold and silver veins in the rock—which is how the deposits of precious metals in the earth came to be created.

But Ganga had not been able to rid herself of all of Shiva's seed. With the few drops that remained within her, she conceived a child who became known throughout the worlds as Skanda or Karttikeya, and who was to lead the gods to victory over the dangerous demon Taraka.

# Ganga's Descent to Earth

Some time after this, a mighty king named Sagara came to rule over the earth. By the blessing of a sage, this king had sixty thousand and one sons. One of his two wives bore a male child in the normal way, but the other gave birth to a fetus that was shaped like a gourd, which then split into sixty thousand pieces. Each of these pieces was placed in a pot of clarified butter where it gradually grew into a male child.

Though the single son, whose name was Amsuman, was pious and well loved by all, the other sixty thousand were evil-minded and their actions caused pain to living beings everywhere.

One day King Sagara decided to perform a horse sacrifice for the good of his realm. Indra, the king of the gods, became concerned that Sagara might exceed him in pious merits and take his heavenly post, which he had himself won through a similar performance of sacrifice. To thwart him, Indra assumed a disguise, seized the sacrificial horse and hid it in a distant place.

The priest in charge of the ritual warned, "If the horse is not recovered a great ill shall befall the kingdom."

The king commanded his sixty thousand sons: "Search high and low for the horse. Apprehend and punish the thief. Leave no stone unturned. If you cannot find the villain on the surface of the globe, then look for him underground, for demons often reside in subterranean caverns."

The princes scoured the earth, but could not find the horse anywhere. They dug beneath the earth's surface and searched there, but to no avail. In their quest, they created tremendous havoc and killed innumerable creatures. Eventually they arrived at the underground hermitage of a sage named Kapila, where they finally found the sacrificial horse grazing nearby, exactly where Indra had left it.

The infuriated princes marched up to Kapila, who was deep in meditation. "You charlatan!" they cried, "We are the sons of Sagara. You have stolen our horse and now you must be punished."

The powerful mystic Kapila was annoyed at being disturbed in his meditation by the arrogant princes. He opened his eyes and in an instant all sixty thousand of them were burned to ashes by a fire that sprang from their own bodies.

In the meantime, King Sagara was becoming concerned about his sons. He ordered Amsuman to go after them. In due course, Amsuman also found Kapila sitting in meditation as well as his brothers' ashes strewn about the sage's ashram. Saddened by their deaths, Amsuman looked all around for water to perform their last rites. Kapila told him that his brothers had descended to hell, adding, "If you desire to liberate them, you must seek the water of the divine Ganga. Beseech her to flow down from the heavens and come to earth."

The sage allowed Amsuman to take the horse, which he returned to his father. When the sacrifice had been completed, King Sagara and his son began to worship the goddess Ganga. They went to the Himalayas where they practiced severe austerities in order to gain her favor, but they failed to bring her to the earth. Several generations of Sagara's family came and went, but none were able to incite Ganga to appear.

Finally, a great soul named Bhagirath appeared in King Sagara's dynasty. Intent on the salvation of his ancestors, he followed Sagara's path high into the Himalayas. There he began summoning the goddess Ganga to the earth with a thousand years of austerities. He would stand in the midst of four blazing fires with his arms upraised, eating but once a month, praying for the celestial river to descend.

Finally Lord Brahma, pleased with his penance, appeared before him and said, "Tell me what you desire."

"Great lord, pray let the Ganga come to earth and soak the ashes of my forefathers, who are now rotting in hell."

"It shall be so. But you must first obtain the favor of Shiva, for unless he breaks Ganga's mighty descent, she may bring untold damage to the earth."

After Brahma had gone, Bhagirath returned to his asceticism, now desiring to propitiate Shiva. He raised himself onto his tiptoes again and stood with his arms upraised for another year, constantly intoning a mantra to Shiva. When the year was up, the god

came before him and said, "I am pleased with you, Bhagirath, and will fulfill your desire. I shall break the Ganga's fall upon my head, whence she may go cascading to the earth's surface."

At the urging of Brahma, Ganga began her descent from the heavens and Shiva placed himself beneath her mighty torrents. When Ganga saw him she smiled inwardly. How would anyone, even Shiva, be able to withstand her onrushing waters? Surely she would sweep him right away before surging on to the realms that lay below the earth.

Shiva understood what she was thinking and decided to check her pride. As the waters of the heavenly stream fell into his thickly matted locks, they completely disappeared. Unable to find a way out, the goddess remained trapped in the tangled jungle of Shiva's hair for many years, until Bhagirath's renewed supplications convinced the god to allow her to continue her journey.

Once on the earth's surface, Ganga coursed unchecked down the mountains to the plains, where she flooded the hermitage of a sage named Jahnu. The sage was so provoked by the interruption to his sacrifice and worship that he opened his mouth and swallowed the mighty river in its entirety, once again thwarting Bhagirath's efforts.

The saintly king appeased Jahnu with gentle words and the sage released the river from his ear, allowing her to continue on her way once again. This is how Ganga gained the epithet Jahnavi, "Jahnu's daughter."

Flowing in three main courses, the great river eventually reached Kapila's ashram where it flowed over the ashes of Sagara's sixty thousand sons, who were at once liberated and ascended to heaven. The water filled the excavations they had made so many years before and became the ocean, which to this day is known as *sâgara*. The place where the Ganges meets the ocean is one of India's greatest pilgrimage spots, Ganga Sagara, the site of a great annual festival commemorating these events.

## Why Ganga Became a River

Once the goddess Ganga came into Vishnu's palace while he was seated at ease, his two wives Lakshmi and Saraswati by his side. Ganga became attracted to the Lord and began casting coy glances in his direction. When Vishnu reciprocated, Saraswati's brows

furrowed. "What do you think you are doing?" she exploded.

She then rose from her seat, stormed toward Ganga, and prepared to strike her. Lakshmi quickly intervened. "Stop! Do not fight before our husband," she said, taking hold of Saraswati.

"Let me go!" said Saraswati. "For having interfered with me, I curse you to be born on earth."

Ganga was in turn angered to see the innocent Lakshmi cursed in that way. She said to Saraswati, "You too shall take birth on earth, but as a river."

Saraswati immediately retorted, "Then so shall you!"

Seeing all this, Vishnu laughed and said, "I give all these curses my approval, for they shall bring great benefit to all humankind: Ganga's waters shall take away the sins of the world. Lakshmi shall bless the world by becoming the holy Tulasi plant. And Saraswati shall also become a sacred river, beloved of the sages."

So it was that the goddess Ganga entered the waters that flowed into the material universe from the Karana Ocean.

## GANGA TAKES A HUMAN BIRTH

The *Mahabharata* tells another story of Ganga Devi appearing in the world among humans.

There was once a truthful and virtuous king named Mahabhisha. At his death, he ascended to heaven as a result of the many great religious rituals he had performed throughout his life. One day in the heavenly realm, the celestials were worshiping Lord Brahma in the presence of many sages and gods. Mahabhisha was also there in that august assembly when the goddess Ganga made her entry dressed in pure white silk robes that shone brilliantly. As Mahabhisha stared at her divine beauty, a stiff breeze suddenly blew through the hall, ruffling Ganga Devi's robes and revealing her exquisite body. The gods and sages all looked away, but Mahabhisha's gaze remained riveted to her faultless form.

Brahma saw Mahabhisha staring shamelessly at the goddess and pronounced the following judgment: "For this rude act you must return to the world of mortals. You shall only return here after spending another lifetime among men."

Mahabhisha accepted the curse humbly, but made the following request, "Please allow me to be born as the son of Pratipa, the most virtuous king in the world."

Brahma agreed and the assembly dispersed. Ganga had noticed the handsome Mahabhisha staring at her and went away thinking of him. On her way out, she encountered the gods known as the Vasus who appeared dejected.

"What troubles you?" she asked "Are you not well?"

"O Goddess of the heavenly river, we have been cursed to take birth as human beings by the sage Vasishta, whom we greatly offended by stealing his cow. We cannot reverse his terrible calamity and are thus inconsolable."

"We cannot stand the thought of entering a human womb," they continued. "Would you become our earthly mother?"

"Who is to be your father?" asked Ganga.

"The pious-minded King Pratipa is to have a son who will become our father."

Realizing that this was to be Mahabhisha, Ganga said, "I agree to your request, for this is also my desire."

The chief Vasu then made a further entreaty, "Gentle lady, in order that we may return to heaven as swiftly as possible, would you please drown us into your waters as soon as we are born?"

"Very well. But so that my union with Mahabhisha will not prove fruitless, let one of your number stay upon the earth."

"It shall be as you desire. One of us will remain."

## GANGA MARRIES SHANTANU

King Pratipa, who was unaware of all these happenings in the heavens, was spending much of his time at the source of the Ganges River, practicing penance and worshiping the gods. One day, as he was seated by the river, the goddess Ganga rose from the waters and came to him. She sat upon his right thigh, which was as stout as a tree trunk.

The king looked at her in surprise. "Tell me what you desire, gentle lady," he said.

"I desire you, good king. I offer myself to you. Accept me as your wife."

"This cannot be, for I have taken a vow to never lust after another man's wife."

"Then there is no problem, for I am yet a maiden. Indeed, I am

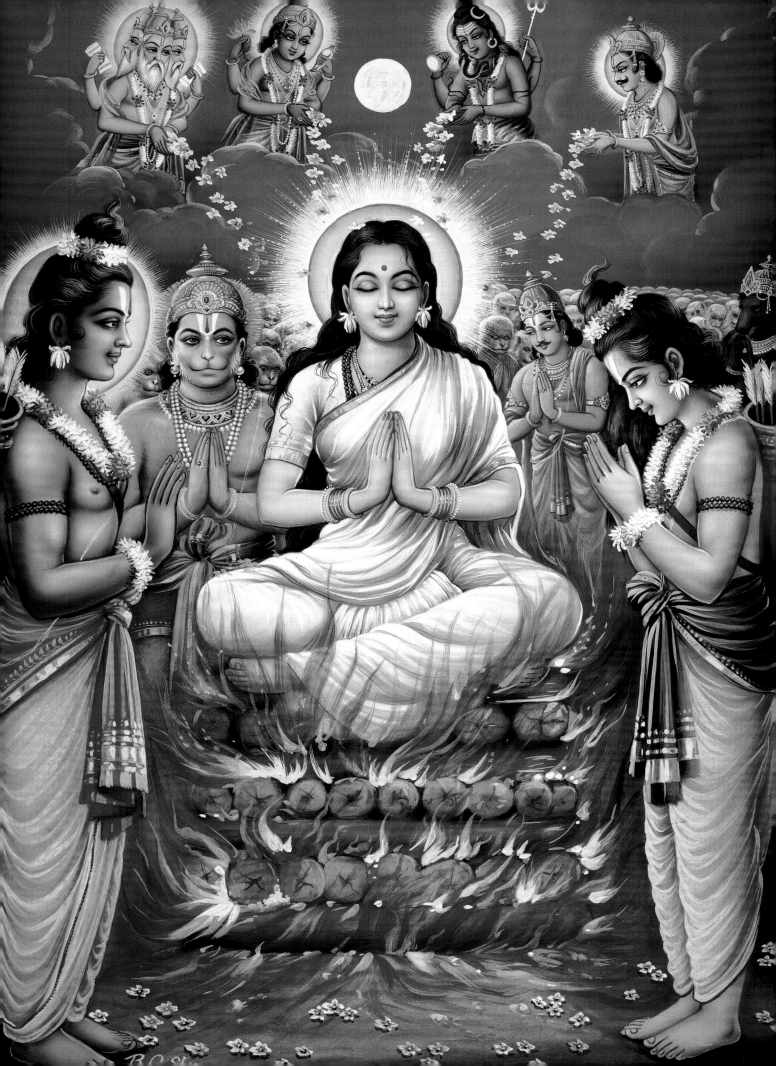

vide the pattern to which the individual may aspire, a range of metaphoric identity,' then this range, in the case of the Hindu woman, is condensed in one model. And she is Sita."

Of course, for Hindus and followers of Vedic culture everywhere, the Sita story is much more than myth, it is sacred history. And although Sita is indeed the emblem of self-surrender in her service to Rama, she is nonetheless considered just as holy. She always stands by his side on temple altars and Rama is never invoked or worshipped without her.

Sita's divine character is best understood through the narrations of her activities, found primarily in the Ramayana, as written by the sage Valmiki many ages ago. These narrations are sometimes hard to fathom. It is perhaps mysterious when we read how the supreme all-knowing God and Goddess exhibit apparently human feelings or limitations. However, these are all exhibitions of the internal energy of the Divine, of the pleasure potency that is personified in the form of the Goddess. They are exchanges of pure spiritual love between God and his eternal consort, or between the Supreme Soul and individual souls such as you and me. Such love finds expression through intense emotions, and these emotions are brought about by the divine pastimes enacted by God when he appears. Simply by reading or hearing about these pastimes we can vicariously experience the same emotions and awaken our own divine love.

## SITA'S BIRTH

 here was once a powerful sage named Kusadhvaja who desired to have the Goddess become his daughter. After offering her much worship and prayer, he finally succeeded in winning her favor and she took birth as his child, named Vedavati. As the girl grew to maturity she became a very beautiful woman, but she was not interested in marrying any mortal man—she wanted only Vishnu, the Supreme Person, as her husband.

One day, as Vedavati moved about in her father's forest abode, she was seen by a demon named Sambhu. Afflicted with lusty desires, the demon went at once to Kusadhvaja. "Grant me the hand of your exquisite daughter," he begged.

"I cannot, for she has vowed to marry no one but Lord Vishnu. I am sure she will not accept anyone from the demon race."

Sambhu went away disappointed and angry, thinking only of Vedavati's spotless beauty. That night he returned wielding a great sword and killed Kusadhvaja. Vedavati heard the commotion and ran out. When she saw what the demon had done, her furious glance reduced him to ashes.

Vedavati then went deep into the forest, more determined than ever to win Vishnu's favor. She engaged in severe asceticism, fasting and meditating for long periods, constantly intoning prayers to Vishnu.

At that time, Ravana, the leader of the Rakshasa demons, was on a rampage, laying waste to the land everywhere he went, raping and plundering, as well as attacking and killing sages wherever he found them. One day, as he was flying past Vedavati's home, seated upon an aerial chariot he had stolen from the gods, he happened to catch sight of her. He descended at once and, using his mystic power to assume a human form, approached the meditating girl.

He spoke loudly, disturbing her reverie, "Tell me most beautiful maiden, who are you? Why do you sit alone in this lonely place? Where is your husband?"

Ravana only inquired after her husband so that he could, if necessary, remove any obstacle that stood in the way of enjoying her.

Vedavati looked up at him. "You are welcome here, for you are a guest. But you should know that I am petitioning Vishnu to become my husband. Do not try to seduce me, for it is impossible for any being other than Vishnu to possess me."

Ravana sneered, "Vishnu? Why bother with him? No one is my equal. I am Ravana, ruler of the mighty Rakshasas. Come to my capital, Lanka, the golden city, and be my queen."

Ravana derided Vishnu, though he knew him to be the lord of all the gods. He cared nothing for universal authority, for he had received a boon from Lord Brahma that protected him from being killed by any created being, either god or demon. He could assume any form at will and go anywhere he pleased. Vedavati's devotion to Vishnu did not intimidate him at all. He continued to devour her with his eyes.

Vedavati flushed red with anger. "How dare you insult my beloved lord? Leave at once for your own good. Do not provoke him to anger."

Ravana laughed. He liked feisty maidens. "Come here!" he growled, lurching forward to grab Vedavati by her long locks. Before he could touch her, however, she uttered a powerful Sanskrit mantra that checked his advance. Pulling away, she rebuked him, "I have been polluted by your touch! Now this body is fit only for rejection. But hear this: I will become Vishnu's wife in my next birth and bring about not only your destruction, but that of your entire race."

With these words, Vedavati invoked the yogic fire from within

her body, and as Ravana watched in astonishment, the flames engulfed it and burnt it to cinders. The demon stood perplexed, not sure what to do. Still dazed by her incomparable beauty, he scooped up her smoldering ashes and took them with him. When he reached Lanka, he placed them in a golden box and concealed them in his room, hoping that this would somehow help him see the divine girl again.

Not long afterwards, however, Ravana began to observe dark omens in his city that foretold disaster. His counselors told him that Vedavati's ashes were the likely cause and advised him to take the box and dispose of it quickly.

Ravana had the golden container thrown in the sea, but the waves washed it onto a beach where robbers found it. Thinking it contained treasure, they carried it off and buried it somewhere inland. Before they could recover it, how-ever, they were caught and ex-ecuted. As a result, the golden box of Vedavati's ashes lay for many years where the robbers had hidden it, completely lost and forgotten.

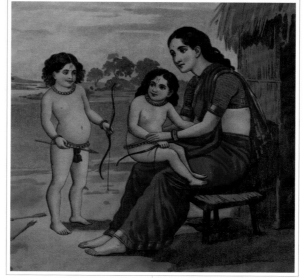

Decades later, it came to pass that a king named Janaka came to that region to perform a fer-tility rite for the earth. As he was plowing the ground with a golden ploughshare, he un-covered the box that Ravana had discarded. On opening it, he found an effulgent baby girl. The king accepted the girl as an offering from the earth goddess and took her to his capital city, Mithila, where he raised her as his own daughter. She became known as Sita, which literally means "furrow."

## A DIVINE UNION

**W**hen Sita had grown up to become a beauti-ful young woman, Janaka began consider-ing her marriage. He knew she desired to marry a godly man of the highest caliber. Indeed, she had been praying that Vishnu himself would become her husband, just as she had in her previous life. Janaka therefore wanted to devise a test for her suitors that only Vishnu could pass. One day he observed an extraordinary incident that gave him an idea of what that test should be.

Janaka possessed a divine bow that had once belonged to Shiva. This great weapon, made of celestial woods, could only be lifted by the combined efforts of three hundred men. That morning, Sita and her friends were gathering jasmine flowers from the vines that wound through the mango trees near the palace. When they saw some exquisite flowers near the top of one particularly tall tree, beyond their reach, they began look-ing for something with which to knock them down. Sita ran into the palace where she saw Shiva's bow. She deftly picked it up and ran out with it, then used it to knock down the flowers they had been looking at.

Astonished by this extraordinary feat, Janaka stipulated that only the man who could single-handedly lift and string the bow would win Sita's hand. Many kings and princes came to try the test, but none of them could even move the bow. Janaka began to despair that Sita would ever find her match, but then he heard that a prince named Rama was coming to Mithila. Rama was widely believed to be an incarnation of Vishnu. Janaka was excited. Perhaps Rama would attempt the test.

Rama entered Mithila ac-companied by his brother Lakshman and their spiritual guide, the sage Vishwamitra. When they reached Janaka's palace, the king came out with his ministers and priests to greet them. Bowing their heads to the ground in a gesture of reverence, they offered their respects to Vishwamitra. The sage blessed the king who then stood up and said, "Welcome indeed are you and these boys, who resemble a pair of gods in luster and beauty. I stand hal-lowed by your very sight. What brings you to my city?"

"Mighty monarch, we have come to examine Shiva's bow."

A surge of joy swept through Janaka. "And so you shall. It is now dawn, a highly auspicious time. Let us therefore go im-mediately to the hall where the bow is kept."

The king led his guests to the weapon, which lay in a long golden chest mounted on many wheels. Studded with numerous celestial gems, it shone with a brilliant aura. Janaka said, "This wondrous bow has been worshiped in my family for generations. Not even the hosts of gods or demons can string it, even in their imagina-tion. How then can any human? Of the kings who have so far at-tempted it, not one has come anywhere near succeeding."

The king looked hopefully at Rama. "If you string this bow, Sita will become your wife. This is my promise."

Rama folded his palms reverentially as he looked upon the bow. "I shall try now to gauge the weight of this bow, and perhaps even to bend and string it."

"Please do so," said Janaka.

Meanwhile, Sita came out onto a balcony overlooking the hall. She looked down at the handsome Rama and something stirred in her heart. Surely this was Vishnu, come at last in answer to her prayers. She held her breath as he reached into the casket where the bow lay.

Rama seized the bow in its center and lifted it effortlessly out of its chest. In order to string it, he placed one end on the floor and pulled the top down toward him. Suddenly, the bow broke with a deafening sound like a mighty crash of thunder. Everyone present was stunned except Rama and Sita. The princess gazed in awe at Rama, recognizing him as her eternal consort. She took up the nuptial garland with trembling hands and went up to him, placing it over his head to signify her acceptance of him as her husband.

## SITA'S PLEA

Not long after the wedding, Rama's father Dasarath wanted to install him on the throne. However, this was not to be. The king had four sons by three wives, Rama being the son of his eldest wife Kaushalya. The youngest wife, Kaikeyi, though at first happy with the selection of Rama as heir apparent, later changed her mind under the influence of her crooked maidservant. She called in a favor owed her by Dasarath, using it to have Rama exiled to the forest for fourteen years so her own son Bharata could become king in his place.

These were the machinations of the gods, who were but acting as instruments of the divine will. Everything was being arranged so that Rama and Sita could bring about the downfall of Ravana, who could only be overcome by God's supreme power.

Rama was exiled on the day he was due to be crowned as king. On hearing that he was to go to the forest, he immediately made his way to Sita's quarters to tell her. Sita was surprised to see Rama pale and perspiring on what was meant to be a joyous occasion. She asked him why he appeared distressed. "Where are the royal servants? Why are you not wearing regal dress? Have you not been installed as king?"

Rama expression was pained as he replied to his beloved wife, "By my father's order I must enter the forest for fourteen years.

Bharata will be anointed as king in my place. Long ago, the ever-truthful king promised to do Kaikeyi's bidding without question if ever she had cause to ask. She has decided that the time has come and has asked him to take these steps. So, to keep my father's word, I am to depart for the jungle at once. I have come here to bid you farewell."

Tears flooded Sita's eyes and she began to shake. Was this true? It surely was, for Rama never lied.

Rama continued, "While I am gone, you should remain firm in mind, observing fasts and praying. Serve my father and mother and wait patiently for my return. The time will pass quickly and I will be back before you know it."

Sita was too shocked to say anything. Her face turned pale. Clearly Rama was not joking. She listened in dismay as he instructed her further, asking her to remain devoted to righteousness and religion.

Finally Rama said, "Dearest one, most high-minded lady, I must now leave."

Sita found her voice at last. There was no way she could let Rama leave her for fourteen whole years. She flared up, her face flushing as she spoke. "What are you saying? My lord, these words do not befit you at all. How can you even suggest that I should seek another's protection? Are you really so powerless?"

Sita's speech was impassioned as she continued, "What refuge has a woman other than her husband? This is the ancient code and I shall not break it now. I will proceed with you to the forest, clearing the path as you go. We cannot be separated. I would rather endure a thousand years of extreme difficulty with you than a single day without you."

Sita implored Rama to take her to the forest. "I cannot leave your side. I am utterly devoted to you and my mind never sways from thinking of you. Nothing but death can part us. My lord, take me with you or see me die."

Rama comforted his sobbing wife. He held her hand and stroked her forehead. "Dearest lady, you are noble and devoted to virtue. Practice that virtue now and do as I ask. I cannot bear to see you suffer and the forest is full of suffering. Just by taking you there I would be neglecting my duty to protect you."

Rama tried to discourage her by describing the forest in detail: there were many dangerous wild animals; food was scarce and one had to sleep on the bare ground; thorny trees and stinging bushes grew everywhere and poisonous insects and snakes were a constant hazard.

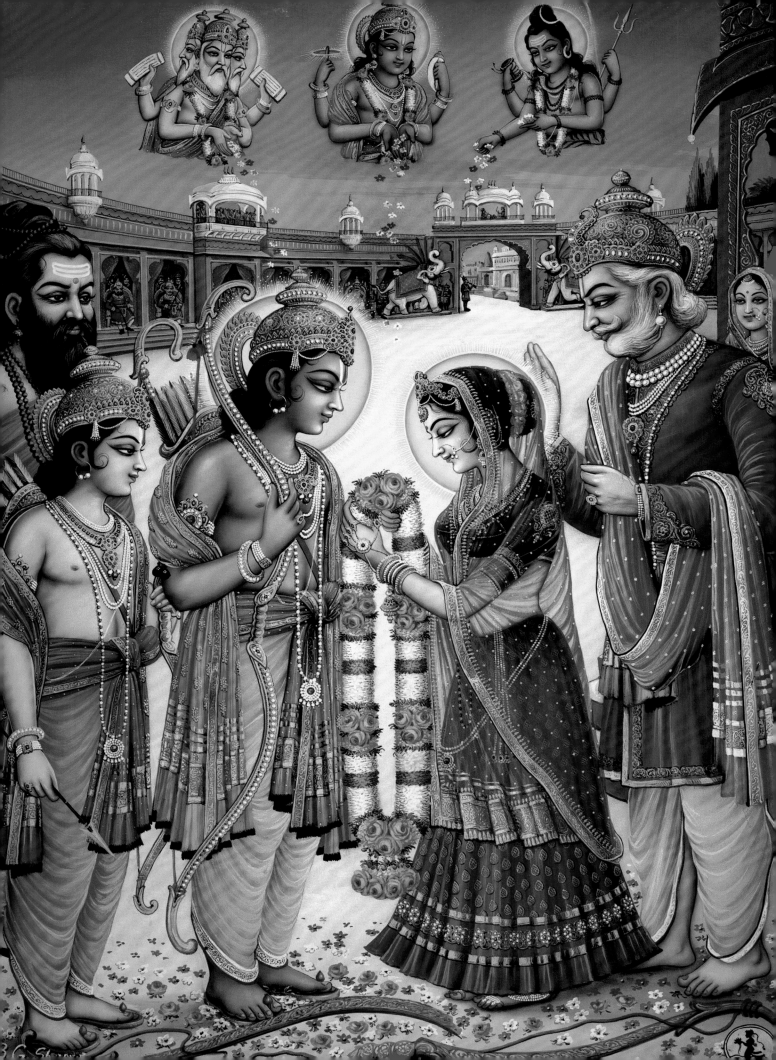

Rama continued trying to change Sita's mind: "The forest afflicts one with all kinds of illnesses and mental anguish. Anger, greed and fear must be completely controlled or one will not survive. Please dear princess, do not follow me there. It is not safe for one as delicate as you."

Sita could not be deterred, "I care nothing for any danger or deprivation as long as I am with you. Why should I fear anything anyway, with you as my protector?"

Sita told Rama that when she was a young girl an astrologer had predicted that she would one day live in the forest. "It seems that time has come, for my religious duty now obliges me to accept exile with you. Any other course will destroy my virtue, mighty hero. You are my husband and my supreme deity. By following you in life I attain the same destination as you after death. What else needs to be considered? You are my life and soul. Take me with you. If I am left behind, I shall resort to fire, poison or a rope, for life will no longer have any meaning."

Rama put his hands to his face and breathed deeply. "I still feel that it would be wrong for me to subject you to such an austere life."

"Rama, where is your valor? What will people say—that this prince could not even protect his own dear wife? Has fear overcome you? Are your weapons now useless?"

Sita beseeched Rama over and over to take her with him. Her beautiful face was streaked with tears that fell continuously from her dark eyes like drops of water from blue lotus flowers. Rama embraced her and gently wiped away her tears. He could not tolerate the thought of her suffering in his absence. Finally relenting, he spoke in soothing tones.

"Nothing could give me pleasure if it made you suffer, dear lady. Plainly you will be happiest in the forest with me. It seems that destiny has decreed this to be so. Follow me then, princess. I will protect you in strict accordance with the moral laws. Get ready to leave, for we must depart at once."

Sita's face bloomed like a full-blown lily. Shedding tears of joy she began preparing for the long trip to the forest.

# THE DEMONESS

Time passed quickly in the forest for Rama and Sita. They built a thatched hut and enjoyed each other's company, attended by Rama's younger brother Lakshman, who had also accompanied them in their exile. Sita prepared meals of wild fruits and vegetables and danced and sang for entertainment. For his part Rama stayed vigilant, his bow at the ready. He knew that the powerful Rakshasa followers of Ravana inhabited the forest. Sooner or later they would show themselves. Rama was looking forward to that opportunity.

One day it came to pass that Ravana's sister, the demoness named Surpanakha, happened upon Rama's dwelling as she passed through the forest. She caught sight of Rama seated outside his hut. His powerful form and majestic bearing immediately attracted her mind. Overcome with desire, she assumed the form of a beautiful woman and came before him, smiling seductively.

"Hail, good sir," she said. "Who are you? You are dressed like a forest sage, yet you wield mighty weapons. Why do you reside in this lonely forest, teeming as it is with Rakshasas?"

Rama replied respectfully, telling her who he was and why he had come there. He then asked the demoness her name. Surpanakha glanced at him and looked away shyly. "I am the sister of the unconquerable Ravana. Good fortune has surely brought me here today. I have lost my heart upon seeing you. Become my husband and accept my embraces."

Rama looked at her in surprise. Ravana's sister? In her fine silks and ornaments she appeared exactly like a celestial maiden. He laughed and said, "I am afraid I am already married. My wife Sita is here with me and I have vowed to be faithful to her."

Surpanakha moved closer to Rama. "You can do better than this skinny wretch of a woman. Take me instead. I'll soon devour her and then the two of us can enjoy together as we please."

Rama shook his head, "I don't think so. Maybe, though, you can convince my brother Lakshman to marry you. He is still single." He threw a playful glance at his brother.

Surpanakha turned her gaze toward Lakshman, who bantered back at his brother, "Oh, I'm no match for her. I think she should stick with you, Rama. She is such a beauty that no one would reproach you if you gave up Sita for her."

Realizing she was being made fun of, Surpanakha lost patience. Reverting to her natural hideous form, she let out a shriek and rushed toward Sita like a meteor falling toward the earth. "Meet your death, woman!" she screamed, "I will not let you stand between me and Rama."

In an instant, Lakshman drew his sword and with one deft movement sliced off Surpanakha's long nose and pointed ears. "Think yourself lucky to be a woman," he said, "or you would already be lying dead."

## Surpanakha appeals to Ravana

 owling in pain, the demoness fled away into the forest where she met one of Ravana's generals, a powerful demon named Khara. Seeking to avenge the dishonor done to his king's sister, Khara led an army of 14,000 Rakshasas against Rama, but the two brothers were unassailable. The Rakshasas fell like hewn trees as they rushed at Rama and Lakshman, and when the battle was over, they resembled a wheat field that had been flattened by a hailstorm.

Her appetite for revenge intensified by this disastrous defeat, Surpanakha went to her brother Ravana. She found him seated on a golden throne in his palace, glowing like a great fire. His huge black body was adorned in celestial robes and jeweled ornaments stolen from the gods. Twenty arms, stout as tree trunks, hung from his body. He looked intently at the wailing Surpanakha with his ten pairs of eyes. "What is the matter, sister?" he asked, in a voice like rumbling thunder.

"Can't you see that I have been disfigured?" she shrieked. "And by Rama, a mere human at that! Oh, how can you tolerate such an insult to your own flesh and blood? Why do you sit here, surrounded by women and enjoying yourself as if nothing were wrong? This Rama is the enemy of all Rakshasas. You must deal with him at once."

Ravana knew that Rama was more than just another human. He had heard people describe him as Vishnu incarnate. Though Vishnu, his avowed enemy, was the lord of all the gods, Ravana believed he could defeat him if he tackled him carefully.

"Tell me more about this Rama," he said.

Surpanakha had witnessed the slaughter of Khara's forces and she described Rama's prowess in battle to her brother. "I couldn't make out any interval between Rama taking up his arrows, bending his bow and shooting. He appears to be invincible. He does, however, have one weakness."

Surpanakha began to paint a portrait of Sita's beauty that stirred Ravana's insatiable appetite for sexual pleasure. "He is accompanied by the most dazzling woman I have ever seen, a second goddess of fortune. Her name is Sita. She has a complexion like molten gold, vividly contrasted by her dark eyes and the black hair that frames her perfect face. With her thin waist and full breasts, she rivals any celestial woman. Surely any man who receives her embrace will completely lose his mind in the ecstasy of love."

Surpanakha knew Ravana would not only want to see Sita for himself, but having once seen her, would be impelled to seize her by force. She went on, "Take this woman from Rama and he will lose his power. You are capable of this, my brother. No one in this universe can withstand you, much less a mere human like Rama. And once he is without Sita, he will be child's play for you."

The plan appealed to Ravana, but he decided to exercise caution. He would use deceit to capture Sita and then deal with Rama later. To this end, he approached Maricha, a demon friend who was able to create the most stunning illusions, and asked him for his help.

## Kidnapped

 arly one morning, Sita was outside her cottage picking flowers. As she moved among the brightly colored bushes, she suddenly saw a startling sight. A small golden deer stood nearby, nibbling at some leaves. Its head was partly white and partly dark, with horns like bright sapphires. The upper part of its snout had the hue of a red lotus, the lower that of a blue lotus. At the end of its slender white legs were hooves like glossy black gems. The deer's belly was dark blue and its flanks golden. All over its shining skin were a number of jewel-like spots. Its tail resembled a rainbow and it glanced about with eyes that shone like diamonds.

Captivated, Sita called out to Rama, "Come quickly and see this, my lord."

Rama ran over with Lakshman and saw the magical deer, which seemed to illuminate the area around it. Lakshman was immediately suspicious. "This cannot be a real deer," he said. "Creatures such as this do not exist. It is surely some kind of demon in disguise. I shall kill it at once."

Sita held up her hand. "No! How can something so beautiful be evil? I must have this wonderful animal as a pet. Let me take it home with us when we return and we can keep it in the palace gardens."

As Sita spoke, the deer ran off into the woods. She urged Rama to follow and capture it. Rama wanted to please his wife. "Very well," he said. "I shall go after this creature. If it is indeed a demon, it will perish at the tips of my sharp arrows. If not, I shall bring it back for you."

After asking his brother to stand guard over Sita, Rama set off in pursuit of the deer. The creature bounded away swiftly into the forest. It kept appearing and disappearing, always remaining just too far away for Rama to catch. After Rama had gone a considerable distance from his hut, he felt that his fears about the animal's being a demon in disguise had been confirmed. No ordinary deer could have run so fast or so far. He placed an arrow on his bow and took careful aim. As the deer leapt into the air, he fired and struck it on the flank.

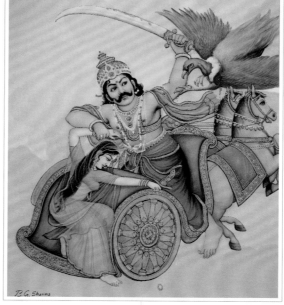

The deer fell to the ground, where it assumed its original Rakshasa form. Rama ran over to the demon, who suddenly let out a great cry, perfectly imitating Rama's voice. "Lakshman! Help me. Come quickly!"

The call for help carried for miles and reached the ears of Lakshman and Sita. Immediately anxious, Sita said, "Lakshman, go quickly to help your brother. Something has happened to him."

Lakshman smiled knowingly. "Nothing can happen to Rama. If even the entire demonic host stood before him, he would face no danger. This cry was doubtlessly made by a demon trying to trick us."

Sita was not convinced. She looked about fearfully, her body shaking. "That was definitely Rama's voice. He is in trouble. You must go at once."

Lakshman tried to reassure her. "No created being can harm Rama in any way. The gods themselves assembled in any number are still no match for him. Do not be afraid."

Tormented by anxiety for Rama, however, Sita began to berate her brother-in-law. "Lakshman! It seems you are happy to see Rama in peril. Have you been concealing your true intentions toward me? Do you really desire me? With Rama out of the way you would be free to enjoy me. But you should know that this could never be. I will give up my life before it happens. Rama is my one and only love."

Lakshman's face cringed in pain as Sita spoke. Her words cut through him like the strokes of a sword. In all this time, he had never even looked at Sita's face. Folding his palms, he said, "Do not say such things, my lady. You are my older brother's wife and I revere you like a goddess. I could never consider doing what you accuse me of, not for a single moment."

But Sita, fully overcome by anxiety for Rama, continued to taunt him, urging him to leave her and help Rama. At last Lakshman relented. "Very well, I shall go even though Rama told me to remain and protect you. But I fear the worst. This is surely a demonic plot. Be on your guard, princess. I shall pray to the forest deities to protect you.

Lakshman ran off after Rama and Sita went into her hut. At that time Ravana, who had been waiting nearby, took on the form of a forest sage and approached the hut. He called out, "Alms! I come as a humble beggar seeking alms. Please give whatever you can."

Sita came out and saw him, dressed in orange robes and holding a pot and a staff. "You are welcome here, holy one. Just wait till my husband returns and we will entertain you."

Dressed like a saintly person, Ravana was like a deep well covered by grass. He moved toward Sita, who was without Rama and Lakshman, just as deep darkness overtakes dusk when it is bereft of the sun and moon. As he came closer to her, the wind died, the animals fled in all directions and even the river seemed to stop flowing. The forest deities hid in fear and the earth itself seemed to sigh.

Ravana said, "Who are you, O lady of splendid grace, and who is your protector? Why do live in this wild and desolate forest? "

Sita replied humbly, "I am the wife of Rama, a king in the solar dynasty. I can offer you some water and fruits for the time being, but he will no doubt give you better care when he returns."

Enchanted by Sita's incomparable beauty, Ravana began trying to seduce her with sweet words, "You are like gold and silver adorned with shining gems. Are you a goddess or a celestial nymph descended from the heavens? Just seeing you, I have fallen in love."

Sita recoiled, but Ravana, gripped by passion, decided to snatch her away then and there. He assumed a godly-looking form and said, "Know me to be Ravana, lord of the Rakshasas. Irresistible lady, it is not fitting that you should live in the forest with some mere human. Come to my city, Lanka. There you shall become my queen and enjoy unlimited opulence, as you deserve."

Sita stepped back in shock, dropping the water pot she was holding. "Do not say such things, you brute! You can never win me. I am wholly devoted to Rama, that lion-like person who easily disposes of jackals like you. I cannot be swayed from him, nor will he ever abandon his surrendered servant. Give up your foolish desire, for it is simply an invitation to death."

Ravana laughed and lunged forward to grab hold of Sita. "Say what you will, you are coming with me right now."

Sita shook herself free. "Vile creature, you are trying to extract a tooth from the jaws of a powerful and hungry lion. You have tied a stone slab to your neck and now you think you can swim across the ocean! One who attempts to steal Rama's beloved consort is trying to lift the planet Earth with his bare hands."

Sita continued to rebuke Ravana with harsh words, but the demon seized her violently and dragged her toward his waiting chariot. As she fought vainly against him, he continued trying to win her over.

"Forget about Rama. His life is all but over, for soon he will face me on the battlefield. Come with me and enjoy delights you could never have imagined. Accept me, Sita, and abandon the worthless Rama who cannot even provide you with a proper home."

Sita refused to look at Ravana. She beat her fists against his chest, but he laughed and pushed her onto his chariot. Drawn by fierce mules with fiendish heads, it rose upward into the sky. Sita wailed and cried like a madwoman, but no one heard her. She called to the trees, the earth, the sky, the forest creatures and the gods to help her. She called out Rama's name again and again, but Rama was still some way off and could not hear her, nor did he see the demonic chariot disappear into the distance.

## SITA'S ORDEAL

Rama was utterly distraught when he discovered Sita missing. In his rage he seemed ready to destroy the earth and the heavens combined, but Lakshman calmed him and they began to search for her. In time they formed an alliance with a tribe of powerful monkey-like beings known as *vanaras*, who discovered that Sita was being held on Ravana's island fortress, Lanka. Rama and his army then lay siege to Lanka, demanding Sita's return. Ravana refused and a great war ensued in which Ravana and his many millions of Rakshasa followers were finally destroyed. Rama then asked that Sita be brought to him.

When Sita heard that Rama had defeated Ravana and was asking for her back she was overjoyed, but also fearful. She had spent almost an entire year in captivity, away from Rama. What would he think of her now? She had not stopped thinking of Rama for a single moment, and every attempt Ravana had made to seduce her had simply left her feeling sick. Surely Rama would have no doubts on that count! But as Sita came into his presence, she saw that his expression was grave. He looked at her without smiling and began to speak.

"Blessed lady, you may now go wherever you please. Ravana is dead and you have been avenged for his atrocities. I have achieved my purpose, but I cannot take you back as my wife, for you have dwelt too long in another man's house. Ravana touched you and gazed at you with passionate desire. How could he have resisted your beauty? In consideration of these things, it is impossible for me to continue being your husband."

Lakshman looked with shock at Rama. What did he mean? How could he possibly doubt Sita? But Rama's stern expression gave nothing away.

Rama remained silent, keeping his feelings in check. He wanted nothing more than to accept Sita back as his wife, but he was now emperor of the world. He had to set a perfect example. Under no circumstances should a husband allow his wife to live with another man.

Sita stood with her head bowed. When Rama told her that he would not take her back, she burst into tears. She flushed red with shame and covered her face with her delicate hands. His speech had struck her like a fiery arrow. She wept for some time. Gradually recovering her composure, she replied to Rama, a note of anger entering her voice.

"Why, great hero, do you treat me so? Am I to be compared with any vulgar woman who might forsake her husband? What has been my fault? Ravana dragged me off without my consent, which he could never have won. My heart stayed under my control and fixed on you, my lord. You and I have lived together for so long, united in our love. If you still doubt me after all this time, then there is no hope for me at all."

Seeing Rama's expression unchanged, Sita went on in ardent tones. "If it was your intention to abandon me, then why did you bother to rescue me at all? You could have simply informed me by messenger. I would have then killed myself and saved you all the effort of going to war on my behalf."

She looked intently at Rama. "Have you forgotten my divine origins? Do you think I am an ordinary woman? Have you become an ordinary man yourself, giving way to suspicion and mean-spiritedness? You have left me no other recourse but death."

Sita's body shook with her sobs, but Rama still remained silent. She turned to Lakshman and said, "These false accusations have cut me deeply. I cannot tolerate them. Build me a pyre that I may enter its flames. If Rama rejects me, I have no desire to live."

There was silence as Sita stopped speaking. Lakshman looked at Rama, but he was still impassive. Slowly, the prince began to construct a pyre. Everyone gazed at Rama, expecting him to intervene and say something, but he simply watched as his brother piled up wood from the surrounding forest.

When the pyre was ready, Sita asked Lakshman to set it on fire. With tears streaming from his face, Lakshman did as he was asked. Sita then folded her palms and approached Rama. She walked around him three times in respect, then went up to the blazing fire and prayed. "If I have ever deviated from Rama in body, mind or word, then let this fire consume me. But if my heart has remained ever true to Rama, then may the fire god bear now witness to my chastity and save me."

Without hesitation Sita stepped into the flames. A gasp of horror went up from the onlookers. She seemed like a goddess fallen from heaven and entering hell as she went into the center of the pyre.

When Sita had disappeared into the flames, Rama finally lost his composure and gave way to tears. He stared at the flames, his face racked with grief. From the heavens, the gods headed by Brahma addressed him: "How could you let this divine lady enter the fire? Tell us, Lord, what game are you playing?"

Rama looked up at the gods and folded his hands in respect. "I am but an ordinary man, the son of King Dasarath. Who do you think I am?"

Brahma said, "Rama, you are the origin of the cosmos. Everything comes from you and enters you again in due course. Your existence and actions are inconceivable."

Rama simply bowed his head and made no reply. Just then, the fire god emerged from the blazing pyre, holding Sita in his arms. She was dressed in a red robe and decorated with a garland of celestial flowers and brilliant gems.

The god placed Sita before Rama and said. "Here is Sita. She is absolutely without fault. She gave not a single thought to Ravana despite being repeatedly tempted and threatened by him. Therefore, Rama, please take her back."

Rama's eyes flooded with tears of joy as he replied to the fire god, "Sita's ordeal by fire has proved her purity to everyone. I had to let this happen, or I would have been condemned as a foolish man, governed by his passions. I know of Sita's undivided love for me. Her own moral power so protects her that Ravana could not have violated her any more than he could seize the sun. Of course I shall take her back. Sita is as inseparable from me as heat is from fire."

Sita glowed with happiness. She sat next to Rama on a golden throne. The gods offered praises to the divine couple who raised their hands in blessing to all.

## ILLUSORY SITA

 ome later accounts of the *Ramayana* story suggest that Sita herself was never actually touched by Ravana. They explain how, when Ravana came to kidnap her, an illusory form of Sita replaced the real one and it was this form that Ravana snatched. According to these accounts, the real Sita was taken away by the fire god and returned when the illusory form entered the fire. This substitute Sita is said to have then gone on to become Draupadi in a later birth.

The *Ramayana* recounts how Sita, after giving birth to two sons by Rama, finally departed from the world. A celestial throne rose up from out of the earth, borne on the heads of four great celestial Naga snakes. Sitting on it was Bhumi, the earth goddess, glowing with divine effulgence. Sita sat next to her, and together they slowly reentered the earth.

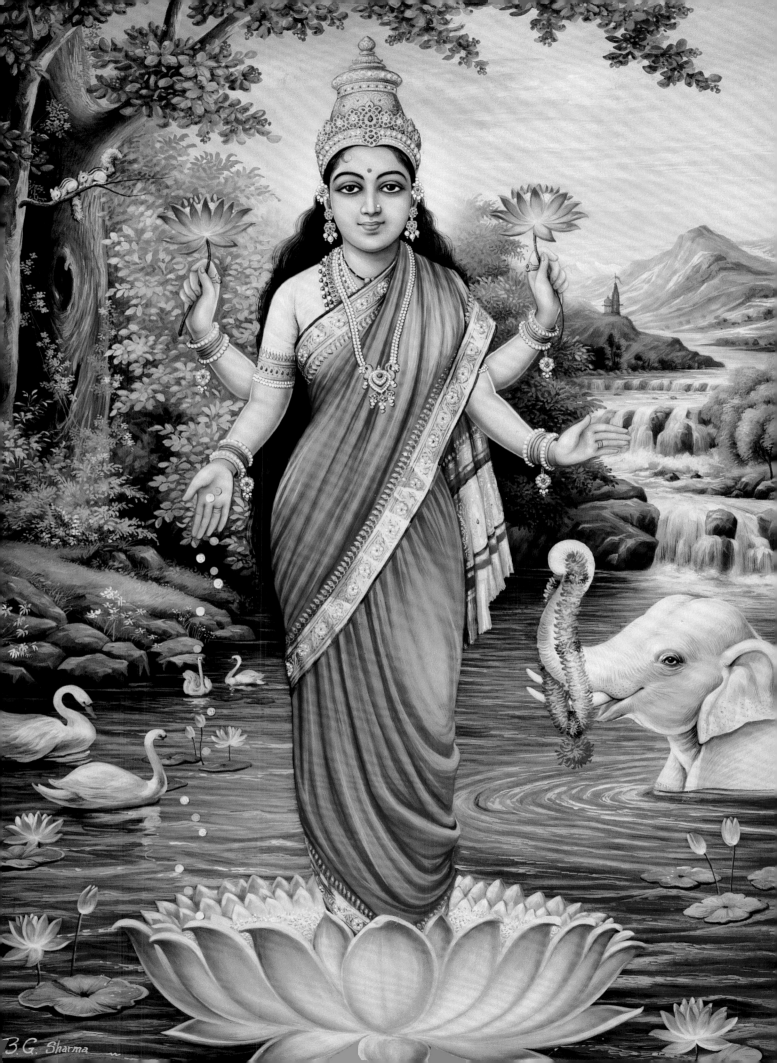

B.G. Sharma

*siddhi-buddhi-prade devi*
*bhukti-mukti-pradāyiṇi*
*mantra-mūrte sadā devi*
*mahā-lakṣmi namo'stu te*

*O Maha Lakshmi! Bestower of success and intelligence, worldly*
*enjoyment and liberation, I bow down to you, O goddess,*
*whose form is the mystic syllable.*

# LAKSHMI

FOR MOST HINDU FAMILIES TODAY, LAKSHMI IS THE GODDESS OF THE HOUSEHOLD. THE SCRIP-
TURES DESCRIBE HER AS THE GODDESS OF PROSPERITY, SPLENDOR, LUMINOSITY AND FOR-
TUNE. HER AUSPICIOUS NATURE AND REPUTATION FOR GRANTING FERTILITY, GOOD FORTUNE,
WEALTH AND WELL-BEING ATTRACT DEVOTEES IN EVERY INDIAN VILLAGE. ALTHOUGH THERE ARE
VERY FEW TEMPLES DEDICATED TO HER WORSHIP ALONE, SHE IS OFTEN SEEN ON ALTARS STANDING BY
THE SIDE OF VISHNU. ACCORDING TO THE VEDAS, LAKSHMI ACCOMPANIES VISHNU AS HIS COMPAN-
ION WHENEVER HE INCARNATES WITHIN THE WORLD. HER NAMES, LIKENESSES AND SYMBOLS ARE
SEEN ON THE DOORS, WALLS, PILLARS AND NICHES OF TEMPLES EVERYWHERE, NO MATTER WHICH
DEITY THAT SHRINE MIGHT BE DEDICATED TO.

Lakshmi Devi is worshipped throughout the year in a variety of festivals and is the object of many religious vows through which her blessings are sought. A devotee may undertake a fast or some other act of piety on her behalf, asking for a blessing such as long life for a spouse, for their marital fidelity or perhaps for the fertility of crops. Lakshmi also symbolizes wealth, and businessmen will worship their account books on days associated with her in the belief that it is she upon whom their prosperity depends.

Goddess Lakshmi is depicted as a beautiful woman standing on a blooming lotus flower. Gold coins cascade from one of her four hands, and in fact the word *lakshmi* is often used as a synonym for money or wealth among Hindus. In another hand she holds a lotus bud, symbolizing purity, fertility and beauty. Her four hands are also said to represent the four great aims of life described in the Vedas, namely *dharma* (religion), *artha* (economic gain), *kama* (material pleasure) and *moksha* (liberation).

She generally wears opulent red robes lined with gold, the red color symbolizing activity and the gold prosperity, the latter arising from the former.

Lakshmi is also commonly associated with kings, and in this connection is known as Raja Lakshmi, or royal opulence. The *Artha Shastra*, the ancient Indian treatise on politics, considers the monarch to be a representative of the divine, virtually an incarnation of God, and thus he too has the goddess of fortune as his consort. However, such a ruler is strongly enjoined to ensure that his godly opulence is properly used in divine service; otherwise, it may well leave him.

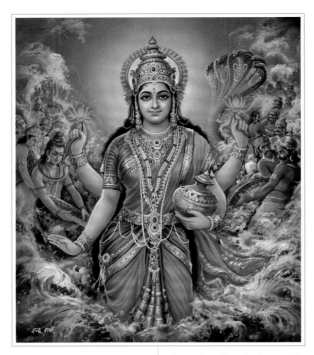

Another epithet frequently used for Lakshmi is Chanchala, which means fickle, as she does not stay with anyone for long. This is especially the case when one tries to enjoy her, that is to say wealth or opulence, separately from her eternal consort Vishnu. She never leaves Vishnu. It is therefore said that no one trying to exploit her for selfish ends will ever succeed.

## LAKSHMI'S APPEARANCE

 he story of Lakshmi's appearance in this world begins with the petulant sage Durvasa previously described in the story of Draupadi. Durvasa's curses and blessings are the catalyst for many a significant event in the world of gods and goddesses!

One day, as Durvasa was making his way along a heavenly pathway toward the capital city of the gods, Amaravati, Lord Indra swept past him on his mount, the celestial elephant Airavata. On seeing the king of the gods going by, Durvasa offered him his neck garland both as a sign of respect and a blessing.

"May all be well with the gods," he said as he held it out.

Barely taking notice of the sage, who was clad in only a loincloth and dusty from his long travels, the mighty Indra disdainfully took the garland and tossed it over his elephant's trunk. Without so much as a word of thanks, he continued on his way. Still within eyeshot of the sage, the garland fell to the ground and was trampled under Airavata's feet.

Durvasa's eyes turned red with anger. He immediately cursed Indra: "As you have been overcome by pride and arrogance, your fortune and opulence will abandon you."

Indra turned and looked again at the sage. Suddenly recognizing him as the very powerful and quick-tempered Durvasa, he realized that he had made a terrible mistake. He climbed down from his elephant and prostrated himself before Durvasa, saying, "Forgive me. Pride stole my intelligence."

Pacified by the apology, Durvasa said, "Having been uttered, this curse must come to pass. Even so, you will again recover your opulence when Vishnu favors you."

The sage then left and Indra continued on to his capital. His power had already been tangibly diminished and he appeared gloomy, his bodily luster reduced. It was not long before word of Durvasa's curse reached the demons. Rightly reckoning that their opportunity for conquest had arrived, the demon hordes led by Bali attacked Amaravati. They soon overpowered Indra and his armies and drove them from the heavens. Bali took his place upon Indra's throne, and Indra's consort, Swarga Lakshmi ("heavenly opulence"), disappeared.

Miserable and dejected, Indra lived incognito for many years while Bali ruled over the heavens. Finally, his spiritual master, Brihaspati, came to him and said, "It is time for you to recover your position. Seek the assistance of Brahma. He will know what to do."

Indra went with Shiva and all the principal gods to Brahma's abode, located at the peak of the celestial Mount Sumeru. They bowed before him and informed him of their plight.

"Lakshmi has deserted us and we are without strength and power. Bali has now seized control of the heavens and taken away all our opulence. Great lord, please help us."

The four-headed deity looked at them compassionately. "You have been overtaken by inexorable time and the results of your own deeds. Under such circumstances, only the Supreme Lord Vishnu can help you."

Taking his celestial retinue with him, Brahma then went to the sacred island of Swetadwip, situated in a vast ocean of milk, where Vishnu resided. Standing on its shores, they began offering him prayers. After some time, pleased with their offerings, Vishnu appeared in a form as radiant as a thousand suns. Though the gods shielded their eyes, they were at first completely blinded by his brilliance. Then, as they gradually regained their sight, they could make out Vishnu's wondrous form. His blackish body resembled the fabulous *marakata* gem, known only in the heavens, and his eyes were reddish like the inner depths of a lotus. He wore garments that glowed like molten gold; a helmet bedecked with valuable jewels crowned his beautiful smiling face. By his side stood the Goddess of Fortune, and his weapons, which had taken human-like forms, surrounded him.

When Brahma and the other gods saw Vishnu, they all immediately fell to the ground in obeisance, offering their prayers: "Just as the earth is the support of all things that come from it and again enter into it, so are you the support of all beings. Be pleased with us and grant our desire, which is surely well known to you."

Vishnu smilingly spoke to the assembled gods, his voice sounding like the rumbling of thunderclouds.

"Listen to me carefully, for I am ever inclined to do good to the gods. Those who seek my shelter are never disappointed. First of all, you should seek a truce with the demons, who are now being favored by Time. Then, with their assistance, you should churn the milk ocean. It will produce *amrita*, a life-giving nectar that will restore your power. From this churning the divine Goddess of Fortune will also make her appearance in the world."

Vishnu told the gods that he would assist them in this cosmic endeavor. They would have to use Mount Mandara as a churning rod and Vasuki, the chief of the Nagas or celestial serpents, as the rope to turn the mountain.

Vishnu continued to speak, "Be patient and the nectar will come. Before that, many other things will be produced by the churning, things that will attract the demons, but you should wait only for the nectar."

Pleased to hear this, Indra then sent a message of peace to Bali. He told him what Vishnu had said. "You demons will profit from this endeavor, and you may also partake of the nectar when it is produced."

Bali agreed to the proposal. The gods and demons then went to Mount Mandara, which was made of solid gold. Despite its great weight, they managed to uproot it from the earth by working cooperatively. They then began dragging it toward the milk ocean, but burdened under its mass, became fatigued and were unable to hold it up any longer. They dropped exhausted to the ground and the mountain fell, crushing many of them to death.

Taking pity upon their plight, Vishnu arrived on the back of his eagle carrier. With his healing glance, he brought the dead gods and demons back to life. Then, placing Mount Mandara on the back of his eagle, he carried it to the milk ocean himself.

When Vasuki had securely wrapped himself around the mountain, the gods and demons each took one of his extremities and began pulling him back and forth, creating huge waves in the ocean. However, the mountain had no support and it quickly sank beneath the surface. The gods and demons looked at one another in dismay. But once again Vishnu came to their rescue. Assuming the form of an immense turtle, he dove deeply into the celestial sea and raised the mountain onto his massive carapace.

Once the mountain was resting firmly on the divine turtle's back, the churning began again in earnest. Its first product, however, was unexpected—a fearful poison known as *halahala*. Seeing its toxic effects beginning to spread all around, the powerful Lord Shiva caught it up in his hand and swallowed it, saving the universe from destruction. Though his neck turned blue as a result, he was otherwise unaffected.

The churning continued. It produced many wondrous objects and creatures, all of which the greedy demons quickly seized. Then a beautiful woman, as brilliant as lightning, was seen to rise from the milky depths. This was Lakshmi, the Goddess of Fortune. Enchanted by her exquisite beauty, her youthfulness, her lustrous complexion and her glorious effulgence, gods and demons alike were overcome with desire.

Indra at once offered Lakshmi a place to sit. All the sacred rivers, such as the Ganges and Yamuna, appeared there in person with water in golden pots and offered it to Lakshmi. The sages performed a worship ceremony for her while the heavenly singers chanted auspicious mantras and others danced and sang. The clouds in personified form accompanied the celestial chorus by beating various types of drums, blowing conch shells and bugles, and playing on flutes and stringed instruments. While this festive music resounded throughout the ten directions, the ocean brought forth a silken garment for Lakshmi, and the god of the waters, Varuna, presented her with celestial flower garlands. The goddess of learning, Saraswati, made a gift of a dazzling necklace, while Brahma offered her a lotus flower and the celestial serpents known as Nagas gave her brilliant golden earrings.

Goddess Lakshmi then began moving about, holding a garland of lotus flowers surrounded by humming bumble bees. Smiling shyly, the earrings dancing at the borders of her cheeks, her beauty was striking. Her rounded breasts were covered with sandalwood pulp and red powder, and her waist seemed as thin as that of a wasp. As she walked back and forth, her ankle bells jingling softly, she appeared like a moving creeper vine of gold.

Lakshmi carefully scrutinized the gods, demons and inhabitants of all parts of the universe who were present there, but could not find anyone naturally endowed with all the good qualities she sought in a husband. None of them was entirely devoid of faults, and therefore she could not abide with any of them.

Searching for the greatest living being in existence, she thought, "It seems that one person may have undergone great austerity and even acquired much mystic power, and yet been unable to conquer anger. Another person may possess great knowledge without having conquered material desire. Yet another may be a great personality, but unable to control his lust. Everyone in this world depends on something else. How, then, can any of them be the Supreme Being?

"Someone may possess full knowledge of religion but still not be kind to all living entities. Someone else may possess great power, yet even he cannot check the force of eternal time. And no one is free from the influence of material nature, which determines the individual qualities of all created beings. I think that only Vishnu can give shelter to all. Therefore I shall select him alone as my lord."

Thinking in this way, Lakshmi approached Vishnu and placed the lotus garland on his shoulders. She stood by his side, looking down shyly. The gods were extremely pleased to see her united with Vishnu and loudly praised the divine couple. Lakshmi then glanced over them mercifully and they felt their former power and strength returning.

## GOD APPEARS AS A WOMAN

Jubilantly, the gods and demons continued churning the milk ocean until at last they saw a beautiful person emerge, holding a brilliant golden pot filled with the celestial nectar. Forgetting their agreement to share it with the gods, the demons at once snatched the pot and began to carry it away. The gods were dismayed to see this and they turned to Vishnu.

"Help us, Lord. The demons are escaping with the nectar."

"Do not be anxious. I will soon bewilder them and you will retrieve it."

As the demons raced away with the pot, they started arguing among themselves.

"I will drink it first," said one.

"No, I shall go first," insisted another, while yet another shouted, "I am the eldest here. Give it to me!"

Before they could get very far, Vishnu assumed the form of an exquisitely beautiful female called Mohini, "the enchantress." She was perfect in every possible way and she glanced about coyly, moving gracefully and making her golden ankle-bells tinkle delightfully. Mesmerized by her loveliness, the demons stopped in their tracks. Every one of them longed to have her. They looked enviously at one another, and began addressing the divine woman.

"What beauty, what grace, what elegance! Who are you, wandering here without any protector? We have lost our minds upon seeing you. All of us desire you, but we have another dispute to settle first. Maybe you could help us. We have seized this pot of nectar and the gods also wish to have it. Tell us who should partake of it first."

Mohini smiled alluringly and the demons immediately lost all their powers of discrimination. They were ready to accept anything she said. She spoke in a voice that made them tremble with ecstasy.

"Why should you place any reliance on my words, good sirs? I am a loose woman. No intelligent man would trust a woman such as myself."

Thinking her to be joking, the demons all laughed. Without hesitation they handed her the pot of nectar. "Here, pray tell us who should drink first and who after that."

"Very well. If you wish me to arbitrate I will do so, but only if you agree to accept whatever I say, whether you think it just or not."

"Yes, yes. Whatever you say is fine with us."

Mohini had the gods and demons sit down in two rows, some distance apart from each other. She then went over to the demons, moving slowly, her hips swinging from side to side and her full breasts moving up and down. The demons' eyes were glued to her as she spoke to them sweetly. "Soon I will give you your share, but for now let me give some to the gods."

Lakshmi motioned toward Bali with a graceful movement of her hand. "This Bali has lately fallen from virtue, entertaining feelings of animosity toward saintly Brahmins. Blinded by ignorance, he has given way to pride. This is why I have left him."

Indra bowed to the goddess. "There is surely no one among the gods, demons or humans who can bear you forever."

"That is certainly true," the goddess replied.

With folded hands, Indra said, "Tell me how you can be made to stay within the world, where you can do good for all."

"If I am divided into four parts and given suitable habitations, then I may stay."

Indra said, "I will do as you ask. The first place where you may reside in one fourth part is the earth. She can surely bear you."

Lakshmi agreed and Indra continued, "Another fourth of you can rest upon the waters."

Lakshmi agreed to this and Indra then asked for another fourth to rest in fire.

"It shall be so," said Lakshmi.

"Then let your last quarter rest among the good and pious on earth. They too can harbor you properly."

Lakshmi agreed, and then disappeared from view.

## LAKSHMI'S INNUMERABLE FORMS

Many take Lakshmi to be the archetypal form of the Goddess. As well as always appearing with incarnations of Vishnu, Lakshmi also appears with Krishna, who is the origin of Vishnu. When Krishna was living in his fabulous city of Dwaraka, as described in the *Bhagavata Purana*, he married over 16,000 wives, each of them an "expansion" of Lakshmi. The divine Goddess is capable of assuming innumerable forms, each with its own individual nature and identity, and each enjoying its own particular relationship with the Supreme Lord.

Nevertheless, Lakshmi is more generally associated with Vishnu or Narayan. She is described as the beauty that dwells in Narayan's heart. Narayan is consequently known as *Sri-dhara* or "he who supports the goddess Sri, or in whom she resides." Accordingly, Lakshmi is often portrayed as resting on his chest.

According to tradition, Lakshmi resides with Narayan in his spiritual realm of Vaikuntha. Only the greatest yogis and mystics can know this transcendental region, an unlimitedly vast and resplendent city located beyond space and time. It is populated by emancipated souls who serve Lakshmi and Narayan in eternal bliss. Vaikuntha is an expression of the majestic opulence of the Divine Couple. Celestial musicians fill the air with enchanting compositions. Pavilions of crystal and gold stand on all sides, as well as palaces furnished with the finest gem-studded seats, golden arches and courtyards with jeweled ponds and gardens. There, in the private abode of Lord Narayan resides the glorious goddess Lakshmi.

As Lakshmi always remains with Narayan, we can attract her favor best by pleasing him. The Vedic sages recommend chanting the names of Narayan or Krishna, who are different expressions of the same person. This also attracts Lakshmi's highest benediction. Although she is able to award material prosperity and influence, she may also grant access to the highest realms of transcendent bliss. This is experienced as we become free from desires for prosperity and increase our spiritual attachment for Lakshmi and Narayan.

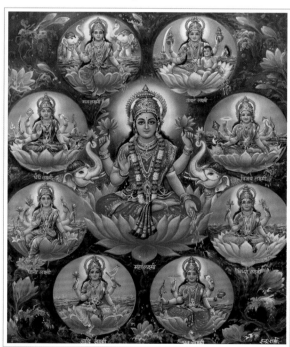

*The divine Goddess is capable of assuming innumerable forms, each with its own individual nature and identity, and each enjoying its own particular relationship with the Supreme Lord.*

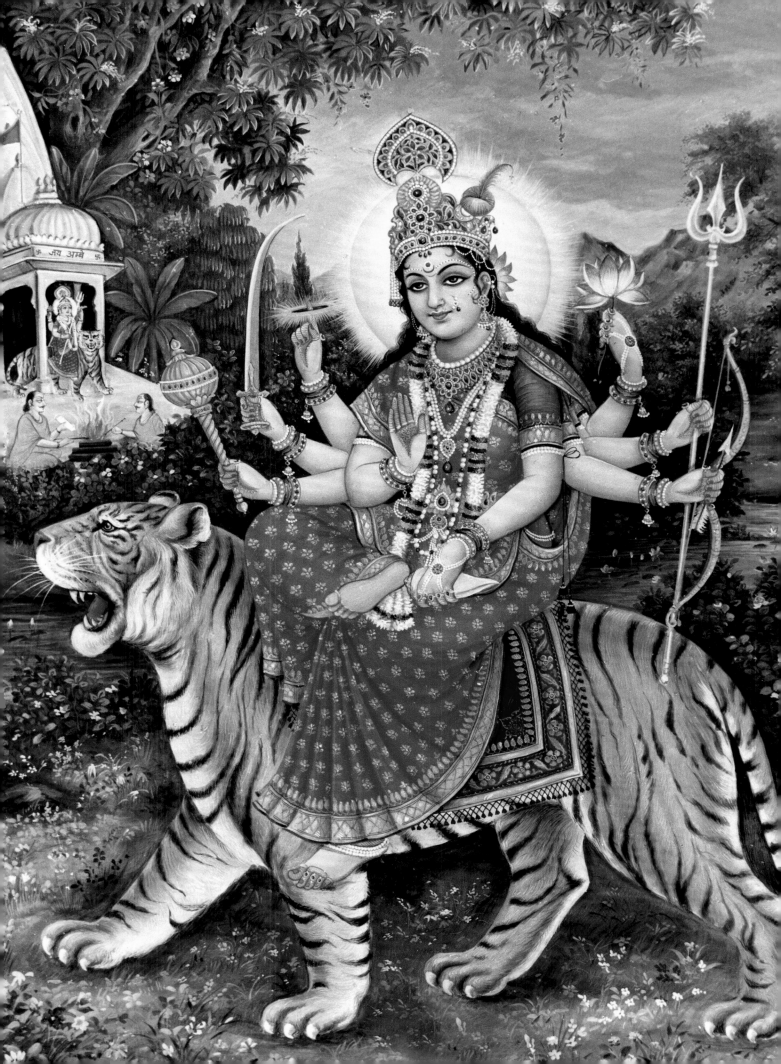

*yā devī sarva-bhūtesu*
*śakti-rūpeṇa saṁsthitā*
*namas tasyai namas tasyai*
*namas tasyai namo namaḥ*

*I bow down again and again to the Goddess,*
*who is manifest in all creatures as strength and power.*

# DURGA

GENERALLY HINDUISM IS DIVIDED INTO THREE BROAD STRANDS, ACCORDING TO THE PARTICULAR VISION OF THE DEITY HELD BY ITS DEVOTEES. THE VAISHNAVAS WORSHIP VISHNU AS THE SUPREME PERSONAL GOD; THE SHAIVITES SIMILARLY WORSHIP LORD SHIVA; AND THE SHAKTAS WORSHIP THE SUPREME AS THE GODDESS DURGA. THE TERM SHAKTA DERIVES FROM SHAKTI, THE SANSKRIT WORD FOR POWER OR ENERGY. DURGA IS THUS IDENTIFIED AS THE SUPREME DIVINE POWER. SHE STRIKES A POWERFUL POSE IN HER TYPICAL MANIFESTATION, MOUNTED UPON A LION, HER NUMEROUS ARMS WIELDING A FEARSOME ARRAY OF WEAPONS. APPEARING AS A BEAUTIFUL WOMAN, SHE ATTRACTS THE DEMONS TOWARD HER ONLY TO ANNIHILATE THEM.

One of Durga's most famous conquests was the near invincible demon, Mahisha, who in the form of a supernatural buffalo had managed to overcome the gods. For killing this colossus she became known as Mahisha-mardini, which is one of her most popular epithets to this day. She is generally viewed as a warrior goddess and is often invoked on the occasion of battle so that her worshiper may gain victory. For example, the famous archer Arjuna invoked Durga on the eve of the great battle of Kurukshetra, in which he was facing a far superior force.

Arjuna and his brothers, the Pandavas, also supplicated Durga on another occasion for a different purpose. They had been living in exile in the forest for thirteen years. According to the terms of their banishment, they had to spend the last year living incognito. If they were discovered, their exile would be extended for another twelve years. As they prepared to disguise themselves for this thirteenth year, they prayed to Durga to protect them from being discovered.

This is significant, as Durga is also known as Mahamaya, or the great power of illusion. On a cosmic scale, she represents what is known as the external or material energy of the Supreme Spirit. It is this energy that keeps all embodied beings in illusion, thinking that they belong to this world, when in fact they are eternal spiritual beings. According to Vedic scripture, as one progresses in spiritual or God consciousness, Durga is transformed into Yogamaya, the internal energy that lifts the illusion and reveals the truth. But as long as one holds onto material attachments, the Goddess shows herself as Durga, hiding the truth.

The name Durga translates as "fortress," for, just as the goddess Durga can never be overcome in battle, the material world or illusion is entirely insurmountable by any endeavor. It is only possible to become free of material bondage when one attracts the grace of the Goddess. This is achieved by spiritual practices that involve the worship of both Goddess and God. As with all forms of the Goddess, this is the type of worship recommended in Vedic texts.

In the *Markandeya Purana* there are seven hundred verses praising Durga. These are known as the *Devi Mahatmya*, the main source of information about the Goddess. She is also described and glorified at length in the *Devi Bhagavata Purana*. In these texts she is generally equated to God, described as incarnating just as he does in order to protect the worlds and kill demons. She maintains and restores cosmic harmony and balance. The Goddess is considered greater than any of the gods, with the exception of Shiva and Vishnu, although she is often placed on a par with even these deities. Like Vishnu, she is said in some verses to create, maintain and destroy the cosmos. Also like Vishnu, she says herself that she "quickly heeds the pleas of her devotees," delivering them from all kinds of calamity.

The worship of Durga has become popular in the Indian subcontinent. In some parts of India, such as West Bengal, the autumn festival of Durga Puja, also known as Navaratri, is the year's most important holiday. Worshipers celebrate in lavish style for nine days, holding great processions in which images of Durga are paraded and worshiped. In this festival she is especially lauded as a battle queen and as the regulator of the cosmos. In fact she is described in the Vedas as being the personification of the material energy, the very basis of creation.

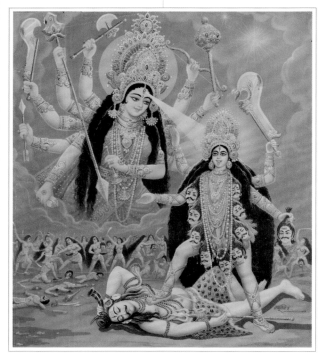

Durga is often associated with her husband Shiva. However, in that form she is more often known as Parvati or Uma. There is, though, a cosmic significance to Shiva's association with Durga, the material energy. Some scriptures explain that Shiva acts as the medium between God and matter. It is said that God "injects" the living beings into matter simply through his glance. That glance is Shiva, the all-powerful god, who thus impregnates Durga, his mate.

## Durga Defeats Mahisha

The story of the fight between Durga and Mahisha is found in various Hindu texts. The following account is taken from the *Skanda Purana*.

Once Durga, then appearing as a young girl, was living in the forest, practicing asceticism and worshiping Shiva with the intention of gaining him as her husband. She worshiped a deity form of Shiva day and night while observing strict fasts and other austere practices. During the summer she surrounded herself with fire and stood on tiptoe with her arms stretched upward. In the winter she stood chest deep in cold lakes. She would stand motionless during heavy downpours of rain, eating only once every three days. Her body glowed with her ascetic power as she chanted various mantras in worship of Shiva.

Meanwhile, in another forest some miles away lived Mahisha, who belonged to the Danava race of demons. Possessed of tremendous power, he had also spent many years in ascetic practices, but for the purpose of defeating the gods rather than pleasing them. As a result of his austerities he had managed to impress Shiva, who had granted him a boon. The mighty demon had asked, "I desire to be invincible to all beings."

Shiva replied, "There must be one class of being that can kill you."

Mahisha haughtily said, "Very well, I shall be invincible to all except women." He laughed. "And what woman could ever slay me?"

Shiva smiled. "So be it." He then disappeared.

Mahisha let out a huge bellow. It was time to assert his superiority over the gods. Taking an immense army of demons, he assailed the heavens and a fierce battle ensued. Mahisha took the form of a buffalo and rampaged in the land and sky. No weapon could harm him in any way. Arrows and spears ricocheted off his iron-like body while he tore into his attackers with horns like thunderbolts. He wrought havoc everywhere, slaying the armies of the gods with impunity. Soon they were run off by the unconquerable demon, who later installed himself on Indra's throne. "Now the worlds will worship me," he declared.

Darkness settled over the universe as even the sun god had been forced to flee the demon. Fierce winds blew, with heavy downpours of rain and hail. Mahisha went about killing the sages and raping their wives. He looted and plundered and killed at will, caring nothing for the law. Seeing him to be unstoppable, the gods went en masse to Durga and addressed her where she sat in penance.

"Protect us from Mahisha. That evil-minded Danava oppresses every living being. Clothed in the terrifying body of a buffalo, he rushes about causing mayhem. He lifts mountains with the tips of his horns, throws them up and then smashes them to powder. He has seized all the heavenly damsels and pressed them into his personal service. Even the ocean has been subjugated by him and obliged to hand over its store of gems. We gods can do nothing, for he has received a boon from your honorable Lord Shiva. We are forced to obey his every whim. O goddess, please save us."

Durga consoled the gods. She spoke reassuringly. "Fear not, immortal ones. Even though you have interrupted my penances to beseech me, I cannot refuse you. Time shall render this powerful demon helpless. Those who transgress the laws of virtue are quickly destroyed. The demon rushes against dharma as a moth rushes into a flame. In due course, I will find an appropriate way to end his miserable existence."

Relieved and encouraged, the gods bowed before Durga and then departed. She then left the wooded mountain where she had been staying and went down to the plains below, taking with her four highly powerful female servants. She said to them, "I will make my ashram here at the foot of this mountain and resume my asceticism. You four should guard the four quarters. Let no one of impure heart approach me, unless it is a guest overwhelmed by hunger or thirst."

The four servants, known as the Batukas, bowed in acceptance of her order and stationed themselves in the four quarters. Durga continued her strict austerities. Because of her influence, the entire region took on a delightful atmosphere. Trees were filled with fruits; fragrant and brightly colored flowers grew all around. The rains fell only at night and soft breezes blew during the day. Even animals that were normally antagonistic to one another lived together peacefully. Everyone living there felt tranquil and feared neither external enemies, nor internal ones such as lust and wrath.

One day, however, Mahisha came to disrupt the peace of the land. Accompanied by a huge host of demons, he drove through the surrounding woodlands, hunting and pillaging and leaving a trail of death and destruction. Some of these demons reached the outskirts of Durga's ashram and were about to slay a herd of deer when the Batuka guard stopped them.

"Halt! You cannot enter this area. Turn back now."

The demons looked at the woman who stood before them wielding a sword and shield. "And who are you?" they asked.

"I am guarding the beautiful maiden who sits here performing penance. No man with weapons may come here, nor anyone who is not pure in thought and deed. This is the goddess's order."

The Danavas examined her closely and concluded, "This woman must surely be an expansion of the Goddess herself and thus hard to assail. It would be better for us to resort to cunning to get our way."

"So be it," said the leading demon, and they all left. When they had gone some distance they assumed the forms of birds and flew over the ashram where Durga sat. They saw the goddess, seated in the lotus position with her eyes half-closed in meditation, glowing like a flame. Repeatedly muttering the mantra, *nama om shivaya*, she sat perfectly still, her breathing suspended.

"We must inform Mahisha," said one of the demons. "He will be very interested to learn that such a splendid woman is here all alone, nor will she be able to resist him." The demons then rose into the sky and returned to Mahisha.

When the buffalo-shaped demon heard about Durga, he was, as his followers had expected, extremely interested. He decided to go and see for himself. Assuming the form of an old sage, he went to the ashram begging for food. He was honored by Durga's servants and given a place to sit. There he saw the Goddess and his heart was immediately struck by lusty desires. He had to have her.

He turned to one of her servants and asked, "Why does she practice austerity?"

"In order to please Lord Shiva, for she desires him as her husband."

Mahisha laughed. "I think she will obtain me as the fruit of her penance, not Shiva."

"What do you mean?" asked the surprised servant.

"Listen, young maiden, I am none other than Mahisha, the most powerful Danava of all time. The universe is at my command. I can assume any form I wish."

He then stood up and went before Durga. "Accept me, the mighty Mahisha, as your lord. I can bestow on you any pleasure you desire. I possess all the treasures of the gods and have seized even their heavenly abodes. Come with me and enjoy."

Durga slowly opened her eyes, still chanting Shiva's name. She laughed and said scornfully, "I will only become the wife of a truly powerful man. If you think you have some special powers, then show them to me."

Mahisha snorted in anger. "Who do you think you are?" he roared. "How dare you question my power?"

He turned himself back into his buffalo form and grew to immense proportions. Bellowing repeatedly, he hurled himself at the mountain and set it shaking by battering it with his horns. Then Durga assumed a great form with many arms. The gods then came before her and prayed, asking her to dispose of the demon quickly.

"It shall be as you ask," she said, raising a hand in blessing.

Durga then mounted her great lion carrier and rode out to do battle with Mahisha. She appeared like the brilliant sun as she came before him. The demon was hardly able to look at her and he ran off to a distance.

Durga considered the best way to kill him. She needed to arouse his anger to a fever pitch so he would charge recklessly against her. The goddess thought carefully. The best way to make a demon angry was to give him good instruction. She asked a Brahmin sage who was in her ashram if he would approach Mahisha and instruct him.

"Tell the foolish demon that the opulence and power given by Lord Shiva will vanish like a mist if he continues to use it against others. He will be utterly destroyed. Tell him to control his mind and stop giving pain to all creatures. He should not think I am a weak maiden he can seduce easily. I cannot be touched by any demon, for I have been infused with Shiva's power. Inform that one of little intelligence that if he cannot follow this advice, I will burn him and his armies to ashes. Let him bring all his forces and stand before me. They, along with him and his mounting pride, will soon be crushed."

The sage folded his palms and listened carefully to the goddess, who continued, "Even though one may try to stop them, people are forced by their own past karma to act in foolish ways. Even so, try to instruct him in this way, telling him to turn toward virtue. Speak kindly and for his good."

Durga finished speaking and urged the Brahmin to go at once to Mahisha. He then approached the demon and repeated everything that Durga had said. Mahisha turned red with fury. He charged at the sage, ready to devour him, but the sage managed to escape.

Mahisha summoned his entire army. It resembled the seven oceans surging together. Fierce demons of every description came ready for battle with every kind of weapon. Mahisha ordered them to advance and soon they surrounded Durga's ashram.

From her body, Durga sent forth a terrible army of avid female warriors. It comprised ghosts, goblins, genies, vampires and numerous other types of dreadful beings. Some had only one leg, some three; some had their faces in their bellies, others had hands like claws with razor sharp nails; some had ears that hung to the ground, while yet others had two or three misshapen heads with rows of frightful fangs. They yelled and screeched in terrifying tones, boasting to one another.

"Where is the enemy? I shall annihilate them all."

"There are not enough of them for me."

"You others may stand down. Leave them to me."

Durga blew her conch and her army flew toward the demons. With the goddess at their head they fell upon Mahisha's forces with loud cries. The demons were swallowed, crushed, mangled, ground into powder and torn apart by Durga's minions. She herself wielded a great bow that was constantly bent in a circle. Flaming arrows flew in all directions and cut down countless demons. Durga's ghostly followers danced among the slaughtered enemy, picking up their carcasses and drinking their blood.

Mahisha charged into the fray. With reddish eyes that rolled frighteningly and reached his ears, he raised huge clouds of dust as he ran headlong across the battlefield. His roars were such that the gods felt they would split the universe. Trampling many of Durga's followers, he simultaneously used his lashing tail to shatter the innumerable weapons that rained down on him.

Gradually, Durga and Mahisha came face to face. Mahisha shouted out a challenge. "Stand and fight if you have the strength and courage."

Mahisha immediately uprooted a mountain and tossed it at her. Durga shattered it to pieces with thousands of arrows. She followed this by striking him with thousands more. The de-

mon only laughed and stood his ground. Durga hurled swords, razor-edged discuses, axes, daggers, spears and other weapons at the demon. Mahisha vanished from the scene and then suddenly reappeared in the form of a lion. He strutted back and forth, roaring ferociously.

Durga's lion rose up and tore open the chest of the demon lion with its claws. Mahisha transformed at once into a blue-striped tiger with gaping jaws. He appeared like a golden mountain filled with vehicles lined up on its sides. His lolling tongue seemed like a flame as he prowled around the goddess.

Durga drew her bow to her ear and released a long, crescent-headed arrow that went straight into the demon's mouth. Passing right through his body it emerged, besmeared with blood.

Mahisha then became an elephant and rushed swiftly at the goddess. Again her lion carrier rose up on its hind legs and struck out, knocking the elephant to the ground. Mahisha then became a demon fighter, wielding a gleaming blue sword that resembled a long streak of lightning. He whirled it about, striving to hit Durga who dexterously evaded his blows. She released a mighty discus that broke apart his head, but he immediately returned to his buffalo shape.

Gathered in the skies, the gods prayed to Durga. "Goddess, the vitality of the universe resides in you, as well as vigor, knowledge and strength. Bring these to bear upon this demon at once. Why do you tarry? Do away with him. Next to you he is as insignificant as grass. For the good of the universe, draw out his life force and end this fight."

Hearing this, Durga leapt from her lion carrier onto Mahisha's back. The demon felt as if the earth itself had settled on him. Oppressed by her weight and pounded by her feet, he thrashed about trying to throw her off. The goddess thrust a trident into his flesh, causing him to scream in pain. Streams of blood flowed from his body, forming a great lake that shone in the evening sunlight. In one of her many arms, the goddess wielded a huge sword with which she severed the demon's head from his body. Mahisha began to emerge in a human form from the trunk of the buffalo, but Durga quickly slew him with her sword before he had even fully appeared.

Taking the demon's head by the hair, Durga danced, surrounded by her followers and worshiped by the gods. After this, feel-ing some guilt for having killed even a demonic worshiper of Shiva, she resorted again to her penance, asking for the great god's forgiveness.

## PRAYERS BY ARJUNA

As the battle at Kurukshetra was about to commence, Arjuna sat in his chariot, which was being driven by Krishna. Gazing out over the vast army gathered against him, he turned to Krishna and said, "My lord, how shall we overcome these foes? They appear insurmountable."

Krishna replied, "Offer first a hymn to Durga, seeking her blessings and power."

Arjuna got down from his chariot and began to pray, "Foremost deity and primary energy of the Supreme, I bow to you. O goddess, wife of Shiva the destroyer, rescuer from dangers, possessor of every auspicious attribute, I seek your mercy. O wielder of the sword! O fearsome one! O lover of battle! You are the giver of victory; you are victory itself! You are the devourer of demons and the goddess of the yoginis!

"You are the Vedas, the highest virtue, the science of the Absolute and the destroyer of those opposed to religion. You favor those engaged in sacrifice and are ever present in holy places. You are the sleep of all creatures that has no waking and the great illusion that binds all beings. You always live in inaccessible regions, in places where there is fear, in the abodes of your worshipers and in the nether regions.

"O great goddess, I worship you with a purified heart. You are consciousness, modesty and beauty. O universal mother! You are the twilight and the day; you support the sun and the moon; you are light; you are growth and you are contentment. You are the prosperity of the prosperous.

"Giver of boons, capable of appearing anywhere at will, you are followed by celestial beings of great power. None can assail or overcome you. Those who worship you to be free of their burdens are never frustrated. You are the refuge of those lost in the wilderness of this world. Persons who remember you are never overcome by calamity.

"You are fame, fortitude and success. You are knowledge and intellect, forgiveness and mercy. When worshipped by those who recognize your position as the divine energy of God, you lead them to ultimate liberation. You remove ignorance, fear, disease, dread and death.

"Most beautiful one, your countenance vies with the moon, your eyes are like lotus petals, and your ears are well shaped and decorated with golden ornaments. With full hips and breasts, thin waist and shining yellow garments, your beauty allures all. The demons desire to possess you, but the intelligent see you as the divine energy, ever the servant of God.

"O Mahakali, Uma, Durga! O Goddess free from old age and decay, I bow before you and seek your grace. May victory ever attend me on the battlefield."

Pleased with Arjuna's prayer, Durga appeared before him and said, "Son of Pandu, you will gain victory in this battle. With Krishna by your side you are invincible. Be blessed."

She then disappeared.

## Madhu and Kaitabha, the "Earwax" Demons

Each time the material universe is created, Lord Vishnu lies down in mystic slumber. From his navel grows a lotus flower where the universal creator, Brahma, appears.

Soon after the present creation was set into motion with the manifestation of Brahma, two demons named Madhu and Kaitabha also appeared, arising from Vishnu's earwax as he still slept. At that time, the Vedas also emanated from Vishnu's mouth as he exhaled. Madhu and Kaitabha, who symbolically represent doubt and dishonesty, at once seized the Vedas and hid them in a distant place. They then returned and challenged Brahma, who was engaged in the business of creation.

"Four-headed one! Stand for battle if you have any prowess. We are here to slay you."

Brahma could understand that the two demons, having come directly from Vishnu, were extremely powerful. He prayed for the Lord to awaken and kill them, but Vishnu remained deep in his mystic slumber. Brahma then began praying to Durga, who he knew was within Vishnu.

"Great Goddess, illusory potency, bewildering energy of the Supreme, please come out. Manifest yourself and these demons will be destroyed. Lord Vishnu will only sleep for as long as you remain within him. Be pleased, therefore, to make your appearance."

Durga then appeared before Brahma and asked, "What needs to be done?"

At the same time, Vishnu awoke and saw the two demons standing nearby. He said to them, "You are welcome here. Ask from me some boon."

Brahma quickly told Durga, "Go and delude them."

Durga, appearing as an irresistible young maiden, went to Madhu and Kaitabha and said, "You are such mighty heroes. Why should you accept favors from anyone else? Indeed, you should be the ones to grant favors."

"This is true," replied the demons. "You have spoken well."

They then went up to Vishnu and said proudly, "Take a boon from us, for we are favorably inclined to you. Ask whatever you desire and it shall be given without fail."

Vishnu smiled. "Very well. I ask from you only one thing, that you be slain by me."

The powerful demons looked at each other. Turning back to Vishnu they said, "We cannot refuse, for our word has been given. But we set one condition: you may kill us only in a place where there is no covering."

The demons knew that the entire universe was a covered shell. Where, then, could Vishnu kill them?

"As you wish," said Vishnu.

Pondering on the situation, Vishnu saw that his cloth had fallen away from his legs, leaving them uncovered. In an instant he reached out and pulled the two demons onto his thighs. With swift blows he slew them both.

Then, taking the form of a divine horse named Hayagriva, Vishnu recovered the Vedas and gave them to Brahma.

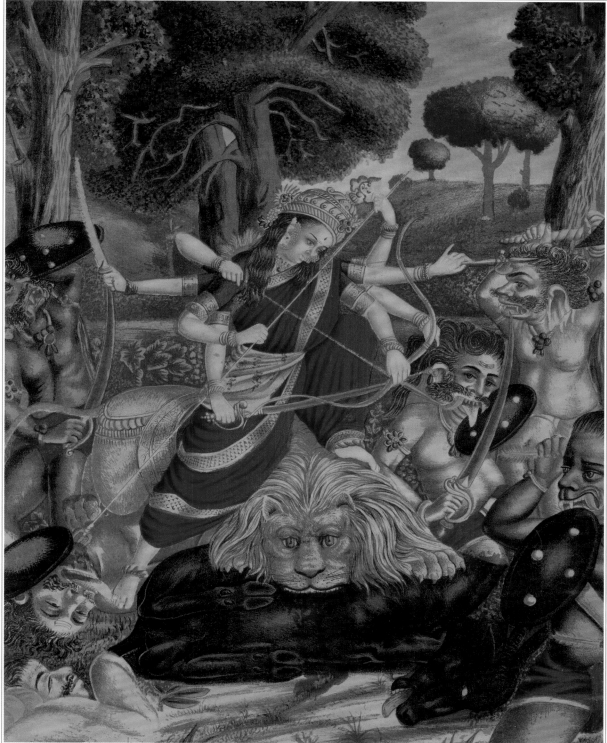

*sarva-maṅgala-maṅgalye*
*śive sarvārtha-sādhike*
*śaraṇye try-ambike gauri*
*nārāyaṇi namo'stu te*

*O auspicious one, O partner of Lord Shiva! O golden one!*
*You make all things possible. You are the refuge of all.*
*You have the third eye of knowledge, I bow down to you.*

# PARVATI

PARVATI IS THE FORM OF THE GODDESS MOST CLOSELY ASSOCIATED WITH SHIVA. IN MANY POPU-
LAR IMAGES, THE TWO ARE SHOWN LOCKED IN A SENSUOUS EMBRACE. ACCORDING TO HINDU
SCRIPTURE, PARVATI TOOK BIRTH AT THE BEHEST OF BRAHMA FOR THE VERY PURPOSE OF LUR-
ING SHIVA INTO MARRIAGE AND HAVING HIS CHILD. THESE ACCOUNTS INDICATE THAT SHE HAD A
PREVIOUS INCARNATION AS SATI, WHO HAD ALSO BEEN SHIVA'S CONSORT. IN THAT LIFE SHE HAD IM-
MOLATED HERSELF AFTER HEARING HER HUSBAND INSULTED, THUS LENDING HER NAME TO THE NOW
INFAMOUS RITE OF SUTTEE, OR SATI AS IT IS KNOWN IN SANSKRIT, WHERE A WIDOW ENTERS HER DEAD
HUSBAND'S FUNERAL PYRE AS A FINAL AND CONSUMMATE ACT OF LOYALTY AND DEVOTION.

Parvati is the ideal chaste wife and devotee of Shiva. She is also his spiritual disciple, and there are many Puranic and Tantric texts in which detailed spiritual instructions are given in the form of conversations between the two. Like her ascetic husband, who is often described as the perfect yogi, Parvati is given to spiritual practices and austerities. However, she also domesticates the renounced Shiva, drawing him into household life and becoming the mother of his two sons, the gods Ganesh and Skanda.

Parvati ("daughter of the snow-clad mountain") is known by many names, such as Girija and Haimavati, which reference her role as the daughter of the Himalaya Mountains, Kameshwari (the controller of the god of desire, Kama) and Uma. In her appearance as Sati, first wife of Shiva, she was known as Dakshayani, or daughter of Daksha. Other names related to her identity as Shiva's consort include Ishani (consort of the trident-bearing Shiva), Bhavani (wife of Bhava, another name for Shiva), Maheshwari (consort of the great lord, Mahesh)

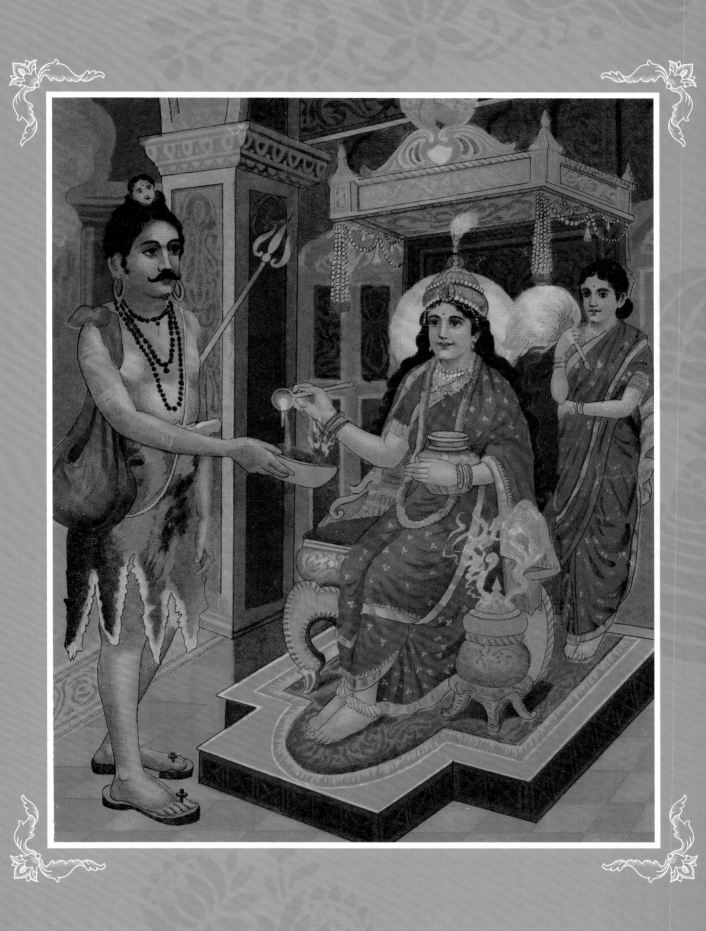

and Yogeshwari (goddess of the yogis). The *Kurma Purana* lists 1,008 epithets of Parvati.

## SHIVA'S "OTHER HALF"

 arvati is so closely united with Shiva that the two are sometimes depicted in a combined form. In this iconography, known as *Ardhanarishwara* ("the god who is half woman"), Parvati adorned with her ornaments is on the left side and Shiva on the right.

According to the *Shiva Purana,* in the beginning of creation Brahma became concerned that the beings he had created would continue to multiply and populate the universe. He sat in meditation, trying to understand what to do. He then heard a celestial voice: "You should carry on creation through the generative power of couples."

Brahma pondered this deeply. At that time the feminine principle had not yet been brought into being. He decided that he needed to call upon Lord Shiva. "Without his power and the power of his consort I will not be able to succeed," he thought.

He began practicing severe asceticism and praying for Lord Shiva to appear to him. After some time, Brahma saw Shiva manifest in this half-male, half–female form. Brahma bowed before the deity, who said, "Brahma, I understand your desire. You wish to populate the universe and I shall assist you."

This androgynous form then split into two distinct persons, Shiva and his consort Shakti.

Brahma said to the goddess, "I have been ordered by Vishnu to engage in the work of creation, but the gods I have created cannot multiply themselves independently of me. Hence I must create them again and again. I desire to make them flourish by procreation, but I do not yet have the power to generate women. Please bestow that power upon me, O goddess."

"So be it," replied the goddess.

Brahma also requested that the goddess later take her birth as the daughter of Daksha, one of the *prajapatis* or progenitor gods, who would be charged with filling the universe with all the myriad forms of life.

After Shakti had bestowed the power of creating females upon Brahma, she merged back into Shiva's body, which then vanished.

## SATI GIVES UP HER BODY

 n accordance with the promise she had made Brahma, the Goddess took birth as Daksha's daughter and was named Sati. From her very childhood, the lovely girl fixed her mind upon Shiva, desiring none other as her husband. She took up a life of austerity, worshiping him within her heart. Shiva became pleased with her and agreed to become her husband, though her father Daksha was not pleased. He considered Shiva an unworthy match for his daughter and tried everything within his power to dissuade her.

"This Shiva is shameless and does not know how to act. He loiters in crematoria and other unclean places. He goes about naked like a madman, sometimes laughing, sometimes crying. He does not bathe regularly, but smears ashes on his body and wears garlands of skulls and bones. Bands of ghosts, goblins and demons follow him about. Thus, although his name means 'auspicious,' he is not auspicious at all."

Daksha had become proud of his position as a *prajapati*. He envied Shiva, who received more respect from the sages and other gods than he did. He went on trying to discourage Sati from her intentions, but could not sway her resolve. Indeed, she was deeply wounded by her father's insults to Shiva.

Daksha decided to arrange a match-making ceremony for his daughter. He said to her, "I will invite all the principal gods and great personalities of the universe. Surely you will find a suitable match among them and forget all about this mad fellow."

The ceremony or *swayamvara* was duly arranged, but Daksha deliberately excluded Shiva from the list of invitees. When all the suitors were assembled, Sati took up the nuptial garland that was to be given to her chosen husband. She stood with trembling hands, not knowing what to do with it. Closing her eyes and thinking only of Shiva, she flung it into the air. When she opened her eyes again, she saw to her surprise that Shiva was standing before her, the garland around his neck.

Daksha was astonished, but there was nothing he could say. It was a *fait accompli*. His daughter had selected the wild and unpredictable Shiva as her husband. Reluctantly, he gave the couple his blessings and they left for the dark god's mountain abode, Kailash.

Though still only a young girl, Sati began to serve her exalted husband with uncommon focus. She became emaciated from hard work and little eating. Seeing her dedication, Shiva became increasingly affectionate toward her.

After some time had gone by, Daksha decided to perform a grand and opulent religious ritual. He invited all the gods, sages and other celestials, but once again neglected to invite Shiva. He did not even inform his daughter Sati about the event, as he was still disappointed with her for choosing Shiva as her husband.

One day, as Sati was sitting with Shiva, she saw celestial vehicles in the sky above her carrying demigods and their wives to the ceremony. The procession members were beautifully dressed and she could hear them conversing.

"I have heard that Daksha's sacrifice will be unlike anything ever seen before."

"Yes, every important personality in the universe will be present."

Sati became anxious. Why had she and her husband not been invited? Perhaps it had just been an oversight. Strongly desiring to attend the function, she went to Shiva and said, "Your father-in-law is performing a great ritual. All the gods are going. If you so desire, we may also go."

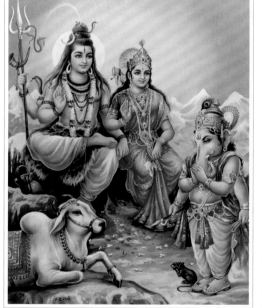

Sati continued, trying to convince her husband, who was not showing much enthusiasm for her proposition. "All my friends and relatives will be there. I would love to see them all. My lord, I know you are above all such things, being fixed in pure spiritual consciousness, but I am not so advanced. So please, please take me there."

Shiva was perfectly aware of Daksha's feelings toward him. He could understand that he and Sati had been deliberately snubbed. Smiling kindly at his wife, he said, "Although there is no fault in going uninvited to a relative's house or function, it is not advisable if the relative bears one ill will. If that relative is likely to be abusive, he should be avoided. The unkind words of relations burn more than fiery arrows, so I do not think we should go."

Sati fidgeted in agitation as he spoke. She found it hard to accept his words. But Shiva went on, speaking gently and trying to convince her that nothing good would come of going uninvited to her father's house.

"Those who are too attached to material enjoyment become envious of the spiritually minded. I am always fixed in meditation on the Supreme and have no interest in worldly things.

This is the real reason your father abhors me. It will not be good for him or anyone else if I go there. You should not go, either, for he will surely be rude to you as well."

Sati wept loudly. Her heart was set on going, with or without Shiva. She was unable to submit to his counsel and decided to leave at once. Riding upon her husband's bull carrier, which was capable of traversing the heavens, she set off. Thousands of Shiva's followers quickly got up and went behind her. She soon arrived at her father's house, where she saw the gorgeous arrangements that had been made for the ceremony. Flags and festoons hung everywhere, along with bright flower garlands. Priests sat performing the ritual with gold implements, making offerings into the sacred fire.

When Sati entered the ceremonial arena, Daksha did not even acknowledge her presence. As for the other guests, they also ignored Sati, not wanting to offend Daksha. Only her mother and sisters greeted her, but she was too deeply hurt by her father's disregard to reply to their words of reception. Breathing heavily, she addressed her father.

"Why has my husband not been invited? Do you not understand his glories? Have you become so mindless that you could insult one as great as the all-powerful Lord Shiva?"

Daksha shook his head and smiled. "My dear daughter, why do you speak in this way? Your husband is not of noble descent. He is the companion of unclean ghosts and goblins. I did not invite him here because he is indecent and ill-behaved. It was a mistake to ever let you marry him."

The lovely Sati seemed like a smokeless fire. Heaving wrathful sighs, she said, "How can anyone hate Shiva? He is gentle, sees no one as an enemy and wishes the best for all beings. Shiva is faultless and is worshiped by even Brahma. How can you find fault with him? How did you become so envious, Father?"

Shiva's followers, seeing her offended, made ready to attack Daksha, but Sati stopped them by raising her hand. She continued furiously, "Both those who reproach Shiva and those who hear them are destined for hell. If one cannot stop such offenses by either killing the offender or cutting out his tongue, then he should give up his own life. I am ashamed to be your daughter. There is no other course for me than to abandon this body."

Daksha remained impassive as Sati sat down and absorbed herself in mystic yoga. As everyone looked on, she became perfectly still and meditated deeply on her husband. Invoking fire from within her body, she burned herself to ashes before the gaze of her father. The gods and sages let out a cry of anguish. How could Daksha have let such a thing happen? But he showed no remorse or upset.

Shiva's followers began to rush in unison toward Daksha, but his chief priest saw the danger. He began chanting powerful spells and throwing offerings into the fire, and in a moment thousands of powerful celestial beings issued forth from the flames. They checked the advance of Shiva's followers, who fled back to Kailash to report to their master.

When Shiva heard what had happened, he bit his lips in anger. He appeared like a smoldering ember about to burst into flame. Laughing like a madman, he pulled a single hair from his head and dashed it to the ground. In the same instant, a horrific black demon burst from it, as high as the sky and as bright as three suns. His hair was like blazing fire and he had thousands of arms, all wielding weapons. A garland of men's heads hung around his neck. He bowed before Shiva and said, "I am Virabhadra, your servant. What shall I do, my lord? Shall I dry up the oceans, grind the mountains to powder or reduce the universe to ashes? By your grace I can do any of these tasks in a moment."

"Go to Daksha's ceremony. Kill him and all his men," said Shiva.

"Consider it done, my lord."

The demon walked around Shiva three times in respect, bowed to him and then left. Followed by hordes of other demons, goblins and genies, he soared through the skies toward Daksha's house, emitting huge roars that shook the earth.

At the scene of the ritual a dense darkness suddenly arose. Everyone looked around anxiously and saw that they were being enveloped by a dust storm.

"What is this?" they asked, looking at one another.

The sages said, "We face great peril because of Daksha. His insults to Shiva's chaste wife will not go unpunished."

Threatening omens appeared on all sides. The sky rumbled menacingly and jackals howled. Suddenly, Shiva's fierce-looking followers surrounded the sacrificial arena. Their bodies resembled black and yellow sharks. Clutching various weapons, they began wreaking havoc everywhere. They bellowed and shrieked as they broke apart the elaborate arrangements Daksha had made for the ceremony. Urinating and defecating indiscriminately, they ran about threatening the women and attacking the priests.

Virabhadra then appeared on the scene. As he arrived, a huge shower of stones fell and everyone began running for their lives. He rushed straight for Daksha and seized hold of him. With tremendous force he tore off his head and threw it a great distance. A gasp of horror went up from the gods still present. Virabhadra was obviously the mighty Shiva's personified anger. The gods all turned and fled. They went at once to Brahma and sought his shelter. Brahma addressed them solemnly.

"You cannot be happy if you blaspheme a great personality. Even if you stand by and listen to such blasphemy, you face grave danger. When you excluded Shiva from the ceremony, you also showed disrespect to his beloved wife. Then you stood by and watched her give up her life without attempting to prevent it. This was a serious error. Lord Shiva is unlimitedly powerful. You must now seek his pardon. No other course is left open to you."

Led by Brahma, the gods went at once to Kailash, where they saw Shiva sitting peacefully beneath a tree, having cast off his anger. Surrounded by saints and sages, he sat upon a deerskin, his left leg placed on his right thigh. His body was smeared with ashes, and he appeared like an evening cloud. A crescent moon adorned his matted black hair and his face was serene. In his right hand were meditation beads and his left hand displayed the *mudra*, or sign of knowledge. He was discoursing on spiritual subjects. After the gods had offered Shiva obeisances, Brahma addressed him on their behalf.

Brahma praised Shiva in many ways and then said, "My lord, ignorant people who are impelled by their baser nature insult great persons like you. Given to harsh and thoughtless behavior, they are sure to be destroyed by their own acts. There is no need for you to kill them, O great one. Kindly show compassion on such fools.

Shiva changed his hand *mudra* to the sign of a blessing, holding it palm outwards. He smiled and said, "I do not take seriously the offenses of the gods, for they are childish and lack intelligence. I punished them only to rectify them. Let Daksha be restored to life. You may replace the head he has lost with that of a goat."

After bowing again to Shiva, the gods left to complete Daksha's ritual. Brought back to life with a goat's head, Daksha realized his mistake and sought Shiva's pardon, praising him and offering him many prayers.

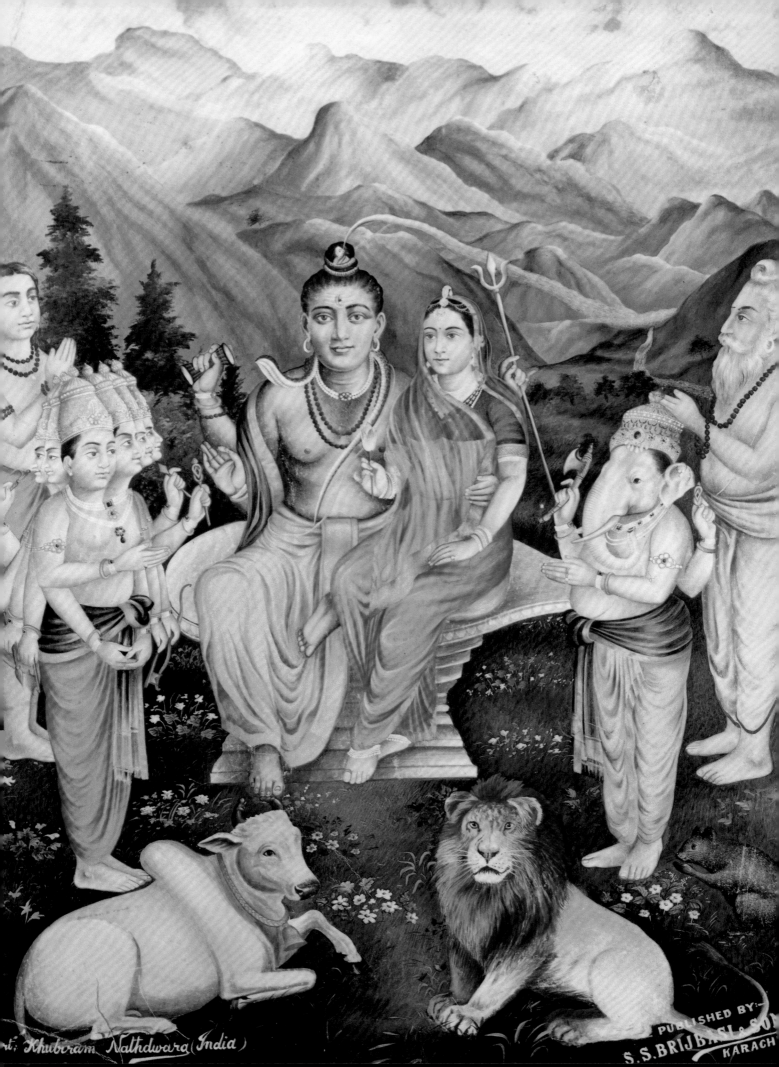

i: Khubiram Nathdwara (India)

PUBLISHED BY:-
S.S.BRIJBASI & SON
KARACHI

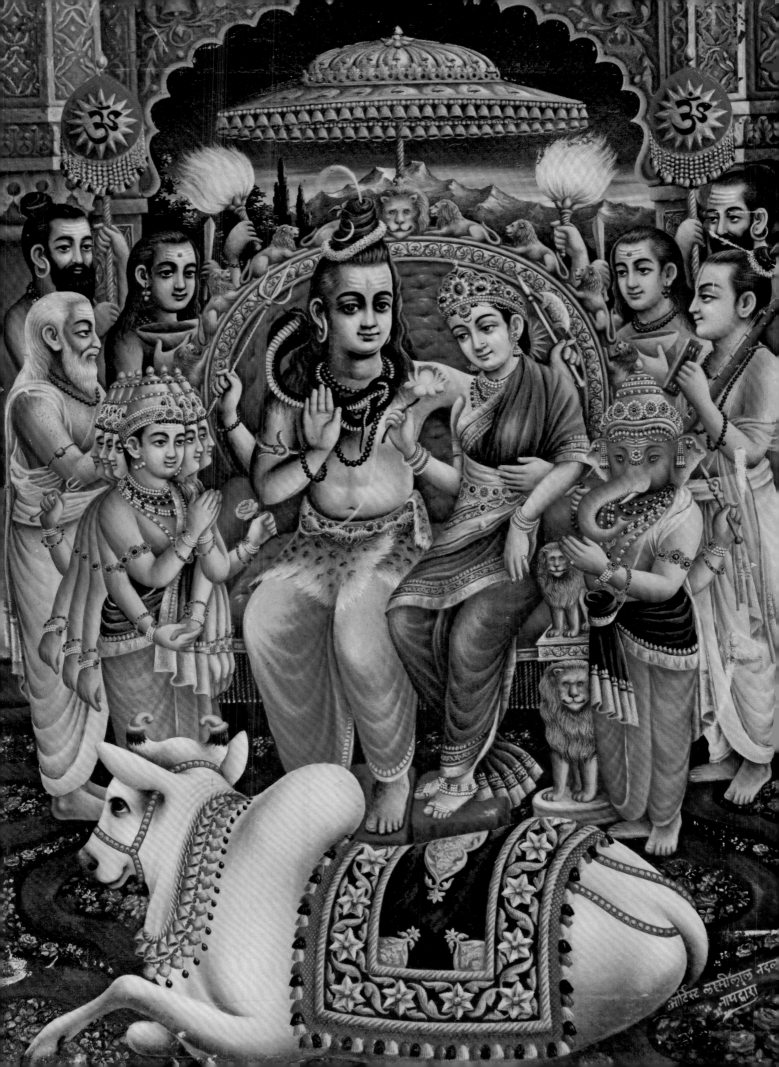

## Parvati, the Mountain Goddess

 hen living with Shiva on Kailash, Mena, the wife of the presiding deity of the Himalayan Mountains, had observed her. Mena had felt great motherly affection for Shiva's young wife, and therefore when Sati gave up her body she decided to take her next birth as Mena's daughter.

After the tumultuous events surrounding Daksha's ritual, the gods had been overcome with great remorse for everything that had happened to Sati. They knew her to be the goddess Shakti, and so began to offer her prayers and beseeched her to reappear. After they had worshiped her for a long time, she appeared before them. Seated on a wondrous, gem-studded celestial chariot, she shone with the brilliance of a thousand suns. The gods bowed to her repeatedly and eulogized her reverentially.

"O mother of the universe, destroyer of all distress, your greatness is beyond both speech and thought. Those who seek your shelter need have no fear at all. Please hear our humble request. Take birth again in the world for the good of all. Become Shiva's wife once again and reside with him on Mount Kailash."

The gods stood with their hands folded and humbly waited for the goddess to reply. She smiled at them and said, "Know that Daksha's delusion was my arrangement. As the illusory energy of the Supreme, I cover the intelligence of all envious men, making them even forget what is in their own best interests. I shall certainly incarnate again upon the earth. My Lord Shiva is tormented with separation from me. Since I gave up my life as Sati, he has retreated into severe asceticism. He roams about here and there, sometimes crying out, apparently in great distress. And I am as anxious to be reunited with him as he with me. I shall therefore appear as the daughter of Himachala and become his devotee. After performing severe penance I will become his beloved. Of this there is no doubt. I give you my blessings."

As the gods looked on, the goddess vanished. After making obeisance to the direction in which she had gone, they returned to their own abodes, their hearts filled with delight.

Soon after this, Himachala and Mena began praying to Shiva that they might bear a child. Distraught at the death of Sati, Mena fashioned a clay image of her and worshiped her with flowers and Ganges water. Fasting and following strict vows, she prayed that the goddess would become her daughter. After many years of such austerity, Mena was blessed with a vision of the Goddess. Appearing in the sky like a second sun,

she said, "Mena, I am more than pleased by your devotion. Ask from me any boon you desire."

"O great one, mother of the universe, I desire only one thing. Become my daughter."

Shakti said, "It shall be so," and then disappeared.

In due course Mena gave birth. On that day, the sky was clear and the earth appeared auspicious in every quarter. Men's minds were enlivened and joyous, and the gods stood in the sky and showered flowers upon Himachala's mountain abode. Assuming the form of a baby girl, Parvati came from Mena's womb like Lakshmi coming out from the milk ocean. She began crying and Mena nursed her with tears of love in her eyes.

The goddess grew up in that mountainous region, her name Parvati immortalizing her connection to the Himalayas. She increased in splendor every day, exactly like the waxing moon. Even as a child she desired to perform austerities and her mother would say "Oh no!" ("U Ma!"); she thus became known as Uma. Like an ordinary child she played with balls and dolls in the company of her friends. She was instructed in the Vedic knowledge by a celestial sage and grew into a beautiful and highly qualified young woman.

One day the great mystic Narada came to Himachala's house, and the mountain god asked of him, "Tell me, saintly one, what will my daughter's future be? You are a seer and expert in the science of astrology. Please let me know what her fortune will be, good or bad."

Narada looked at Parvati's palm and also examined her limbs and other features carefully. He meditated for some time and then said, "This girl's body is decorated with all auspicious signs. She will delight her husband and heighten your glory. But she will marry a naked yogi who cares nothing for the world. He will be free from material lust and indifferent to both honor and dishonor. He will appear to be a madman and have neither home nor possessions."

Himachala looked anxious. "What will happen to her if she marries such a man?"

Narada laughed and replied, "It is the great Lord Shiva of whom I speak. There could be no better spouse than he. Whatever seems inauspicious in him is in fact auspicious. All virtuous qualities reside in him. Let your daughter accept him and both you and she will experience the greatest happiness."

Narada then left on the path of the skies and Parvati, filled with joy to hear his predictions, began to pray fervently that Shiva would soon become her husband. Not long after that, the god

came to the Himachala Mountain with many of his followers, intent on practicing asceticism on its peaks. Himachala greeted him with great respect and said, "Please allow my daughter to serve you."

Himachala brought Parvati before Shiva. She was in the first flush of youth. Her complexion resembled a full-blown blue lotus and her face rivaled the moon in full splendor. Her neck was delicate and shaped like a conch shell, and her eyes were wide with long, dark lashes. With slender waist and high, firm breasts, blackish locks falling about her shoulders and perfectly formed limbs, she was lovely beyond compare. Shiva felt she was capable of disturbing the meditation of even the greatest saint. He closed his eyes and absorbed himself in thoughts of the supreme absolute truth.

Himachala said, "My lord, pray tell me why you have closed your eyes. Is my daughter not worthy of being seen?"

Shiva replied, "Mountain god, please take this girl away. Do not bring her here or you shall never see me again."

"Why do you say this, my lord?"

Shiva laughingly said, "Contact with women causes worldliness to spring up, detachment to vanish, and any merit gained from the performance of penances to be destroyed. I am an ascetic given to yoga and meditation. How then can I allow such a beautiful girl into my company? It will ruin everything I am trying to accomplish."

Himachala was not sure what to say in reply. He stood silently with his daughter by his side. But Parvati was not disheartened. She bowed to Shiva and said, "Great one, please hear my words. You perform penance because you are possessed of energy. Indeed, you are known and revealed only by your energy. Can you exist without it?"

Shiva laughed again. "By penance I aim to become free of all things outside of my pure self. What need do I have for any energies, which are inferior to me?"

"My lord, greatest yogi, everything you do, everything you say, all that you see, hear and know, all depends upon energy. None within this world can ever become free from that energy. O eternal husband, you should know that I am the energy and you are the energetic. How can we be separated? If you are truly superior, then why should you fear me?"

Shiva's expression was gentle and his speech mild. He smiled. "If you say so, sweet-voiced lady. You may come each day and render service, as you wish."

After this, Parvati began to serve Shiva in all kinds of ways. She washed his feet and drank the water. She wiped his body with a warm cloth. She offered him varieties of cooked food, sang sweet songs and offered fragrant incense. Sometimes she simply sat and gazed at him with love. She pleased him in every way, and Shiva longed to be united with her again as husband and wife. But he wanted her to first become free from all shreds of ego. He therefore waited. She would herself have to engage in strict asceticism; only then would he accept her.

## CUPID DESTROYED

At around that time, a very powerful demon named Taraka was assailing the gods. He could not be overcome by anyone. After a thousand years of penance he had received a boon from Brahma that he could only die if killed by a son of Shiva. The demon had calculated that the god was completely fixed in yoga and detachment. "He will never unite with a woman, so there will never be any son," he thought.

The gods approached Brahma and said, "Thanks to your boon, Taraka has become haughty beyond all limits. He has deposed all the ruling gods and installed his demon henchmen in their place. We can find no way to defeat him. What shall we do?"

Brahma spoke reassuringly. "Do not fear. Taraka is destined to die at the hands of Shiva's son. Parvati will give birth to this boy. You gods should arrange it so that Shiva impregnates her. She is now serving him in his penance in the high Himalayas, but he is persisting in his celibacy. Go and do what is necessary."

The gods then summoned Kama, the celestial Cupid, who drew near them with his consort Rati and Vasanta, the personification of spring.

"What must I do?" Kama asked the gods.

Indra said, "We require your help, Kama Deva! A great misery has befallen the gods and you alone can be our deliverance, for you are never thwarted in your purpose and your power is greater than even my thunderbolt weapon."

"I shall do whatever is required. Why, I can topple gods, demons and sages through the sidelong glances of beautiful women. As far as humans are concerned, they are mere child's play for me. Tell me how I may serve you."

"We need you to induce the mighty Shiva into amorous activities with Parvati. She will then conceive the son who is destined to slay Taraka, the scourge of all the worlds. This is the best ser-

vice you can do for us, Kama, and you should do it at once."

Kama smilingly replied, "I promise you that I shall succeed." Taking up his flowery bow, he left for Himachala followed by his wife Rati and Vasanta, the spring personified. When they reached the place where Shiva sat in meditation, Kama first sent Vasanta to create a pleasant ambience. Soon flowers bloomed and trees blossomed, spreading their sweet fragrance all around. Bees hummed and cuckoos sang pleasingly, while a gentle breeze blew and the full moon shone. So alluring was the atmosphere that even the forest sages felt disturbed in mind. All sentient beings in that region were attracted to amorous affairs; even the trees seemed to lean toward each other.

Shiva sat silently absorbed in thought of Vishnu. Even though he detected the change of atmosphere, he continued his meditation without allowing his mind to be deviated. Kama then stealthily approached him with his bow of desire at the ready. Accompanied by Rati, the emotion of love, he tried to enter Shiva's mind, but found it impossible.

Just then, Parvati arrived, her exquisite beauty casting a glow in all directions. She bowed to Shiva and began worshiping him. Shiva's meditation was broken and he gazed at Parvati. With flowers in her hair and the perfection of her limbs radiating through her humble ascetic apparel, she captured his mind. As she bowed, her cloth slipped from her shoulders and revealed the exquisite rise of her breasts. Shiva's eyes opened a little wider.

Kama saw his opportunity. He came closer to Shiva and placed his flowery arrow on his bow. Shiva, his heart stirring, spoke gently to Parvati.

"Are these your eyes or lotus petals? Your eyebrows resemble Kama's bow and your face has the countenance of the moon. I have not seen a woman equal to you in beauty anywhere in the three spheres."

Shiva went on praising her loveliness and slowly lifted a hand to touch her. Her delicate form enchanted his mind. If he derived so much pleasure simply from seeing her, then how much more would he feel by embracing her?

Parvati glanced down bashfully, though she had long been awaiting the touch of Shiva's gentle hand. However, the god

suddenly checked himself, realizing that he had somehow become deluded. How had it happened? What could have made him break his meditation? How had he been overwhelmed by the desire to touch a woman's body? What example was that to set for ordinary men? He was supposed to be practicing yoga!

Shiva looked around and saw Kama close by drawing back his bow. Deluded by the illusory energy, Kama released his flowery arrow of love at the mighty god, the arrow that would have put an end to his meditation once and for all. But to his amazement the usually unerring missile dropped harmlessly to the ground in front of Shiva. Kama began to tremble in fear. Without a doubt this had been a terrible mistake. Shiva was plainly infuriated. The god of love thought of Indra and the other gods, who at once all appeared there. But before they had time to say, "Let him be forgiven," a flame shot from Shiva's third eye and reduced Kama to ashes where he stood.

A cry of lamentation went up from the gods. Seeing her husband slain, Rati fell unconscious to the ground. Coming back to her senses after some moments, she cried out in anguish, "What shall I do? Where shall I go? How can I live? Kama, my lord, where are you now?"

Rati beat her breast and wailed piteously. She cursed Indra for having induced Kama to approach Shiva. Hearing her cries, even the birds and beasts in the forest felt misery.

Indra said, "Gentle lady, take your husband's ashes and preserve them. Shiva will surely restore him to life one day. Do not blame the gods for what has happened, for no one causes another's misery. Everyone receives only the results of their own deeds."

Seeing that Shiva had calmed down after discharging his anger, the gods began worshiping and praising him in various ways. They prayed to him to bring back Kama, "Please forgive him. He acted in this way at our behest, driven as we were by our desire to eradicate the demon Taraka."

Pleased by the god's submission, Shiva said, "What has happened cannot be reversed. Kama will remain bodiless for now, but his soul will reside within me. In time, when the all-powerful Krishna appears on earth, he will take birth as his son and Rati will be reunited with him then. Everything I say shall come to pass."

Shiva then vanished and the gods went back to their abodes. Rati departed for Mathura, where Krishna would appear, to await her husband's rebirth.

## PARVATI UNITED WITH SHIVA

After Shiva had vanished, Parvati returned home with her maidservants. Her heart burned in separation from her lord. She found no peace or happiness in anything. She cursed her beauty and wept loudly. Crying, "I am doomed," again and again, she lay on the ground with her hair and clothes in disarray. She thought only of Shiva, remembering his gestures and movements. His name was always on her lips.

Himachala and Mena tried to console her, but without success. She hardly ate or slept. Continuously wailing, she frequently fainted and let out great sighs of sorrow.

Some time thereafter, the sage Narada visited Parvati. Seeing her pitiful condition, he said, "Shiva has been pleased by you, but he is a great yogi and is unattached. You had some pride, which he has removed. Now you should seek him again by performing penance. He will surely take you as his wife."

Parvati's heart leapt. She wept with relief. With full faith in Narada's words, she went to her parents and sought their permission to go to the forest for penance. Her father gave her permission, but Mena felt distressed.

"Dear child, how can you go? You are a young woman and should never be unprotected. Furthermore, your body is delicate and penance is hard. Stay here and worship Shiva in the safety of your home. Why must you go alone into the forest?"

Parvati beseeched her mother. "It is the advice of the great sage Narada. Please let me go."

Eventually Mena relented and allowed her daughter to leave. Parvati went up into the mountains. When she reached the place where Shiva had sat, she was overcome again by pangs of separation. She looked around in anguish, hoping to see him somewhere. With tears streaming from her eyes, she sat down to begin her meditations. She cried, "Alas, Shiva!" repeatedly. Gradually calming her mind, she began to chant the Shiva mantra.

Parvati took food only every second or third day and remained outside through the changing seasons, bearing all the extremes of climate. Giving up her fine dress, she matted her hair and clad herself in clothes fashioned from tree bark. Her austerity became more and more severe as time passed. With her mind fixed on Shiva, she tolerated all kinds of bodily distress. For

three thousand years she meditated, waiting for Shiva to appear. She amassed so much power that the very balance of the universe was threatened. The gods became distressed, feeling scorched by Parvati's increasing splendor. They sought shelter from Brahma.

"My lord, save us. What is happening? The universe with its mobile and immobile beings appears about to be burnt up."

Brahma told them it was due to Parvati's penance. "She intends to propitiate the great Lord Shiva. We must go to him. Only he can stop her."

The gods went at once to Kailash, the heavenly abode of Lord Shiva situated beyond the reach of ordinary men. They saw Shiva seated in a yogic posture, absorbed in trance. After they had eulogized him for some time, he slowly opened his eyes and asked them why they had come.

"Great god, we seek your protection. Taraka, the evil-minded one, is assailing us. Only a son begotten by you can slay him. Therefore we beg that you accept Parvati as your wife. Even now she practices penance to win your favor. That too is giving us distress, as she has become very powerful. Please unite with her for the good of all the worlds."

Shiva smiled slightly. "How can this be good? If I accept the beautiful Parvati, it will surely bring Kama back to life within me. Kama leads to hell, for he induces men to lust, which in turn brings anger and delusion; he is the destroyer of knowledge and spirituality."

Shiva again closed his eyes in meditation and the gods looked at each other in anxiety. They thought of Vishnu, who then appeared before them. After hearing of their plight, he began praising Shiva. Once again Shiva opened his eyes and Vishnu began to address him.

"Be pleased to accept the gods' request. Take Parvati's hand in marriage. This will surely lead to the greatest good."

Shiva was still reluctant. "Marriage is a great fetter. A man bound with ropes or locked in irons may somehow escape, but one bound by worldly enjoyment is trapped. How then can I accept Parvati?"

Seeing the gods standing with folded palms before him, their faces hopeful, Shiva finally relented. "Very well, even knowing this I will marry Parvati. Through her I shall beget a son who will soon destroy Taraka. Peace be with you. I shall go now to the mountain where she is meditating."

Shiva decided that before accepting Parvati he would test her

resolve. He therefore assumed the form of an old sage. Carrying a water pot and leaning on a staff, he went before Parvati and said, "Who are you and why are you engaged in penance? Most beautiful lady, you appear fit for palaces and the finest dress. Why, then, this ascetic garb and abode in the forest?"

Parvati replied, "Know me to be one whose heart and mind are set upon Shiva. I desire to attain the shelter of that all-powerful person of limitless glory. But though I have sought him for thousands of years I have not been successful. Therefore, I shall now consign myself to the fire. Wherever I take birth again, may I worship Shiva."

Even as Shiva in the form of the sage tried to prevent her, Parvati threw herself into the sacred fire that blazed in her ashram. But due to her ascetic power the fire felt cool and did her no harm. She came out again, lamenting, and the sage said, "Your penance is wonderful! Your body has not been harmed by the fire! Yet, in spite of so much austerity, your desire remains unfulfilled. Why do you seek this Shiva who does not answer your prayers?"

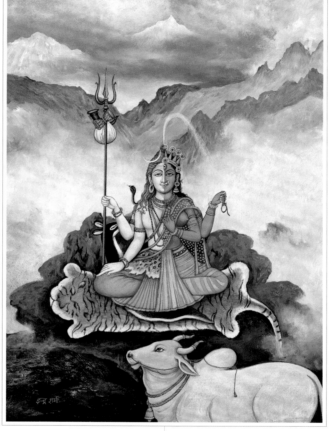

"I cannot accept anyone else as my lord, not even Brahma or Vishnu or any other god. I desire only to serve Shiva."

The sage laughed. "Gentle lady, please think again. Shiva is not a wise choice. He goes about naked, smeared with ashes, with thick matted hair and serpents entwining his limbs. His birth and pedigree are unknown; he is the resort of ghosts and goblins, has no learning and is detached from everything. Why, he is said to be a madman and has no qualities that one like you will find attractive."

The sage went on criticizing Shiva for some time, suggesting that Parvati choose another husband instead. When he had finished, Parvati breathed heavily with anger. Taking some moments to calm herself, she responded by praising Shiva's many transcendental attributes. Finally she said, "One who censures Lord Shiva is not fit to be seen or heard. Indeed, he should be killed. But, as you are a Brahmin, I can neither reject your words nor kill you. I must therefore leave this place. Never can I tolerate criticism of my lord."

Parvati stood up to leave, but just at that moment Shiva revealed his true form. Parvati fell to the ground in obeisance. Tears streamed from her eyes. She praised Shiva again and again.

"You are the cosmic soul and I am the cosmic energy. This is the truth. I am your devotee forever and your wife. Take pity on me. Let us again be united."

After this, Parvati returned in great joy to Kailash with Shiva. In due course, after many years of loving exchanges, Shiva impregnated her with a powerful son named Karttikeya who became the gods' general and slew the demon Taraka. In another pastime Shiva and Parvati also conceived the god Ganesh.

PARAVATI

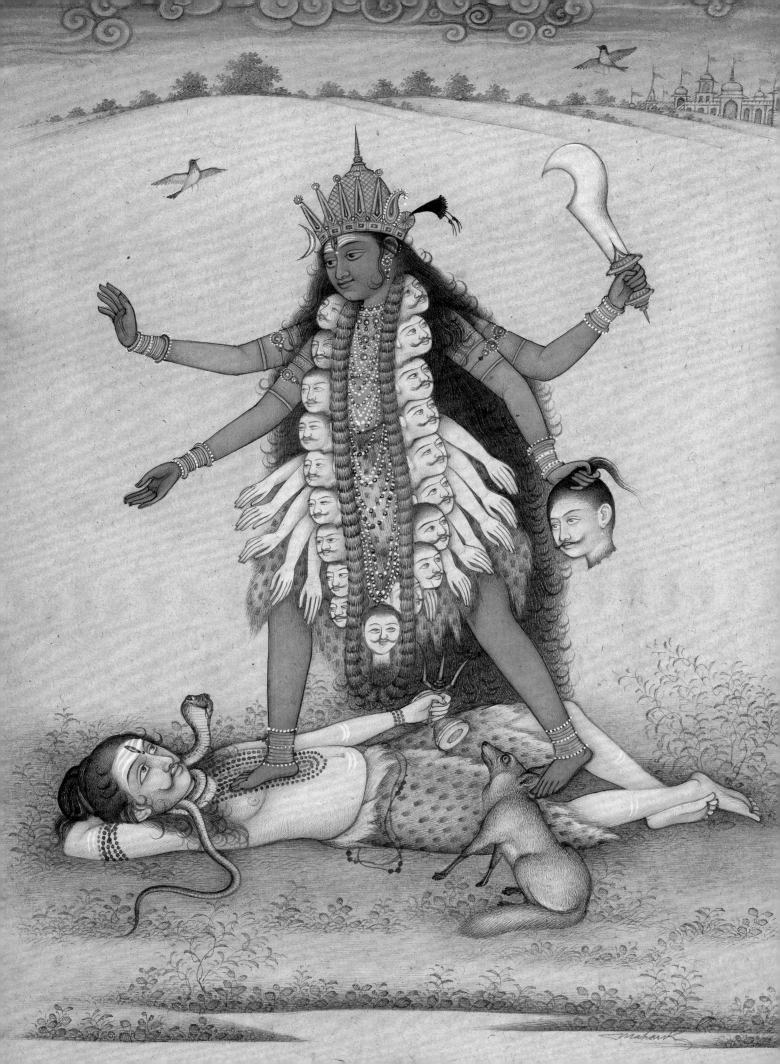

*pracaṇḍa-caṇḍa-muṇḍayor mahā-balaika-khaṇḍinī*
*hy aneka-ruṇḍa-muṇḍa-yug-raṇe balaika-dāyinī*
*kvacit tv aśakti-kāriṇī ramā-vilāsa-dāyinī*
*mude'stu kālikā sadā samasta-pāpa-hāriṇī*

*May Kali, who takes away all sins, bring you joy. She was the only one able*
*to destroy the terrible demons Chanda and Munda, and is the only one able*
*to give courage and strength to a warrior on a battlefield littered with head-*
*less corpses and skulls. She sometimes robs the strength of those not devoted*
*to her, though she gives good fortune to those who are.*

# KALI

OF ALL THE GODDESS'S MANIFESTATIONS, KALI IS SURELY THE MOST TERRIFYING. HER BLACK BODY IS ADORNED WITH A GARLAND OF SKULLS AND A GIRDLE OF SEVERED ARMS. HER EAR-RINGS ARE THE CORPSES OF CHILDREN AND HER BRACELETS ARE SERPENTS. SHE HAS BLOOD SMEARED ON HER LIPS, LONG FANGS AND CLAW-LIKE HANDS. HER FAVORITE HAUNTS ARE BATTLEFIELDS, WHERE SHE BECOMES DRUNK ON THE HOT BLOOD OF HER VICTIMS, OR CREMATION GROUNDS, WHERE SHE SITS ON CORPSES SURROUNDED BY JACKALS AND GOBLINS. GREAT WARS ARE SAID TO BE SYMBOLIC REPRESENTATIONS OF KALI, CONDUCTED UNDER HER DESTRUCTIVE INFLUENCE, AND HER WORSHIPERS ARE ALWAYS AT RISK OF BEING ANNIHILATED BY HER WHEN THEY ASK FOR HER FAVORS.

Like Durga, Kali is associated with Lord Shiva, the universal destroyer. She is described as his "dangerous" energy, at times uncontrollable in her fury and blood lust. Only Shiva himself, who lies at her feet in supplication, can pacify her. Indeed, there is a popular image of Goddess Kali standing atop the prone body of Shiva. This is usually interpreted to mean that Shiva is inert or a corpse (*shava*) without his energy, Kali.

Kali is the object of much devotion and worship, especially in eastern India, where many temples are dedicated to her. Her worshipers often approach her as a mother, but there are also many Sanskrit invocations to the warlike Kali aimed at gaining success against one's enemies.

## Kali Slays Raktabija

Perhaps the most famous story about Kali is about her killing of a mighty demon named Raktabija. Once, many ages ago, the god Brahma had given Raktabija ("Blood-seed") the boon that every time a drop of his blood was spilled he would instantly reproduce himself. Drunk with power and feeling himself invincible, he attacked the gods, assisted by a vast army of demonic followers. The gods fought him with all kinds of divine weapons, wounding him severely, but to their astonishment they saw that hundreds and thousands of Raktabijas sprang into existence on the battlefield.

"What is happening here?" they asked. "Each time we kill this demon, he seems to multiply himself and then attack us with renewed fury."

Perplexed, they went to Shiva. "Great lord, please help us. We cannot rid the world of this demon."

Shiva was deep in meditation and said nothing, so the gods approached his consort, Parvati, who sat by his side. "O divine energy of the Lord, please help us."

Parvati agreed. She rose up, manifesting the form of Durga from her body. As Durga, she mounted her lion carrier and rode out to do battle with Raktabija. She brought a blizzard of weapons to bear upon the demon, slicing and chopping him in every possible way. However, once again the demon continued replicating himself, filling the battlefield with countless identical forms.

Raktabija laughed and taunted the goddess, "Do not waste your time, foolish woman. I cannot be defeated by you or anyone else!"

Durga looked around. Armies were rising up from the pools of blood she had created by repeatedly killing the demon. Mounted on elephants and chariots they surrounded her, laughing and shouting derisively.

Durga knitted her brows in fury. Her eyes turned deep crimson and she began to breathe fire. Suddenly, a terrible black female figure, which the demons at once recognized as the goddess Kali, emerged from her forehead. Gaunt, with sunken eyes, clad in a tiger skin, she wore a garland of human heads and held a skull-topped staff. Emitting hideous cries, she rushed out into the thick of the demon forces, her huge gaping mouth revealing rows of blood-soaked fangs.

Kali whirled about, seizing the demons with her many arms and devouring them, laughing all the while and sending a chill of terror into Raktabija. Her matted black hair blew wildly about her shoulders. She stared menacingly at the demon hordes, killing many simply by the power of her terrifying gaze. Others dropped to the earth, frozen with fear just on hearing her bloodcurdling shrieks. Kali stretched out her bright red tongue and began swallowing the demon army, along with its horses, elephants and chariots. At the same time she released countless arrows, as well as swords, daggers, axes, heavy clubs and many other dreadful weapons, slaying the demons in droves.

Kali shouted out to Raktabija, "Stand before me now, evil-minded one. I am here to finish you for good."

Raktabija, though hardly able to look at the enraged goddess, raised a huge scimitar and charged at her with a great cry. But with just one hand she caught hold of him and lifted him high into the air. With a swift stroke of her sword she lopped off his head, catching all the gushing blood in her gaping mouth. Not one drop reached the ground.

Having sucked the demon dry, Kali threw aside his lifeless corpse and began careening about the battlefield in a mad fury. With her claw-like fingers she tore the remaining demons apart. Others she trampled into the ground or hacked to pieces. Her hideous cackling filled the earth and sky. No one could approach her without being instantly slain. It seemed that her rampaging would not stop with the destruction of the demons. Even the gods began to look on in fear. They went again to Shiva.

"Great lord, please arise. Your consort threatens the very stability of the universe. Dancing in her divine mood of anger, she is shaking the earth with its full load of mountains. She slays whoever comes anywhere near her. It seems she will not be satisfied till every creature in the world lies dead. We think that only you can pacify her."

Shiva opened his eyes. "Have no fear. I will take care of this matter."

The god went out onto the battlefield and began speaking to Kali, "Dear goddess, desist from fighting. Your enemies have all been defeated and the universe delivered from danger. Stand down and be at peace."

But Kali went on killing, dancing on the dead bodies and reducing them to a mush, all the time letting out great shrieks of horrible delight.

Shiva tried again and again to calm her, but it seemed she could not hear him. At last he ran before her and threw himself on the ground. The goddess began dancing upon his

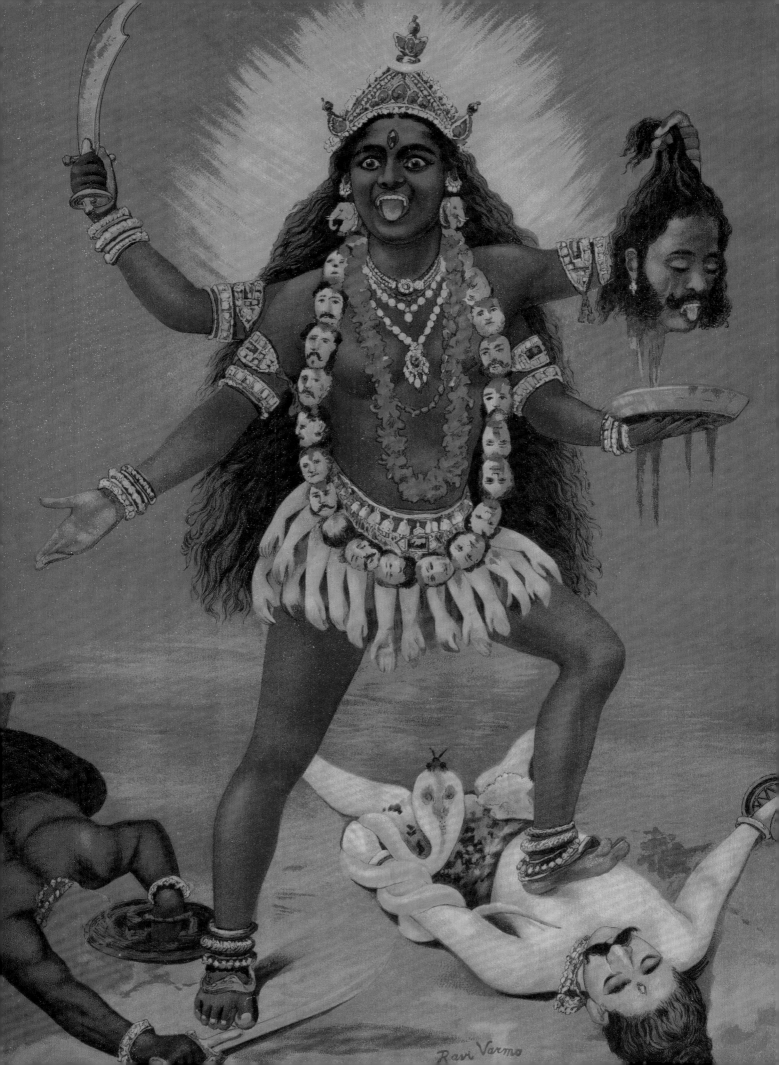

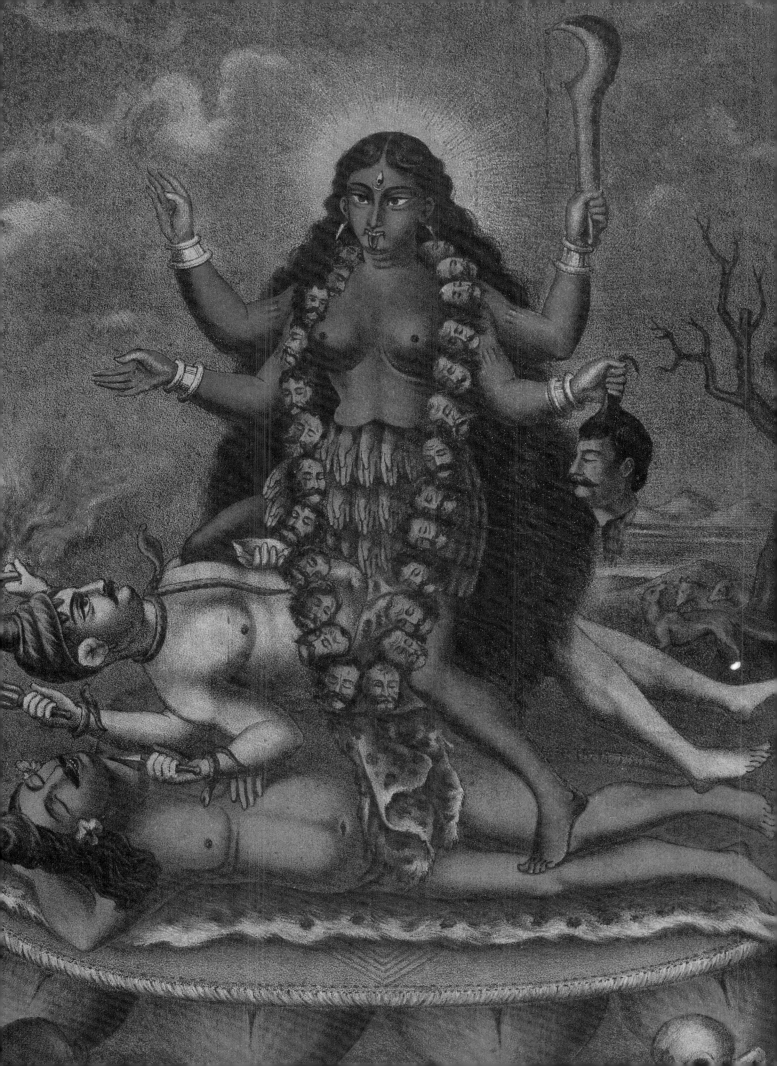

body. Suddenly she realized what she was doing. She calmed down at once, seeing that she was standing on her beloved lord. Gradually she transformed back to her gentler form as Durga, and then to Parvati, Shiva's eternal consort.

# DANGERS OF KALI WORSHIP

The worship of any god or goddess independently from the Supreme is ultimately not recommended in the Vedic texts. The purpose of these scriptures is to elevate us to pure God consciousness, and the separate worship of lesser deities is seen as an obstacle to that goal, particularly when it is motivated by material desire. For example, Kali is designated as the deity to whom one may make offerings of flesh if one desires to eat meat. By and large, meat eating is condemned in the Vedas, but in recognition of the fact that some people desire to engage in such activity, a provision has been made for it. This should be seen as a kind of damage limitation, to prevent wholesale animal slaughter. Thus the injunction is that one may offer a goat or buffalo to Goddess Kali on the full moon night, slitting its throat while chanting a mantra that literally means, "I will be you and you will be me (in your next life)."

This ritual has given some the impression that the goddess desires flesh offerings, but that is a mistake. Most authorities of the tradition suggest that, as a divine and pure being, Kali never accepts offerings of slaughtered creatures, but rather that she leaves them for her ghostly and demonic followers to consume. In any event, on the basis of scriptural sanctions such as the above, many sacrifices of animals and even humans have been made to Kali. However, such acts are fraught with peril, as the following story from the *Bhagavata Purana* illustrates.

There once was a king named Bharata who became highly advanced in spiritual consciousness. He retired from his duties and went to the forest to pursue his quest for spiritual perfection. Toward the end of his life, however, he somehow became so attached to a baby deer that he was absorbed in thought of it at the time of his death. As a result, he took birth again in a deer's body, though due to his spiritual advancement, he was still able to remember his previous birth.

When Bharata died again, he took birth in a Brahmin's family. Still remembering who he had been in his previous lives, he was determined to avoid becoming attached to anything or anyone again. His conviction was so strong that he acted like a dumb and foolish person. He was thus given the name Jada, which means "dull." Thinking him capable of little else, his father put him to work in the fields, guarding his cows.

It so happened that a band of robbers was operating in the vicinity of Jada's home. They were worshipers of the goddess Kali and were looking for a man they could offer her as a human sacrifice. The robbers' leader instructed his followers, "Look everywhere. We must find someone soon, for the moon is almost full. Find a stout fellow who is more like an animal than a man."

The robbers ran off in all directions, looking for a suitable victim. After some time they came across Jada sitting in a pasture with the grazing cattle. They called out to him, "Hey, you there! What are you doing?"

Jada made no reply. He looked at them quizzically, opening and closing his mouth stupidly.

"This one will surely do," said one of the robbers.

The others agreed and seized Jada, dragging him back to their leader.

"Just see what we have found," they said.

"Very good. Take him into the temple, prepare him and then bind him with ropes. We must begin the ritual."

Jada felt no fear. He believed that life and death were both in God's hands, and he allowed the robbers to take him into the temple and get him ready for the sacrifice. They dressed him in new clothes, decorated him with ornaments, smeared his body with scented oils and sandalwood pulp, and hung garlands around his neck. They gave him a meal and then brought him before the statue of Kali, whom they began to worship with offerings of lamps, flowers, grains, sprouts and fruits. According to their own rites, they worshiped her with music and song, playing drums and bugles and chanting various prayers. They then made Jada sit directly in front of the statue.

As their chief priest approached Jada with a sharpened sword in his hand, the robbers intoned different mantras:

"O great goddess, drink the hot blood of this victim whom we now offer in sacrifice to you."

The priest raised his blade to kill Jada, but before he could deal the fatal blow, a great sound reverberated through the temple. The robbers looked up in shock and saw that the statue had split in two and the goddess herself was emerging from it, her red eyes flashing and her gaping mouth revealing rows of fierce, curved teeth. In her many arms she brandished swords and butcher's knives that she whirled above her head. She was followed by a host of terrible looking beings that fell upon the horror-struck robbers. Kali and her hordes began killing them, severing their heads and throwing them about like balls. They quaffed the blood that spurted from the robbers'

KALI

necks, shrieking and laughing with ghastly delight.

After all the robbers were killed, Kali said to Jada, "These stupid men tried to kill you, even though you are an exalted personality realized in spiritual truth, thinking that such an offering would please me and win my favor. For this reason they have been punished. I am never pleased by concocted rituals."

Kali and her followers then disappeared from the temple.

## THE GODDESS OF DEATH AND DESTRUCTION

 On a cosmic scale, Kali represents the totality of material existence, which she first of all brings into being and then destroys by the influence of time, another of her manifestations. Indeed, the name Kali is derived from the Sanskrit word for time, *kala*. Her iconography is steeped in symbols of death, but many of these have deeper meanings. Her garland of fifty skulls represents the fifty letters of the Sanskrit alphabet, which encompass everything that is within the material world, for everything created has a form described by language. These skulls also represent Kali's different *shaktis* or energies, which often appear with her when she performs pastimes. The human arms forming her girdle are the organs of karma or work, indicating her intimate involvement with creation. She is described as the primordial potentiality of matter, known in Sanskrit as *mula prakriti*, which precedes the manifestation of material forms.

But it is mainly her power of destruction for which the dark and fearsome Kali is famously known. When Shiva dances his *tandava* dance at the end of an age, bringing about the total destruction of the universe, Kali is by his side. In the *Mahabharata* there is an account of a slaughter brought about by Kali at the end of the great war. Out of six million warriors who began the war, all had been slain except a few thousand on the side of the Pandavas, and only three on the other side. One of these three was Ashwatthama, who longed for vengeance against his enemies.

Late one night, when everyone was asleep, Ashwatthama, a worshiper of Shiva, lit a fire and began offering prayers to that powerful deity. Shiva, with his many frightening followers, appeared to him and said, "I have protected the Pandavas throughout this battle, as they are staunch followers of Krishna, whom I always worship. But now the tides of Time have changed. Soon they will resume their eternal spiritual positions with Krishna. I will therefore empower you to bring about their death."

Shiva then infused Ashwatthama with Kali's destructive power and he went on to single-handedly slaughter all the remaining members of the Pandava army.

## KALI, BORN FROM SHIVA'S POISON

 n another story found in the Puranas, Kali is said to be formed of the poison stored in Shiva's throat, which he swallowed when it was produced during the churning of the milk ocean, as described in the chapter on Lakshmi.

There was once a celestial demon named Daruka who had acquired immense powers. As is the usual wont of such demons, he set about harassing the gods in every way possible. And, as they often do, the gods then made their sorry way to Shiva to ask him for his help.

"Lord, save us from Daruka. We are unable to slay him, for he is destined to only be killed by a woman."

Seeing the gods in supplication, Shiva smiled. "Do not be afraid."

He turned to Uma, who was sitting by his side, and said, "Splendid lady, for the good of the worlds, please slay this demon. This is my request to you."

Hearing this, Uma entered Shiva's body in a subtle form. Then, creating another, black and terrible body from the poison stored in his neck, she came out again. She stood before the gods as the all-powerful goddess Kali, with her wild matted locks and three reddish eyes. Taking up a sharp trident she set out for the destruction of Daruka. After a short fight, she beheaded the demon and drank his foaming blood. Still her anger was not assuaged. The entire universe seemed to shake as she vented her fury with terrific shrieks. She danced and spun around, her feet pounding the earth with the sound of many huge thunderclaps.

Shiva at once assumed the form of a small boy. He sat in a cremation ground near to Kali and began to cry. The beautiful child immediately attracted the goddess. She went over to him and tenderly raised him upon her lap, offering him her breast. As she suckled him, Shiva sucked out her wrath and she became entirely peaceful, assuming once again her form as Uma.

Kali also appears from Uma or Parvati on another occasion, when the goddess hears her husband insulted. Becoming infuriated, she transforms herself into Kali and a number of other formidable goddess manifestations. And in an account found in the *Linga Purana*, which describes how Shiva set

out to destroy the cities of the demons, Kali follows behind him, "whirling a blazing trident and intoxicated from the blood of her victims."

Without doubt Kali is the most furious and deadly of all Goddess manifestations. It seems that whenever there is killing and destroying to be done, the Goddess takes the form of Kali.

She thus attracts the worship mainly of persons strongly desirous of material power and worldly enjoyments. But, as the anecdote of the robbers shows, this is a risky business. It is the great paradox of material life. The more one tries to extract enjoyment from the material energy, the more one becomes exposed to the possibility of pain and suffering. Kali is the extreme representation of this truth. Approached for pleasure, she inevitably delivers pain.

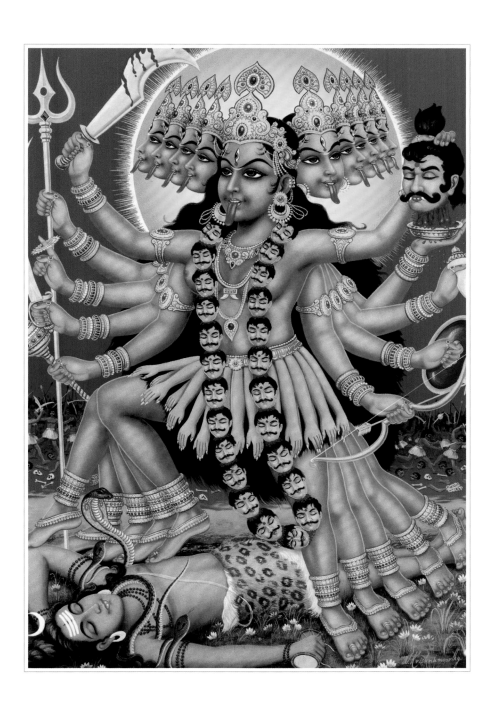

*Oh Goddess, with what can your valor be compared?*
*Where is there a form likeyours, striking fear into enemies with*
*its extreme beauty? A compassionate heart and severity in battle*
*are seen only in you throughout all the three worlds.*

# THE MAHAVIDYAS

AS AN EXTREME MANIFESTATION OF THE ANGER OF THE GODDESS, KALI IS NOT ALONE. ACCORDING TO THE *DEVI BHAGAVATA PURANA*, WHEN SATI WAS REFUSED PERMISSION BY HER HUSBAND SHIVA TO ATTEND HER FATHER'S RELIGIOUS CEREMONY, SHE BECAME INFURIATED AND MANIFESTED TEN DIFFERENT FORMS. THESE HAVE BECOME KNOWN AS THE MAHAVIDYAS, OR "WISDOM GODDESSES."

According to the Puranic account, when Sati became angry a terrifying transformation took place in her body. A third eye appeared in her forehead, radiating a blinding light. Her three glaring and anger-filled eyes stared down on Shiva, who was completely taken aback by the sudden change in his usually docile and accommodating wife. Sati's form started to vibrate, causing the earth below and the skies above to tremble. Mountains shook and hot lava spurted out from cracks in the once icy Himalayan range. Sati's lips parted and her gaping mouth revealed rows of dagger-like teeth.

Shiva observed that his wife had lost her golden luster and had become dark like the night sky, clothed only in space. Her hair flowed chaotically in long, wavy strands that streamed around her. On her crown rested a brilliantly shining crescent moon, and her awesome form was outlined by a lightning-colored aura.

It is said that Shiva was so startled by Sati's awesome appearance that he took off in flight. As he did, he heard her voice echoing behind him, "Be not afraid!" But he kept running, his footsteps pounding the earth like thunder. Wherever he ran he encountered another form of the Goddess standing before him. Shiva tried to escape in all the ten directions—the four cardinal and four inter-cardinal points, above and below—and each time Sati manifested a different form to stop him.

Finding himself surrounded by many fearsome apparitions of his wife, Shiva closed his eyes and meditated on Vishnu. After a time of silence, he opened his eyes to be accosted by a dark, elderly woman of dreadful countenance. He called out to her, "Who are you? Where is my beloved Sati?"

The woman answered, "I am your Sati, standing before you. You have become so confused that you are unable to recognize me."

Shiva replied, "Why have you come to me in such a ghastly form? What am I to think of all these unfamiliar and horrifying manifestations? Tell me who you truly are and what is your real nature?"

"O Shiva, lord of yogis! As the divine energy, I create, maintain and destroy all the worlds. I am the root of everything. Though I usually appear to you as your beloved wife Parvati, I have countless other forms.

She then described the ten forms she had just shown Shiva. "I appeared before you in the east as Kali, with dark complexion and terrifying form. In the west, I am Tara, taking on the color of a rain cloud. To the south, I appear as Chinnamasta, decapitated with streams of blood flowing from my neck. In the north, I appear as Bhuvaneshwari, sovereign of the worlds. In the southeast, I am the widow Dhumavati; in the southwest,

Kamala. In the northwest I am Matangi; in the northeast I appear as Sodashi, a girl of sixteen. Below you is my form of Bhairavi, and above is Bagalamukhi. All of these forms are my expansions, reflections of my inexhaustible nature."

## SIGNIFICANCE OF THE MAHAVIDYAS

 hese wisdom goddesses, who represent the entire spectrum of the feminine archetype, are well known and worshiped throughout India by Shaktas and Tantrics. Kali is the most prominent among them, and she is referred to as the Adi Mahavidya, or the original form of these ten goddesses.

For Shaktas, the Goddess is the Supreme Absolute from whom everything has emanated, as is Krishna or Vishnu for the Vaishnava tradition, or Shiva for the Shaivas. And just as the Vaishnava *Bhagavata Purana* lists ten divine incarnations of Vishnu or God who are known as the Dasa Avatars, so does the Shakta text *Guhyatiguhya Tantra* list the ten Mahavidyas and compare each of them to one of the Vishnu avatars. However, the ten goddesses differ significantly from the avatars in both appearance and function.

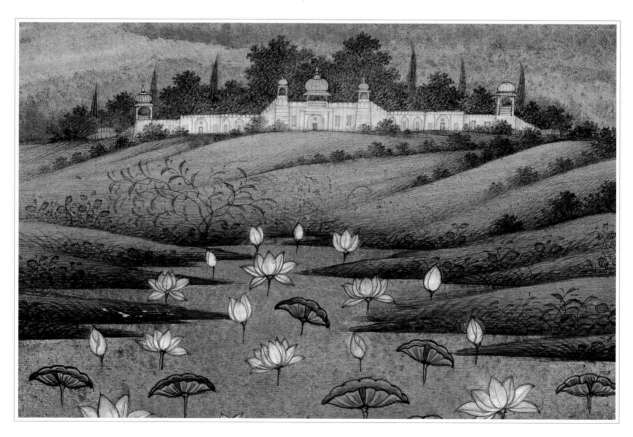

 *śvetāmbarāṁ śārada-candra-kāntiṁ*
*sad-bhūṣaṇāṁ candra-kalāvataṁsām*
*kartrī-kapolānvita-pāṇi-padmāṁ*
*tārāṁ trinetrāṁ prabhaje'hila-dharyai*

*For the purpose of attaining all kinds of prosperity and fulfillments,*
*I meditate upon the three-eyed Goddess, whose luster is like that of the*
*winter moon, whose head is bedecked with the crescent moon and who*
*holds scissors and a skull in her lotus-hands.*

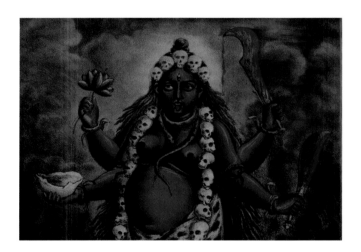

# TARA

TARA IS MOST SIMILAR TO THE FEROCIOUS GOD-
DESS KALI. Her name means saviour, or the one who can take
people across the material ocean. She is also the remover of fear
of the stormy seas of material existence. Because of this, she is
the form of the goddess preferred by sailors, who pray to her for
protection from storms, and by those living near riverbanks, who
seek her protection from floods. She is also the governing deity of
the emotions and their expression, including speech.

Tibetan Buddhists also worship a goddess with the name Tara,
who is the embodiment of compassion and the center of a constel-
lation of 21 female deities, some peaceful, some wrathful. Though
there may be some historical connection between the two Taras,
they are not the same.

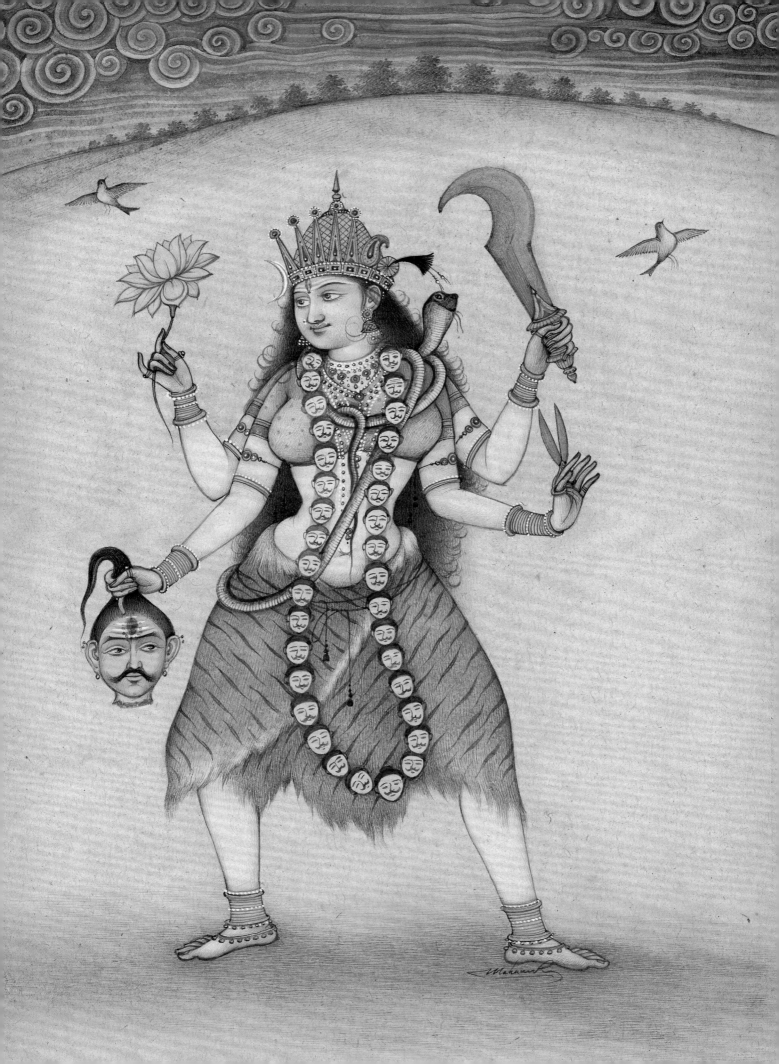

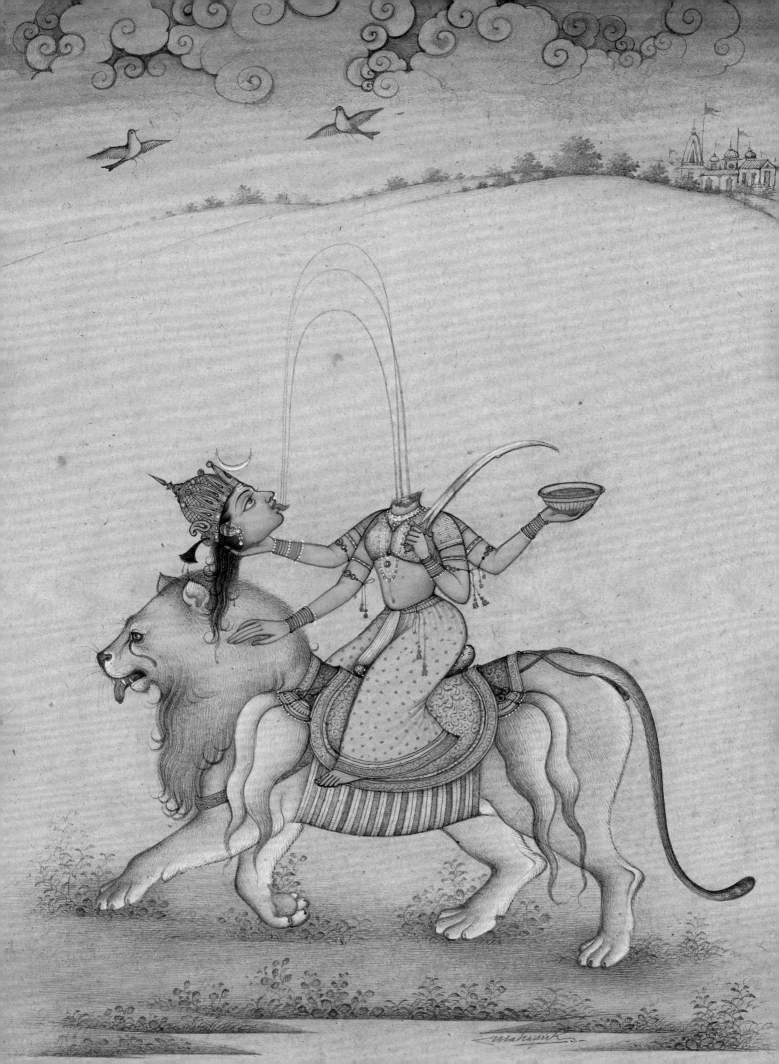

*I meditate upon the goddess Chinnamasta, who is seated in the center of the sun disk. In her hand she holds her own severed head, with dishevelled hair, and with her gaping mouth she is drinking the streams of blood that gush from her own neck. Rejoicing with her friends Dakini and Varnini, she stands on Rati and Kamadeva who are engrossed in sexual dalliance.*

# CHINNAMASTA

THIS INTRIGUING IMAGE IS FULL OF SYMBOLISM, conveying the truth that life, sex and death are inextricably interwoven. Sex produces life but it also produces death as all creatures are born only to die. Furthermore life feeds on and is nourished by death.

The chopped off head symbolizes freedom from the bondage to the senses and the awakening of the sixth sense of intuition in the sixth psychic center or chakra. She performs the cosmic dance of destruction on the body of Kama (not shown here), the principle of desire, symbolizing that she gives the aspirant complete control over his or her primary impulses and instincts. The three streams of blood represent the three subtle paths of energy in the body, known as the ida, pingala and sushumna.

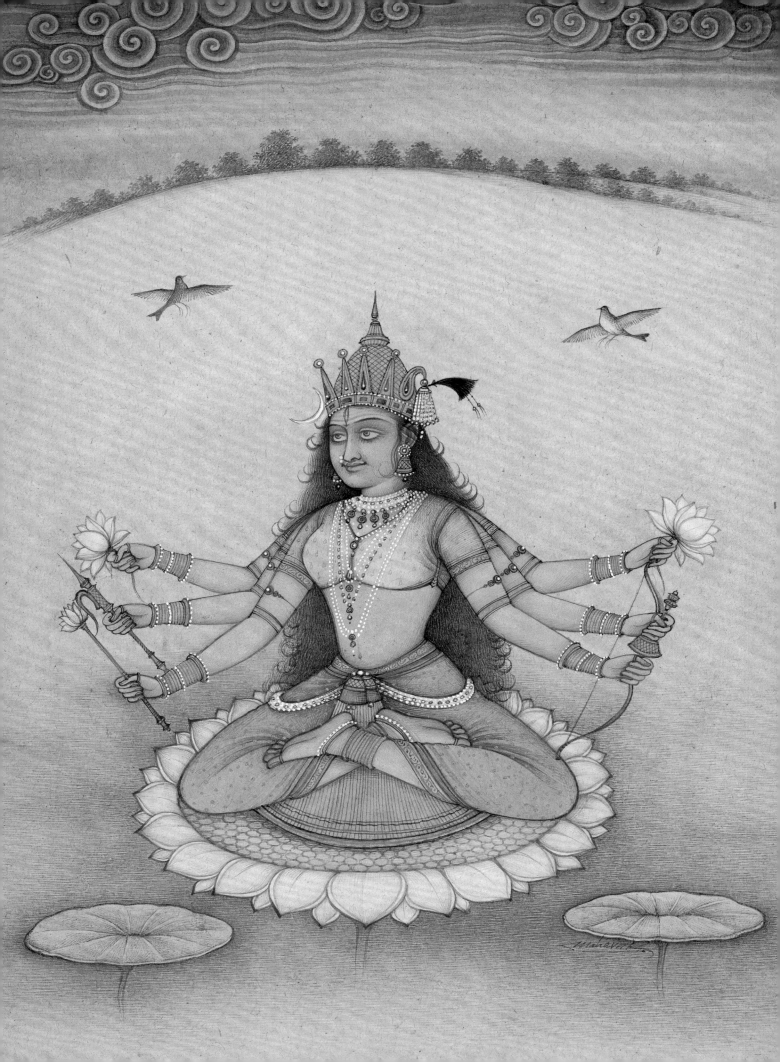

*viśveṣāṃ jananīṃ śaśāṅka-kapalāṃ pāśāṅkuśe bibhratīṃ*
*hastābhyām abhayaṃ varaṃ ca dadhatīṃ dvābhyāṃ parābhyāṃ tathā*
*dugdha-klinna-kucāmbarāṃ smita-mukhīṃ padmāsanā-saṃsthitām*
*vande tāṃ bhuvaneśvarīṃ trinayanāṃ sṛṣṭi-sthitī kāriṇīm*

*I worship Bhuvaneshwari, the World-Mother, the creator and maintainer of the universe. She has three eyes and her forehead is adorned with a crescent moon. She holds a noose and a goad. She shows the gesture of blessings and signals fearlessness. The cloth covering her breast is wet with milk and she smiles in motherly affection.*

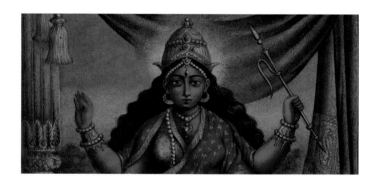

# BHUVANESHWARI

THE WORD *BHUVANA* MEANS THE PHENOMENAL WORLD. Bhuvaneshwari is the queen or sovereign of this manifest creation. The *Devi Bhagavata Purana* recounts that once Brahma, Vishnu and Shiva quarrelled over which of them was supreme. The Divine Mother intervened and took the three gods to her abode where they saw themselves as her female attendants. They realized that they had forgotten that they were merely tools used for the creation, preservation and destruction of the world. Their source was the same and they were but different aspects of her infinite energy.

Bhuvaneshwari is seen as the source of consciousness and knowledge. She is the queen and mother of the universe and as such presides over it and the welfare of her subjects and children. She is present in the heart chakra. According to scripture, by worshiping her, one pierces the illusory coverings of the creation and understands the divine plan. Such a change of heart results in a change in consciousness and awareness and even brings about a change in bodily chemistry.

 *sauvarṇāsana-saṁsthitāṁ trinayanāṁ pītāṁśukollāsinīṁ*
*hemābhāṅga-ruciṁ śaśāṅka-mukuṭāṁ sac-campaka-srag-yutāṁ*
*hastair mudgara-pāśa-vajra-rasanāḥ sambibhratīṁ bhūṣaṇair*
*vyāptāṅgīṁ bagalāmukhīṁ trijagatāṁ saṁstambhinīṁ cintayet*

*Meditate on Bagalamukhi, the paralyser of the three worlds, seated on a golden throne. She has three eyes and her entire body covered in ornaments; her luster is like gold, she wears a tiara like the crescent moon, and a garland of champa flowers. She holds a mace, and the severed tongue of her enemy in her hands.*

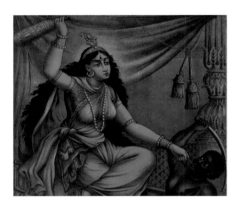

# BAGALAMUKHI

BAGALAMUKHI MEANS "THE CRANE-HEADED ONE."
The crane is the symbol of deceit. She is a powerful goddess who rules magic for the suppression of an enemy's gossip. These enemies are not only the external enemies of this world, but also the temptations that impede spiritual advancement, including those presented by one's own tongue. This goddess rules the spirit of deception, which is at the heart of most speech.

Bagalamukhi threatens to turn the eloquent speaker into a mute, the king into a beggar and learning into ignorance. On the other hand, one who petitions her can become free of all obstacles, paralyse his or her enemies, stop the wind and clouds, be victorious in contests and win fame.

She is also the goddess of light, symbolized by the color yellow, which is all-pervading in her worship. One who serves Bagalamukhi becomes perfectly secure, harmonious, self-confident, courageous, independent and invincible.

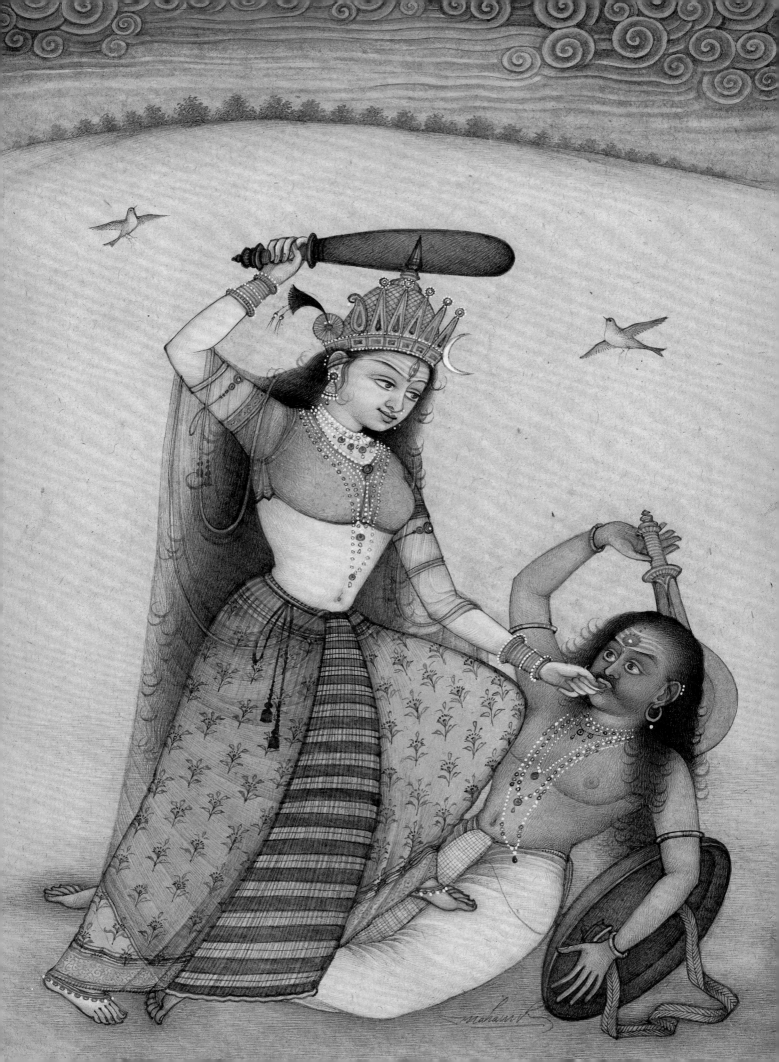

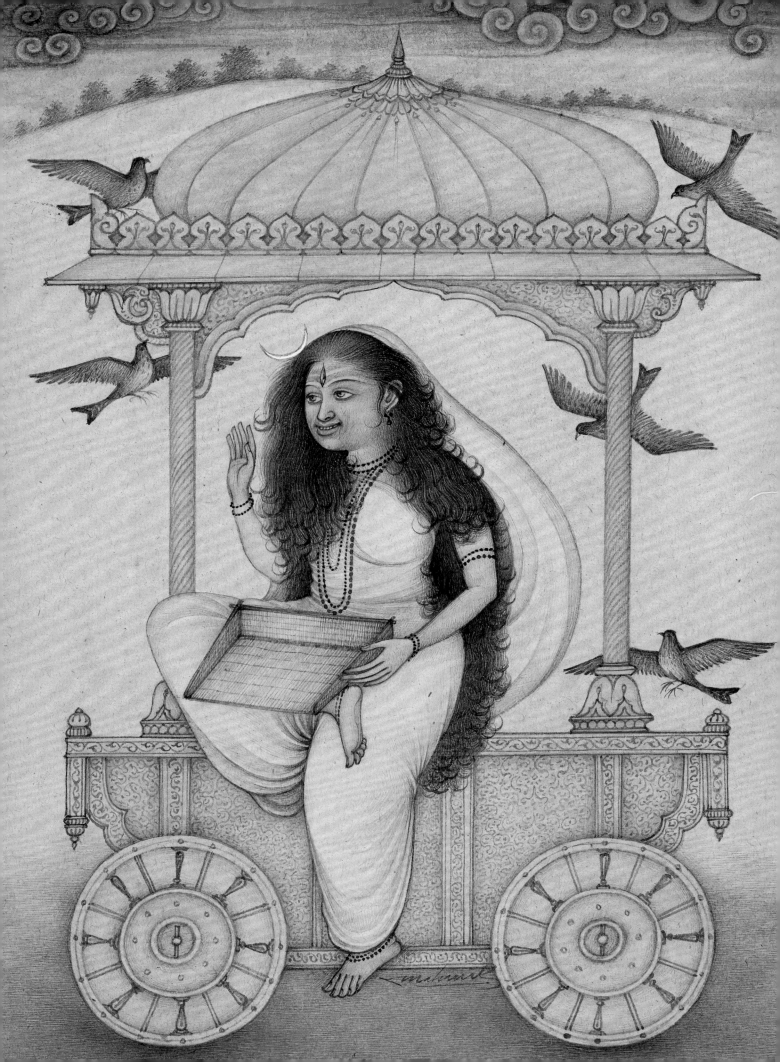

*atyuccā malināmbarākhila-janodvegāvahā durmanā*
*rākṣākṣitritayā viśāla-daśanā sūryodarī cañcalā*
*prasvedāmbu-citākṣudhākula-tanuḥ kṛṣṇātirūkṣa-prabhā*
*dhyeyā mukta-kacā sadā priya-kalir dhūmāvatī mantriṇā*

*Meditate on Dhumavati as a very tall woman wearing dirty clothes, and of disgusting appearance. She looks dejected. She has three dry red eyes, big teeth and her belly is like the sun. She is of a fickle and restless temperament, her entire body soaked with perspiration, always tormented by hunger. Her complexion is dark and her body rough. Her tresses are loose and dishevelled, and she always revels in strife and quarrel.*

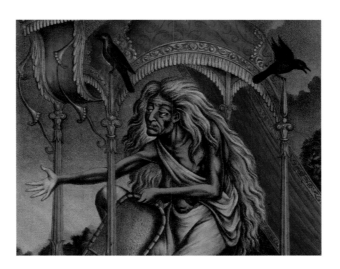

# DHUMAVATI

DHUMAVATI IS THE "WIDOW GODDESS," often depicted as an ugly old hag with pendulous breasts who rides on a crow. She is the personification of bad fortune. The crow symbolizes dark forces and black magic. In her hands, she holds winnowing basket (or *shurpa*), which symbolizes the separating of wheat from chaff. She tests the weak and casts them aside. Thus she is also known as Darunaratri, "the night of frustration."

She is the distorted form of the Goddess, representing unorganized energy. She is worshiped in the burning grounds in order to invoke dark forces, to destroy enemies, to read minds, to tell the future and to destroy diseases.

MAHAVIDYAS

*udyad-bhāskara-sannibhā smita-mukhī raktāmbarālepanā*
*sat-kumbhaṁ dhana-bhājanaṁ sṛnimatho pāśaṅkarair bibhratī*
*padma-sthā kamalekṣaṇā dṛḍha-kucā saundarya-vārāmnidhir*
*dhyātavyā sakalābhilāṣa-phaladā śrī-jyaiṣṭha-lakṣmīr iyam*

*The lotus-eyed Kamala, the original goddess of fortune and the fulfiller of all desired objectives, should be meditated upon as sitting on a lotus. She is an ocean of beauty; her bodily hue is the luster of the rising sun; she is cheerful, she is full-breasted, decorated with red garments and sandal paste.*

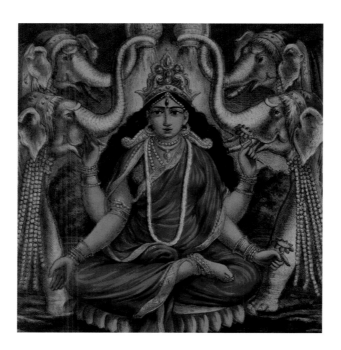

# KAMALA

KAMALA IS THE TANTRIC LAKSHMI. She is invoked for peace, harmony, progress and wealth. Because of her alluring nature, it is not easy to worship her. One who wants to petition this goddess should start by being generous with others, while being careful to avoid the pitfalls of selfish behavior. Kamala is very sensitive and moves away from those who are greedy.

Kamala is generally approached in order to preserve the spirit from calamity, and to attain peace and prosperity.

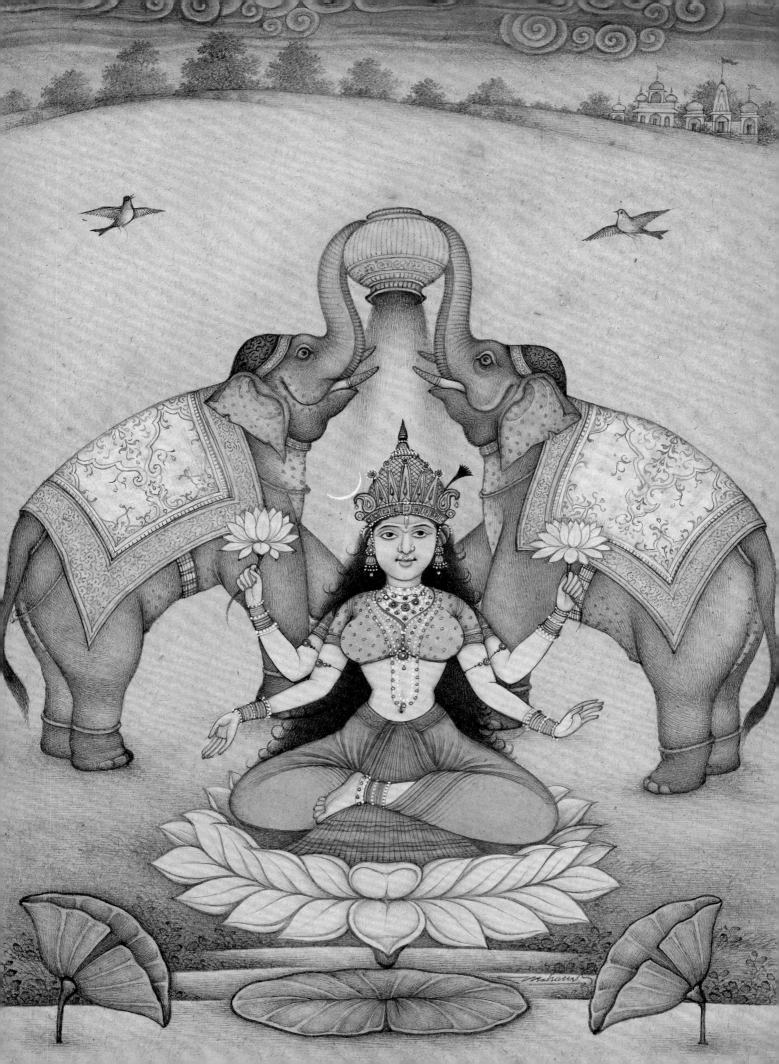

*ghana-śyāmalāṅgīṁ sthitāṁ ratna-pīṭhe*
*śukasyoditaṁ śṛnvatīm rakta-vastrām*
*surā-pāna-mattāṁ saroja-sthitāṁ śrīṁ*
*bhaje vallakīṁ vādayantīṁ mātaṅgīm*

*I meditate upon Matangi, seated on a jewel-studded pedestal*
*in a lotus and playing a lute. She is wearing a red cloth and her*
*complexion is black like the clouds. She is intoxicated after drinking*
*wine and she listens to the chirping of a parrot.*

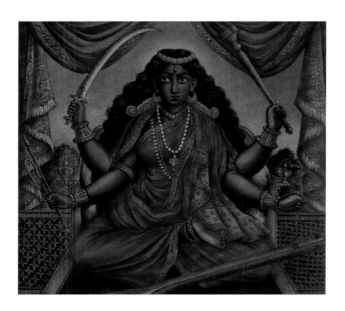

# MATANGI

MATANGI IS CONSIDERED TO BE ANOTHER FORM OF
THE GODDESS SARASWATI. Her seat is in the fifth chakra,
or psychic center, in the throat. Her vina or lute symbolizes the
human body. The vina is made of two gourds connected by a stalk,
which represents the human spine. The strings are the nerves
and the two gourds represent the first chakra (*muladhar*) and the
seventh at the top of the skull (*sahasrara*) .

Matangi gives the power of oratory, fluency in speech, creativity,
music, knowledge and fine arts. Moreover, she removes all
disharmony and brings wisdom.

*110*

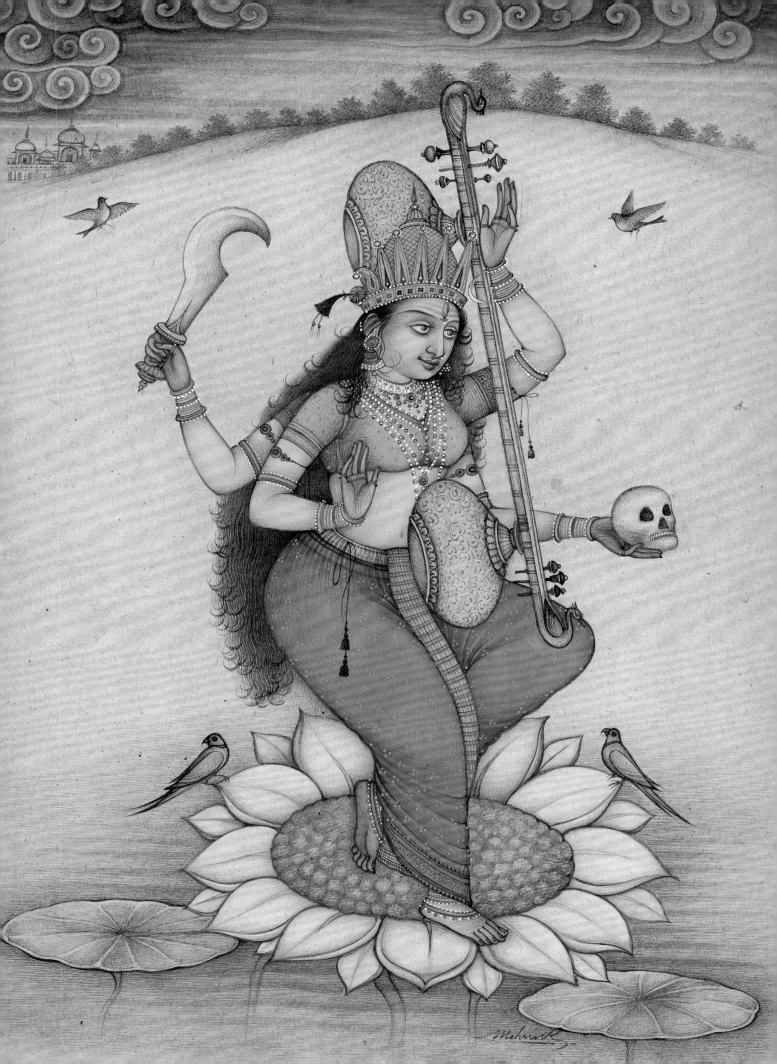

 *dhyāyatām bhairavīm devīm tri-netrām dhūmra-varnakām*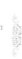
*bibhratīm danda-khatvāngau tīksna-damstrā-bhīma-mukhām*
*vyāghra-carmāvrta-katim tundilām rakta-vāsasam*
*jatābhāra-lasac-candra-khandām tām munda-mālikām*

*Meditate on the goddess Bhairavi, who has three eyes and is the color of smoke.*
*Her mouthful of sharpened teeth is most frightening. A sliver of the moon*
*decorates her matted locks, and a garland of skulls adorns her neck.*

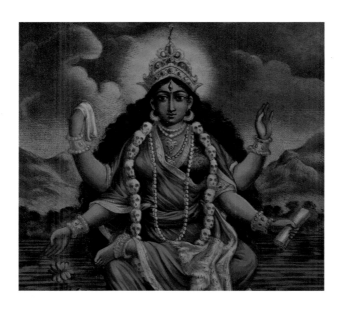

# BHAIRAVI

BHAIRAVI IS THE FORM OF THE GODDESS WHO ENGAGES IN THE DESTRUCTIVE DANCE at the end of creation. She is immanent on the three planes of existence—physical, astral and celestial. She destroys the nine impediments of the mind: sickness, incompetence, doubt, delusion, sloth, intoxication, delusion, non-attainment of yoga and the inability to maintain *samadhi*, or the yogic state.

Bhairavi or Tripura Bhairavi destroys all the obstacles that hold the aspirant back from union with the Supreme. She is radiant like the rising sun. She makes the upward movement of the Kundalini energy possible, and makes it possible for those who have experienced it to control and absorb the powers that are released.

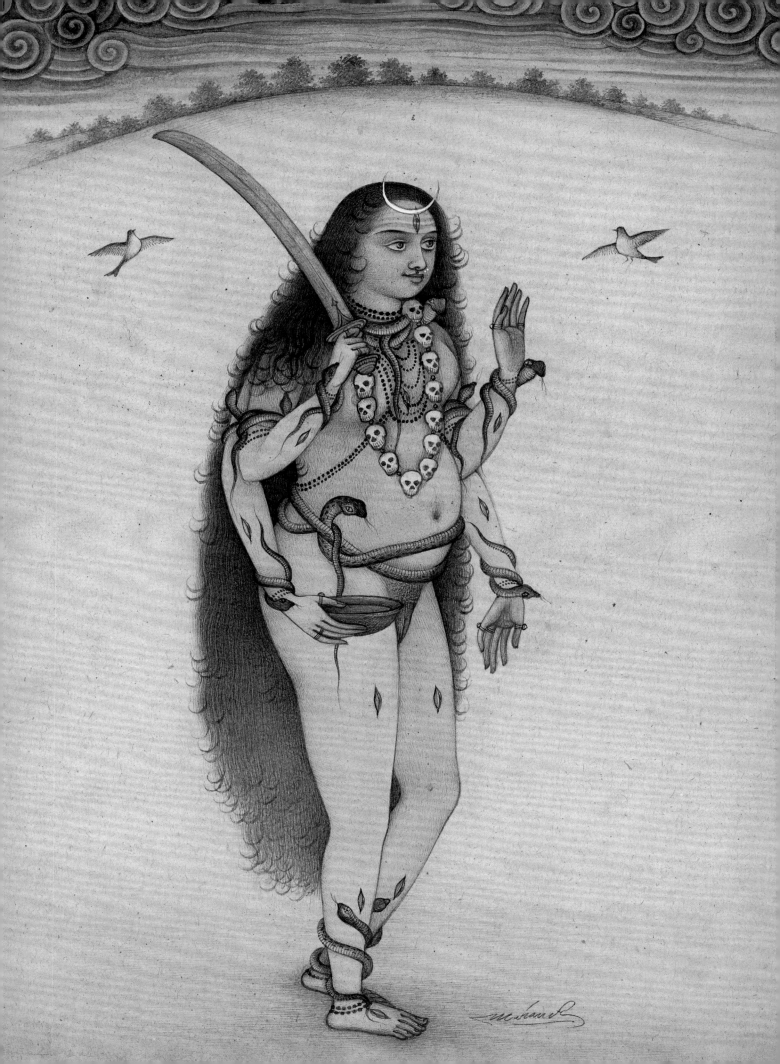

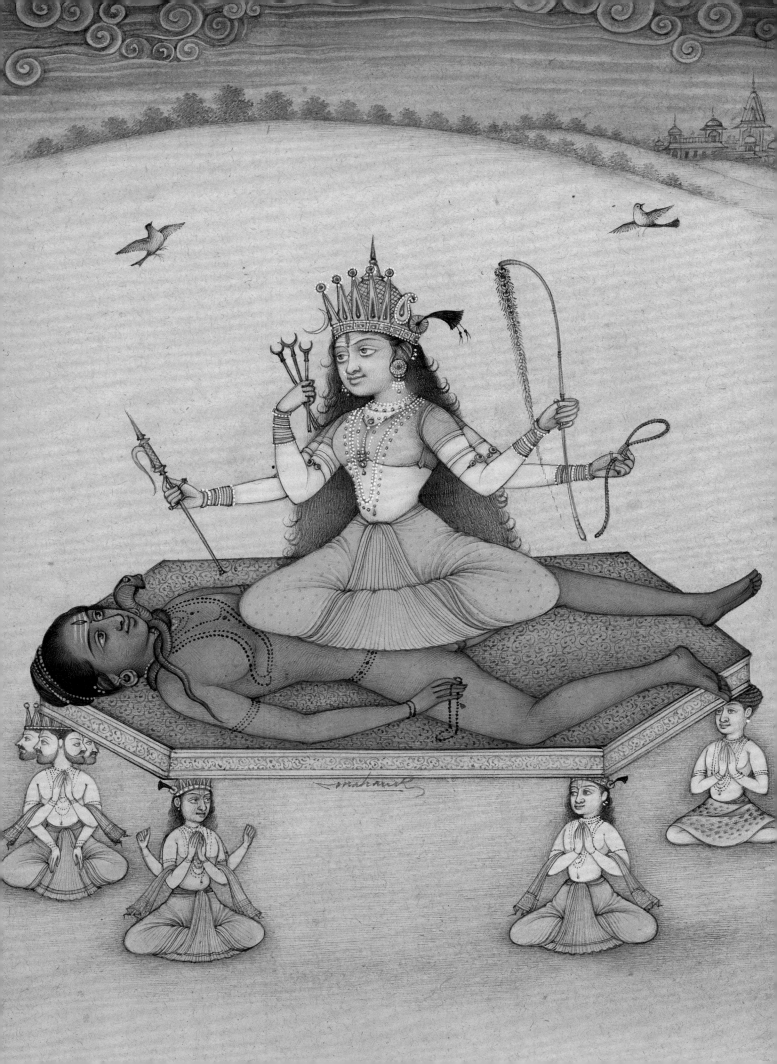

*sa-kuṅkuma-vilepanām alaka-cumbi-kastūrikām*
*sa-manda-hasitekṣaṇaṁ sa-śara-cāpa-pāśāṅkuśam*
*aśeṣa-jana-mohinīm aruṇa-mālya-bhūṣāmbarām*
*japā-kusuma-bhāsurām japa-vidhau smarāmy ambikām*

*Repeating her names, I remember Ambika, the Divine Mother, who is smeared with vermilion, her hair scented with musk, her eyes smiling gently. In her four hands, she holds an arrow, bow, noose and goad. Radiant with the color of hibiscus flowers and dressed in clothes and garlands the color of the dawn, she enchants everyone in the world without exception.*

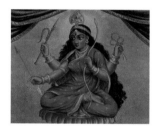

# SODASHI

SODASHI IS A SIXTEEN-YEAR-OLD GIRL (sodashi literally means "sixteen") who sits on the body of Shiva, sometimes in a position of intercourse. She is also known as Lalita Tripura Sundari, in which form she is one of the great warrior goddesses.

After Kali, Lalita Tripura Sundari is the most widely venerated Mahavidya. Regionally, Kali's worship is more widespread in the north and east of India, whereas Lalita Tripura Sundari is better known in the South. An extensive literature—philosophical, devotional and ritual—has grown around her. In particular, her worship is central to the Sri Vidya tradition, a manifestation of Shakta Tantrism that merges both the Vedic and Tantric approaches to spirituality.

Different descriptions and images of these goddesses will be found in various texts, and like all celestial beings they are capable of manifesting different forms. The Mahavidyas are for the most part not individually revered and are seen in general as representing numerous aspects of the divine Goddess. They appear in stark contrast to the chaste and submissive Sati, from whom they emanate, showing another side of her nature as independent, powerful and fearsome. By exerting her will over Shiva in these ten forms (including Kali) the Goddess seemingly intimidates him into allowing her to go to her father's religious ceremony.

## The Story of Lalita Tripura Sundari

The story of how Shiva burned Kamadeva is recounted in the chapter on Parvati. In the version of this myth told in the *Tripura-rahasya*, it is said that after Kamadeva had been reduced to a pile of ashes, one of Shiva's attendants, a skilled artisan named Chitrakarma, collected these remains and moulded them into the image of a man. Kama's wife Rati begged Shiva to revive her husband, and so he cast a merciful look on the image, infusing it with life.

Chitrakarma was thrilled and instructed the newly created being to supplicate Shiva by reciting select Vedic hymns and asking for his blessings. Shiva was pleased with the prayers and granted the young man the boon that he would be stronger than any of his enemies and would rule over the three worlds for sixty thousand years.

But the creature born of Kamadeva's ashes was completely different from the playful god of love. Because the ashes from which he had been shaped were the result of Shiva's anger, the boon only served to make him arrogant, unscrupulous, and cruel. Lord Brahma thought, "What a fool Shiva has been to give his blessings to a person who will only misuse them!" So he called him a buffoon, or *bhanda*. Consequently, his creation, the evil king, was known as Bhanda.

Bhanda made his home in Shunyaka, the well-fortified original capital of the asuras, from which he tyrannically ruled the universe, confident that he was well protected by Shiva's boon. He subjected Indra and the other denizens of heaven to so many indignities that, on the advice of the celestial sage Narada, they took to the performance of a great sacrifice according to the Sri Vidya ritual. On the last day, as the yajna was coming to its completion and the gods were offering their final prayers, Lalita Tripura Sundari suddenly sprang out of the sacrificial flames. Elated, the gods sangs hymns of praise, convinced that she would soon free them from their subjugation to Bhanda.

Lalita prepared to wage war. She organized her soldiers into batallions: some were on horseback and others rode enormous elephants, while her chief ministers traveled on

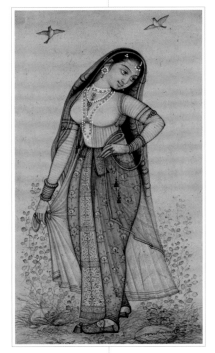

heavily armored chariots. Lalita mounted her lion and rode into battle, accompanied by countless manifestations of her power, Shaktis, who chose to ride on exotic carriers like majestic peacocks and graceful, long-necked swans. These warrior goddesses, armed with every imaginable form of weapon, not least of which were their mystic powers, were equipped to bring despair to even the most formidable foe.

Lalita gave the order for conches, battle drums and bugles to sound the battle cry. All the male deities had also assembled to support her and their shouts and cheers reverberated through the sky: "Victory, victory unto the supreme goddess, Lalita!"

In Shunyaka, inauspicious omens became visible all around; the war cries of Lalita's army shook the city walls and alarmed its inhabitants, who feared ensuing disaster. Bhanda went to his ministers for counsel. Though on the one hand they advised him to send spies to discover her strengths and weaknesses, they also gloomily prophesied, "Victory is in the hands of the Shakti, for she is no mortal woman."

Blinded by arrogance, Bhanda's self-assurance remained unshaken. He mocked the forces of the Goddess as an army of soft and delicate women and praised the iron strength of his own forces. He immediately dispatched his generals with their troops to initiate battle on the front lines of Lalita's army, wrongly thinking it would be a brief affair.

A fierce struggle ensued, lasting the whole night. By dawn, Bhanda's army lay lifeless on the battlefield and the Shaktis reveled, intoxicated with the wrathful energy instilled in them by the Goddess. Lalita's forces set up camp within a ring of fire that glowed throughout the day and on until dusk. As night fell, the fire raged and began to consume the immediate area. In its center, Lalita stood on her chariot, appearing like the divine presence in the heart of the solar orb.

Bhanda sent wave after wave of soldiers, including his own sons into battle against Lalita's army, but one after the other they were all defeated. Finally, he would have to step out onto the battlefield to personally challenge the Goddess.

Various missiles flew overhead throughout the day and great warriors on both sides were slaughtered. In desperation, Bhanda used his own magical powers to call forth the most

treacherous warriors in the history of creation to come to his aid. Among these infamous demons were Hiranyakashipu, Ravana and Kamsa, who had all appeared at different times to cause mayhem in the cosmos. In response, Lalita called upon the different descents of Vishnu, such as Rama, Krishna and Kalki, to subdue their antagonists just as they had before.

Finally, it was time to put an end to Bhanda. Lalita let forth a missile that set his body ablaze. With Bhanda fallen, she marched into the city of Shunyaka and burnt it too to the ground.

All the gods, from Brahma, Vishnu and Shiva to the minor divinities, appeared on the site to offer the Goddess songs and hymns of praise. They glorified her for her courage and success. Rati prayed for her husband to be restored to her and Lalita mercifully brought him back to life. Thus the grateful Rati was reunited with her beloved Kamadeva.

Her mission accomplished, Lalita resorted to the sacred place known as Srinagar in Kashmir where she would be worshipped for time everlasting.

## LALITA TRIPURA SUNDARI AND THE SRI CHAKRA

The worship of Lalita Tripura Sundari has been historically associated with Sri Shankara, the Vedantic preceptor said by Vedic texts to be an incarnation of Shiva. One of his most famous works is a poetic composition in her praise called *Saundarya-lahari* ("Waves of Beauty"). His disciplic descendents have followed him in the worship of Tripura Sundari and of Sri Chakra, which is her yantra or iconic form.

The Tantras hold that there are three kinds of external symbols used for worship of the Supreme Being, which they hold to be formless and nameless. Its gross or external form is the image cast in human form but holding the symbols of its divinity. The supreme aspect (*para*) is the mantra, which is the deity or divine power appearing in sound vibration. Between these two come the Deity's subtle (*sukshma*) aspect, the yantra. These are representations of the Deity in geometrical diagrams, also known as the mandalas or chakras. A yantra is considered to be the living manifestation or visible expression of a specific god or goddess.

The Sri Chakra or Sri Yantra is probably the most famous of all yantras, as well as being one of Hinduism's most recognizable symbols. It represents Tripura Sundari as the image of cosmic wholeness. Its particular form is said to be consistent with the very nature of reality, which is infinite and can only be con-

ceived in symbolic terms.

The worship of Sri Chakra has taken on a particular significance, representing the process by which the originally unified, undifferentiated divinity assumes the binary character of the masculine and feminine Shiva and Shakti, and thence creates the universe. Every aspect of the Chakra depicts a particular cosmic function and the powers or deities that preside over it.

The Sri Chakra is not only a map of the cosmos, but of the human individual as well, in accordance with the notion of microcosmic-macrocosmic parallelism, one of the central theoretical components of most Tantric teachings. In consonance with the overall symbolic function of the Mahavidya cluster, the Sri Chakra also indicates the various phases or stages of development to be traversed by the spiritual aspirant. To worship Sri Chakra successfully thus means to enter a transcendent vision of both creation and one's part in it.

These interpretations of Sri Chakra—as a map of the universe and the individual, and the stages of evolution of consciousness—are only three of its many levels of symbolic meaning. They are drawn from the structure of the *yantra* itself, where the overlapping and interweaving of lines and shapes represent the interactions of cosmic energies and basic principles. To fully understand the theoretically explanations of the yantra, a familiarity with a wide range of philosophical and metaphysical principles is required.

The most prominent feature of Sri Yantra is the set of intersecting triangles that comprise its inner circle. These upright and inverted triangles are symbolic of the union of masculine and feminine principles, Shiva and Shakti. The manner in which they intersect form geometrical equations that reflect the structure of the cosmos as it unfolds from subtle to gross.

Sri Yantra is thus meant to symbolize various experiences of reality or levels of consciousness. The entire spectrum of human experience is said to be charted in this structure, representing a gradation from conventional, dualistic reality to the ultimate standpoint of absolute, non-dual consciousness.

## EVOLUTION AND DEVOLUTION

Indian culture, philosophy and spirituality deal with two universal principles at the basis of existence. These are the evolution of matter and energy from Spirit and the involution of these principles back to their primeval source. These are the evolutionary and devolutionary currents of Shakti—the ascending and descending trends that unfold and direct the course of human life and the natural world.

The Sri Chakra, as a functional symbol or living energy structure, operates as a model by which we contemplate, interface and identify with these universal energies in a direct way. Meditating on the Sri Chakra allows us to reorient our own being to a wider view of reality by channeling the energy intrinsic to its structure.

Several important texts describe the methods of contemplating on the Sri Chakra. In particular, the *Bhavana Upanishad* delineates a method of meditation based on an understanding of Sri Yantra as a metaphor for the human body and mind.

The Sri Chakra can be drawn or engraved in bark, or metal plates. One can also construct a three-dimensional yantra with a pyramidal shape. Such models lend a visual clue to the symbolic schemes inherent in the yantra. The nine ascending *puras* or planes of the Chakra represent subtler and subtler gradations of reality. As a map of the subtle body, the nine planes are identified with nine chakras in the subtle anatomy of the human being, differing somewhat from the Indian yogic tradition, which traditionally puts the number of such chakras at seven.

## SRI VIDYA MANTRA

All of Hinduism's major deities are ultimately to be realized and worshiped through sound vibration (i.e. by the chanting of various mantras), which are said to be non-different from the forms of these deities.

Tripura Sundari is similarly invoked through her own mantra, which according to text and tradition is the inner secret of the Vedic Gayatri mantra as well as the primordial Om. As the mantra is deemed identical with the yantra and Divinity, a direct correlation can be drawn between their respective constituents.

Tripura Sundari's root mantra is called the Sri Vidya mantra—the mantra of supreme wisdom. Sri denotes auspiciousness and prosperity, or worldly accomplishment. Vidya here denotes wisdom—the perfect knowledge that liberates. The Sri Vidya mantra is declared the supreme granter of all perfection (*siddhi*). Worship of Tripura Sundari through the recitation of her root mantra in combination with the contemplation and ritual worship of her yantra constitute the primary practices of the Sri Vidya tradition.

All the sounds of the Sanskrit language are said to exist in the letters of Lalita's mantra, signifying that all the powers of creation are contained in this all-comprehensive, all-powerful mystic utterance. Various levels of esoteric meaning have been found for each syllable of these mantras.

Sri Vidya interpret sound itself as a manifestation of the principle of Shiva and Shakti combined. All consonants are masculine energies and cannot be pronounced without being combined with a vowel, the feminine energy of sound.

The Sri Vidya tradition holds that meditating on this mantra and engaging in ritual worship of the Sri Chakra and the form of Tripura Sundari are an effective means to spiritual success, understood as the realisation of the oneness of all existence as supreme spiritual energy or Brahman, as taught by Sri Shankara.

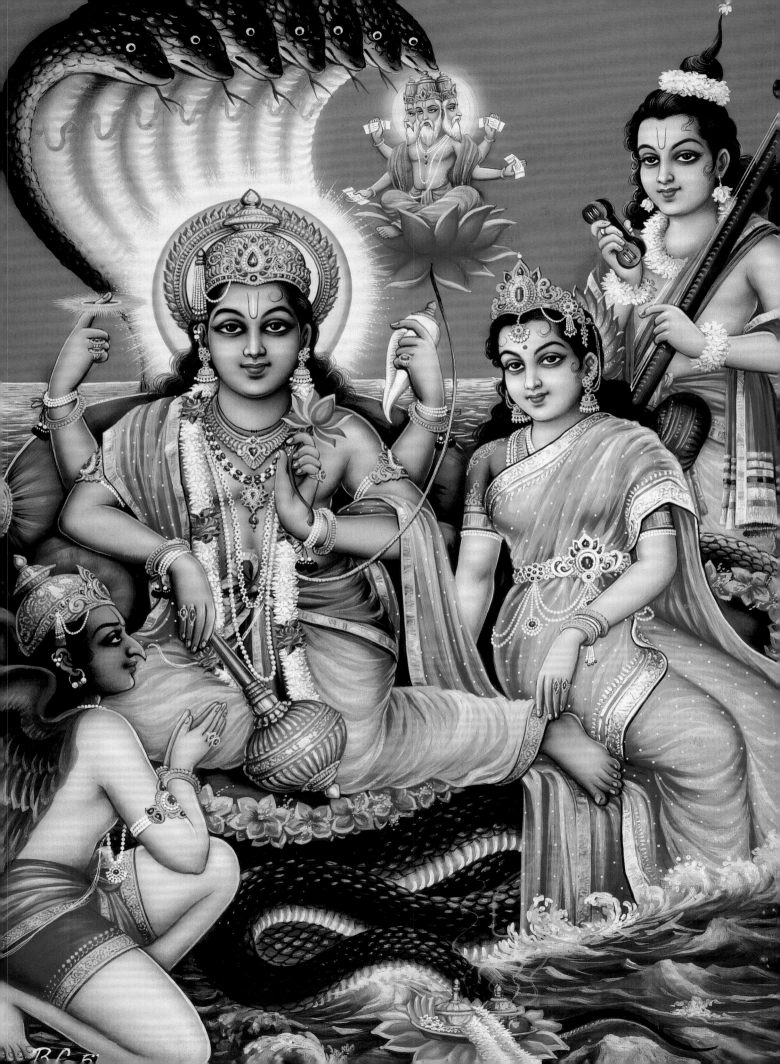

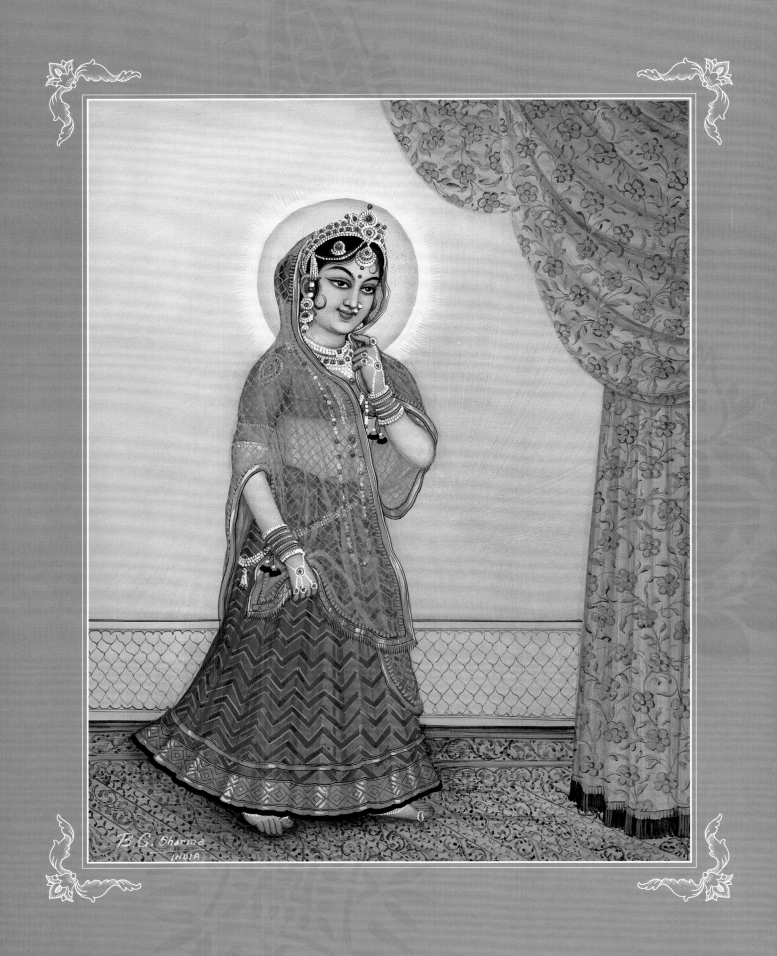

*ślāghyāśeṣa-tanuṁ sudarśana-karaḥ sarvāṅga-līlā-jita-*
*trailokyāṁ caraṇāravinda-lalitenākrānta-loko hariḥ*
*bibhrāṇāṁ mukham indu-sundara-rucaṁ candrātma-cakṣur dadhat*
*sthāne yāṁ sva-tanor apaśyad adhikāṁ sā rukmiṇī vo'vatāt*

*Rukmini's entire body is praiseworthy, whereas only Krishna's hand can*
*be called beautiful (i.e., he holds the Sudarshan disc in his hand). She*
*triumphs over the three worlds easily by any one of her limbs, whereas*
*Krishna had to step over them with his lotus feet (in his incarnation as*
*Trivikram). Rukmini's entire face is itself as beautiful as the moon, while*
*Krishna is only moon-eyed. Thus it is right and just that Krishna found*
*her to be superior to himself, so we ask her to protect us.*

# RUKMINI

ALTHOUGH SOME CULTURES ALLOW MEN TO HAVE MORE THAN ONE WIFE, EVEN THOSE MOST TOLERANT OF POLYGAMY WOULD FIND THE IDEA THAT ANY ONE MAN MIGHT HAVE OVER 16,000 WIVES QUITE PREPOSTEROUS. EVEN THE HAREMS BELONGING TO PAST EMPERORS AND KINGS RARELY NUMBERED MORE THAN A FEW DOZEN. WHO COULD EVER HAVE THE ENERGY OR RESOURCES TO MAINTAIN SO MANY THOUSANDS OF WOMEN? AND EVEN IF HE DID, IT WOULD BE A MATHEMATICAL IMPOSSIBILITY. FOR IF THE MAN SAW EACH WIFE FOR ONE DAY AT A TIME, EACH WIFE WOULD SEE HIM ONLY ONCE EVERY FIFTY YEARS.

Nevertheless, the Vedas inform us that when Krishna appeared on earth some 5,000 years ago, he married 16,108 wives, each of whom was an expansion of the goddess of fortune, Lakshmi. Of course, Krishna is identified in the epics and Puranic texts as the Supreme Person, the origin of all divine incarnations, so perhaps for him it is not so wonderful. The *Bhagavata Purana* further describes that he was able to be present with each and every wife at the same time. The sage Narada personally witnessed this by visiting each one of the 16,108 palaces Krishna had built for them in his city of Dwaraka.

Krishna had at first married only eight wives by his own choice, but was later solicited to become the husband of a further 16,100 princesses after he had released them from the clutches of an evil king who held them prisoner. Even so, he went on to father ten sons, who were all said to be the incarnations of various gods, in each one of his wives.

The first of all of Krishna's wives, and generally considered to be the chief among them, was Rukmini. The Hindu tradition holds her to be a full incarnation of the original Goddess,

Lakshmi. Just as Krishna is said to be the "fountainhead" of all incarnations of Vishnu, so is Rukmini said to be the origin of all the divine consorts who act as his wives in his numerous appearances.

Rukmini appears in this world as a most beautiful princess who is the object of desire for many princes, yet she herself desires only Krishna as her husband. As she is the divine energy of the Supreme, she is intended for him alone. Anyone wishing to enjoy her is positioning himself in opposition to Divinity.

As with all goddess manifestations, Rukmini is to be approached and worshiped as the eternal consort of the Supreme Godhead. When prayed to in this way, she can bestow upon us unlimited transcendental bliss, far superior to the ephemeral enjoyment of sensual pleasure. Rukmini, who can be seen in some temples standing next to Krishna on the altar, can give us access to Krishna in the divine realm of Dwaraka, where he eternally appears as a powerful ruler.

Along with Rukmini, the other seven principal goddesses who married Krishna are Satyabhama, Jambavati, Nagnajiti, Kalindi, Lakshmana, Mitravinda and Bhadra. The stories of how he married these and the other 16,100 are contained in the *Bhagavata Purana*.

## RUKMINI BETROTHED TO SISHUPALA

 ukmini's story begins with her birth as the daughter of a powerful king named Bhishmaka. This king ruled over a quarter of the entire earth and some called him the reincarnation of the saintly King Janaka, the father of Sita Devi. Bhishmaka had four sons and one daughter, the exalted Rukmini.

Bhishmaka was fond of saints and sages and would often entertain them in his palace. Rukmini would tend to their needs, serving them their food and helping them with their religious rituals. As she did so, she would hear their conversation. The sages often spoke of Krishna, who at that time was living in Dwaraka, the great city he had constructed on an island just off India's western coast. They would talk about his exploits and personal qualities, which Rukmini found extremely attractive.

When Rukmini had grown up to become an accomplished and beautiful young woman, her father began to discuss her marriage with his eldest son, Rukmi.

"We must find her a suitable match. In beauty, grace and all other feminine attributes she is no less than the goddess Lakshmi. I have received petitions for her hand from all over the world, but she is only interested in one person, Krishna. In my view, this would be a good match. Krishna is a very mighty ruler. Indeed, the sages describe him as Vishnu himself. Who could be a better husband?"

Rukmi pulled a face. "I am not so sure, Father. Krishna comes from a village background—he grew up as a lowly cowherd. I have heard that he is tricky and unreliable. What is more, he has fought many battles against our great friend and ally, King Jarasandha. In my view, he is the wrong man for my sister."

Bhishmaka tried to convince his son otherwise, for he knew that Rukmini would be deeply dismayed if she could not wed Krishna. But Rukmi was adamant.

"No, Father, leave this to me. I will arrange her marriage with King Sishupala. In any event, I have heard that Sishupala has sworn to kill Krishna, and we would hardly want Rukmini to become a young widow, would we?"

Rukmi smiled at his father. Bhishmaka sighed. He knew Rukmi was the only one in the family who preferred Sishupala to Krishna, but out of affection for his eldest son he acquiesced to his request. Perhaps it was destined to be. And if it was not, then how could it happen anyway? After telling Rukmi to make the necessary arrangements, the king retired to his chambers.

When Rukmini heard that she had been given to Sishupala without her approval, she was distraught. "How can they even suggest such a thing?" she tearfully asked her maidservant. "Sishupala hates Krishna."

"I know. I have also been told he is a harsh and angry man, given to drinking and gambling."

"Well, I am not just going to let this happen," Rukmini declared. "I think there is something I can do."

She decided her only hope was to contact Krishna directly and ask him to snatch her away. Without telling anyone, she wrote a letter and then secretly summoned an old Brahmin whom she knew to be trustworthy. When he arrived she said, "Good sir, I am depending on you. Please take this letter to Krishna in Dwaraka. You must tell nobody about this."

"It will be my pleasure, dear princess. To see Krishna is the perfection of sight."

The Brahmin left that very night, making his way unnoticed out of Bhishmaka's city and on toward Dwaraka. Within a few

days he arrived at that great city and went to see Krishna, who received him with all respect.

"Welcome to you, learned sage. Please take my seat."

Krishna rose from his throne and helped the old Brahmin sit upon it. Calling for a bowl of water, he then personally washed the Brahmin's feet and asked after his welfare. When the Brahmin had rested and taken food, Krishna inquired why he had come.

"I am anxious to know what has brought you here. Is there some problem in your kingdom? What may I do for you?"

"My lord, I bring a message from the black-eyed princess, Rukmini."

The Brahmin began to read Rukmini's letter: "My dear Krishna, having heard about your beauty, power, wisdom and character, I have shamelessly fixed my mind upon you. Who can equal you in any way? Simply hearing about your activities relieves one of all distress. What great benefits must then come of associating with you! I have therefore chosen you to be my husband."

Krishna smiled as the Brahmin spoke. He had also heard about Rukmini's many superb qualities and had decided that she would make an ideal wife.

The Brahmin continued to read from the letter: "Please come quickly and rescue me, for I am to be wed to Sishupala. Do not let the jackal steal what is meant for the lion. Bringing your troops in battle array, kidnap me from the midst of my relatives. Crush their forces and win me with your valor."

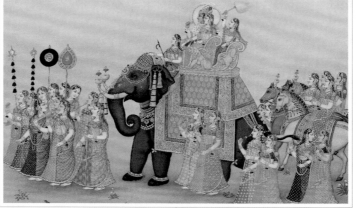

Rukmini informed Krishna that there was soon to be a grand procession in her city that she would attend. "That will be the ideal moment. Please come and take me then, if it so pleases you. If you do not, then I will give up my life, and then keep on taking birth until I can be with you."

Having finished reading the letter, the Brahmin looked up at Krishna and said, "There is not much time, Lord."

Krishna took the Brahmin's hand. "Just as Rukmini's mind is fixed on me, so is mine rapt in thoughts of her. I can hardly even sleep. I shall go there and deal with Rukmi and his forces, according to her wish. I shall take Rukmini from their midst just as one extracts blazing fire from wood."

Krishna then called for his chariot. When the golden car was yoked to its four horses and ready to depart, Krishna had the Brahmin mount it and then followed him aboard. He issued orders to his charioteer and the four horses sped away, seeming to rise up into the air. Sending up a great cloud of dust, they raced toward Bhishmaka's capital, Kundina. They reached the outskirts of the city in a single night.

## KRISHNA KIDNAPS RUKMINI

ukmi wasted no time in arranging for his sister's wedding. He sent out a messenger to have Sishupala come at once. Meanwhile, the city was decorated with brightly colored flags and festoons. It had been thoroughly cleansed and the streets were sprinkled with perfumed water. Rukmini's impending marriage to Sishupala was announced everywhere. The temple deities were worshiped to invoke auspiciousness, and priests made all the necessary preparations for the ceremony.

Soon Sishupala arrived, bringing with him a vast army of infantry, horsemen and elephants. They entered the city with great pomp, creating a tremendous clamor of horseshoes and iron chariot wheels on the broad stone streets. Bhishmaka greeted Sishupala respectfully. "Welcome to my city. The ceremony will take place tomorrow. Please rest now." He showed the prince to his luxurious quarters and then went to see Rukmini.

The princess was alone in her chamber. She repeatedly pulled back the silk drapes on her windows in the hope she might see Krishna. If he did not come soon, her wedding to Sishupala would take place according to her brother's plan. The thought was unbearable. Should she take her life right away? But what if Krishna came that night, or even the next day during the ceremony? But why should he? Why would such a great personality accept her? He could marry any woman on earth, or even in the heavens. Probably he had laughed at her letter. It was simply her bad fortune. Maybe she had offended some deity, perhaps the great Lord Shiva or his wife Parvati, whom she worshiped every day. She might have made some error in that

worship, making the goddess unfavorable toward her. It could be that she herself was the reason Krishna had not come.

Rukmini paced back and forth in her room, wringing her hands and shedding tears, vexed by a thousand reasons why Krishna might not come. When her father looked in on her she tried to smile, not wanting to upset him. She knew that he too had wanted her to marry Krishna. It was her cruel-hearted brother who had selected Sishupala.

"Please do not cry, my gentle princess," the king said, stroking her forehead. "All will be well. Who knows what may happen tomorrow?"

The king had heard rumors that Krishna might try to kidnap his daughter, a method of winning a girl often chosen by heroic fighters.

Rukmini looked at him hopefully. "All I want to happen is for Krishna to accept me."

Bhishmaka smiled and, after consoling her a little more, went to his own rooms.

When morning came, Rukmini's many servants dressed and decorated her in preparation for the ceremony. They spoke to her as they worked, but she hardly heard a word they said. Her mind was fixed on Krishna. He had to come now or all would be lost. Suddenly she felt her left eye, arm and thigh twitch, a highly auspicious sign in a woman. At the same time, Sishupala and his followers experienced the same thing, which for a man means the very opposite.

Suddenly the old Brahmin came into Rukmini's room. She jumped up at once. "What news do you bring, good sir?"

The Brahmin's face was effulgent and his movements serene. "Excellent news, princess. Lord Krishna has arrived in Kundina. His brother Balaram is not far behind him."

Rukmini's heart pounded. She dismissed her maids. After they were all gone, she asked the Brahmin what Krishna had said. When she heard that he intended to take her away she cried with joy. "Gentle Brahmin, your news is wonderful. I cannot possibly repay you."

Rukmini looked around for something to give the Brahmin, but seeing nothing suitable she simply bowed to him. He told her that her pleasure was payment enough and then took his leave.

Bhishmaka, hearing that Krishna and Balaram had arrived in Kundina to see the wedding, ran out to greet them. He made many offerings to them and worshiped them with great attention. "Blessed am I to see you both today," the king said. "Please make yourselves comfortable in my palace. At noon, the wedding will commence."

Many citizens had also come onto the streets to greet Krishna. They prayed that he and Rukmini would be united. None of them liked the idea that she would marry Sishupala.

Just then Rukmini came out of the palace like the full moon rising in the east. Surrounded by her maidservants and Brahmins chanting sacred mantras, she made her way in procession toward the temple of Durga for the traditional worship before the wedding. Many instruments played, drums were beaten and conch shells blown. There were singers, bards and courtesans in the procession, as well as many beautiful girls bearing gifts of garlands, scents, clothing and jewelry meant for the deity. The king's soldiers, weapons at the ready, guarded the whole procession on all sides.

Rukmini entered the temple and bowed to the Goddess on the altar. She prayed quietly. "Ambika, wife of Lord Shiva, mother of the universe, be kind to me. Let Krishna become my husband."

Rukmini then worshipped Durga with all kinds of paraphernalia and offered her choice foodstuffs. When the worship was complete, she came out of the temple, holding her maidservant's hand. As soon as she appeared on the sunlit street, the many kings and princes present were held spellbound by her beauty. They gazed at her graceful form, which was as alluring as the illusory potency of God. Her lovely face was adorned with gold earrings and her eyes with dark mascara. Around her thin waist was a jewel-studded belt that held her silk dress close to her body. Hoping to see Krishna, she glanced about as she walked slowly, her dark hair falling in ringlets around her reddish cheeks and her hips moving from side to side.

Some of the kings almost lost consciousness as they stared at her. They toppled from their horses in a heap on the ground,

124

BEAUTY, POWER & GRACE

their weapons clattering around them. Passion seized their hearts and they hopelessly longed to hold or even touch Rukmini, who desired only Krishna.

With the ends of her finely manicured fingernails, she pushed some strands of hair away from her face and looked out of the corner of her eyes at the kings. Then, all of a sudden, an extraordinarily effulgent prince caught her eye. Although she had never seen him before, she was certain it was Krishna. His blackish complexion, exquisite features and celestial ornaments all brought to mind the stories she had heard about him. She saw him looking at her with an intense gaze, as though recognizing his eternal partner, and felt a ripple of excitement go through her body. There was no doubt: this was Krishna.

As Rukmini walked by Krishna, he set his chariot into motion. Reaching down, he seized her hand and pulled her aboard. He then moved slowly off with the princess by his side, looking around at the other kings as if daring them to challenge him.

King Jarasandha, ever a sworn enemy of Krishna, spoke out furiously. "What is this? How can we allow this to happen? A mere cowherd is stealing our honor, along with this maiden. It is just like a jackal taking away a lion's kill."

The other kings rallied around Jarasandha. "Yes! This cannot be tolerated. Let us take up arms at once and challenge this brazen wretch!"

Krishna's chariot began to pick up speed. Behind him, the kings issued orders to their armies: "Give chase to Krishna. Kill him and bring Rukmini back."

With bows and swords in hand, they rushed after Krishna. But before they could catch him, Balaram and the forces he had brought from Dwaraka intervened and a fierce battle commenced.

In Krishna's chariot, Rukmini trembled fretfully. This was all her fault. What if her brothers or father were hurt? Krishna reassured her, "Do not be afraid, Princess. This fight will soon be over."

The opposing forces shot iron arrows and hurled spears, lances and spiked balls at one another. Shouting out their war cries, they clashed furiously. Thousands of warriors were slain in a very short time; strewn over the battlefield were their hands, still clutching swords or clubs, as well as their heads, decorated with shining earrings. Under Balaram's leadership, the army from Dwaraka quickly overpowered Jarasandha and his allies, who began to flee. They went back to Sishupala, whose face was downcast and shrouded in darkness. His hated enemy Krishna had taken Rukmini. The pain of it was hard to bear.

Jarasandha tried to console him. "Do not be sorry. Happiness and distress come and go with time. There is nothing we can do here. Krishna has been successful today, but our chance to avenge this humiliation will come soon enough."

Rukmi, however, had no intention of letting Krishna escape. He could not stand the thought of his sister marrying a man he detested. Taking a division of soldiers, he skirted around the Dwaraka army and rushed after Krishna. He made a grave vow as he pursued his kidnapped sister. "If I do not recover Rukmini, I will never reenter my city again."

He managed to catch up with Krishna and roared out a challenge, "Evil defiler of your own people! Stand and fight! See now my power."

Rukmi at once shot three long arrows at Krishna that glanced off his armor. His angry voice rang out again.

"Release my sister, vile one! You are like a crow stealing the sacred food from an offering to the gods. Stop now before you are made to lie on the battlefield by my sharp arrows."

Krishna made no reply, recognizing Rukmi's words to be nothing more than boastful posturing. In a matter of seconds, he shot back a number of powerful arrows that killed Rukmi's four horses and his chariot driver. With two more arrows he broke apart Rukmi's bow and cut down his chariot flag. In a frenzy, Rukmi grabbed and hurled every weapon he had in his chariot. Iron bludgeon, three-pointed spear, mace, pike, javelin, darts and daggers—all flew toward Krishna, who cut them down by means of well-aimed arrows.

Rukmi then jumped from his chariot and rushed at Krishna, sword in hand. Like a bird flying into a gale, he flew toward the implacable Krishna. Krishna met him with a volley of arrows that knocked his sword from his hand and broke apart his shield. Krishna then took out his own sword, but as he did so, Rukmini fell at his feet.

"Spare him, please. He is my brother; let him go."

Rukmini shook in fear and her throat choked up in sorrow. Her brother might be a fool, but she loved him nevertheless.

Krishna assured Rukmini that he would not kill her brother. Even so, he seized hold of the hapless prince and tied him up with strips of cloth. He then took a razor-sharp dagger and shaved off half of Rukmi's hair and moustache before setting him free.

By then Balaram had caught up with them. Seeing the miserable-looking Rukmi, he said to Krishna, "My dear brother, the

punishment you have given this prince is worse than death for a noble warrior. You have so shamed him that he will be unable to show his face anywhere."

Balaram saw Rukmini feeling sorry for her brother and he said to her, "Do not lament, gentle lady. No one suffers anything but the result of his or her own acts. In ignorance men are driven to perform various deeds out of pride and attachment. Though such acts inevitably lead to suffering, the true self never suffers. Like a dreaming man, the soul merely imagines his distress. Spiritual realization dissipates all pain by awakening self-knowledge. Fix yourself in this knowledge and do not grieve."

As Rukmi shuffled away, Balaram went on instructing Rukmini. She felt soothed by his words. After all, her brother was still alive and she herself had become Krishna's consort. Her dream had come true. Thinking of this, she became cheerful.

For his part, Rukmi swore to take vengeance on Krishna, but true to his vow not to return home without him, he headed off to find another place to live.

## RUKMINI'S MOOD

In her married life with Krishna, Rukmini displayed the mood of perfect submission. Among Krishna's many wives, some, such as Satyabhama, were argumentative. Satyabhama would often sulk, becoming upset and making various demands that Krishna felt obliged to fulfill. But Rukmini's mood was different. On one occasion, Krishna decided to put it to the test.

Satyabhama had just made him go all the way to the heavenly planets to fetch her a special celestial plant, the Parijata tree, after she had seen the sage Narada offer Rukmini a flower from it. Krishna had never seen Rukmini become angry or jealous with him, and he thought that surely this incident would provoke in her at least a little jealousy. However, Rukmini showed not the least sign of resentment and continued to assiduously and selflessly serve her husband. Wanting to see if anything could ever agitate her, Krishna decided to tease her.

One day, Krishna was relaxing on Rukmini's bed while she gently fanned him. She appeared resplendent in a crimson sari decorated with gold and girdled with a belt studded with priceless gems. Her necklace glittered and her golden bangles jangled pleasingly together. She seemed to be showering nectar as she waved a fan made of peacock feathers to keep Krishna cool.

Admiring her incomparable beauty, Krishna smiled at her and said, "My dear queen, many kings as powerful as gods sought your hand. They had so much wealth, power and influence, as well as physical might and generosity. Why did you reject them in favor of me? Why did you spurn Sishupala, who is surely more qualified than I? He is a king from a noble line, whereas I come from a family of humble cowherds."

Rukmini frowned slightly but continued to fan Krishna, who went on speaking.

"I have made enemies of mighty monarchs and have been forced to build my home here in the sea. Like my devotees, I have no interest in material possessions. What can I offer you? You were meant for better things, fairest one. Ours is an unequal match. Only through folly did you choose me. Now you should rectify your error. I suggest you select a better person to be your husband, a first class man of the royal order who can help you achieve all your desires."

The hand in which Rukmini held the fan dropped to her side. She stared disbelievingly at Krishna. What did he mean? They had been married for years and already had many children. Krishna still spent so much time in her company. Had he become tired of her? It was completely out of character for him to address her in such a way. She had been so sure of his love, but he seemed serious. Plainly, he was suggesting a separation. The mere thought of such a thing made Rukmini's heart tremble. Her mind became confused. It was utterly bewildering.

Not sure what to say or do, Rukmini scratched the floor with her toes. Tears darkened by her eye shadow ran down her cheeks and dripped onto her breasts, which were decorated with red cosmetic powder. Her head dropped and the fan fell from her hand. Suddenly she fainted, falling headlong to the floor like a tree toppled by the wind, her hair and ornaments scattering.

Krishna jumped up to catch his distraught wife. He had not meant to cause her any pain. Obviously, his joking words had been taken too seriously. Manifesting four arms, he gently lifted Rukmini onto the bed and stroked her face, straightening her disheveled hair. As she opened her eyes, Krishna began to console her.

"Most beautiful lady, forgive me. I spoke only in jest. Knowing your devotion for me, I wanted to see what you would say. I also wanted to see the beauty of your face while your lips trembled in loving anger. I wanted to see the reddish corners of your eyes throwing angry glances at me and your exquisite eyebrows knitted in a frown. Householders nearly always enjoy joking with their wives, and I was simply indulging in that pleasure. Do not think otherwise, O timid one."

Rukmini regained her composure and smiled bashfully. She looked lovingly at Krishna and said, "Actually, everything

you said was true. We are certainly not an equal match. What woman could equal you, the lord of all moving and unmoving beings? Even the gods worship you, but only those who are free of all material desire attain you. I wish for no one else as my lord. Those other kings you mentioned are inferior creatures, no better than dogs or jackals. How can they be compared to you? And how could I even think of leaving you? Please bless me that I always remain unswervingly attracted to you."

Krishna took Rukmini's hand. "I have now seen the strength of your love for me. Even though shaken by my cruel words, your mind could not be deviated from me. In all my palaces I could find no other wife as loving as you. I am unable to repay you."

Fully pacified by Krishna's words, Rukmini smiled and resumed her service to him.

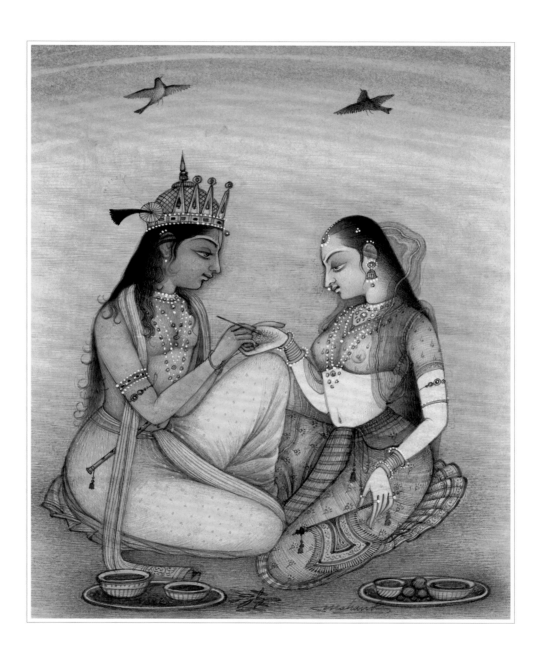

RUKMINI

*vṛndāyai tulasī-devyai*
*priyāyai keśavasya ca*
*viṣṇu-bhakti-prade devi*
*satyavatyai namo namaḥ*

*I bow down repeatedly to you, O goddess of truth, O Tulasi, O Vrinda Devi!*
*You are most dear to Lord Vishnu and bestow devotion to him on all.*

# TULASI

HINDUS, WITH THEIR MANY GODS, GODDESSES, TEMPLE DEITIES, SACRED COWS, STONES, TREES, MOUNTAINS AND RIVERS, TRY TO SEE THE SACRED OR THE DIVINE IN ALL THINGS. CERTAIN NATURAL PHENOMENA AND SPECIES ARE ESPECIALLY SINGLED OUT AS FOCAL POINTS OF DIVINE ENERGY. ONE OF THESE IS TULASI, A PLANT FOUND IN PRACTICALLY EVERY HINDU TEMPLE.

The Tulasi plant is a manifestation of the Goddess. She is considered so holy that everything about her, including her leaves, twigs, flowers, buds and even the soil she grows in, is said to possess great spiritual power. According to scripture, neither Krishna nor Vishnu will accept offerings of food without Tulasi leaves.

The *Padma Purana* states that a person who is cremated with a Tulasi twig immediately attains salvation, even if he or she has committed many sins. The Supreme Lord is personally present wherever the plant is kept and worshiped. All inauspiciousness is destroyed and peace prevails where Tulasi is honored. Simply by walking around the Tulasi plant, one wipes out all karmic reactions and becomes eligible for liberation. By watering her, a person can obtain the fruits of countless other religious acts. One who wears a necklace of Tulasi wood gains religious merit with every step he or she takes, and need have no fear of entering hell after death.

The most sacred place mentioned in the Vedas is Vrindavan, the eternal home of the divine couple, Radha and Krishna. The name Vrindavan means "forest of Vrinda or Tulasi," and countless Tulasi bushes still grow there. Like the sacred rivers, Tulasi also has a personified human form. She takes the appearance of a beautiful maiden in Vrindavan. How this goddess became a plant is narrated in the Puranas.

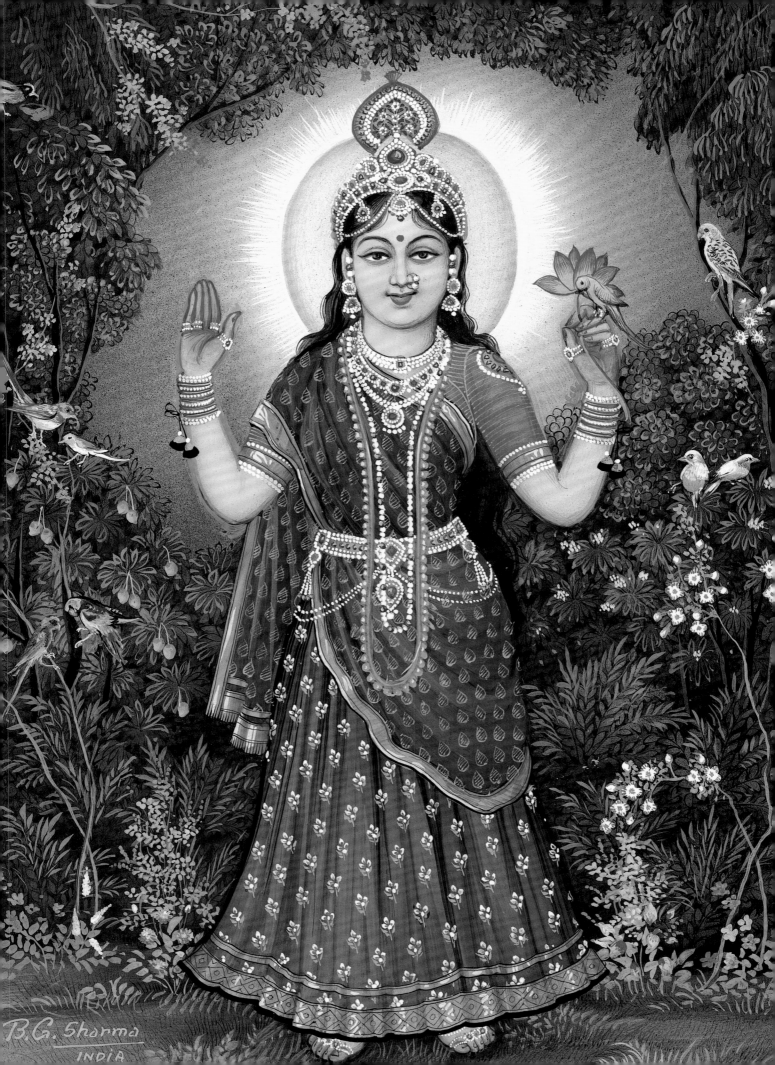

# TULASI'S APPEARANCE AND HOW SHE BECAME A PLANT

 he *Shiva Purana* tells the story of a powerful king named Savarni who lived many ages ago. He was devoted to the worship of Shiva and even issued an edict that no one in his kingdom should worship any other deity. The gods were angered, but did nothing out of fear of offending Shiva. When this had gone on for some time, however, the sun god Surya could contain his anger no longer. He cursed King Savarni: "You and your dynasty shall lose whatever prosperity you possess."

When Shiva heard of this he was infuriated. Taking up his trident, he went after Surya, who immediately fled in fear. Surya went to Brahma, but he too was fearful of Shiva's anger. The two gods thus went to the abode of Vishnu, known as Vaikuntha, and begged for his protection.

"Lord Shiva has become enraged and is pursuing me with his blazing trident," said Surya, looking about anxiously for signs of the great god.

"Do not fear," said Vishnu. "Shiva's acts are all-auspicious. He will do nothing that brings harm to you or any other being."

As Vishnu spoke, Shiva arrived on his great bull carrier, his eyes red with anger and his trident held aloft. But when he saw Vishnu he became calm and climbed down from the bull, lying flat in a gesture of respect. Vishnu welcomed him and had his servants present him with a jeweled seat. They then worshipped him and began fanning him with pure white whisks.

"Tell me why you have graced my abode," said Vishnu.

"My Lord, Surya has angered me by cursing my devotee, King Savarni. But now I see he has taken shelter with you, so what can I do? You are the assurance of even my safety, so how can I punish Surya?"

Vishnu laughed. "In the half hour since you arrived here in Vaikuntha, dear Shiva, tens of thousands of years have elapsed on earth. Savarni has long since died, as have his son and his

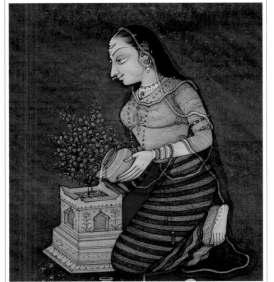

son's sons. Now his descendant Dharmadhvaja rules over the earth, still afflicted by Surya's curse. Soon, though, its effects will end, for he is worshiping the goddess Lakshmi to obtain her favor."

Vishnu asked the gods to return to their own abodes. "Continue with your universal duties. All will be well with Savarni's dynasty."

After the gods had left, Vishnu said to his consort Lakshmi, "Go and take birth on earth."

Not long after this, Dharmadhvaja, who had been ardently praying to Lakshmi for her grace, conceived a child in his wife Madhavi. In due course she gave birth to a girl that resembled a celestial being. Marks of the lotus flower decorated her feet, her face looked like the autumnal moon, her eyes resembled lotus petals and her eyebrows curved like Cupid's bow. The soles of the infant's feet and soft palms were reddish. Her body was delightfully warm in the winter and cool in the summer. The light shining from her body surrounded her like a halo.

"This girl is surely Lakshmi incarnate," said the sages. Because of her unrivaled beauty she was named Tulasi, meaning literally "without comparison."

As the girl grew to maturity she showed intense devotion toward Krishna. She decided that only he could become her husband and so began to practice asceticism with this in mind. For many years she sought his grace by meditating in solitary places and observing many fasts. Finally the god Brahma appeared before her.

"What do you desire, beautiful maiden?" he inquired. "Ask it of me, for I shall give anything that is within my power."

"I have but one desire in my heart. Listen, O lord of the universe, as I recount my tale. As a result of my meditations, I can recall my previous life when I was a cowherd girl in Vrindavan, an associate of the divine and supreme goddess, Radha. I was her constant companion, assisting her in the service of Krishna. One day, during her absence, Krishna made love to me. The joy of our intimacy was so great that I fainted and lay unconscious for some time. When Radha came by and saw me in that state, she guessed what had happened and spoke to me in anger.

"'You hussy! How could you? Are you not ashamed to have seduced my beloved? May you be cursed to take birth among the mortals!'

"With those words, she stormed off, leaving me disconsolate. I would have to abandon Krishna and his spiritual abode. Just then, Krishna came and told me not to lament, for when I was on earth he would marry me in his four-armed form as Narayan. But I desire only Krishna himself. Therefore I sit here, praying for him to accept me back."

Brahma said, "All this is known to me. I also know that another resident of Vrindavan has been cursed by Radha and fallen to earth. His name is Sankhachuda and he was formerly the cowherd named Sudama in Vrindavan. He has long wanted to marry you and in my view would make you a good husband. Go to him for now. Soon he will approach you. In time, the Lord will accept you as his wife."

"As you wish," said Tulasi, and she returned to her home.

## MARRIED TO A DEMON

There was a powerful denizen of the heavenly worlds known as Dambha who, although he had been married for many years, had no children. He went to the mountains and performed austerities, hoping to please Vishnu. Eventually Vishnu appeared before him and asked what he desired.

"Lord of lords, I desire a son who will be more powerful than the gods, and who will be devoted to you."

"It shall be so."

Soon after this, Dambha's wife gave birth to a child they named Sankhachuda. He grew up in luxurious ease in his wealthy father's home, but upon attaining maturity entered the forest to practice asceticism. He could remember his former life as Sudama and his attraction for Tulasi, whom he knew had taken birth somewhere in the world. After many years of ardent austerity and meditation, he saw Lord Brahma, who asked him what he desired.

Although devoted to Vishnu, Sankhachuda belonged to the Danava race, which is normally inimical to the gods. He therefore asked, "Please make me invincible to the gods. Please also grant that I may marry Tulasi."

Brahma consented. He also gave Sankhachuda an amulet that had once belonged to Vishnu. It was known to bestow success in all endeavors. After this, Brahma told him where to find Tulasi and departed.

Sankhachuda left at once to find Tulasi, going there in a jeweled airplane that flew simply by the power of thought. Tulasi saw him approach as she stood by her father's house. He looked exactly like a god, appearing as an astonishingly handsome young man decorated with a garland and golden ornaments. She was immediately love-struck and bowed her head shyly. Sankhachuda was also at once attracted to her. He asked, "Who are you, most lovely maiden?"

Tulasi made no reply. She covered her head modestly with her dress and looked away.

"Please bless my ears with your melodious speech. Simply upon seeing you I am lost in love for you, O gracious one."

Tulasi glanced up at him. "I am King Dharmadhwaja's daughter. But who are you? Why do you address me? A cultured man does not speak in private with a woman other than his own wife."

Sankhachuda smiled. "That is so, goddess, but I am here at the behest of Brahma, the all-knowing god. I was formerly Sudama and I know that you were Vrinda. Long have I cherished a love for you. Please become my wife."

Tulasi bashfully agreed, and after her parents had given their consent they were married. Brahma came to sanctify their union and blessed Sankhachuda that he would be unconquerable for as long as his wife remained chaste and faithful to him. For many thousands of years, the couple lived happily together. The mighty Sankhachuda ruled over the universe with all its gods and demons. The gods repeatedly tried without success to overpower him, but by the power of Vishnu's amulet and Brahma's blessing, he was unassailable. Finally, the frustrated gods retreated to Vishnu's abode to seek his help.

"Dear Lord, an arrogant and invincible Danava has taken over the heavens. We cannot defeat him. Please restore the universal order, if it so pleases you."

Vishnu spoke reassuringly. "This Sankhachuda of whom you speak was cursed by Radha to become a Danava, but the curse is drawing to an end. It is time for him to return to the spiritual world."

Vishnu instructed Shiva to kill the Danava in battle. "First I shall go to him myself disguised as a Brahmin and beg the amulet from him. I shall also arrange for his wife's chastity to be lost. In his weakened condition he will be vulnerable to attack."

The gods left, and Shiva went to the outskirts of Sankhachuda's capital, where he encamped with his associates. He then sent a

messenger named Pushpadanta to speak with the Danava. Making his way through the vast city, Pushpadanta marveled at its opulence. It was built of crystal and gems, with thousands of beautiful buildings inlaid with gold and silver. Sankhachuda's palace was spherical and brilliant white like the moon, with four moats of fire surrounding it and ramparts that seemed to reach the sky. It was inaccessible to enemies, but offered no hindrance to friends.

A guard with a hideous face, copper complexion and tawny eyes showed Pushpadanta in to see Sankhachuda. He was seated upon a great throne, dressed in celestial garments and being fanned by heavenly nymphs.

"Welcome, good sir," he said to the messenger. "I hear you carry a message from Shiva. Tell me what it is."

"Presently, my lord waits outside your city. He has just come from Vishnu and is prepared to challenge you to battle. Or, if you prefer, you may peacefully hand back the gods' kingdoms and property. What is your reply?"

After laughing loudly for some time, Sankhachuda said, "Go back to your master. He shall receive my reply in the morning."

Meanwhile all the gods, along with the goddess Kali, bearing a wide assortment of deadly weapons in her many hands, joined Shiva. Kali was accompanied by a vast horde of ghosts, goblins and other demons. Shiva guided everyone into battle array, waiting for Sankhachuda to emerge from his city.

## VISHNU'S TRICKY BEHAVIOR

As dawn approached the next day, Tulasi spoke with her husband. "My lord, I fear the worst. Stay with me for just a little while. Satisfy my eyes with your presence. Last night I had a dream that filled me with anxiety. I saw you going to Death's abode."

Sankhachuda gently stroked his wife's head. "All of us must reap the results of our own acts, good and bad. In time we receive happiness and distress without fail. Nothing of this world will endure. Providence has brought us together, dear lady, and it will again separate us. This cannot be avoided."

Tulasi began to weep, holding on tightly to her husband's hand. He continued speaking softly. "How can I be your everlasting shelter? I am but a mortal. Therefore seek the shelter of Krishna, the eternal Lord of all creatures. In him

alone will you find peace and unending happiness."

Sankhachuda held Tulasi tightly against his chest while she sobbed. "We are both Krishna's eternal servants. Fix your mind on this truth, beloved lady. Soon we shall return to him and our sorrow will be over."

The Danava king then went to the temple to worship Durga. He gave in charity to the Brahmins and bowed before his spiritual teacher. Dressing himself in armor, he took up his weapons and mounted his war chariot. Followed by millions of demons yelling out their battle cries, he ordered the vast city gates to be drawn back. He rode out and told his charioteer to take him to Shiva. When he reached that all-powerful god, he descended from his chariot and bowed reverentially. He also offered respect to Kali, who stood at Shiva's left side, and to his son Karttikeya who was on his right.

Shiva stood up to greet him. "Welcome, mighty Danava king. I know you to be devoted to Krishna. Indeed, you are Sudama, his eternal friend. How then have you become so interested in material possessions? Why have you snatched away the gods' kingdom? What pleasure can it give one like you, who knows the highest spiritual bliss? Give back what you have taken and avoid this war. There is surely no need for it."

Sankhachuda folded his palms and replied, "Great lord, I am presently a Danava and, as such, am antagonistic to the gods. Who can deny his nature? This is the way of the universe. The gods and Danavas always fight, sometimes one side winning and sometimes the other. So I must ask you why you are getting involved in these affairs, almighty one. Are not the gods and Danavas all the same to you? Why do you favor one side over the other?"

Shiva's peaceful expression did not change. "The gods sought Vishnu's protection and he has asked me to help them. Hence I am here, for I can never disobey Vishnu. Now you must either hand back the heavens to the gods or prepare to fight with me."

Sankhachuda bowed to Shiva and remounted his chariot. Lifting his bow, he said, "We fight!"

The two armies arranged themselves in opposition. Trumpets and horns blared out and thousands of drums were beaten. When the order to charge was given, the armies came together like two oceans colliding. The leading warriors on each side engaged one another in fierce combat. Mystical and supernatural weapons of every description were employed. The battlefield was lit up by blazing missiles as the combatants fought on the

earth and in the sky. Warriors were torn apart and cut to pieces. Others were burnt to ashes or decapitated. Headless bodies ran about still clutching weapons. The air was thick with arrows and the ground muddy with blood. Gradually the Danavas were driven back, as Kali and Karttikeya led the gods' assault.

Sankhachuda then rushed into battle, showering huge boulders, trees, hissing serpents and fiery iron balls on the enemy. A ferocious fight ensued between him and Karttikeya, with first one and then the other gaining the upper hand. But Sankhachuda could not be slain. Kali rushed at him and tried to overpower him with a rain of deadly weapons. Still he remained standing. She then began to invoke Shiva's most powerful weapon, the Pashupata, but a voice spoke from the heavens, stopping her.

"Do not use the Pashupata. This Danava cannot be slain for as long as he wears the amulet and his wife remains chaste. Your weapon will do him no harm, but will rather destroy the world instead."

Kali stopped her invocation and turned her attention to the other demons, killing them in droves. Shiva also fought with Sankhachuda, but even he could not slay him. The fight continued for a full year, with neither side able to overcome the other.

One evening, when the fighting had ceased for the day, an old Brahmin approached Sankhachuda. The Danava could never refuse the request of a Brahmin, and when he saw the sage he inquired, "What may I do for you? Ask for anything."

The Brahmin, who was Vishnu in disguise, said, "Please give me your amulet."

Without hesitation, Sankhachuda removed the amulet and handed it over. He knew his end was near.

Vishnu, still in disguise, then left the battlefield and took on Sankhachuda's appearance. He entered the Danava's palace and saw Tulasi, who greeted him with tears of joy.

"My lord, you are back. How did you defeat the gods, headed as they were by Shiva? Great indeed has been your victory."

Vishnu shared some details of the battle with Tulasi while she helped him settle back in. As evening fell, they retired to their inner chambers and lay down on Sankhachuda's jeweled bed.

The next day the battle began again in earnest. Knowing that Sankhachuda could now be defeated, Shiva rushed at him clutching a terrible trident. This divine weapon was capable of destroying an entire world. It glowed like the sun as Shiva hurled it straight at the Danava. Seeing it fly toward him, and knowing that it could not be thwarted, Sankhachuda sat down upon the battlefield in a yogic posture, meditating on Krishna. The trident reached him

and circled three times before impaling him to death.

A cry of victory went up from the gods. Their deadliest enemy was slain. Shiva then took up Sankhachuda's bones and threw them into the ocean. "These bones shall become the sacred conch shells used in worship everywhere," he declared.

With his spiritual vision, Shiva saw Sankhachuda's soul rising up toward the supreme transcendental abode in his original form as Sudama. There, Radha and Krishna greeted him, and he reentered their eternal pastimes.

## TULASI AND SHALAGRAM

n Sankhachuda's palace, Tulasi began to suspect something. The man lying with her seemed to be someone other than her husband. His embraces and caresses were not the same. She jumped up from the bed. "Who are you?" she asked fearfully. "You are surely not my husband. Whoever you are, you have deceived me in order to take advantage of me. What an outrage! How dare you?"

Vishnu assumed his own form, with four arms and a complexion like the blue lotus. Wearing yellow robes and many divine ornaments, he was so dazzlingly attractive that he caused Tulasi to faint. But when she regained consciousness, she still felt anger at having been tricked.

"O Lord, why did you use deception to violate my chastity? You have thereby killed my husband. You have shown the heartlessness of a stone; I therefore curse you to become one."

She fainted again and Vishnu raised her onto the bed where he tried to console her. "Exalted one, do you not recall how you prayed for me to become your husband? I have fulfilled your wish. Indeed, you are my eternal companion in the spiritual world. Now you should return there. Give up this body. It shall become a holy river named Gandaki and your hair shall become a holy tree. This tree will be worshipped throughout the three worlds and will be most dear to me."

Vishnu also said that he would accept her curse to become a stone. "I shall remain close to the Gandaki River. The stones from that river will be known as Shalagram, and righteous people will worship them. Indeed that worship will always be done with Tulasi leaves. So, never again shall we be parted, either in this world or my spiritual abode."

Restored again to her original spiritual consciousness, Tulasi cast off her anger and abandoned her body, going with Vishnu to his eternal domain.

*cid-ānanda-bhānoḥ sadā nanda-sūnoḥ*
*para-prema-pātrī drava-brahma-gātrī*
*aghānāṁ lavitrī jagat-kṣema-dātrī*
*pavitrī-kriyān no vapur mitra-putrī*

*O Yamuna, O daughter of the sun! You are the object of Krishna's love,*
*the sunshine of eternal consciousness and bliss! Your body is the flowing*
*liquid form of Brahman. You wash away all the world's sins*
*and bring it auspiciousness. Please purify us.*

# YAMUNA

THE GODDESS YAMUNA IS THE EMBODIMENT OF INDIA'S SACRED RIVER, WHICH HAS ITS SOURCE HIGH IN THE GARHWAL HIMALAYAS, SOME 10,000 FEET ABOVE SEA LEVEL. HERE THE CLEAR WATERS OF THE RIVER RISE BEFORE DESCENDING THE MOUNTAIN THROUGH AN ENCHANTING LANDSCAPE, AMIDST GRASSY ALP AND JUNIPER BUSH. IN THESE UPPER REACHES, NUMEROUS HANGING VALLEYS, CARVED BY GLACIERS DURING THE LAST ICE AGES, OVERLOOK THE MAIN RIVER VALLEY. DEEP ROCK BENCHES, INTERLOCKING SPURS AND NARROW GORGES FORM A DRAMATIC BACKDROP AS THE RIVER FLOWS ON, CUTTING ACROSS THE MUSSOURIE RIDGE, THEN FINALLY DOWN ONTO THE PLAINS AND INTO THE BEWITCHING TONS VALLEY.

In such majestic sceneries it is easy to believe in the sanctity of this great river, but as she enters Delhi it is, sadly, less apparent. The liquid body of the goddess Yamuna, usually depicted as a voluptuous woman riding a fish, is today the receptacle for all kinds of pollutants. Nevertheless, she retains her spiritual potency and her appeal. According to the ancient *Rig Veda*, the goddess is the daughter of Surya, the sun god, and the twin sister of Yama, the lord of death. Therefore, it is said that one who bathes in her waters shouldn't fear death, as they will surely attain liberation. Knowing this, countless pilgrims can be seen bathing in her waters throughout the year.

The Yamuna flows eastward from Delhi to join the Ganges at Prayag or Allahabad. The waters of both rivers are proclaimed by the Vedas to be the same, but the spiritual benefit of bathing in the Yamuna is purported to be one hundred times greater than the Ganges. Her spiritual power is increased by a connection to Lord Shiva. The Vedas recount how Shiva, while lamenting the

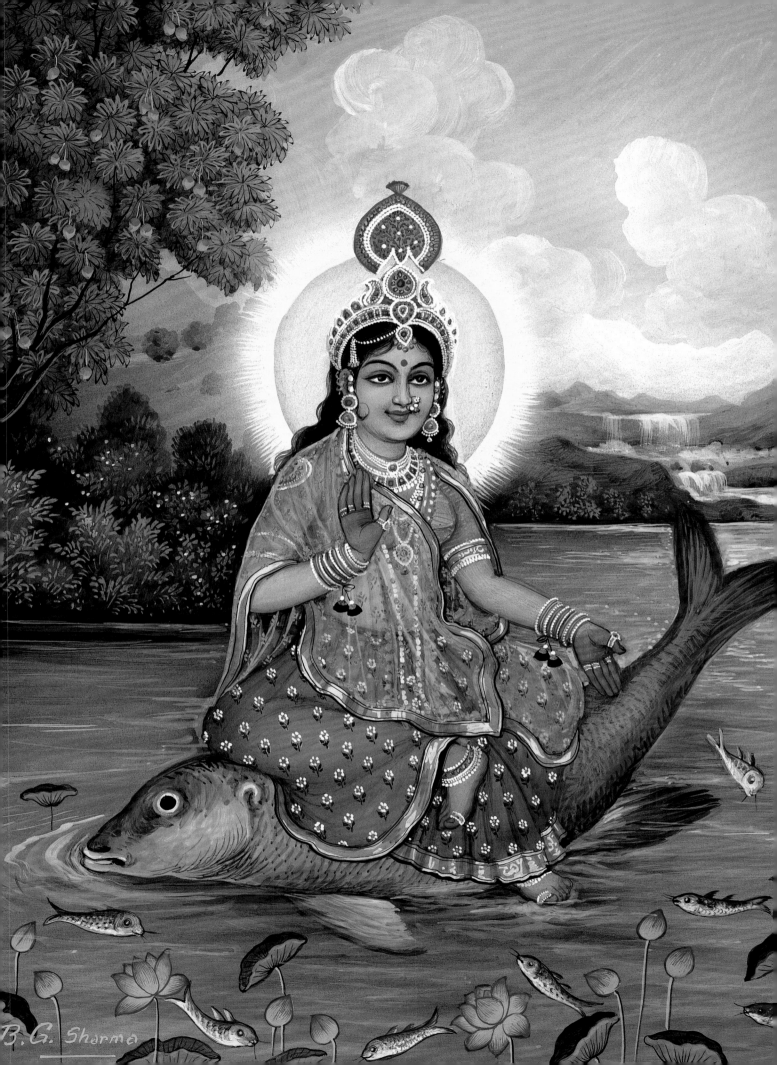

B.G. Sharma

death of his consort Sati, wandered about trying to find relief for his burning grief. When he saw the Yamuna River, he plunged in and turned her waters a bluish black, as they often appear today. It is also said that she exhibits this color out of the ecstasy of having Krishna—who is of the same dark hue—bathe in her.

Yamuna is known for her close connection to Krishna. According to the Puranas, when baby Krishna was being carried across her waters (see Subhadra), he fell from his father's arms into the river, thereby sanctifying it. Additionally, the Yamuna flows through Vrindavan and plays an important part in many of Krishna's pastimes. She even appears in a human form as one of his wives, Kalindi, which has become another name for the river.

The story of how Yamuna became Krishna's wife is narrated in the *Bhagavata Purana*. There it is described how one day when Krishna and Arjuna were out hunting together they came to the Yamuna to refresh themselves in her waters. They saw a beautiful young girl strolling on the riverbank who introduced herself as Kalindi, the goddess of the river. She said that she wanted Krishna to accept her as his wife. Her father, the sun god, had constructed a home for her within the river where she had been waiting for many years for Krishna to arrive. Krishna at once agreed to accept her hand, and they were married on the spot by an exchange of garlands.

## YAMUNA SAVED BY KRISHNA

 he *Bhagavata Purana* also describes how Krishna saved Yamuna from the poison of a powerful demon. This story has taken on symbolic meaning for modern environmentalists trying to halt the pollution of India's rivers.

It all began with a sage named Saubhari, who had submerged himself in the waters of the Yamuna to engage in undisturbed meditation. Having suspended his breathing, he sat on the riverbed with his mind fixed upon the Supreme. One day, Vishnu's mighty eagle carrier, Garuda, came to the Yamuna in search of a meal. Diving into the water to catch fish, he created a great disturbance, annoying Saubhari. The yogi uttered the following curse: "If Garuda comes here to fish again, he will immediately fall dead. This is certain."

Garuda heard of this curse and, although able to counteract its effect, he decided to stay away from the river out of respect for the sage. Instead he took to catching large serpents for food from the celestial planet Nagalaya, where the race of snakes known as the Nagas dwelt. Being a natural enemy of serpents, Garuda would catch some and kill others at will. He was causing great destruction among the Nagas, so they decided to strike a deal with him.

"Mighty eagle, if you refrain from killing us we shall place before you a fine food offering each time you come here."

Garuda agreed and every month he would come to Nagalaya and receive the offerings. All the Nagas would make a contribution, but one of them, named Kaliya, began to object.

"This has gone on for long enough. Why should we keep feeding this evil bird? I am powerful and will challenge him to a fight."

The other serpents suggested that this was a foolish proposition, but Kaliya would not listen. The next time offerings were made he ate them all himself and sat in wait for Garuda. When Garuda arrived and saw what Kaliya had done, he was furious.

"Arrogant snake! Death shall be yours today."

Kaliya raised his many hoods to attack Garuda, spitting poison like fire. Garuda responded by tearing at him with his talons. Kaliya tried biting Garuda with his terrible fangs, but the eagle was too fast. He struck Kaliya terrific blows with his wings, and the Naga retreated. Stunned and defeated, he rushed toward the Yamuna to find safety, knowing of Saubhari's curse. He entered deep into its waters and found a large lake in one of its curves where Garuda could not reach him, and there he made his abode.

As time passed, Kaliya's poison completely polluted the river lake. The water was continually heated and it boiled from the fiery venom. It gave off toxic vapors that caused birds flying overhead to fall down dead. Droplets of poisoned water carried on the wind, destroying all the surrounding vegetation and killing many animals. The lake was eight miles wide and as deep as the ocean. Many other serpents took up residence in holes around its banks and a thick noxious fog constantly hovered over it. Within theses stagnant waters, Kaliya used his mystical powers to build a virtual city.

One day Krishna and his young friends were playing along the banks of the Yamuna close to the poisoned lake. Having become thirsty they drank the river water and as a result fell to the ground apparently dead. Krishna at once glanced over them and brought them back to life by his divine potency. He then decided to take action against Kaliya.

Krishna tightened his waistcloth and tied back his hair. He climbed to the top of a tall tree that was overhanging the lake. Then, as all his friends looked on, he dived straight into its waters. The waters heaved and overflowed on all sides as if some huge weight had been thrown in. All the snakes in the lake became agitated and breathed heavily, exuding even more poison. Krishna splashed around, swimming back and forth, creating a great disturbance. Kaliya could understand that someone was in his lake. Unable to tolerate it, he rose swiftly to the surface and looked around.

The furious Naga saw Krishna smiling and playing in the water, his attractive body glowing like a white cloud. Despite his beauty, Kaliya at once bit him on the chest with terrific force. He then wrapped him in his coils and held him fast.

On the shore the boys were horrified. "Help! Help! Somebody help Krishna! The snake has him in its grasp."

Krishna was dearer to them than life, and they could not even draw breath as they saw him caught in Kaliya's clutches. They fell senseless to the ground. The earth trembled, meteors fell and people quivered. Seeing this, the inhabitants of Krishna's village, Vrindavan, ran out in great haste.

"Something is happening to Krishna and his friends," they cried. Racing into the forest they searched out the boys' footprints and followed them to the river. There they saw Kaliya thrashing about in the lake with Krishna still held in his coils. Everyone was distraught. Lost in pure love for Krishna, they forgot everything about his supreme power and divinity.

"Do something quickly!" they shouted. "We must help Krishna."

Krishna's gopi girlfriends stood like statues, their gazes fixed upon their beloved. His mother and father had to be forcibly restrained from jumping into the deadly waters. They shed torrents of tears and wailed loudly.

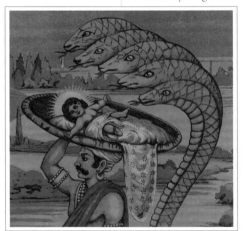

Krishna remained within Kaliya's coils for some time. It seemed like forever to his loved ones. Then at last he began to expand his chest and force apart the serpent's coils. Slipping out from his grip, Krishna moved around him with great agility. Kaliya raised his dozens of hoods and glared at Krishna, his eyes full of fire. He licked his lips with his bifurcated tongue and looked for an opportunity to strike.

Krishna swam so swiftly around Kaliya that the snake became fatigued and his hoods began to droop. Then, to the extreme delight of everyone watching from the shore, Krishna jumped upon the serpent's heads and began to dance. The gods and celestial sages watched from the heavens as he pounded the snake with his flashy footwork. They played musical instruments and showered him with flower petals.

Trampled into submission by Krishna, Kaliya finally gave up the fight. He began to pray to Krishna. "My birth as a snake has made me envious, ignorant and angry. It is difficult to deny one's nature in this world, which is born of illusion. My Lord, please help me to become free of this illusion, if you so desire."

Pleased by Kaliya's surrender, Krishna let him go. He told him that he should return home. "You need have no more fear of Garuda. When he sees the marks of my feet on your body he will not touch you."

Krishna then said, "Anyone who bathes here in the Yamuna and remembers this pastime will become free of suffering and the fear of snakes."

Kaliya then left the lake and the river was restored back to its former purity.

## Yamuna Destroys All Karma

The *Varaha Purana* tells a story that illustrates the spiritual benefits of bathing in the Yamuna. Long ago, a Brahmin couple in the Panchala region had six children: five sons and one daughter. While the daughter was still only a baby, the eldest of the five sons, Devadatta, left home and went traveling in search of wealth. Time passed but he did not return.

The daughter, Tilottama, grew into a beautiful young woman and got married. Her husband died soon after, however, and she was left a young widow. In grief she took the cremated remains of her husband to Mathura, where the Yamuna flows, having heard that anyone whose ashes were deposited in that river would attain salvation. She then decided to remain in that holy town for some time, engaging in penance and religious practices.

Tilottama had a fair complexion and an abundance of dark, curly hair. Her body was shapely, with tapering thighs, a thin waist and full breasts. With a graceful neck, sparkling teeth, red lips and eyes like lotus petals, her beauty rivaled even the celestial nymphs known as *apsaras*. Any man that saw her would be astounded and stand perfectly still, like a painted picture, transfixed by her form.

Tilottama spent her days bathing in the Yamuna and meditating on its banks. One day a group of courtesans who were employed by an inn in the town saw her and tried to induce her to join them. They said, "Do not waste your youth and beauty in this way. Enjoy life while you can. You can perform penances later, when your youth is gone."

Tilottama was gradually swayed by their coaxing and began to spend time at the inn. She learned the arts of the courtesan, becoming expert in music and dance. Before long she was surrounded by all manner of men and began to enjoy with anyone who offered her sufficient wealth.

When Tilottama had fully committed herself to this way of life, her brother Devadatta arrived in Mathura. In the course of his travels he had become a wealthy man, and a large retinue of followers accompanied him. During the day, he and his men set up their camp near the Yamuna, and in the evening they went to the inn for refreshment. There Devadatta saw Tilottama and was immediately struck by the arrows of desire.

Devadatta spoke with the matron of the inn, "Please arrange for me to enjoy the company of this woman. I will bestow gold, jewels and expensive clothes on you both in profusion."

The matron set up their liaison and the brother and sister, not knowing each other's identity, passed the night in sensual pleasures. Days passed in this way, and the attachment of the two lovers increased. Devadatta gave Tilottama jeweled chains, bangles, perfumes and all manner of other gifts. Devadatta would spend the nights with her, return each morning to his tent, bathe in the Yamuna and then go about his daily business.

A sage named Sumantu who lived by the river observed Devadatta following this routine. One day, after it had been going on for some time, the sage spoke to him.

"Good sir, tell me who you are. Where are you from? What do you do throughout the day and the night?"

"My name is Devadatta. I am from Panchala. I have come here on business and I spend my nights in the town. During the day I visit the temple of Shiva and I also worship this sacred river."

Sumantu said, "I have been watching you come to this river and bathe every day, and I have observed something quite extraordinary. With my spiritual vision, I am able to see your subtle body. In the morning when you arrive, it is covered by the dark aura of sin, which normally would produce great suffering in the course of time. But when you come out of the Yamuna after bathing, your subtle body shines like that of a celestial being."

The sage asked him to consider if he was committing some immoral act. "Perhaps you are unwittingly doing something wrong. Try to think what it might be. It appears to be very grievous."

Devadatta was surprised. Sleeping with a courtesan was not good, but it was hardly a heinous sin. What did the sage mean? He was uncertain. "I cannot think what it might be," he answered him.

When he was with Tilottama that night, Devadatta began to make inquiries. "Tell me a little bit about your life, O beautiful one. Whose daughter are you?"

Tilottama smiled but made no reply. Devadatta pressed her to answer, but she kept silent, too ashamed to tell him that she was a Brahmin's daughter.

A few days passed and Devadatta kept asking. Finally, he threatened to give up his life if she did not give him a reply. Tilottama relented and said, "I was the youngest daughter of a Brahmin in Panchala. At a young age I became a widow and traveled here. Since then I have turned to prostitution. Alas, I have brought disgrace on my family by my sin. "

As the tearful Tilottama gave him more details about her family, the truth gradually began to dawn on Devadatta. She was his sister. Overcome by shame, he lost consciousness and fell to the ground. Tilottama wiped his face with cool water and revived him. She then asked him why he was so distressed.

"I am your older brother. Without knowing it, we have been committing incest again and again. Oh, what should I do now? How can I be released from this sin? I am fit only for hell."

Now it was Tilottama's turn to faint from the shock of what she had heard. When she came back to consciousness, she exclaimed, "How wretched am I! Who could be a worse sinner than I? I have slept with my own brother."

After consulting with various priests, Devadatta concluded that there was only one way to expiate his sin. "I shall enter blazing fire and give up this body," he said.

Tilottama decided to follow him into the flames. She gave away all her jewels, clothes and ornaments, and her brother donated his wealth to the Brahmins. They then prepared a pyre on the bank of the Yamuna, and after bathing in the river, set light to the wood. As they were about to enter the fire, however, the sage Sumantu ran up to them.

"Stop! There is no need for this."

Devadatta bowed at his feet. "Great sage, your vision was unfailing. The sin you perceived has come to light: it is incest. Ever since I arrived in this holy city of Mathura, I have been lying with my own sister. Now I must purify myself by entering fire."

Just then a voice thundered from the heavens: "Desist! Do not go into the fire. You are both free of all sin. This is the place where Krishna played and it has no equal on earth. Sins committed elsewhere are destroyed simply by visiting this holy land of Mathura. Sins committed here stick to one like

powerful glue, but bathing in this sacred river destroys even those. All karmic reactions are dissolved in the Yamuna, leaving one eligible for the highest liberation."

Astonished, both Devadatta and his sister gave up their plan to kill themselves and settled permanently in Mathura, living lives of peaceful devotion.

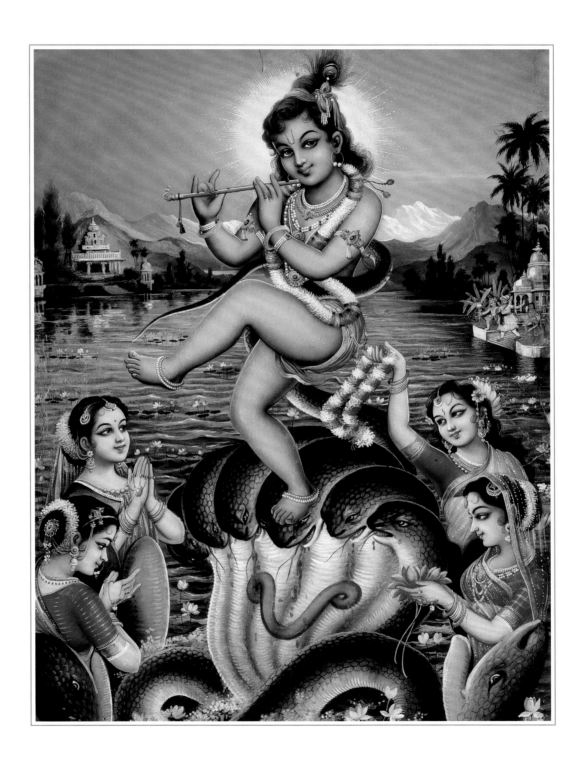

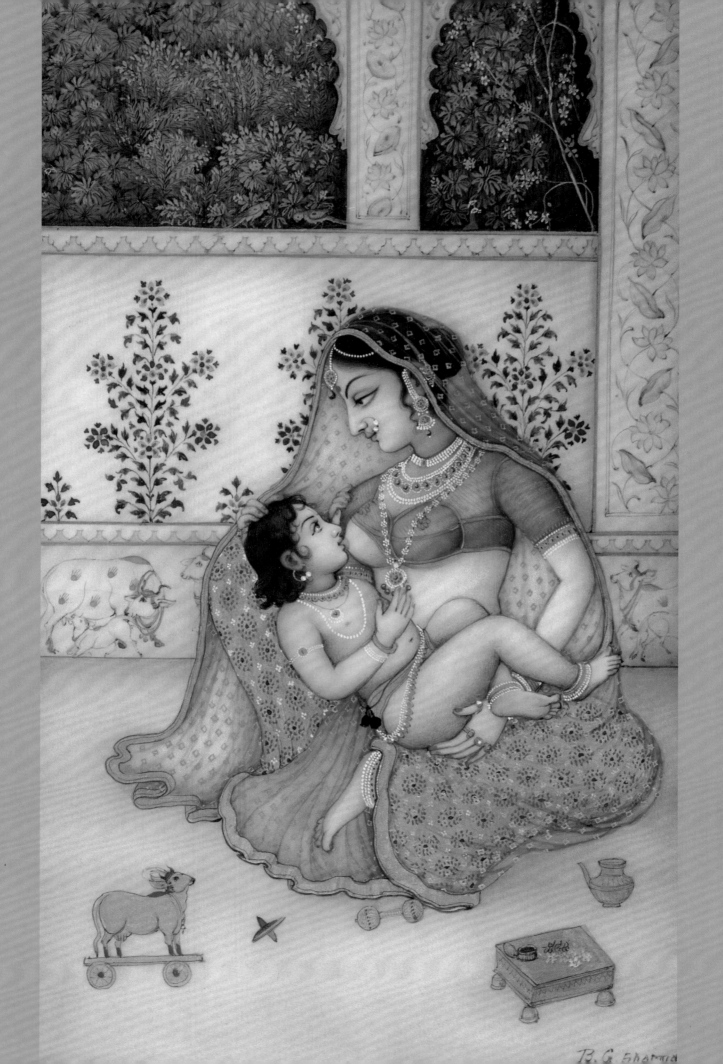

*aṅkaga-paṅkaja-nābhāṁ*
*nava-ghanābhāṁ vicitra-ruci-sicayām*
*viracita-jagat-pramodāṁ*
*muhur yaśodāṁ namasyāmi*

*I constantly bow down to Yashoda, the embodiment of motherly love, on
whose lap lies the lotus-navelled Krishna. Dark like a cloud and effulgent
like lightning, she brings joy to the entire universe.*

# YASHODA

VAISHNAVAS, THE MOST THEISTIC OF ALL INDIAN MYSTICS, HAVE AN INTERESTING PERSPEC-
TIVE ON THE IDEAL OF DIVINE SERVICE. THEY TEACH THAT GOD WILLINGLY ACCEPTS A SUB-
ORDINATE POSITION TO THOSE WHO LOVE HIM SELFLESSLY.

We find in our mothers the epitome of selfless love. A mother protects and nurtures her helpless child with all of her being. This love is one of the great archetypal relationships, expressed ichnographically in Christianity as the Madonna and Child, and throughout the world in other variants of the "Mother of God" theme. In Hinduism, this motif is found especially in the image of the baby Krishna, or Gopal, lying in the lap of his mother, Yashoda. Here, it is not God or Goddess who is seen as the nurturing mother, but God who agrees to play the helpless child. He is utterly dependent on the love of the devotee who takes on the motherly role.

Recall that Krishna was born in Kamsa's prison house as the princely son of Vasudeva and Devaki, and then taken by his father to Vrindavan and exchanged for the daughter of the cowherd queen, Yashoda. Krishna grew up in the pastoral village, where Yashoda nursed him as her beloved baby, chastized him when he was naughty and lamented his departure when he returned to his royal life in Mathura as a teenager.

Thus, though Yashoda was Krishna's foster mother, she nonetheless had an ever stronger bond with him than Devaki because she took care of him throughout his childhood. During the 14 or 15 years Krishna remained in Vrindavan, he performed many extraordinary acts, most of which are described in the *Bhagavata Purana*. Although Yashoda often saw the incredible powers and abilities of her divine child, she could not see him as God. Lost in pure motherly love, she only saw him as her son, ever in need of her protection. And Krishna reciprocated by perfectly playing the role of a loving child.

Yashoda embodies the highest devotional ideals and is revered as an exalted divine personality. She is praised in numerous songs and prayers within the Vaishnava tradition. One of Krishna's most prominent names is Yashoda Nandan, "the beloved son of Yashoda."

Here then are some of the cherished stories about Krishna and Yashoda during their time on earth.

# THE WHIRLWIND DEMON

 oon after King Kamsa heard that Krishna had taken birth on earth as the eighth child of Vasudeva and Devaki, he consulted with his demonic ministers. Tormented by the prediction that this child would cause his death, but not knowing where he could be found, he gave orders for his soldiers to go everywhere in the kingdom and indiscriminately kill all recently born children. He further dispatched a number of powerful witches and black wizards on the same heinous mission. These demons went off in all directions and some of them found their way to Vrindavan. Trinavarta, who possessed the power to change his bodily form at will, soon arrived on the scene.

On that day, Yashoda had been coddling and nursing baby Krishna when she suddenly found him to be unbearably heavy. Troubled by this unnatural change and fearing malicious forces, she momentarily rested him on a cloth covering the ground and went looking for ingredients to use in a protective ritual.

At that vulnerable moment, Trinavarta spotted Krishna. Assuming the form of a whirlwind, he swept the baby high into the sky, intending to let him plunge to his death. At the same time, he whipped up violent winds on the ground, making a great roaring sound and filling the air with dust and pebbles.

Yashoda immediately became fearful for Krishna's safety and ran to the spot where she had left him. She was shocked to find him missing. She tried looking for him, but the wind, dust and clouds so blackened the sky that she could barely see herself, much less anyone else.

She cried out, "Help! Someone help me. I cannot find Krishna."

Everyone in the household came to help look for the lost child,

but the storm was throwing stones and branches and the rain was lashing in every direction, making it impossible for anyone to even step outside. Helpless, Yashoda sat down on the ground, lamenting pitifully and praying, "O God, please protect my Krishna."

Up in the sky, however, as Trinavarta rose above the clouds, he suddenly got the impression that Krishna, who at first had seemed as light as a feather, was growing increasingly heavy. He began to feel like he was carrying an emerald mountain and not a baby. Distracted, the demon lost control of the spell that gave him his whirlwind form. Stunned and disoriented, the demon suddenly reverted to his normal hideous shape. He thrashed about in the sky, trying to free himself from Krishna's clutches, but the baby clung firmly onto his neck as if enjoying the piggy-back ride through the heavens. Soon Krishna became so oppressively hefty that the demon began to plummet.

The increasing force of Krishna's stranglehold caused Trinavarta's eyes to pop out. Unable to move his arms or legs or make any sound, he crashed lifeless to the ground within sight of Yashoda. Shaking, she and the villagers surrounded the cadaver, asking, "What is this? Where did it fall from?"

At first Yashoda was afraid on seeing the body of the gruesome demon, but a different kind of anxiety overcame her as soon as she saw the lost child playing carefree on its chest. One of the cowherd women picked the baby up and handed him to his mother, saying, "Death is dead. The one death took away is still alive. Now take your life and live."

These words acted like a magic spell, snapping her out of anxiety. Yashoda, with the child back in her arms, could breathe again. "Krishna! Thank God you are unharmed," she shouted. Tears of relief and joy washed over her as she anxiously examined every square inch of his body for the slightest sign of injury.

All were struck with disbelief at Krishna's miraculous escape. "How has this most powerful flesh-eater perished, while our tiny child has escaped?" they wondered. The village elders finally concluded, "Perhaps it is true that the evil are killed by their own sins, while the pious are delivered from danger by their own virtue."

After this, Yashoda and the other cowherd ladies cleaned little Gopal, washing off the blood of the demon and mud that had spattered his body. Then they performed rituals for his protection to ward off any further danger.

to Nanda and Yashoda, for the Supreme Brahman is crawling about in their backyard, having taken the form of a baby boy."

In this way Mother Yashoda enjoyed many tender pastimes with Krishna until at the age of fifteen he left Vrindavan. While he was away, she never stopped feeling intense separation from him. Due to her ecstatic love, it seemed to her that she saw Krishna wherever she looked. She cried incessantly and could not be consoled. When some years later Krishna's friend Uddhava went to Vrindavan on his behalf to pacify his parents and the gopis, he saw that Yashoda had gone blind from her tears. But he also saw that in her unbroken meditation on Krishna, she was never separated from him and was, in fact, exhibiting the symptoms of the highest divine bliss.

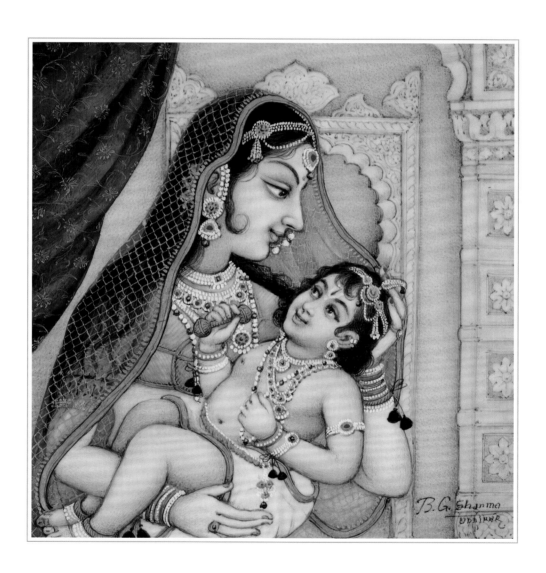

*vande nanda-vraja-strīṇāṁ*

*pāda-reṇum abhīkṣnaśaḥ*

*yāsāṁ hari-kathodgītaṁ*

*punāti bhuvana-trayam*

*I bow to the cowherd girls of Vrindavan, taking the dust of their feet
again and again. They purify the three spheres of the
universe with their singing of Krishna's glories.*

# THE GOPIS

THROUGHOUT HISTORY, PHILOSOPHERS AND POETS HAVE OFTEN COMMENTED ON THE POWER OF LOVE. SOME, LIKE THE ROMAN POET VIRGIL, HAVE BOLDLY PROCLAIMED IT TO BE THE GREATEST POWER OF ALL. IN HIS WORDS, "LOVE CONQUERS ALL THINGS." AND, OF COURSE, WHO HAS NOT HEARD IT SAID THAT GOD IS LOVE?

A story is told about a famous 19th century English statesman, William Gladstone, during the time he was Prime Minister of Britain. One day, one of his ministers came to see him about a pressing matter of some urgency, but rather than being immediately ushered into the Prime Minister's office, he was asked to wait outside. The minister settled into a chair and began to read the newspaper. After some time had passed and he was still waiting, he became curious about what was keeping Mr. Gladstone. He walked over to the office door and peered through the keyhole. There he saw the great man on all fours on the floor, carrying his young granddaughter on his back and pretending he was a horse. The minister shook his head in wonder. Even critical state business took second place to Gladstone's loving exchanges with his granddaughter!

Though some envision God as a formless entity that stands beyond the creation and needs nothing from it, others see him as a personal being, realizing his fullness in the expression and exchange of love. Since most human societies are patriarchal, God is most frequently conceived of in masculine terms. As we saw in previous chapters, however, even in the patriarchal world of Hinduism, an entire religious school arose in recognition of the divine female power, Shakti. Yet even within the sphere of Vishnu worship, where the supreme deity is seen as male, a transformation took place whereby the female aspects of the divine were given ever-increasing status until it was recognized that the Goddess ultimately conquers God.

This Vaishnava tradition tells us that though God is the most powerful person and no force can overpower him, he still becomes subservient to one who loves him unconditionally.

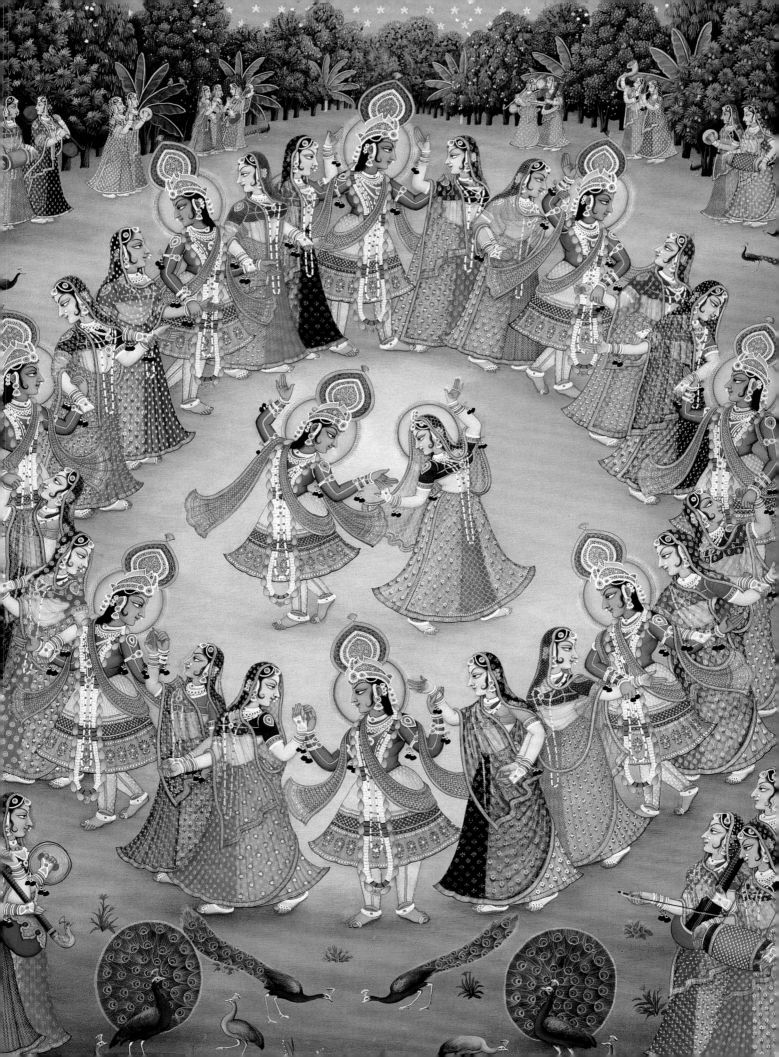

Though the Goddess too is endowed with infinite powers, it is in this way that she is truly more powerful than God, for she has the greatest love.

The story of the Goddess's ascendancy begins with the cowherd girls of Vrindavan, or gopis, whose absorption in the conjugal loving mood toward Krishna is so complete that it approaches madness. These young maidens display a pure quality of love that has Krishna completely spellbound. "Though I try," he tells them, "I am unable to repay your love. Therefore, your love for me must be its own reward."

The gopis' love for Krishna accepts no limits, internal or external. He is not their husband in a legal sense, but their paramour. As in the Hebrew *Song of Solomon*, their love for him is a metaphor for the love of every individual soul to God, the supreme attractive force. For the mystic, the love of God is the ultimate value in life, which overrides every other duty or responsibility. Though God is the one true husband of the soul, this world acts as a jealous husband, insisting that our duties lie with it and not with the Divine. The greatest Hindu text, the Bhagavad Gita, concludes with Krishna's immortal words, "Abandon all other duties and surrender to me alone." The gopis are the living exemplars of such surrender. Compelled by their love, they are prepared to break all social convention and moral edicts to be with him.

The definition of love as given by the Vaishnava saints is that it is free of exploitation: it does not seek any "trade-offs." One loves his or her beloved simply because of their lovable qualities. This love manifests as a desire to please the beloved rather than oneself. Erotic love in this world is mostly about satisfying our own senses, but when we use the term in relation to God it means satisfying his senses only. Those who love God in this way experience an intense spiritual ecstasy. It is an exchange that takes place on the plane of transcendence and has nothing to do with bodily pleasure whatsoever.

Though the love of the gopis for Krishna is not an ordinary love affair, we can nevertheless get some insight from the comparison. Of all the varieties of love in this world, that between a man and woman is the richest and most intense. Such love has many aspects—joking, teasing, anger, tears and tenderness, as well as physical love. Indeed, it includes aspects of all the other kinds of love—friendship, servitude, and even the protectiveness of parental affection. Similarly, the highest mood of divine conjugal love manifests in countless ways, and these are expressed by countless gopis.

There is always the danger that we may misinterpret these stories and see them through the mental filter of our own material consciousness. Even so, the descriptions of the gopis' activities with Krishna are an ocean of bliss that is ever increasing. If we have the right understanding, we too can plunge into that ocean and taste the sublime sentiments of their love. Here then are a few drops from that ocean.

## STEALING THE GOPIS' CLOTHES

 he young girls of Vrindavan village, the gopis, could never remember a time when they had not loved Krishna, so when they reached puberty, the stirrings of romantic love for him entered their hearts. They had heard Krishna's divine flute playing and seen his superlative beauty, and they had observed his extraordinary personal characteristics and heroic deeds. As a result, the gopis wanted nothing more than to have him alone as their life partner. Deciding to follow the tradition of worshiping Goddess Durga in order to obtain a good husband, they went to the banks of the river Yamuna.

They fashioned a clay deity of the goddess to worship and offered it lamps, fruits, garlands and other items. They prayed, "Dear Goddess, possessor of great mystic power! Mighty controller of all! Please make Krishna our husband."

For an entire month they performed this daily ritual. They arose each day before sunrise and assembled in the village. Then they would leave for the Yamuna, loudly singing songs about Krishna all the way. The gopis would bathe in the river and then worship Durga with great attention. They also observed a vow of eating only very simple, unspiced food.

On the last day of their month-long vow, they entered the river for a final bath. They left their clothes on the bank and dipped into the water completely undressed, as was the custom. Just at that time, Krishna happened by with some young boys from the village and saw the gopis' garments on the riverbank. Giving his friends a wink, he quickly gathered up the clothes and climbed to the top of a tree. Then he called out merrily to the bathing girls.

"My dear girls, I have found your clothes. You may come and get them from me, but you must come one at a time. I won't make things difficult for you because I know you have been strictly following your vow of worshiping Durga and are tired. Just come here and I will give them to you."

The gopis looked at one another, their faces breaking into smiles. They began giggling and joking among themselves, covering their embarrassment at being naked in Krishna's presence. He called down to them again.

"Please do not think I am joking with you. I will give back your clothes. I never tell lies, and these friends of mine know it well. Therefore, O slender-waisted maidens, come forward and take

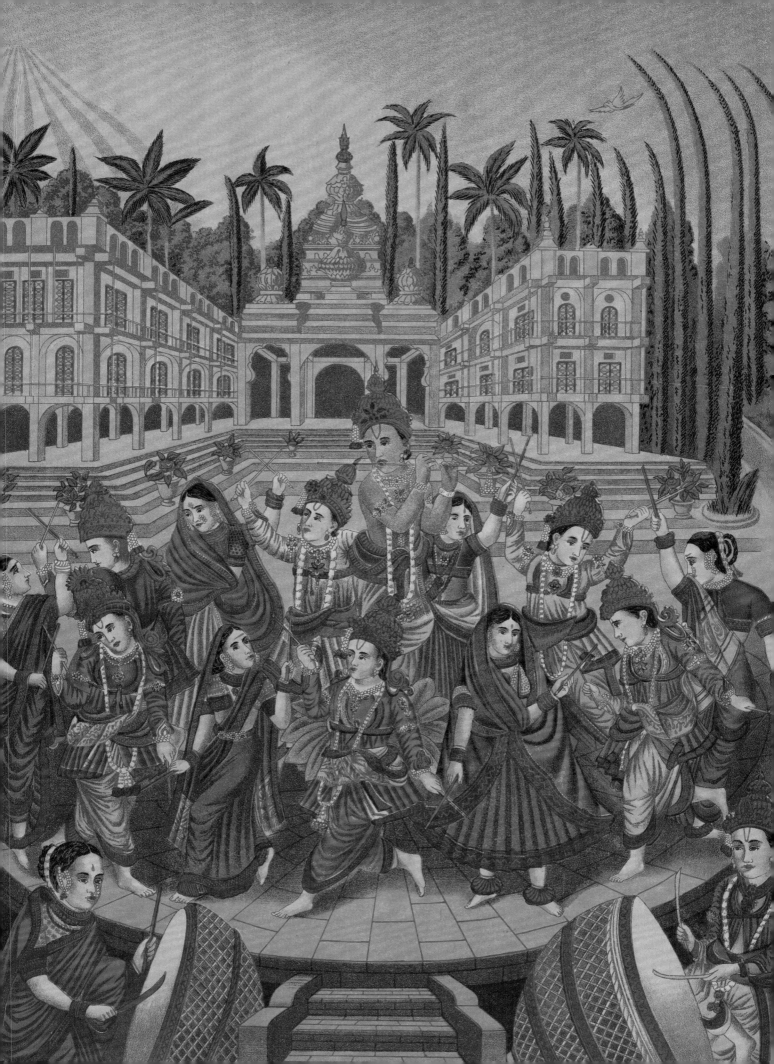

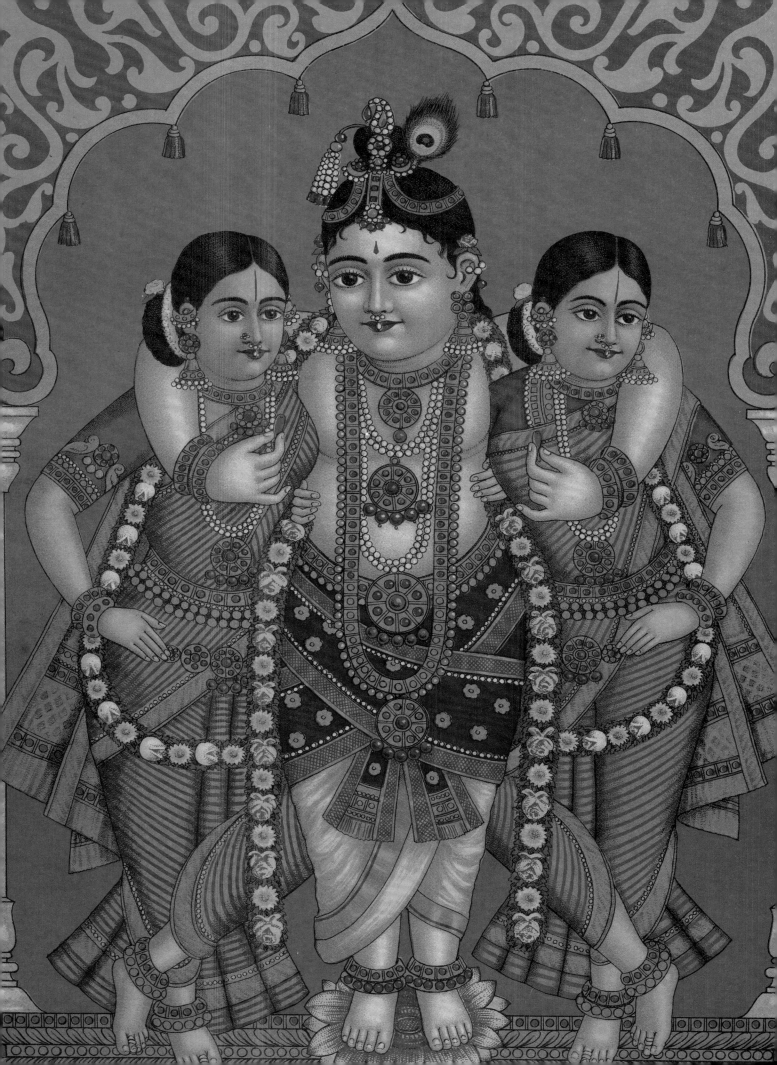

them from me. You may either come all together, or one by one, whatever you prefer."

Immersed in love, the gopis went along with Krishna's playful mood. They wanted to enjoy the jokes. Krishna was dealing with them as if they were already his wives, which was exactly what they had hoped to achieve. Keeping themselves submerged to their shoulders, they urged one another to go first.

"Go on! You go and see if Krishna plays any tricks. We will go after you."

The young girls were shivering with the cold, but they did not mind in the least. They had Krishna's full attention. As they spoke to each other, they threw glances up at him in the tree, where he sat smiling broadly.

One of the braver girls called up to Krishna, "You are making us freeze to death. It isn't fair. How can we come out and get our clothes while you are sitting there? We are eternally devoted to you and will do whatever you ask, but we don't think it is right that you ask us to break the codes of good behavior. If you don't give us back our dresses, we'll tell your father. And if he doesn't do anything, we'll complain to the king!"

The gopis nodded in unison. They feigned annoyance, relishing every moment of the exchange.

Krishna said, "If you really are devoted to me, and if you really will do anything I ask, then come here in good cheer and take away your clothes. If you don't, then I will simply keep them. Go ahead and complain to my father. He's old and can't do anything anyway."

The girls realized they had no choice. In any event, they wanted to do whatever Krishna wished of them. And they were also becoming fearful that some other man might pass by. Assuring each other that coming out to fetch their clothes was the best idea, they left the water one by one, covering their modesty with their hands as best they could.

Krishna felt great pleasure to see the gopis prepared to do his bidding. They were from high-class families and to appear unclothed before a man was unthinkable for them. To test them

even further, Krishna grinned and said, "You girls have surely offended the god of the waters, Varuna, by bathing naked. I think you had better seek his pardon. Fold your hands above your head and bow down to him."

Without hesitation, each girl did exactly as Krishna had suggested. The religious law books of the time declared that a woman could only bare herself to her husband, so the gopis knew that by this act they had effectively become Krishna's wives. Their prayers to Durga had yielded the desired result.

Krishna handed the girls back their clothes and they got dressed quickly. But they did not move from the spot. They stood together, shyly glancing at Krishna.

Understanding their desire, Krishna said, "I know that you have worshiped Durga simply to get me as your husband. Your goal has been achieved and before long we shall consummate our relations as husband and wife. I shall call you when the time comes, but for now return home to your families."

Slowly and reluctantly, the gopis began to walk along the forest path toward their homes, turning back frequently to look again at Krishna, who stood watching them.

And so it is said that those who wish to find God must be ready to bare themselves before him, discarding the coverings of selfish desire and possessiveness.

## THE NIGHT MEETING

When autumn arrived, Krishna's mind turned toward love and he remembered his promise to the gopis. A full moon shone from the starlit sky and night-blooming lotuses opened under its cooling rays. Blossoming jasmine flowers filled the forest with sweet fragrance. In that pleasing environment, Krishna started to play his flute. Carried by a gentle breeze, the transcendental flute song reached the gopis in their homes. They immediately recognized it as a call from Krishna. Enchanted by the sound, they stopped whatever they were doing and headed at once for the forest.

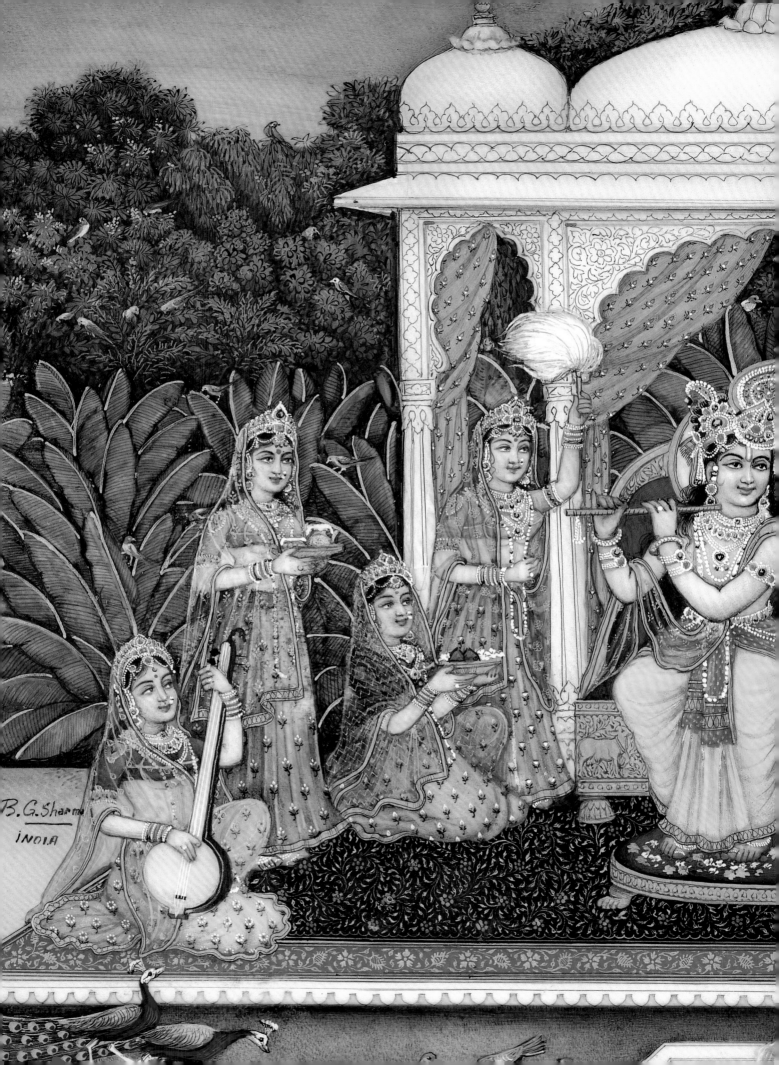

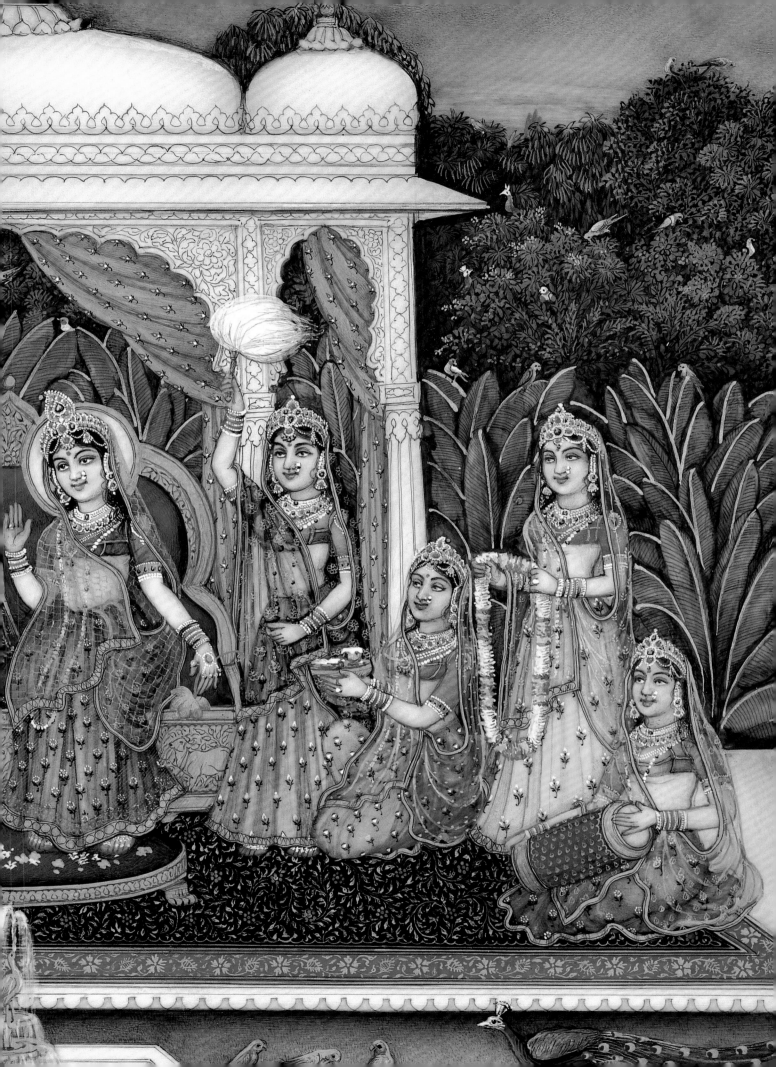

Some of the gopis were cooking, but they simply left the pots boiling on the stove. Others were serving food to their families, or breastfeeding their babies; some were eating, others attending to their husbands, but nothing mattered. They all dropped everything and ran off.

Some wanted to decorate themselves with cosmetics and dress nicely, but were so eager to see Krishna that they could not do it properly. Their make-up was applied haphazardly and their clothes put on in disarray, their skirts and petticoats wrapped around their shoulders and their shawls tied around their hips.

As some of them dashed away, their family members tried to check them. "Wait! Where are you going?"

"To Krishna. Can't you hear his flute? He is calling us."

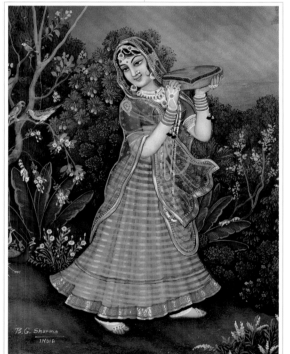

But even as their husbands, fathers, brothers and other relatives protested, the gopis ran out into the night without looking back, their hearts and minds fixed on Krishna. Some of them were forcibly restrained and even locked in their rooms. These gopis simply meditated intensely on Krishna and became fully absorbed in pure spiritual consciousness. They felt simultaneously both the unbearable pain of not being able to go and immeasurable ecstasy in their total meditative trance.

Those gopis that managed to escape raced toward the forest, their earrings swinging back and forth. They glanced about furtively, each hoping she was the only one to have heard the flute and that none but she was going to Krishna. Wanting only to satisfy their Beloved, the girls lost all shyness, sobriety and fear. Within a short time, many thousands of gopis had assembled under the banyan tree where Krishna stood, the flute held to his lips.

On seeing that everyone had arrived, Krishna put down the flute and addressed them in charming tones, "Welcome to you, most fortunate ladies. What brings you here at this hour of the night? I hope nothing is wrong. Is there anything I can do for you?"

The gopis looked at each other and smiled. Krishna's teasing words thrilled them. He knew very well why they had come. Had he not summoned them with his irresistible flute melodies?

Krishna went on speaking, a smile playing round the corner of his lips. "You must know that the forest is a dangerous place at night. So many ferocious animals are on the prowl. You are just young girls and really should not be out alone like this. Go home before something happens to you."

The gopis said nothing. They kept smiling at Krishna, enthralled by his speech. He surely did not want them to go back. His expressions and looks in their direction belied his words. They glanced at him coyly as he went on.

"You are surely the most beautiful girls imaginable and I am more than pleased to see you, but still I think you should return home. Your husbands and guardians must be worried. They are no doubt looking for you in great anxiety. Go back and bring them peace of mind."

Krishna's insistence that they turn back began to annoy the gopis. Was he actually serious? He knew they could not go back now. It was too late for that. They had already sacrificed their honor and respect for his sake. Was he now going to reject them? Feeling embarrassed by his apparent equivocation, they began to look away, directing their eyes to the enchanting forest.

"The forest is certainly most beautiful tonight," said Krishna. "Now you have enjoyed looking at the view, you should go back and take care of your husbands and children. That is a woman's first duty. To take a lover and commit adultery is condemned and leads only to suffering."

Krishna concluded by telling the gopis that the best way to increase their feelings for him was to think of him, talk about him and chant his name. They could do that just as well at home. Indeed, he implied that their love would increase even more in separation than in physical proximity.

Hearing such discouraging words, the gopis felt morose. They hung their heads and began to shed tears. Breathing heavily, they scratched the ground with their toes. It seemed they would not get the chance to dance with Krishna, as they desired. How could he be so unkind? They were ready to do anything for him.

Gradually regaining their composure, the gopis addressed Krishna in faltering voices. "You are very cruel to us, Krishna. We have left everything behind to come to you. You should not reject us in this way. We have no other resort aside from you. Even our so-called protectors at home all depend upon you, for you are the Supreme Soul of all living beings. What is more, attachment to anything other than you brings misery. Our relatives in this world cannot make us happy. Only you can do that, Krishna. We therefore appeal to you to accept us as your maidservants. We have cherished this desire for so long, you cannot refuse us now."

Different gopis spoke, telling Krishna how they had become entirely infatuated with his beauty, power and unlimited qualities. They addressed him as the Supreme Person and begged that he be merciful to them. If he did not, then they would have no more use for living.

Hearing the gopis' despondent words, Krishna finally put aside his masquerade and embraced them. He and the girls began wandering through the forest, enjoying each other's company. In their midst, Krishna resembled the brilliant full moon surrounded by the stars of the firmament. With Krishna sometimes singing solo and sometimes harmonizing with the gopis, they reached the sandy banks of the Yamuna River.

When the gopis saw how much Krishna was enjoying their company, they began to feel proud. Each felt that she alone was the most fortunate woman in the world. Krishna noticed this and so, in order to check their pride, he suddenly disappeared from their midst.

## THE MADNESS OF LOVE

When Krishna vanished, the gopis looked forlorn and lost. They scurried about everywhere, trying to find him. They could think only of his playful glances, his embraces and loving smiles. Fully immersed in thought of him, they began to imitate the way he walked and talked, acting out some of the wonderful deeds he had done in the past. "I am Krishna! See how I walk and play my flute. Just watch my dancing!"

With every moment of his absence, the gopis' pain increased and they began to address the trees and bushes, as though they were people who could answer them. "Have you seen Krishna?" they asked. "O fig, banyan and palm trees! Has Krishna passed this way? Tulasi tree, you are so dear to him; surely you know which way he went. Oh, where has he gone? Someone please tell us. We gopis are about to lose our minds."

The gopis ran in all directions, crying piteously. They asked the earth, the sky and the wind to show them Krishna, but to no avail. All they could see was the empty forest. They then began praying to the earth.

"Tell us, O Goddess, how did you become so fortunate? You have been blessed by the touch of Krishna's feet. What pious deeds did you perform in previous lives to get such a benediction?"

Seeing trees that were heavy with fruits, some gopis said, "We think you must have seen Krishna come this way since you are bowing down in reverence. Tell us quickly, where did he go?"

One girl noticed the creepers wrapped tightly around some majestic trees. "My dear creeper, plainly you are jubilant and are therefore clinging to your husband the tree. Is this because Krishna passed by here and touched you? Where is he now?"

The gopis wandered deeper and deeper into the forest, asking the plants, animals and even stones if Krishna had come that way. As they walked, they suddenly noticed Krishna's footprints on the ground. The distinctive markings on his soles, such as a flag, thunderbolt and trident, were clearly visible. Excitedly, they began to follow them. Then they noticed another set of footprints alongside Krishna's.

"Whose prints are these?" they exclaimed. "It looks like they were made by a young girl. Surely this is a gopi who has been especially favored. She must have worshiped Krishna in some special way. How great is her fortune!"

The gopis spoke as if jealous, but in their hearts they felt ecstasy to see that Krishna had been so pleased by one of them. They knew that this was Radha, his dearest lover, whose virtues were so great that it was impossible for anyone to be envious of her.

"Look, here Radha's footprints are gone, but Krishna's are deeper. He must have been carrying her."

They ran further down the forest path. "Look here! There are flower petals strewn all about. It seems that the two lovers stopped here. Krishna must have decorated his beloved's hair with flowers. How did she manage to capture Krishna's heart? He is self-sufficient and fully independent; he has no need of anything from anyone, and yet he has chosen to show such love to Radha. She must be very proud of her position, thinking herself the greatest of Krishna's lovers."

Then, just as they were thinking such thoughts, they found Radha sitting alone beneath a tree. Her face was buried in her hands and her shoulders shook gently as she wept. Her friends ran up to her, whatever feelings of jealousy they may have had gone.

"What happened? Is Krishna here?"

Radha looked up at them with swollen eyes. "I do not know where he has gone. Like a foolish child, I asked him to carry me. He lifted me into his arms for a few moments, but then I became too proud and now he is gone. Oh, I am lost. What shall I do? Where shall I go to find Krishna?"

Commiserating with each other about their situation, the gopis sat down on the sandy bank of the Yamuna River. The night drew on but they did not notice the time. They were fully immersed in thoughts of Krishna, singing about him and discussing his activities continuously.

As midnight approached, Krishna suddenly reappeared in the midst of all the gopis. Wearing yellow silk garments and a garland, he appeared more beautiful than even Cupid. The gopis jumped up at once and crowded around him. It seemed as though water had been poured on wilting plants—so completely were they transformed by his return. Gazing at his face, they felt relieved of all distress. They quickly made a soft seat for him with their shawls, and he happily sat down.

Even while worshiping him, the gopis' looks of love were tempered by frowns of anger. With a tone of slight annoyance, they asked him a question, through which they meant to reproach him. "Krishna, please instruct us in the ways of love. We have heard that there are three kinds of lovers. One type simply takes from his beloved. Another reciprocates nicely even if his lover is contrary. And the third type are those who are just indifferent to the persons who love them. Which of these is the best?"

Krishna said, "So-called friends or lovers who only show love when they are receiving it are just like merchants. It is self-interested and cannot really be called love. Others, like one's parents, show selfless love and affection. These are true well-wishers, who follow the path of righteousness. The last class, who are indifferent, might be self-absorbed and not even notice another's need, or they might not act because they see nothing in it for themselves. Or they might be callous and ungrateful, or even outright inimical."

Krishna was smiling and exuding love toward the gopis, who were listening intently to his every word, nodding and wondering which of these last four categories of indifferent men he belonged to. But Krishna went on, explaining that he belonged to an entirely different category of lover.

"I may not appear to reciprocate immediately, my dear gopis, but in fact I act as I do because I wish to intensify your love for me. Ultimately, this ever-increasing infinite love itself is the only thing that can bring you happiness and fulfillment. I know that you girls have abandoned everything for my sake, so how could I ever stop loving you? Please do not harbor any bad feelings for me because I left you all alone here in the woods.

In fact, I never really left you, but was always close by, closer to you than even the breath of life."

Merged in loving ecstasy, the gopis then followed Krishna as he led them along the Yamuna's bank. When they arrived at a large clearing in the forest, he commenced his *rasa* dance. He expanded himself into numerous forms in order to dance with each and every gopi and to reciprocate with her individually, exactly according to her temperament. Due to his mystic potency, each girl felt that Krishna was with her alone. They danced in a circle, with the gods appearing in the sky above them and playing various celestial instruments. The gopis' ornaments, bangles and ankle bells jangled as they danced. They pressed their cheeks against Krishna's and embraced him, even as they performed a variety of graceful movements to the transcendental harmonies.

The dance continued throughout the night. Completely forgetting their anxieties, the gopis felt as if they had left their bodies and been immersed in the blissful ocean of spiritual love.

Those who look at the *rasa lila* as a metaphor for the mystical journey see each step of the story as a different stage of the soul's passage to God. Krishna's flute playing represents God's first revelation of himself to the individual seeker as the All-attractive. Helplessly drawn in by God's infinite attributes, the true seeker abandons everything for his sake, overcoming tests coming from friends and family. Then, even when on the threshold of union with God, the soul is put through various tests by God himself. Sometimes God seems to repulse her, sometimes he unveils himself; the joys of union and pain of separation combine to purify her love. Then, when the heart is fully sanctified by this love, he gives himself fully in the blissful circle dance of eternal union.

## PURE SELFLESSNESS

hen Krishna reached the age of sixteen, he left the village of Vrindavan and went to live in the city of Mathura. The sage Narada was a regular visitor at his palace. He knew Krishna's glories well and had even become a little proud that he was able to have such unfettered access to the Lord.

One day, Krishna decided to teach Narada a little lesson in the real meaning of selfless love. Feigning a headache, he told the sage that he was feeling ill.

"Then we must fetch the best physicians," said Narada, wondering what divine pastime Krishna was showing.

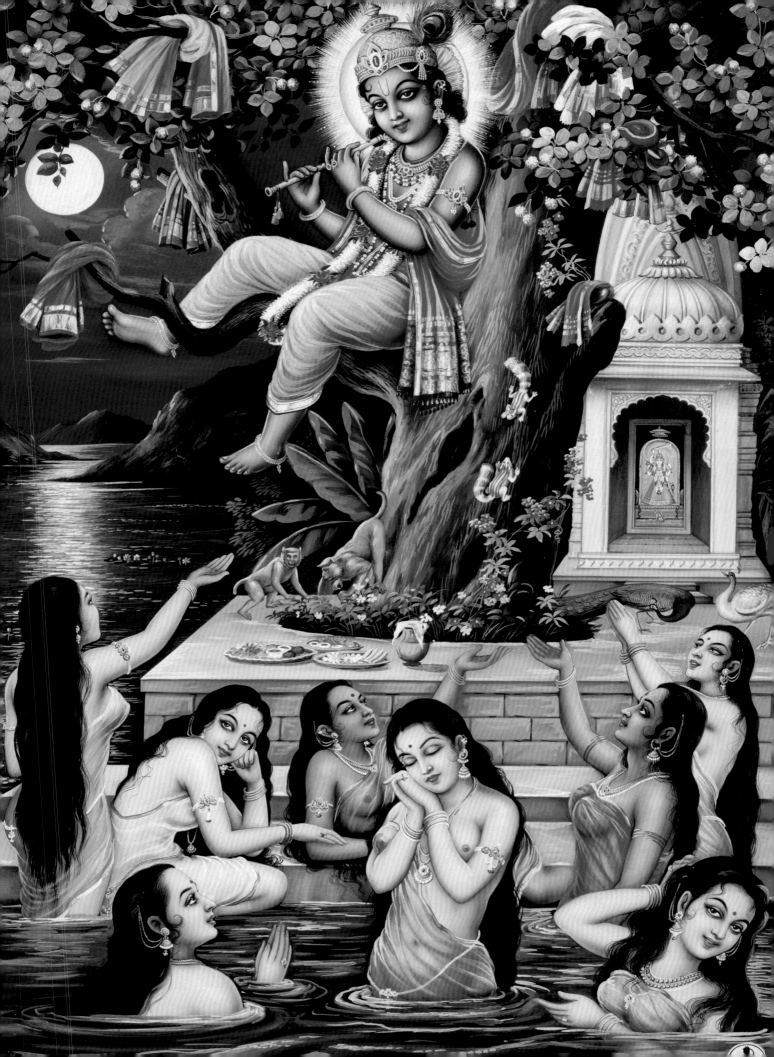

"No, I do not think any physician can help me. The only cure for my headache is the dust found on the feet of my devotees. Please fetch me some and I will put it upon my head."

Narada looked surprised. In India, one traditionally touches the feet of a superior as a sign of respect, but no social inferior would ever allow his own feet or even the dust from them to touch a superior. So what devotee would be so senseless as to allow the dust from his feet to touch Krishna's beloved head?

But Krishna was insistent, so Narada did as asked and went to try and find someone who would consent to do Krishna's bidding. But though he looked everywhere, he could not find anyone willing to do as he asked. "What? Put the dust of my feet on Krishna's head? Surely not. What kind of hell would I go to for that?"

Narada went back to Krishna to report on his failure. Krishna then asked the sage if he himself might not oblige him. "I could never be so presumptuous," protested Narada. "Your feet should go on my head, not the other way round."

"Then go to Vrindavan and ask the gopis, who spend their days pining for me."

Narada left at once and went to the gopis, to whom he recounted Krishna's request. Distressed at any thought of Krishna's suffering, the gopis began without any hesitation to gather the dust from around their feet, creating little pits in the ground in their enthusiasm to get at it.

"How can you do that?" Narada asked. "You will surely get a bad karmic reaction if your foot dust goes on Krishna's head."

"We don't mind," answered the gopis. "We shall go to hell, if necessary, just as long as Krishna's headache is cured."

Narada shook his head in wonder. He had learned a valuable lesson. The highest love is manifest when one is ready to subject him or herself to the greatest danger in order to relieve the beloved of even a minor discomfort.

*yo brahma-rudra-śuka-nārada-bhīṣma-mukhyair*
*ālakṣito na sahasā puruṣasya tasya*
*sadyo-vasīkaraṇa-cūrṇam ananta-śaktiṁ*
*taṁ rādhikā-caraṇa-reṇum anusmarāmi*

*I meditate on the dust of Radharani's lotus feet, which has unlimited*
*power, for though Krishna is not easily attainable by any of the great*
*gods or sages—like Brahma, Shiva, Shuka, Narada or Bhishma—*
*just a little of that powder quickly brings him under her control.*

# RADHA

AMONG THE GOPIS, RADHA STANDS OUT AS SUPREME. INDEED, AS MORE PEOPLE BECAME AWARE OF HER ATTRIBUTES, THEY INCREASINGLY RECOGNIZED HER UNIQUE POSITION IN THE HINDU PANTHEON. THOUGH AT FIRST SHE WAS JUST ONE AMONG MANY GOPIS, IN TIME SHE WAS SEEN AS THE SOURCE OF THEM ALL. RATHER THAN BEING UNDERSTOOD AS A METAPHOR FOR THE INDIVIDUAL SOUL, SHE WAS SEEN AS THE SUM TOTAL OF ALL DEVOTION AND LOVE. FINALLY SHE WAS UNDERSTOOD NOT SIMPLY AS AN APPENDAGE TO GOD, BUT AS ONE MODERN VAISHNAVA SAINT CALLED HER, "THE DIVINE MOIETY"—THE EQUAL AND COMPLEMENTARY ASPECT OF GOD.

So it is said in the *Chaitanya Charitamrita*: "Radha and Krishna are the One Soul, but in order to enjoy the exchange of love, they have separated themselves eternally."

The novel idea is this: when the One without a second takes on attributes for the sake of experiencing joy, it brings about dualities. Where there is male, there is also female. Thus, for those who revere Radha and Krishna, the existence of a supreme male god without an equal supreme female goddess makes no sense; it is like saying that an electron can exist without a proton.

Nevertheless, the specific nature of this Divine Couple is that on both sides there is complete dependence. Theirs is the inner world of love and intimacy, and not the outer world of conquest, public glory and magnificence.

Krishna Das Kaviraj explains this identity of Radha and Krishna in his *Chaitanya Charitamrita*:

"Radha is the transformation of Krishna's love. She is his personal energy, who brings joy to him and his devotees. The essence of this joy is love of God, and the essence of that love is

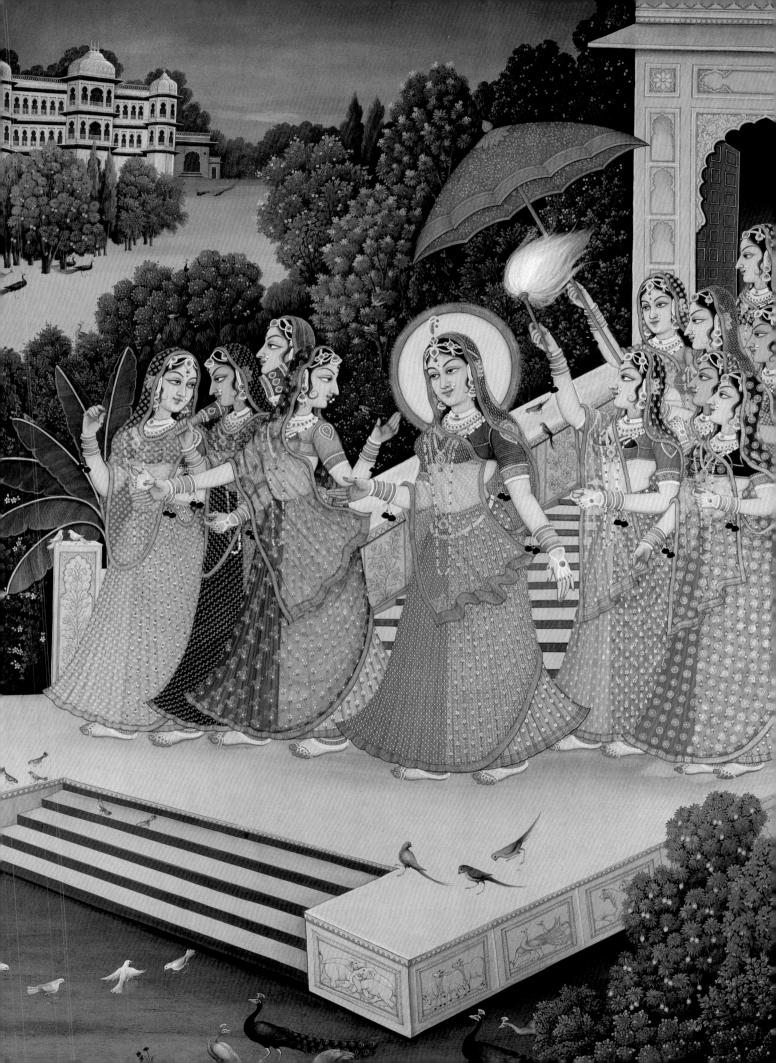

transcendental emotion, known as *bhava*. This culminates in the ultimate stage of divine love known as *maha-bhava*. Radha is the embodiment of *maha-bhava*. She is the repository of all good qualities and the crest jewel of all Krishna's energies.

"Radha is the storehouse of spiritual love and her countless expansions manifest unlimited aspects of that love. Resplendent and most beautiful, she is worshipable to everyone; she is the protector of all and the mother of the entire universe. She is the full power and Krishna is the possessor of that power. Radha and Krishna are inseparable, like musk and its scent, or fire and its heat. They exist in two distinct forms only to enjoy the exchanges of love."

## THE POWER OF LOVE

The Vaishnavas see Radha as the fountainhead of all other goddess forms. In her expansions as Durga or Kali, she displays her material power, but as Radha, she displays only the power of love. As the story of the gopis illustrated, this is the greatest of all powers. The progression of spiritual consciousness by the practice of yoga and meditation moves one increasingly toward divine love. The practitioner gradually loses interest in anything other than its attainment. No extraordinary power or opulence can attract the person who experiences the divine loving ecstasy of union with the Absolute. Radha alone bestows this ecstasy, of which she is the epitome and pinnacle. Without her grace one cannot achieve the spiritual perfection of unadulterated love. Therefore she is always worshiped along with Krishna.

In the famous Maha Mantra, the word *Hare* is a form of the name Harâ, which means divine energy and thereby indicates Radha. By chanting this mantra, one simultaneously supplicates both Radha and Krishna, praying to be connected with God through the medium of his loving energy. The great saint Chaitanya taught that one who attains success in this chanting will experience the true meaning of love.

When Chaitanya became absorbed in these ecstatic visions, he exhibited "transcendental madness" in the mood of Radha as he continuously called out to Krishna. Although it may never be possible for anyone to experience such levels of intensity, the Vaishnavas nevertheless feel similar sentiments by engaging in the practice of bhakti yoga taught by Sri Chaitanya.

Nevertheless, a word of caution is required. The esoteric pastimes displayed by Radha and Krishna are manifestations of pure spiritual energy and have nothing to do with matter or material desire. Unscrupulous artists and writers sometimes try to depict these pastimes in mundane erotic terms, but this is mistaken. Those on the spiritual path understand that spiritual ecstasy is experienced in proportion to one's detachment from selfish desire, or lust. All branches of the Vedic literature describe licentiousness as an obstacle to spiritual realization. How then could the highest spiritual experience be in any way sexual? When one attains complete perfection in yoga or God realization, he or she is liberated from the material body. Fixed in an eternal spiritual identity, bodily impulses such as lust no longer arise.

The pure love of Radha is described in many wonderful stories in which she exhibits a range of loving feelings. Sometimes these feelings appear negative, such as anxiety, grief or anger, but they are always manifestations of different types of ecstasy. Free from any tinge of selfish desire, Radha's emotions are displays of the most sublime sentiment. Again, our ability to appreciate these sentiments depends upon our spiritual evolution. Eventually we reach a stage where simply hearing them plunges us into an ocean of transcendental bliss, where all material miseries are forgotten.

Spiritual activities are enacted in the realm of the absolute; hence there is no difference between the activities themselves and descriptions of them. This is realized when we reach transcendental consciousness, which can be achieved simply by hearing spiritual narrations such as the pastimes of Radha and Krishna. It is both the means and the goal. Just as when we place wood in fire it becomes hotter and hotter until it becomes fire itself, so in the same way, by placing our mind in the "fire" of spiritual discussion, we become spiritualized to the point of complete purity. Then we can fully enter the spiritual world and participate in the divine activities that eternally take place there.

Here then are a few of the stories told about Radha.

## THE GITA GOVINDA

The religious and literary history of India was profoundly changed by a simple poem written in the twelfth century. Jayadeva's *Gita Govinda* inspired Hindu art, literature and religion by telling the story of the loves of Krishna and Radha in a way that broke the customary idea of an all-powerful male God. With his poem, Jayadeva changed forever the way that people in India looked at the Deity.

On the surface the *Gita Govinda* appears to be a simple human story of infidelity, jealousy and reconciliation, but ultimately it establishes the supremacy of female qualities and their ability to conquer the most powerful forces. The poem starts where the *rasa lila* leaves off—Krishna surround-

ed by hundreds of gopis, all vying for his love and attention. He looks to the entire world like erotic love incarnate, intoxicated by the spring, his every limb draped by an adoring goddess.

When Radha saw this, she became jealous and angry, and left the scene in a huff, unable to tolerate being treated as just another of Krishna's many mistresses.

Suddenly, Krishna became aware of Radha's absence and he saw that his playboy prowess was an indulgence he could not afford. She was irreplaceable. Without her, he was lost. Radha was, he realized, the thread that kept his world in order. Unable to bear even one more moment without her, he abandoned all the other admiring beauties of Vrindavan and began looking for her.

Krishna searched high and low, but could not find her anywhere. The arrows of love pierced his weary mind until he was exhausted. He called out to the god of love, "Don't mistake me for Shiva and burn me with your arrows. Why do you rush at me vengefully? I have already been vanquished by the living goddess of love!"

While Krishna was in this state of despair, one of Radha's girlfriends came to him and described how Radha herself was suffering in his absence. She too was unable to endure being without him and had begun to regret her anger. "She curses the sandal balm and moonlight, which instead of cooling her body seem to scorch it. The normally refreshing evening breezes feel to her like the vapors arising from a nest of poisonous snakes."

The messenger appealed to Krishna to come and heal Radha of her love-sickness. "She found your neglect unbearable," she admitted, "but now I am worried that she will not be able to survive your separation if it endures any longer."

Knowing that the messenger girl had come on her own initiative and not at Radha's request, Krishna asked her to go back and communicate his own condition to Radha, to assure her of his devotedness to her and to ask her to forgive him. "Tell her that in her absence, I have abandoned the comfort of house and home to roam the wild forest. Unable to tolerate the comfort of my bed, I toss and turn on the bare ground, calling out her name throughout the night. I meditate on her without sleeping; I chant magic spells in the hope of attaining the curing elixir of her touch."

Radha was immediately won over on hearing Krishna's profession of love and asked her go-between to bring them together. Radha then began anxiously awaiting her lover's arrival; she dressed and decorated herself and the bower where she hoped to soon hold him in her arms. Each falling leaf made her think that Krishna was about to arrive. She went into long periods of reverie, or occupied herself in a hundred different activities in the joyful anticipation of his coming.

But Krishna did not come at the appointed time. Radha could not understand what had kept him. She became angry at her girlfriend for having cheated her with false promises, for it seemed that once again Krishna had let himself be waylaid by some other temptress.

When Krishna finally arrived, it was too late for lovemaking. His eyes were bloodshot from his sleepless night and his body covered with the telltale signs of infidelity— lipstick and mascara stains, scratches and love bites.

Radha denounced him bitterly: "You killed the witch Putana when you were a child, but I now understand that you take pleasure in murdering women. What a cruel cheat you are to flaunt your infidelities in front of me! Fie on you, Madhava! Don't try to make any excuses. I don't want to hear your lies. Go back to her if she means that much to you!"

Krishna left in shame, but it was not long before Radha again began to feel remorse and self-pity. Seeing her weakness, her friend intervened once more on Krishna's behalf. "When he is tender, you are harsh. When he is pliant, you are rigid. When he is passionate, you are hateful. When he looks at you expectantly, you turn away. You leave him just when he starts to behave in a loving manner. Why are you so perverse? Don't turn all your anger on him, for he has his pride too. You don't want to lose him, so why condemn your heart to loneliness? Let him come and apologize."

Finally Radha admitted Krishna into her presence, but not with open arms. Krishna had to beg her for forgiveness. In his stammering appeals, Krishna implored her, "Give me just a drop of nectar from your lips and return my life to me. Place your flower-like foot on my head, and dispel the poison of our separation."

Mollified by this act of complete surrender and subordination, Radha forgave her lover. The two fell into each other's arms in blissful reunion.

Radha then manifested herself as the independent goddess who had fully conquered the empire of Krishna's heart. She fearlessly ordered him to dress and decorate her, to do her every bidding as a servant and lover, a role that he joyfully accepted as the fulfillment of his entire being.

There is a legend about Jayadeva, who is said to have felt some reticence about writing that Krishna fell down at Radharani's feet to beg for her forgiveness. So, before committing these words to paper, he decided to take his bath and think over his inspiration.

While he was away from the house, however, Krishna himself came inside, disguised as the poet. He took the palm leaf with the verse awaiting completion and wrote in the words: "Place your flower-like foot on my head, and dispel the poison of our separation."

Jayadeva's wife Padmavati was surprised to see her husband back so quickly from his bath and asked him, "What are you doing here? You only left just a moment ago."

The disguised Krishna answered, "I had an inspired thought on my way down to the river and was afraid I might forget it, so I came back to write it down."

Not long after Krishna had written the fateful words and gone, the real Jayadeva returned. This time, Padmavati was truly astonished to see him. She said, "Just a few minutes ago you were writing in your manuscript. Then you left a second time to go for your bath. How could you have finished it and come back again so quickly? I am beginning to wonder who that was and who you are!"

Jayadeva went straight to his desk and looked at where his unfinished lines had been. When he saw the words that Krishna himself had written, the hair stood erect over his entire body and the tears came pouring from his eyes. He called to Padmavati and said, "You have been blessed and your life's purpose fulfilled, for you had the good fortune to see Krishna himself. I am so lowly that I did not have that opportunity!"

## The "Snake" of Separation

After the rasa dance, life in the cowherd community took on an entirely new atmosphere. Krishna and the gopis were constantly finding new ways to meet each other and express their love.

One day the powerful mystic Durvasa came to Radha's village. Everyone knew Durvasa was prone to become angry at the smallest thing, and so they hid to avoid any possibility of receiving his curse. But Radha was not afraid. She greeted him nicely and lay flat on the ground in obeisance.

"Dear girl, I am most pleased with you," said Durvasa. "I bless you that your cooking will always taste like ambrosia and whoever eats it will never become ill."

Word of this blessing reached Krishna's parents, Nanda and Yashoda, and they came to see Radha's family to ask that she be allowed to cook for Krishna. Out of friendship with Nanda they agreed, but Radha's mother-in-law Jatila was not happy. Knowing of Krishna's tricky ways and how he was always trying to meet with Radha, Jatila did her best to prevent Radha from going to Nanda's house.

One day when Jatila had stopped Radha from seeing Krishna, she felt an unbearable pain. She uttered a cry and fell down on the ground in a swoon. One of her close friends ran to Jatila to tell her.

"Mother, come quickly! Radha has been bitten by a snake."

Jatila rushed to her daughter-in-law, who was lying completely inert on the ground. "What shall we do? Who can help?" she cried anxiously.

Just then Radha's friend Champakalata came into the house with a young girl. "This is the daughter of the sage Garga. She is expert in healing snakebites. Leave her alone with Radha and she will deal with the poison. She knows many effective mantras."

"Very well. I will wait outside."

Jatila left the room and as soon as the door was shut, the girl began speaking loudly from within the room, "Ah, there you are, you wicked snake. I see you. Why have you come here? What made you bite this young girl?"

Jatila, who had her ear pressed to the door, heard a deeper, hissing voice answer, "I have come from Mount Kailash to destroy Jatila by killing this girl, who is her life and soul."

"Why? What has Jatila done?"

"She will not allow Radha to cook for Krishna. This is a great mistake."

"But is it too late to save Radha?"

"If Jatila promises to never again prevent Radha from cooking for Krishna, I will retract my poison and she will be saved."

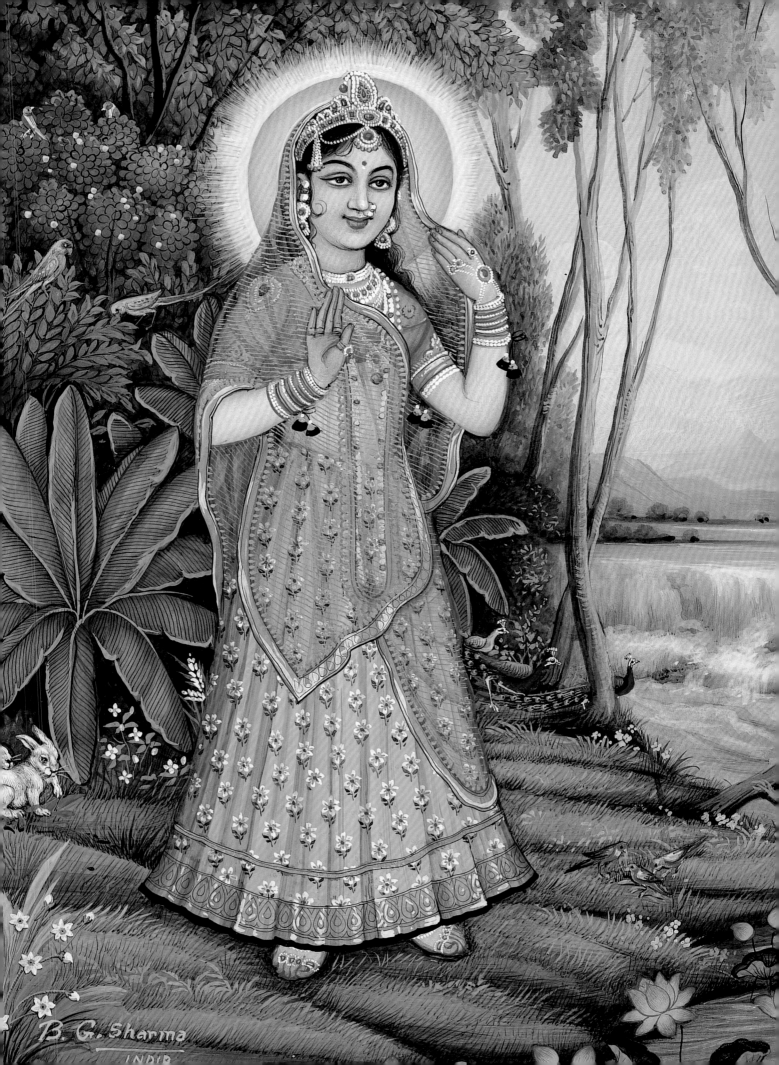

B. G. Sharma
INDIA

Jatila had heard enough. She burst into the room. "I promise! I promise! Radha will go every day to Nanda's house. Just please do not let her die!"

As soon as she said this, the color returned to Radha's face and she sat up. Jatila ran over to her and helped her stand. "Dear girl, you are well. You must go and cook for Krishna straightaway."

Radha then left with her friend and the girl who had "cured" her. As soon as they were out of sight, the so-called girl revealed herself to be Krishna in disguise.

## DEVASTATION

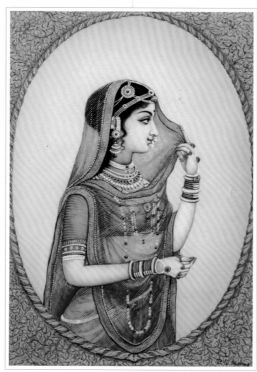

Not long after the *rasa* dance, the time came for Krishna to fulfill the prophecy that had preceded his birth. He left Vrindavan, where he had spent his childhood, to go the city of Mathura. Vasudeva and Devaki, his parents, had been arrested and imprisoned there by the tyrannical King Kamsa. Kamsa had learned of Krishna's presence among the cowherd community and made numerous attempts to kill him by sending powerful wizards and demons there, but they had all failed; Krishna dispatched them, one by one. Finally, Kamsa decided that the best way to kill Krishna would be to bring him to Mathura where he could employ all his forces to deal with him. He therefore sent Krishna's uncle Akrura to invite him to Mathura on the pretext of participating in a wrestling competition. Wanting to kill Kamsa and release his parents, Krishna agreed to go.

When Radha heard that Krishna was going to leave the village, she was devastated. Disbelief engulfed her. She knew she was everything to him, and he everything to her. How then could he leave, and how could either of them go on living if they were apart? She refused to accept that Krishna was going and simply carried on in denial, as though nothing was to change.

The next day, however, all the gopis gathered on the road that led to Mathura, surrounding Akrura's chariot. They threw themselves in front of the horses in the hope that they could stop this tragedy from unfolding. When Krishna promised that he would be back soon, the other residents of the village, equally mortified by his imminent departure, pulled the gopis out of the way to let the chariot pass.

Radha was overwhelmed with grief. Her sole reason for living was dwindling to a speck in the distance, enveloped by the clouds of dust thrown up by the horses' hooves. How could she live without Krishna? Why had the furrows made by the chariot wheels not opened further so that the earth could swallow her up?

Seized with anxiety, she stood up and sat down repeatedly, breathing heavily. She felt sure she would die then and there. If that happened, Krishna would surely rush back. But if she died, he would certainly be unhappy, for she was sure he loved her. How then could she die? She only wanted to make him happy.

Completely bewildered, she spoke with her close confidante Vishakha. "My dear friend, Krishna is gone and with him goes my life. What shall I do? If I could see him in my dreams, that would be my great good fortune. But sleep plays tricks on me now. Indeed, it has become my enemy. Since hearing of Krishna's departure, I cannot sleep at all."

Shedding constant tears, she turned to another friend. "Dear Lalita, please listen to my plight. I cannot describe how my heart burns. It has sunk in an unfathomable sea of sorrow. Where can I find peace?"

Time passed and Krishna did not return as he had promised. Radha lost all interest in eating and appeared emaciated. Her body took on a blackish hue, similar to that of Krishna. She cried incessantly and found no peace anywhere. If she could speak, it was only to talk about Krishna, but her speech at times seemed like the ravings of an insane person. She could think of nothing but Krishna. Burning with the grief of separation, she resembled a lotus scorched by the midsummer sun.

Catching her friend's hand, she poured out her heart. "Oh, where now is the glory of Nanda's family? Where is he whose complexion is like a sapphire, who wears a half moon ornament in his hair, who plays the flute exquisitely and dances so expertly? I am dying of a disease of the heart and he is the only cure."

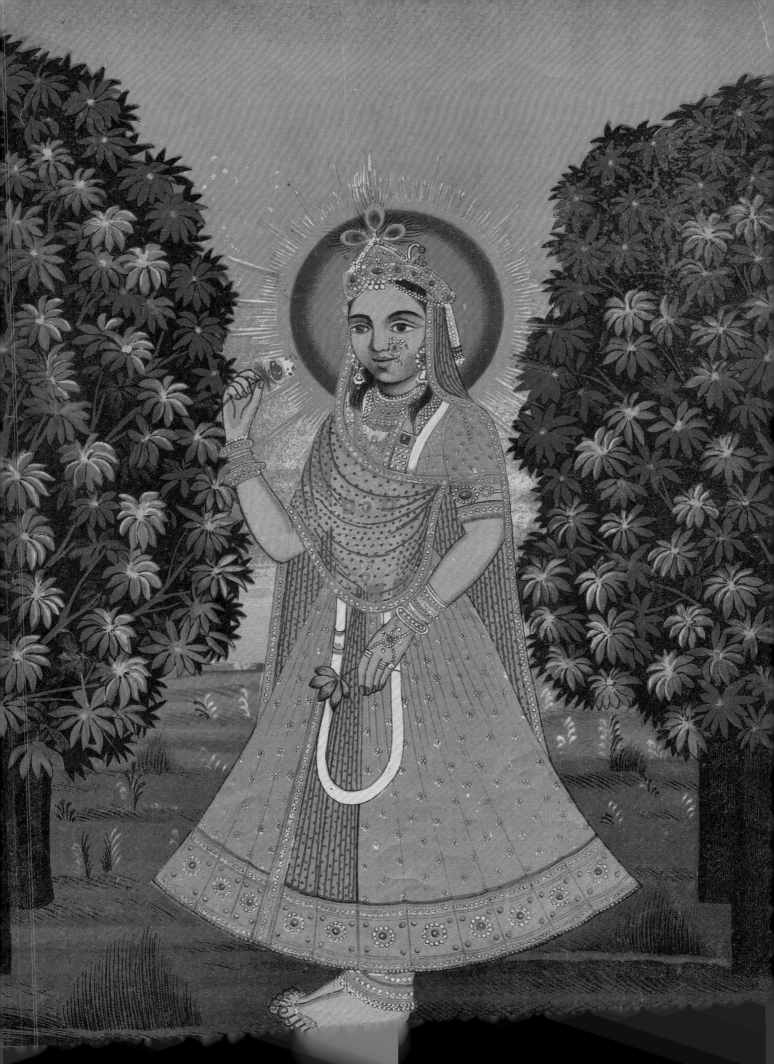

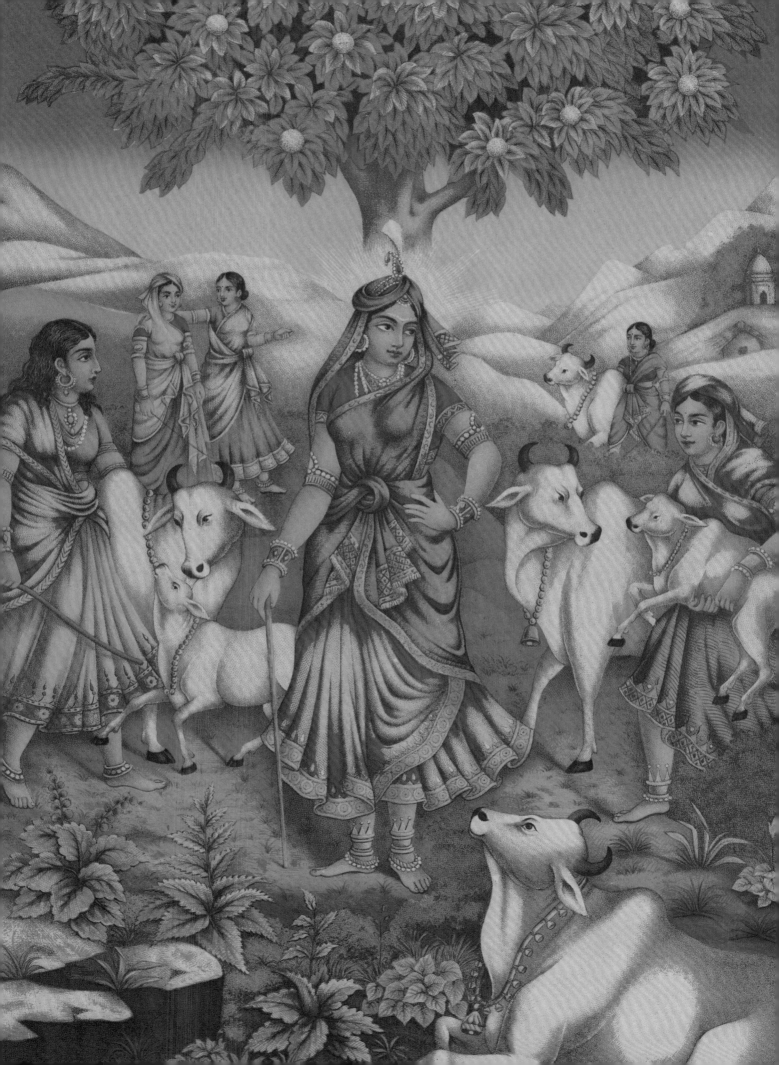

In her transcendental grief, Radha sometimes laughed like a madwoman. At other times she rolled on the ground and called out for Krishna, asking of his whereabouts from anyone and everything without distinction. Sometimes she fell unconscious and lay perfectly still, hardly even breathing. At other times she ran about, searching everywhere for her beloved.

As her friends, themselves suffering a similar ecstatic pain, tried to comfort her, Radha poured out her feelings. "Krishna's beauty, his fragrance, his touch, the sound of his voice and his kisses are all indescribably sweet. Attracted by this sweetness, my senses pull the chariot of my mind like five wild horses trying to go in five different directions. Pulling it this way and that, they threaten to destroy it completely. How can I endure this torture?

"If you ask me to rein in my senses, what can I say? I cannot become angry with them, for Krishna's attraction is irresistible. My mind is not strong enough to control them. His words wreak havoc in my heart. They bind me to him so that I have no life of my own. His fragrance is maddening and his smile bewitching to the hearts of all women. Tell me, where shall I go? What shall I do?"

In this way, Radha lamented day and night for Krishna.

## RADHA'S DIVINE MADNESS

T he *Bhagavata Purana*, the main source for the accounts of Krishna's life, tells us that he never returned to Vrindavan, but that Radha and the gopis pined for him unceasingly for the rest of their lives. Even so, Krishna often exchanged letters with them. In one particular incident recorded in the Purana, Krishna sent his closest associates, Uddhava, with a message for the gopis. Uddhava was a minister and Krishna's closest confidante in Dwaraka, the great city he had gone on to build as his capital. But there was another purpose to sending Uddhava; Krishna felt that even he could learn about the deeper aspects of divine love from the gopis.

Krishna called for Uddhava and, taking hold of his hand, said, "My dear friend, please go to Vrindavan and bring joy to my parents and the gopi girls. All of them are constantly absorbed in thoughts of me, and have all but lost their minds.

They only manage to keep on living because they expect me to return some day. Alas, I cannot go there, as I have promised to remain here in Dwaraka with my birth parents, Vasudeva and Devaki. But I also feel a deep obligation to sustain the lives of the gentle inhabitants of Vrindavan. Therefore, dear Uddhava, please take my message of love and in this way pacify their minds."

Uddhava respectfully received Krishna's message and then mounted his chariot and set off for the cowherd village. After arriving, he first spoke to Nanda and Yashoda, and then went to see Radha and the gopis. Uddhava's bodily features closely resembled Krishna's, and when Radha saw him, her already intense meditation on Krishna was heightened even further. She gazed at him in wonder. Who was he and why had he come? He looked like Krishna in every respect; even his dress was the same. Fortunate indeed was the woman who had him for her husband.

Radha and her friends all innocently surrounded Uddhava. "Who are you, good sir? What brings you here?" they asked.

"I have a message from Krishna," Uddhava replied.

"Oh, from Krishna. It is just as we thought. Why has he not returned to us? Surely he has sent you here only for the sake of his parents. Family ties are strong, but the ties of friends and lovers are not so. Men like Krishna enjoy young girls only out of their own interests, abandoning them just as soon as their purpose is fulfilled, exactly as a bee leaves a flower once it has taken the nectar."

Displaying their loving anger in various ways, the gopis bustled Uddhava to a secluded place. Although criticizing Krishna, they wanted nothing more than to hear his message. They began discussing him among themselves, recalling all the many activities he had performed in Vrindavan. Uddhava looked on in astonishment as they sang loudly and cried shamelessly, expressing their ecstatic grief of separation from Krishna. Radha was particularly afflicted and she began to speak with a bee that was humming around her feet, imagining it to be a messenger from Krishna.

"Honeybee! Stay away from me. I know your whiskers are smeared with pollen from the flowers of Krishna's garland, which has been crushed by some other woman he has embraced. Don't let it touch my feet. And don't expect any charity

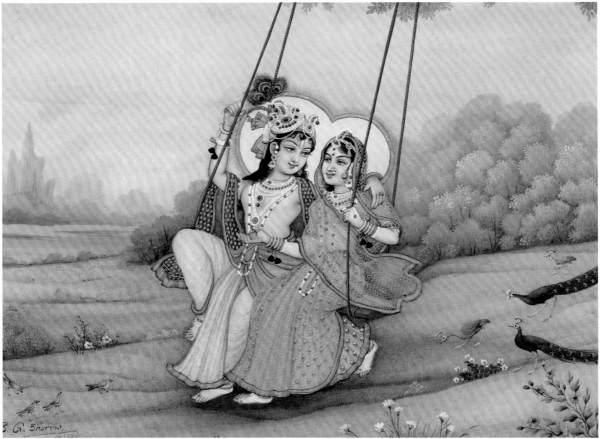

from me for delivering your message. Go to the royal women in Dwaraka. They are the ones Krishna now loves, not us. Tell them about him, for we already know everything there is to know about the fickle and deceitful Krishna."

Completely distracted and oblivious to her surroundings, Radha spoke as if mad, addressing the bee that hovered nearby. The greatly experienced Uddhava saw that she was exhibiting all the symptoms of transcendental ecstasy, fully absorbed in a trance of divine love. Uddhava was deeply moved. He had never seen anything like it. The other gopis were also showing signs of divine madness as they spoke about Krishna. Uddhava tried to pacify them.

"My dear gopis, surely you have attained complete perfection in life. Your love for Krishna is no ordinary thing. It is very hard to achieve such love. Even the great sages cannot surpass your devotion to Krishna. You have abandoned everything for his sake and I feel blessed to witness your ecstatic emotions of loving separation from him. Indeed, the whole world is blessed by you fortunate ladies."

Uddhava went on to tell them that he had a message from Krishna, and the gopis urged him to deliver it. They were not interested in hearing their own good qualities extolled. "Please tell us Krishna's words," they said.

Uddhava smiled and began to speak. "This is his message for you: 'You should always know that you can never be separated from me at any time, for I pervade all things as the soul of creation. Nothing is outside of me, and I am present everywhere.'"

In his message Krishna further explained this philosophical point and then said, "'But, my dear gopis, the reason I have stayed away from your sight is to intensify your loving feelings for me. Due to your constant absorption in me you will soon see me again, have no doubt.'"

Pleased to hear Krishna's words, which increased their remembrance of him, Radha and the gopis thanked Uddhava and continued to speak and meditate deeply upon Krishna. Uddhava stayed with them for some months, marveling at the intensity of their love and talking with them about Krishna in order to dispel their sorrow of separation.

## RADHA AND KRISHNA MEET AGAIN

Some years after Krishna's departure from Vrindavan, there occurred a solar eclipse. Advised by their astrologers, the residents of Vrindavan decided to go to the pilgrimage site of Kurukshetra to perform sacred rituals to counteract any negative effects the eclipse might have.

It so happened that many of the residents of Dwaraka, including Krishna and his family members, the Yadavas, had also come there for the same purpose. The Yadavas appeared quite majestic as they thronged the vast fields of Kurukshetra with their great chariots, elephants, decorated horses and royal dress. They appeared like so many gods descended to earth with their celestial consorts. The blare of their brass instruments and the beating of their drums created a tumultuous sound. In their midst sat Krishna and Balaram, divinely ornamented with gold and jewels, attracting everyone's gaze.

The simple gopis felt overwhelmed by this display of opulence. They looked in wonder at Krishna's many thousands of wives, with their fine silk saris and dazzling ornaments. How could they ever compete with such sophisticated beauties?

But Krishna was deeply desirous of meeting his beloved gopis again. After the religious rituals were complete and he had spoken with the other Vrindavan inhabitants, he immediately took the gopis to a secluded place. Completely lost in their love for Krishna, Radha and her friends gazed at him, cursing the fact that they had to blink and momentarily stop looking at him. They took him into their hearts and embraced him to their full satisfaction. But Krishna, seeing that they were in an ecstatic trance, expanded himself into many forms and physically embraced each one of them, thus bringing them back to their senses.

As the gopis came back to external consciousness, Krishna laughed and said, "My dear girlfriends, do you still think of me, even though I left you behind and have stayed away from you for so long? Please know that I did this for the sake of my relatives, in order to protect them from their enemies. Perhaps you think I am an ingrate for not reciprocating with your unconditional love for me, but I am actually never separated from you."

Krishna spoke again as he had in his message delivered by Uddhava, explaining the philosophical truth of his presence everywhere. The gopis listened quietly, never taking their eyes from him even for a moment. But Radha, even though seeing Krishna standing before her, felt strangely dissatisfied. The philosophy spoken by Krishna did little to assuage her longing to be with him again as she previously had in Vrindavan. This manifestation of Krishna was not at all like that simple cowherd boy she had known. Here he was dressed like a prince, surrounded by the trappings of royalty. Where now was the young boy who had played his flute and completely captivated her heart? Where was that sweet feeling of intimacy and love they had enjoyed as they strolled along the banks of the Yamuna? This meeting in such formal and ceremonious surroundings could not compare with those transcendentally sublime days in Vrindavan.

All the gopis felt the same. Krishna's philosophical instructions felt like the scorching sun when they wanted only the cooling moon of his smiling face. Yet they could not go with him to Dwaraka, even if he invited them. They were simple cowherd women. Vrindavan was their home and they wanted Krishna to come back. However, they knew it was too late for that. Krishna had too many responsibilities now in Dwaraka. He could not go back to the carefree days of his youth. Thinking only of the time when they had been together in Vrindavan's groves and forests, and realizing that he would not return, Radha and her friends bade Krishna farewell and made their sorrowful way back to Vrindavan without him.

## THE FORM OF TRANSCENDENTAL LOVE

Radha is the very emblem or personification of devotional love for God, or *bhakti*. Followers of the bhakti path aspire to follow in her footsteps and serve Krishna in a similar mood of pure and selfless love. They see this as life's perfection, as the greatest possible attainment. Everyone is seeking happiness, and pure love for God is accepted by the Vedas as the highest possible happiness. Radha alone bestows this love.

"Not even Krishna himself can reach the limit of Radha's divine qualities," declaim the poets, "How then can we expect to count them? And yet, unable to restrain ourselves, we do as best we can."

Raghunath Das, one of Radha's greatest devotee poets, describes her in one famous hymn as follows: "Radha's body has been carved out of the most resplendent gem of ecstatic love. It shines with lustrous splendor after being massaged with the fragrant oils of the other gopis' friendship.

"She then bathes, first in waves of the nectar of compassion, then in a shower of the elixir of youth, and finally takes a third bath in an ambrosial flood of charm. Her graceful limbs are next covered with the silken garment of her modesty, powdered with the saffron of beauty's essence, and dappled with the black musk of her passionate love for Krishna.

"The ornaments decorating her body are the transcendental ecstasies of love, headed by jubilation. She is garlanded with the flowers of her wondrous virtues, such as her sweet-tongued speech. She is daubed with perfumed powders that exude from her sometimes sober and sometimes restless moods. Craft and possessiveness are concealed within the braids of her hair.

"Her forehead is brightened with the gem of her immense good fortune. Krishna's name and qualities are the earrings that swing in splendor and jubilation from the lobes of her ears. The reddish color of her lips is produced from the betelnut of her obsession for Krishna. Her artful dealings in loving affairs constitute the black ointment around her eyes.

"So decorated, she sits down daintily on the bed of pride within the inner apartments of her bodily fragrance, wearing the dangling necklace of the fear of losing her beloved, even when he is in her arms. Her breasts are concealed in the bodice of her wounded vanity. The music of her lute is her fame and glory, which withers the faces and hearts of her competitors. She is the embodiment of love itself.

"Her preparations complete, she places her lotus hands on the shoulder of a friend, the personification of her budding youth, and stands ready to pour the intoxicating wine of her deep love for Krishna."

The poet Krishna Das Kaviraj also celebrates Radha in another Sanskrit hymn:

"If one asks what is the origin of love for Krishna, the answer is that it is Radha alone. Who among those who love him has such unparalleled virtues?

Even Krishna's exalted queens, like Rukmini, desire the fortunate position and excellent qualities of Radha. The goddess of fortune, Lakshmi, and the wife of Lord Shiva, Parvati, also envy her beauty and her virtue. Indeed, Arundhati, the wife of the great sage Vasishta and supreme symbol of fidelity aspires to emulate Radha's chastity and religious principles, for her mind never deviates even slightly from Krishna.

For those who worship the Goddess in her form as Radha, she is the sum total of all love for God. She symbolizes the supreme power of devotion to sway God himself. As such, she is revered as greater than God himself. Thus, in Vrindavan, the sacred land where Krishna passed his childhood, it is not his name that is on the lips of every inhabitant or used to greet people in the street, but that of Radha, *Jaya Sri Radhe* ("All glory to Sri Radha!").

She is not seen as a means to the goal of Krishna, but as the goal itself.

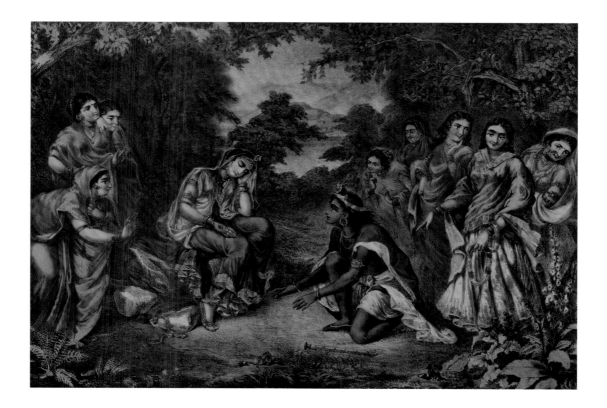

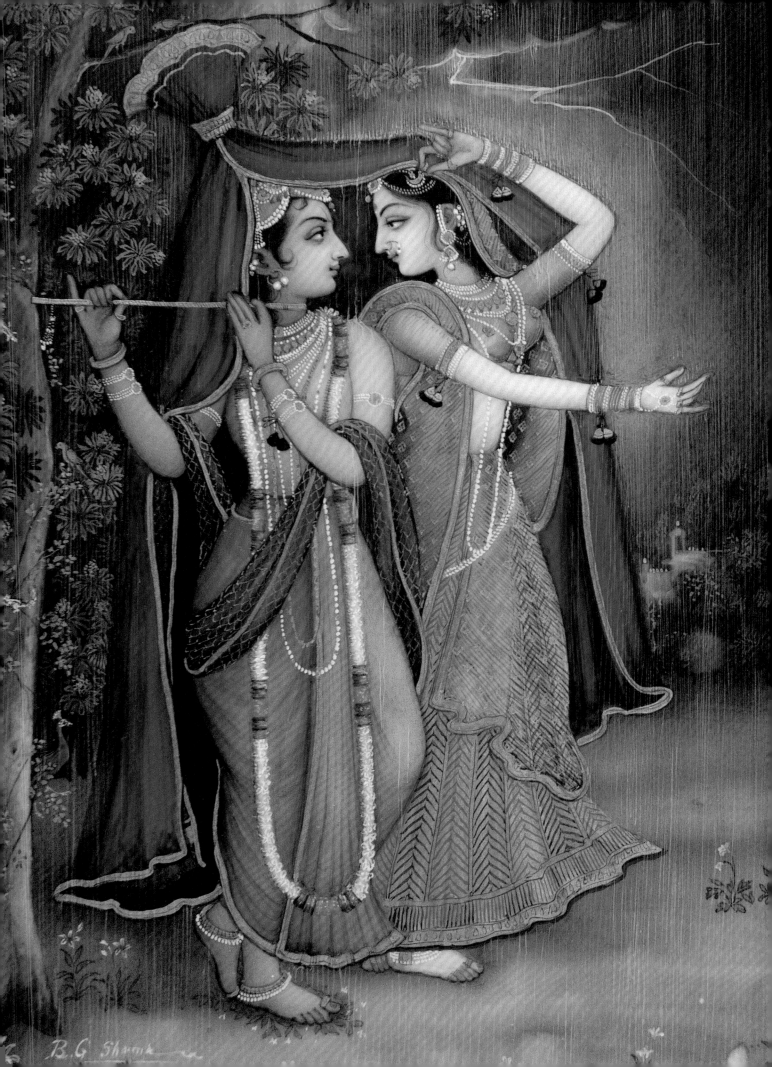

B.G. Sharma

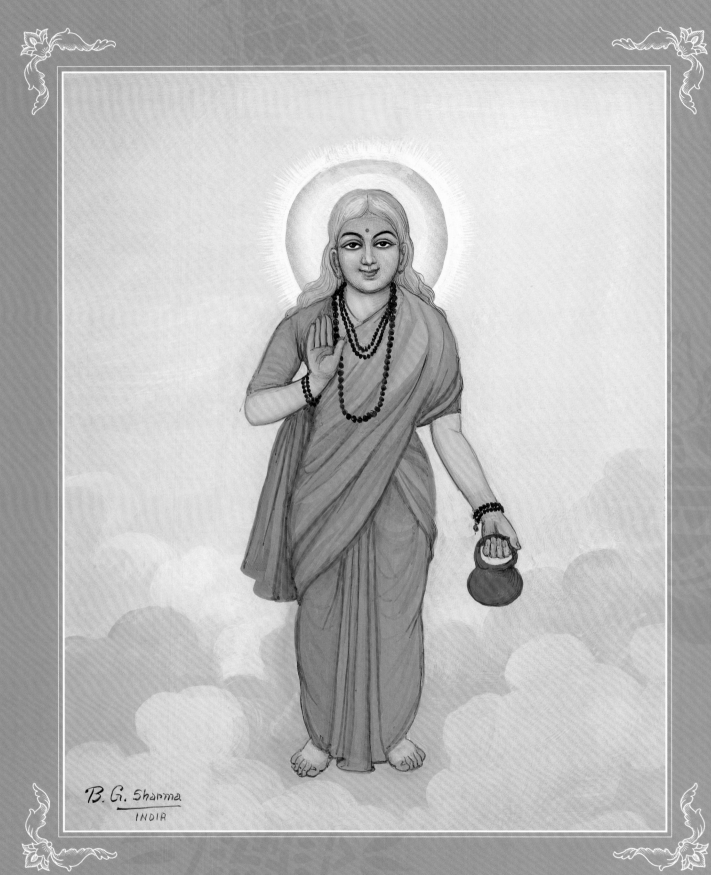

B. G. Sharma
INDIA

# PAURNAMASI

THE TIMELESS AND EVER-BLISSFUL REALM WHERE RADHA AND KRISHNA DWELL IS GOD'S INNER WORLD. THERE, THE DIVINE COUPLE LIVES IN THE MIDST OF SWEETNESS AND BEAUTY AND IN THE FULLNESS OF LOVE AND UNENDING ECSTASY.

There, the God and Goddess play the role of apparently ordinary human beings and, for the sake of increasing the drama of this eternal existence, submit to higher powers over which they have no apparent control. The presiding deity of this world, known as Goloka Vrindavan, is the goddess Paurnamasi, the personification of the Yogamaya energy, whose one purpose is to facilitate and enhance the loving exchanges between Krishna and its residents.

Paurnamasi appears in Vrindavan as an old ascetic woman. She is a prophetess and a yoginis, displaying magic powers and possessing great wisdom. Highly respected by all, she is the mother of Krishna's teacher, Sandipani Muni, and disciple of the celestial sage Narada. Like Yashoda, she acts as Krishna's superior, feeling a similar motherly sentiment toward both Radha and Krishna, but one that finds fulfillment in seeing them joined in loving union.

Paurnamasi's role may not always be apparent in these pastimes, but it is pivotal, especially in intensifying the loving mood of Krishna's exchanges with Radha and the gopis, which she is usually orchestrating from behind the scenes. As Yogamaya, her mystical power plays a part in every one of his divine activities.

At the same time, she is worshiped by devotees in this world as the energy that brings us closer to God and reveals him to us. This energy is nothing more than the Lord's own desire. It is his greatest power, so great that the *Bhagavata Purana* states that he "takes shelter" of his Yogamaya potency.

# THE GOPIS' MARRIAGES

The *Bhagavata Purana* has inspired numerous other works, one of which is *Gopala Champu* by the Vaishnava saint Jiva Goswami. In it, Jiva tells of the role Paurnamasi plays in some of the more mysterious events in Krishna's life.

Krishna is notorious for being the gopis' paramour, and the gopis for abandoning their homes and husbands to meet him secretly in the dark forest. At the same time, it is also said that these girls, the icons of exclusive devotion, virtue and pristine beauty, are his eternal consorts. How then could they possibly have ever been married to anyone but him? What is the meaning of this contradiction? To answer this question, Jiva tells the following story:

One day Vrinda Devi came to Paurnamasi in complete anxiety. Seeing the forest goddess's sorry state, Paurnamasi asked, "What troubles you, gentle maiden?"

"Alas, it seems that those girls who are eternally beloved of Krishna are about to be wed to other men."

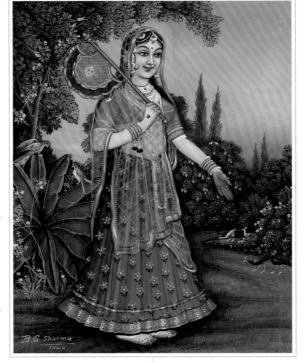

The gopi girls were reaching puberty and, in accordance with custom, their parents had made arrangements for them to be married. Vrinda had rushed to Paurnamasi immediately on hearing this news, but was surprised to see that the effulgent ascetic woman was impassive. Vrinda pressed her, "Why are you not anxious, respected lady? This is a calamity!"

Paurnamasi, who had been softly chanting on her prayer beads, looked up and said, "No marriages have yet taken place, have they?"

"No, but it will not be long."

Paurnamasi smiled. "Do not be afraid. I shall not allow this to happen. They will never accept anyone but Krishna as their husband."

With these words of consolation, Vrinda left, feeling reassured. But a few days later she returned, looking even more anxious.

"My dear mother, you said the gopis would wed no one but Krishna, but this very morning they have been married to other men!"

"Relax, my dear girl. There have been no weddings. People only think that such ceremonies have taken place through a collective dream. This is all my doing."

"But everyone believes they are real. In due course these girls will be sent to their husbands' houses."

Paurnamasi placed a hand on Vrinda's shoulder. "We shall see. Now go home and stop worrying."

In the meantime, the gopis, distraught at having been married against their will to cowherds they did not even know, decided to end their lives. Knowing that the Kaliya serpent had poisoned the River Yamuna, they made their way to its banks, intending to throw themselves into the deadly waters. They all met at the river and made ready to hurl themselves in.

Suddenly a voice spoke from the skies: "Stop! Do not act foolishly. You will never have to give yourselves to anyone you do not desire."

The young girls looked at one another in surprise. Who had spoken? And what was the meaning of it?

Just then Paurnamasi appeared before the sorrowful girls. Repeating the words of the disembodied voice, she assured the gopis that they would not have to give themselves to their so-called husbands. "Krishna will be your only consort," she said. "Why are you taking such a drastic step? Haven't you heard that even a single drop of affection for Krishna can protect one from the greatest danger? How, then, could anything inauspicious happen to you who have such deep love for him?"

The gopis stood with their heads bowed, looking like so many golden saplings bending in the wind. The tears that flowed from their eyes were like raindrops washing over the leaves of those trees.

Paurnamasi told them to return home. "Do not worry about anything. Remain obedient to your elders and all good will come to you."

The gopis, headed by Sri Radha, did as they were told. Holding each other's hands, they made their way through the woods and back to their houses. But they were still fearful. It was late summer and they were due to go their bridegrooms' houses at the end of the autumn. Time passed slowly for them, and they thought only of Krishna and how they could become his wives instead. Their faces appeared withered with anxiety and their parents began to regret having made the marriage arrangements. Like all Vrindavan residents, they too were devoted to Krishna. They knew their daughters loved him, but in accordance with religious principles they had felt obliged to find husbands for them. After all, how could every girl in Vrindavan marry Krishna?

By the end of the autumn, both the gopis and their parents were beside themselves with anxiety. The girls were wondering how they could avoid the impending liaison with their unwanted spouses, and their parents were thinking that it would kill their daughters if they made them go. But what about their religious principles? And what too about the bridegrooms' families? These families had been hearing rumors that the girls were not coming, and this was greatly disturbing their minds.

At this time Paurnamasi came to see the gopis. She again told them not to do anything rash. "You must now go to your husbands. Have faith that everything will work out well. In due course you will obtain Krishna as your true husband, exactly as you desire."

Fully trusting Paurnamasi, the guru of all the cowherds, the gopis then went to their husbands' homes. Later, they did indeed get the opportunity to become Krishna's consorts. The *Bhagavata Purana* explains how the gopis surrendered themselves only to Krishna. They went to join him in their spiritual bodies, in their true eternal identities. Only their external material bodies remained with their husbands. It is also said that by the inconceivable arrangement of Yogamaya, Krishna became those different husbands, so that the gopis were never touched by any other men.

## KRISHNA MEETS RADHA

It is perhaps astonishing that God has such a variety of activities where he seems to act just like an ordinary person. Apparently forgetting his supreme position, he acts as child, or a besotted lover, or a young boy wrestling with his friends. It is Yogamaya who brings about this forgetfulness and absorption in his divine pastimes. She makes it possible for the Lord to enjoy in so many ways, reciprocating with the loving mood of his devotees.

Krishna exhibits the greatest bewilderment in his pastimes with Radha, the chief gopi. He appears to be completely controlled by

her love for him. The *Gopala Champu* recounts the occasion when he first touched Radha, an event engineered by Paurnamasi.

Krishna had been practicing his flute, and the power of its transcendental sound to enchant had been increasing. Beginning with the birds and beasts, he had gradually developed his talent to the point where the gopis would tremble with ecstasy just on hearing the first notes as they drifted through the ether.

One day, when his playing had reached full maturity, he blew the divine flute song across the sky, whence it fell on Radha like a thunderbolt, causing her to fall unconscious to the ground. Her friends tried to wake her, sprinkling cool water on her forehead and calling her name, but to no avail.

Paurnamasi happened to be nearby, accompanied by Vrinda Devi. She said, "I know how to revive Radha. Bring her to my cottage and leave things to me."

Radha's friends agreed and carried her into Paurnamasi's house. The ascetic then told her grandson Madhu Mangala, who was a good friend of Krishna, to go and fetch him. When Krishna arrived, Paurnamasi said, "This poor girl lies unconscious because of you. Your exquisite flute playing has rendered her senseless. Now you must do something to neutralize its effects."

Krishna looked down in embarrassment. "What do you mean?"

Paurnamasi replied, "The situation is too critical for me to explain everything right now. Just touch her and she will regain consciousness."

"But who is she?" asked Krishna.

Madhu Mangala placed an affectionate arm around Krishna's shoulders. "Who *is* she? My dear friend, a cloud may not know the lightning while it is still hidden within itself, but how can it not recognize it when it flashes forth! How, then, can you not recognize the love of your life, who is an eternal part of you?"

Krishna frowned and said to Paurnamasi, who was smiling, "This is nothing but foolish prattling. However, you are revered by all the cowherds, so tell me what I should do. I am not sure about your suggestion that I touch this girl."

Paurnamasi said, "Krishna, you have made it your vocation to protect the residents of Vrindavan. This girl is Radha, the shining jewel of its womanhood, so surely she deserves your protection. What harm will come to you if you revive her with your touch?"

Krishna looked doubtfully at the supine Radha as Paurnamasi continued, "If you must remain indifferent to Radha, then

what can I say? I am a simple ascetic woman and incapable of understanding the dealings between lovers."

Seeing that Krishna was still not moved, she said insistently, "Why do you still ignore my request?"

"Because you ask me to do something that goes against the principles of religion. A man should never touch any woman but his own wife."

"Then let me take the karma for it," said Paurnamasi. "I will bless you that your piety increases. Have no fear."

"Can't you ask me to do something other than touch her?"

"This is the one thing that will unfailingly bring Radha back to life," said Paurnamasi.

Krishna gazed at Radha. She was his life and soul. Everything that was dear to him would be meaningless if she did not care for him. But was this really Radha? She appeared entirely inert. Was it just a statue placed there by Paurnamasi's magic power to test his love for her? Surely not! She was too beautiful. Tears flowed from Krishna's eyes as he gazed at Radha. His face seemed like a moonstone melting under the rays of her moon-like countenance. His body trembled and all his bodily hairs stood on end.

Paurnamasi, seeing Krishna losing himself in divine ecstasy, looked toward Vrinda, who was nearby. The forest sylph then said, "Krishna, this girl is deeply in love with you. She had been thinking that as you reached adolescence you would feel a desire to enjoy with young girls, and she wants to please you in that way. She cares nothing for her own happiness."

Krishna spoke in a faltering voice, "What must I do?"

"Place your hand over her heart," replied Vrinda.

Krishna could not agree. "That is too inappropriate," he said.

"Then at least touch her with your foot," Vrinda begged.

Krishna remained silent and Vrinda fell at his feet, pleading with him to revive Radha with his touch. Seeing that he still would not move, she forcibly took hold of his foot and placed it on Radha's chest. As she did so, Krishna was overcome with dizziness and uncontrollable trembling.

As soon as Krishna's foot touched her, Radha at once opened her eyes. Seeing him standing there, she raised her eyebrows, which resembled Cupid's flowery bow. Krishna looked into her eyes, holding her gaze for a moment that seemed like an age.

His breath would not come out and his limbs appeared frozen.

Regaining his senses, Krishna quickly looked away in embarrassment. Covering his head with a cloth, he folded his palms in respect to Paurnamasi and then ran off, tripping and stumbling as he went. Madhu Mangala held him up and teased him to lift his mood.

Radha got up slowly, thinking that she had just had a dream. "Did I really see Krishna?" she asked, crying softly and holding onto Vrinda. When she saw Paurnamasi, she bowed before her and then, with Vrinda's help, slowly made her way back to her own house.

## RADHA'S CORONATION AS QUEEN OF VRINDAVAN

 ne of Paurnamasi's greatest moments took place on the day she presided over the festive celebration of Radha's coronation as Vrindavan's queen.

In the Radha and Krishna legends, it is often said that the residents of Vrindavan bicker among themselves about who is the greater of the two. Some say it is Krishna, who was once anointed the lord of Vrindavan by the chief god Indra. Others favor Radha, who is often called the Queen of Vrindavan. But if she is indeed a queen, then when was she officially crowned? In another of his writings entitled *Madhava Mahotsava*, Jiva Goswami tells the story of Radha's coronation.

One day, Paurnamasi sent Radha a message: "Dear girl, the full sweetness of your beauty will soon be revealed in a great ceremony wherein you will be established as the supreme sovereign of Vrindavan. These celebrations will end any lamentation you have at being subject to the will of your so-called husband and your in-laws, and will fill the land of Vrindavan with joy."

But Radha had competitors. Two other gopis, Chandravali and Padma, would always vie with her for Krishna's attentions. Despite Paurnamasi's desire, these girls had been pressing Krishna to accept Chandravali as Vrindavan's queen instead of Radha. They felt they had succeeded in convincing him and were expecting Krishna to make this arrangement on the following full moon day, the first full moon of spring.

On hearing this, Radha felt betrayed by Krishna. She bit her lips in anger and hot tears fell from her eyes. How could Krishna be so cruel after everything he had said to her? Obviously it had all meant nothing. She turned to her friend Lalita and said, "I want nothing more to do with that fickle boy."

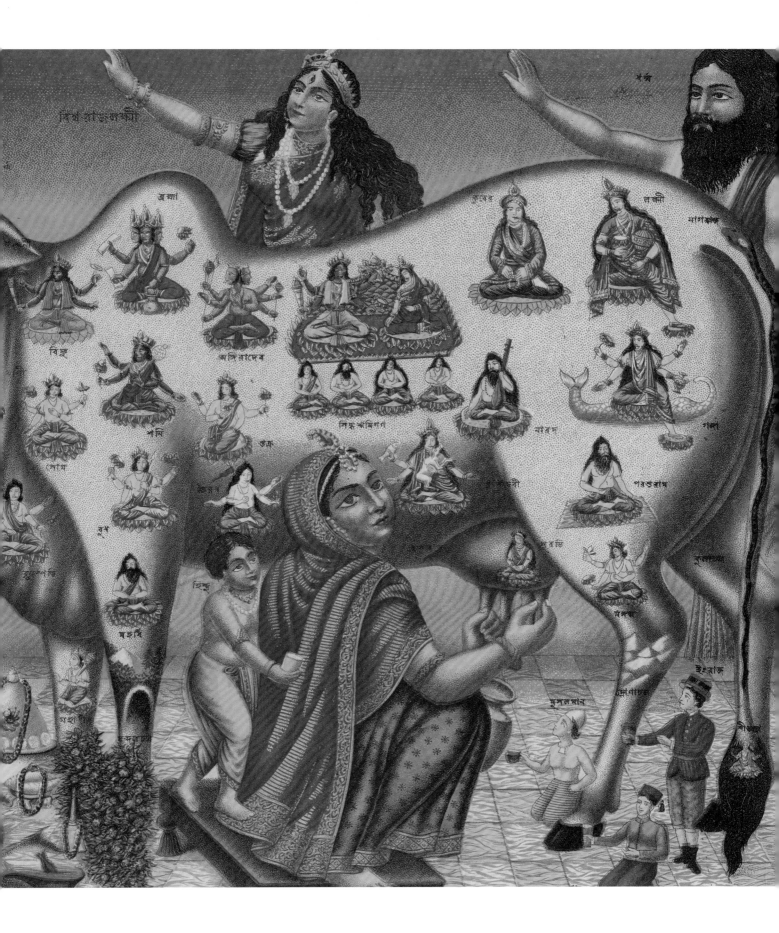

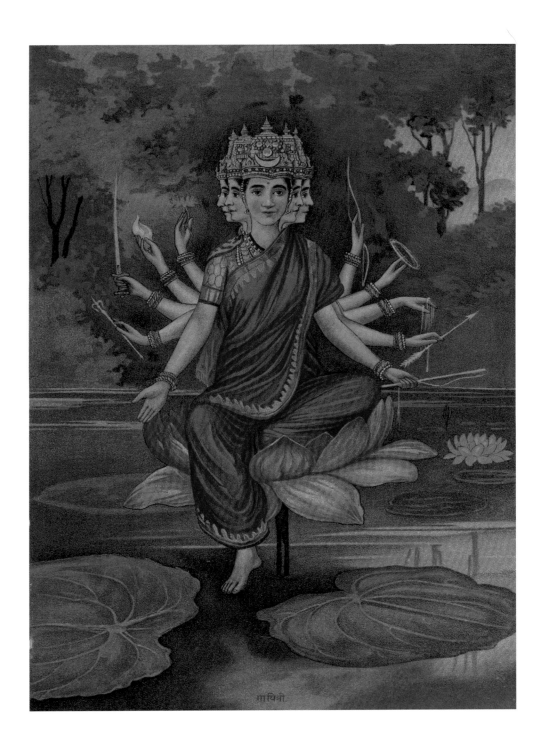

## GAURI

The "golden goddess," a mild and benevolent figure, is usually identified with Parvati, wife or consort of Shiva. In this iconic depiction, the artist portrays Gauri as a regal figure.

## GAYATRI

The Gayatri mantra, best known of all Vedic hymns, is addressed to the sun and is supposed to be recited each morning and evening by twice-born Hindu males. Personified as a goddess, Gayatri came to be identified as a wife of Brahman, who is closely associated with the Vedas.

# CONCLUSION

WHILE IT WOULD BE DIFFICULT, IF NOT IMPOSSIBLE, TO PRESENT AN EXHAUSTIVE STUDY OF ALL THE HINDU GODDESSES WITHIN THESE PAGES, MANY OF THOSE WHO ARE DESCRIBED IN THE CLASSICAL TEXTS OF HINDUISM, SUCH AS THE VEDAS AND THE PURANAS, HAVE BEEN PRESENTED HERE.

Those ancient texts also tell the stories of countless other goddesses, each of whom has a particular function in relation to the universe. Therefore we find separate goddesses of the dawn, the twilight and the night. There are goddesses of fertility and childbirth, goddesses who protect against snakebite, goddesses of sleep and even goddesses of different diseases, such as Sitala, the widely worshiped smallpox deity.

As fascinating and informative as the accounts presented here may be, it must be remembered that they constitute only the visible tip of a vast world of lore. Being almost entirely excluded from the written word, Indian women nevertheless created their own oral folk traditions, which have been preserved locally and regionally throughout the subcontinent. Thus there is an almost unlimited amount of such material—stories, songs and rituals—that is only now being discovered and collected.

Throughout this volume, it has often been observed that the God and Goddess are ultimately indivisible. Certainly many Hindu traditions have held that women in society are subordinate to men, and yet in their quest for liberation both are seen as equal partners in seeking Divinity. Transcending the mundane aspects of the male and female forms is the foundation from which Hindus propel themselves into a deeper level of spiritual awareness.

One message the Goddess delivers is that Divinity is present in the full manifestation of feminine virtue and power, and it is the duty of each individual to awaken that power in themselves. This principle reaches its highest application when aspiring to follow in the footsteps of the great goddesses of the spiritual realm, who exist beyond those of the material world. These goddesses embody a degree of devotion that exceeds our experience and redefines our understanding of the true nature of spirit and love.

But if there is one lesson that is present in Vaishnavism and its vision of Sri Radha as the fountainhead of all goddesses and the wielder of the power of love, it is that ultimately Divinity is neither male or female, but both. Yet the quest for spirituality ultimately rewards the female virtues. It was this Vaishnava spirit that informed much of Gandhi's non-violence, as he adopted the spirit of moral strength rather than physical strength. He adopted the spirit of love in the face of prejudice and misunderstanding—humility and forbearance as the true weapons of progress.

The many faces of the Goddess presented in these pages form an introduction to India's great goddess tradition. Let it stand as a small testimonial to the beauty, power and grace of the Goddess and the potential of all souls to find fulfillment and joy in worshiping and serving her divine forms.

The Publisher

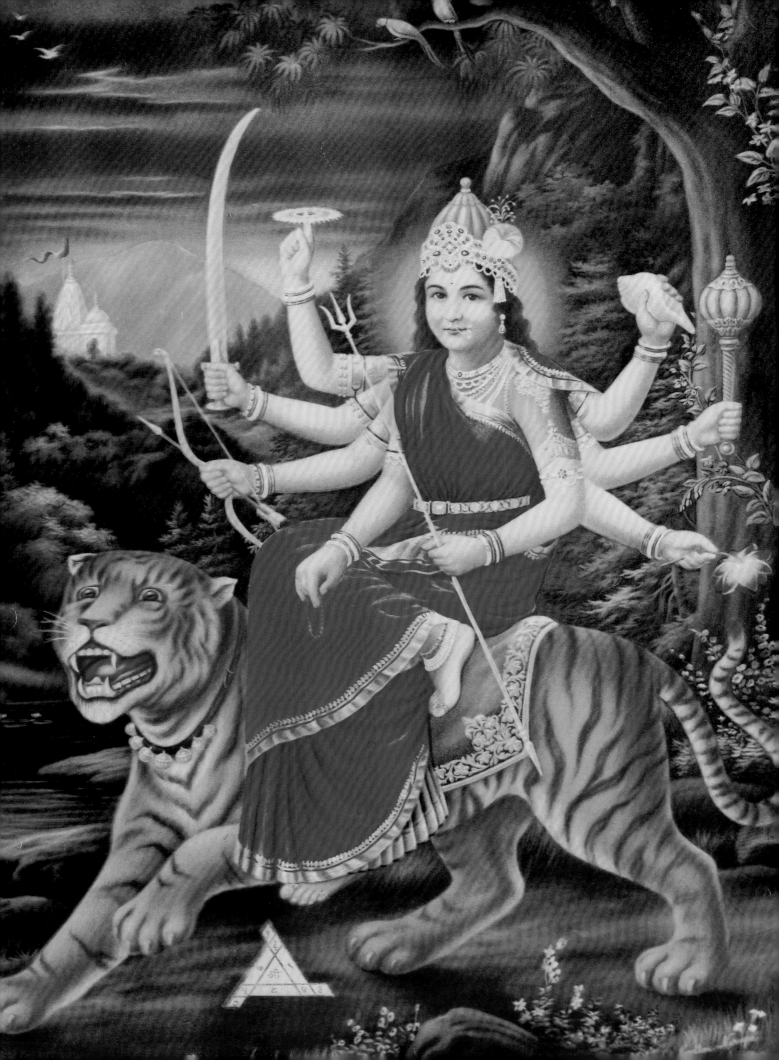

# List of Illustrations

BEAUTY, POWER & GRACE

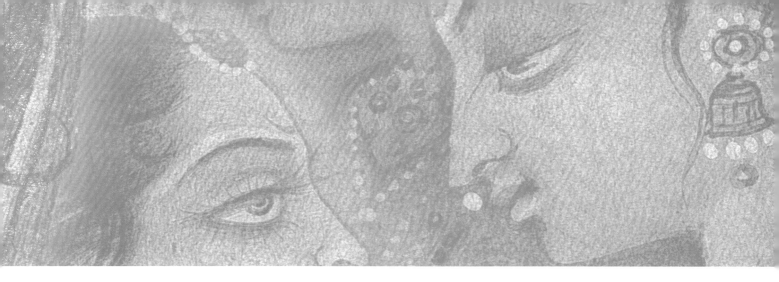

| ILLUSTRATION | ARTIST | PAGE NO. |
| --- | --- | --- |

LIST OF ILLUSTRATIONS

*Paintings with asterisks courtesy collection of Mark and Elise Boisanté*

**MANDALA**
PUBLISHING

PO Box 3088
San Rafael, CA 94912
www.mandalapublishing.com

 Find us on Facebook:
www.facebook.com/mandalaearth

 Follow us on Twitter:
@mandalaearth

© 2014 Mandala Publishing
All rights reserved. Published 2014

Illustrations by B.G. Sharma
and Mahaveer Swami

Additional illustrations by Indra Sharma and
various traditional Indian painters

Cover illustration by B.G. Sharma

Text on pages 184–187 written by
Richard H. Davis

No part of this book may be used or
reproduced in any manner whatsoever
without written permission except in the
case of brief quotations embodied in critical
articles and reviews.

Library of Congress
Cataloging-in-Publication Data
is available.

ISBN 978-1-60887-383-8

**COLOPHON**
Publisher: Raoul Goff
Design: Insight Editions
Editor: Kaitlin McComb
Production Manager: Anna Wan
Editorial Assistant: Hanna Rahimi

ROOTS of PEACE    REPLANTED PAPER
Insight Editions, in association with Roots
of Peace, will plant two trees for each
tree used in the manufacturing of this
book. Roots of Peace is an internationally
renowned humanitarian organization
dedicated to eradicating land mines
worldwide and converting war-torn lands
into productive farms and wildlife habitats.
Roots of Peace will plant two million fruit
and nut trees in Afghanistan and provide
farmers there with the skills and support
necessary for sustainable land use.

Manufactured in China by Insight Editions

10 9 8 7 6 5 4 3 2 1

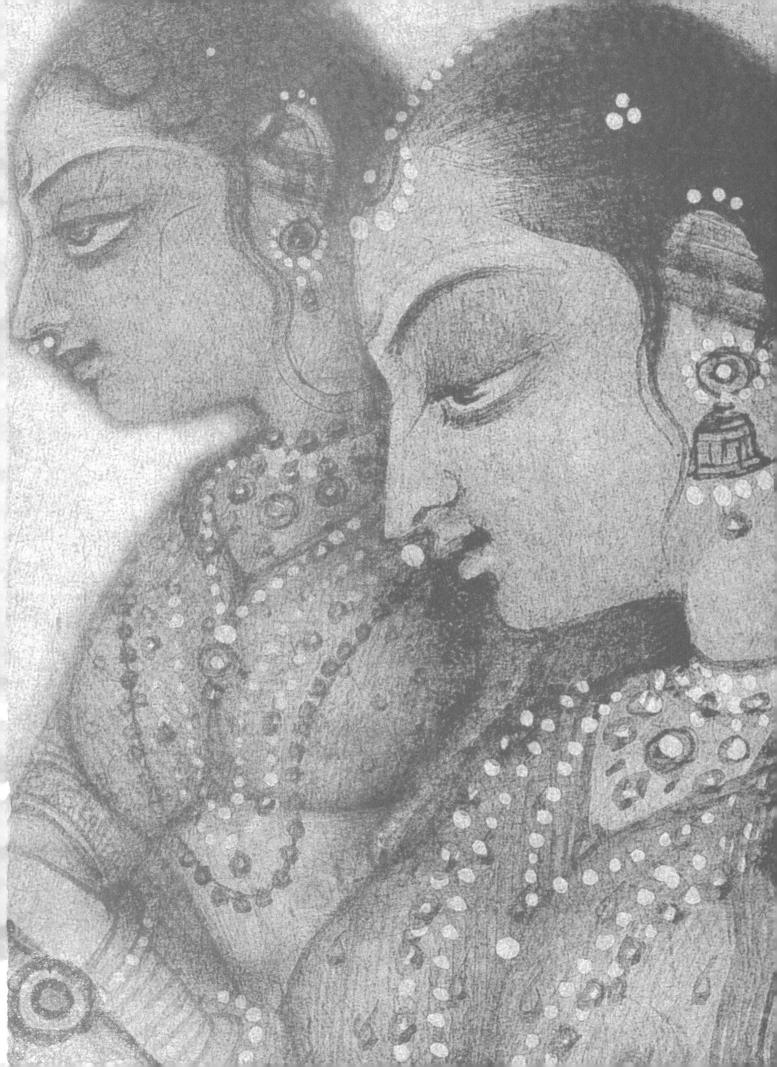

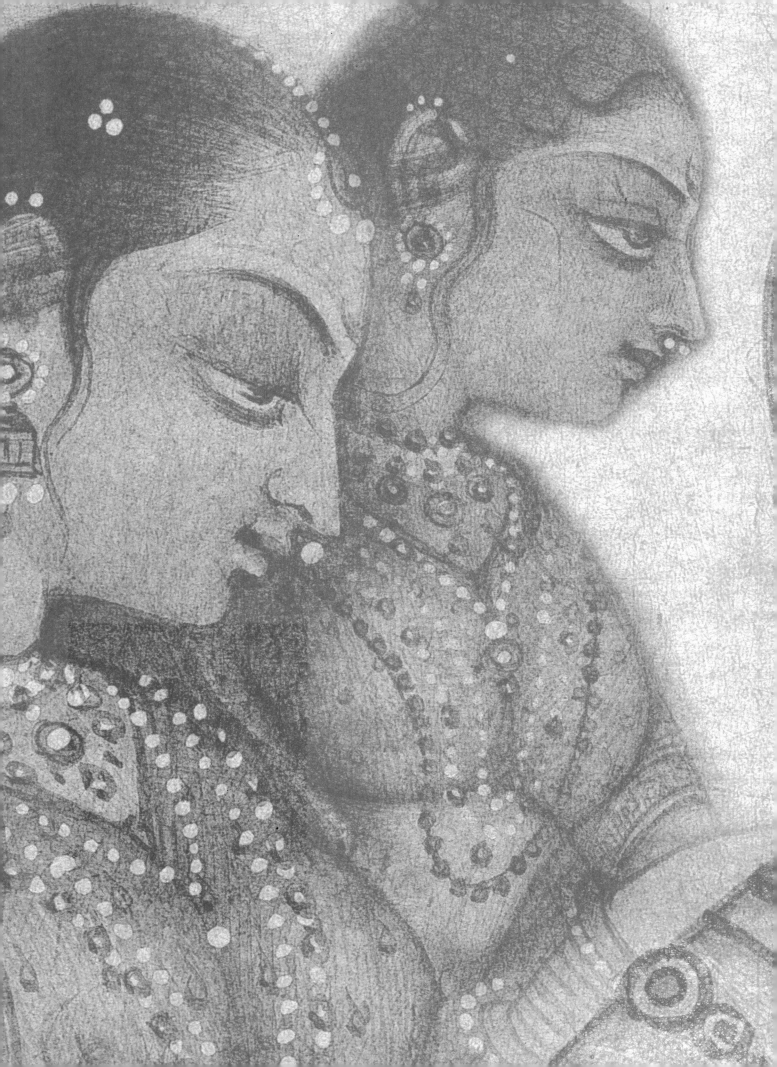